Complete
Painting
and Drawing
Handbook

DK

LONDON, NEW YORK, MELBOURNE,
MUNICH, DELHI

Senior Editor Simon Tuite
Project Art Editor Simon Murrell
Managing Editor Julie Oughton
Managing Art Editor Louise Dick
Production Editor Kavita Varma
Production Controller Sophie Argyris
Associate Publisher Liz Wheeler
Publisher Jonathan Metcalf
Art Director Bryn Walls

First published as four separate titles
in Great Britain in 2006 by
Dorling Kindersley Limited
80 Strand, London, WC2R 0RL
This edition published 2009

A PENGUIN COMPANY

2 4 6 8 10 9 7 5 3 1

ISBN 978 1 4053 4741 9

Printed and bound in Singapore by
Star Standard

Discover more at
www.dk.com

Contents

Complete
Painting
and Drawing
Handbook

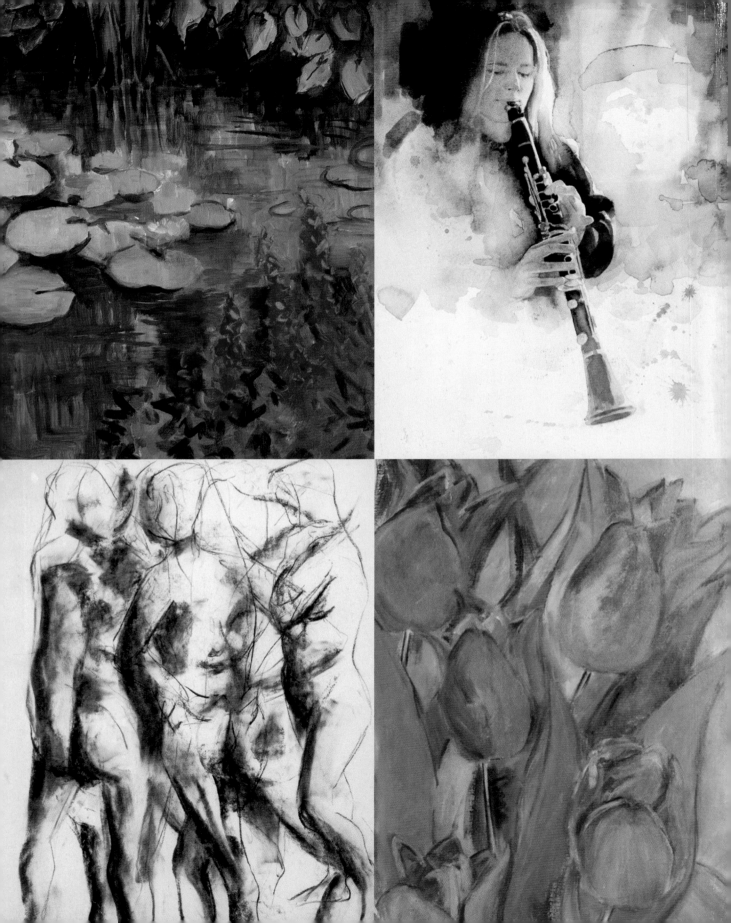

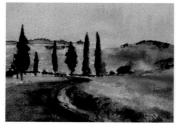 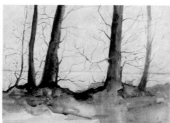 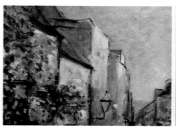 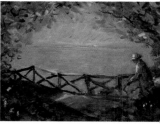

Oil-Painting Workshop

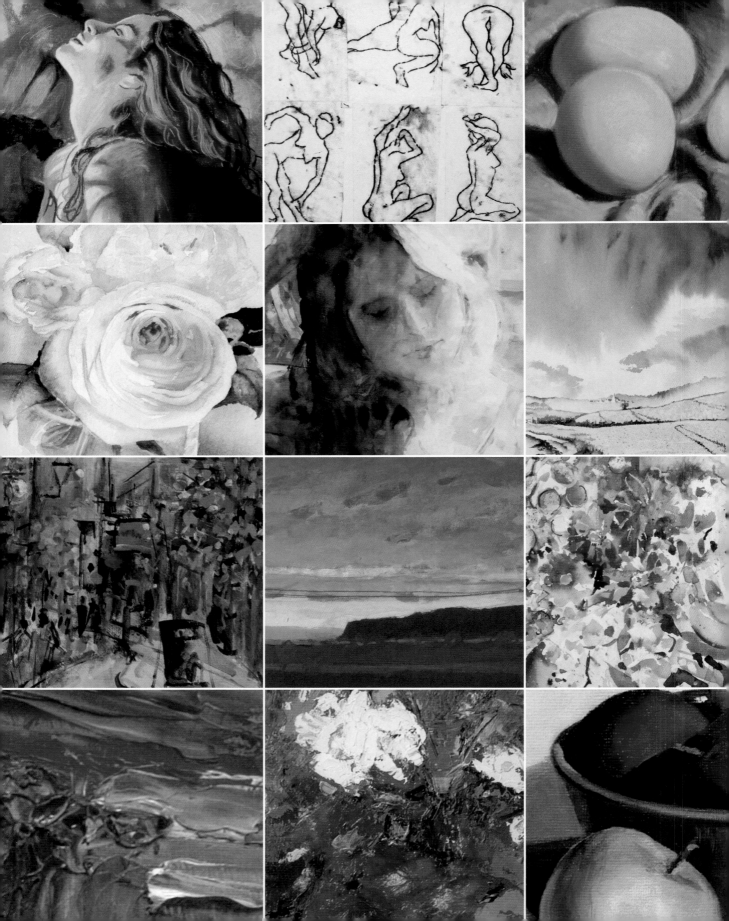

Introduction

There is something in this book to appeal to every aspect of an artist's character, whether it is the spontaneity and simplicity of drawing, the delicacy and radiance of watercolours, the speed and immediacy of acrylic paint, or the sensuousness and plasticity of oil paint.

If you want to learn how to master a new medium, or just improve your existing skills, this book puts all the information you need at your fingertips. The opening sections cover the fundamental materials and key techniques of each of the media, and then progress to working through the main elements of picture composition, each element explained with step-by-step instructions and demonstrated in projects that encapsulate that particular skill.

Accompanied by galleries of examples by professional artists to instruct and inspire, this is the perfect artist's companion and the ultimate practical illustration reference work.

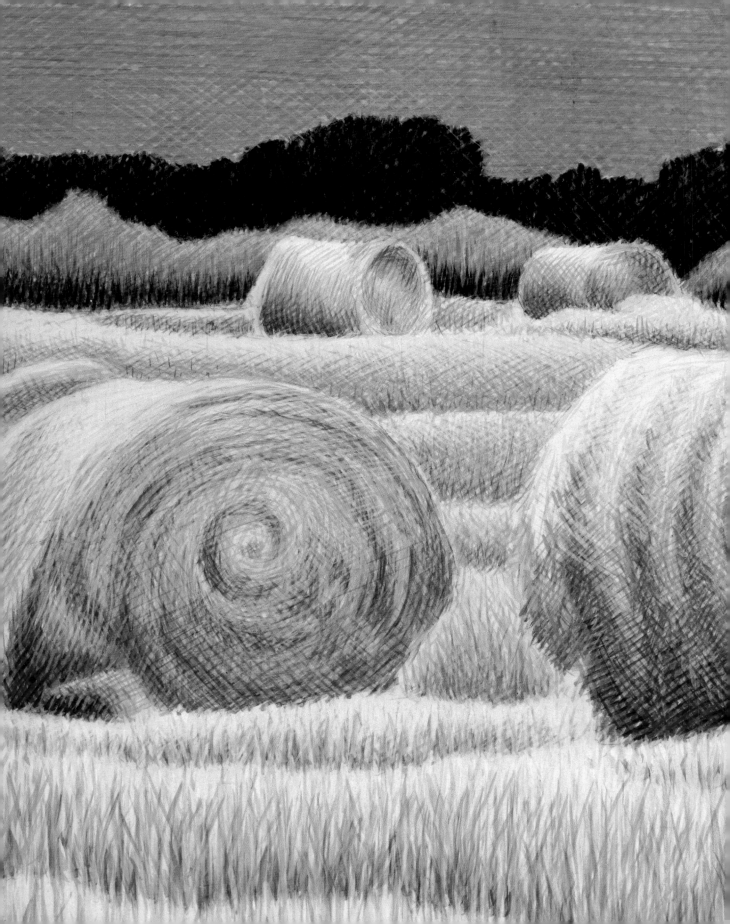

Drawing
Workshop

 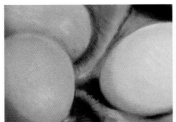 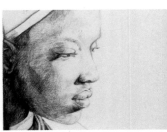

Introduction to drawing

Children find the external world utterly absorbing but, as time goes on, their brains learn to edit out most of what they see, homing in only on what is important. Drawing takes the opposite approach. Half the battle is close observation. It can make you see afresh, marvel at the most familiar sights, and notice detail you've overlooked for years.

Because the brain rapidly scans any given scene, it tends to override the effects of perspective. It knows that a bus in the distance is the same size as the one you're getting on. It is aware that horizontal lines of buildings are level and don't tilt. When it comes to drawing, you have to quell that logical voice and believe your eyes. The simple rules of perspective are what makes a drawing look right and you can learn them in tandem with gaining fluency with pencil strokes.

Ever since Cézanne took a multiple viewpoint on a bowl of fruit towards the end of the 19th century, the merit of these rules of realistic drawing has been in question. Many artists have no wish to pretend paper is three-dimensional, and would rather emphasize its pattern-making qualities. Fine, but you have to know the rules before you can break them, so that you are in control. Once you can draw a foreshortened figure or a distant winding path, you can elongate, distort,

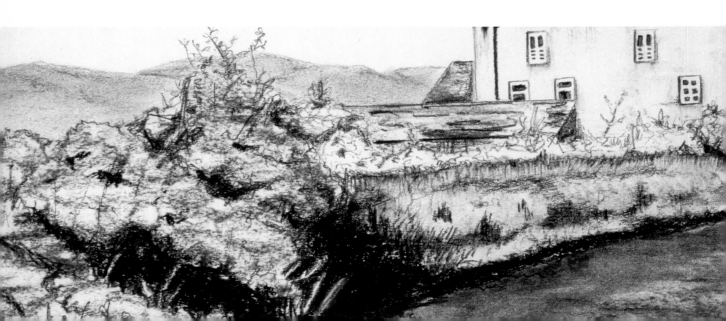

 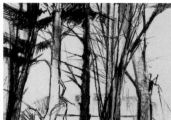 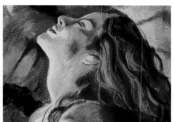 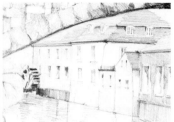

or flatten the human form or a landscape all you like for dramatic effect.

Just as with learning the piano, regular practice brings about noticeable improvements. Draw the events of your day in a sketchbook diary. Try out compositions and thumbnail sketches, doodle, and copy whatever catches your eye. No one else needs to see your efforts.

Drawing offers you spontaneity and freedom. Don't be afraid to make mistakes or become too dependent on erasers. Accept your limitations and paradoxically your horizons will expand – literally. Try out the wealth of drawing media available and introduce

colour to your repertoire. Drawing is an art in its own right, but it is also an essential foundation to painting.

This section will show you the difference between looking at something normally and looking for drawing. Professional artists then teach you how to put what you see down on paper, whether you are working in pencil, charcoal, pen, coloured pencil, or pastel. Once you understand your materials and have practised the techniques, the projects help you apply your knowledge and skills to create finished pictures, translating what is in your mind's eye on to paper. Draw as much, and with as much relish, as you did when you were three years old.

 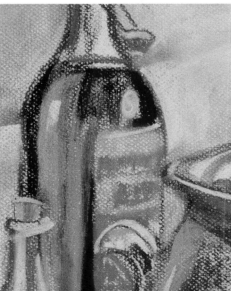

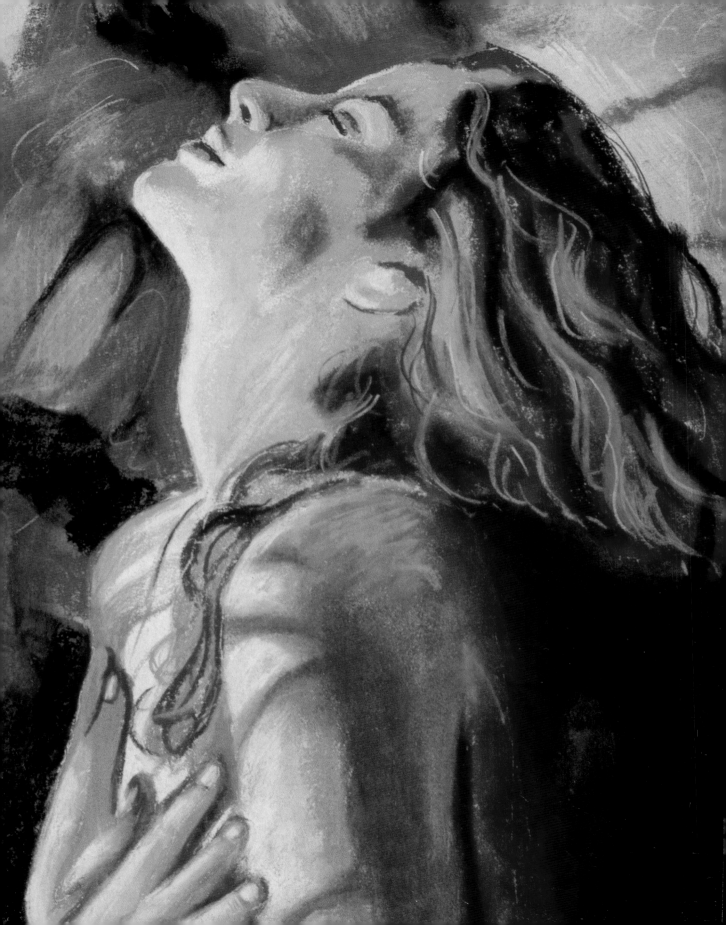

Drawing
Materials and Techniques

Drawing with pencils

Pencils are ideal for drawing. They are a versatile medium for building up varying degrees of line and tone, are simple to carry around, and can be easily rubbed out. When you take up your pencil relax your grip, and try working with your hand higher up the shaft for bold sketchy lines: drawing is not the same as writing and your sketches will look cramped if you clench your pencil tightly near the lead.

GRAPHITE PENCILS

Available in a variety of grades, pencils range from 8H or 9H, the hardest, to 8B or 9B, the softest pencils for shading. Start with a B (for black), 2B, and 4B, an HB, which is halfway between hard and soft, and an H (for hard). Clutch pencils have a retractable lead and do not need sharpening. Graphite sticks are chunkier in line and lend themselves to large-scale bold work.

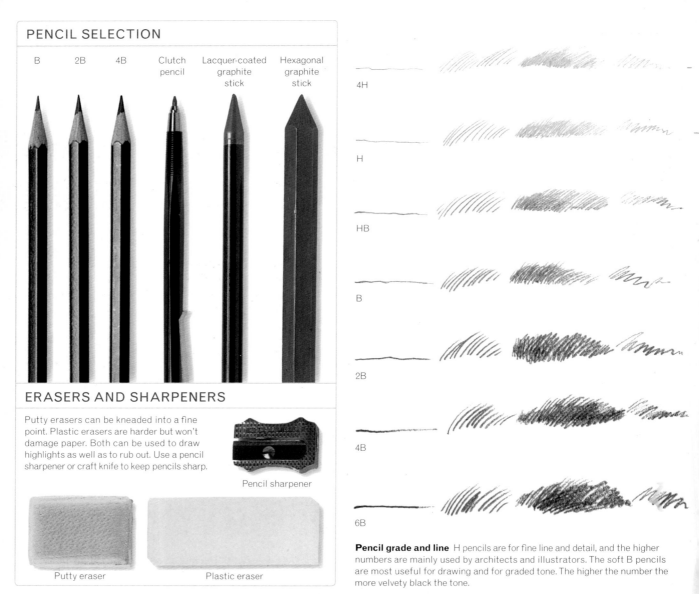

PENCIL SELECTION

B 2B 4B Clutch pencil Lacquer-coated graphite stick Hexagonal graphite stick

ERASERS AND SHARPENERS

Putty erasers can be kneaded into a fine point. Plastic erasers are harder but won't damage paper. Both can be used to draw highlights as well as to rub out. Use a pencil sharpener or craft knife to keep pencils sharp.

Pencil sharpener

Putty eraser

Plastic eraser

4H

H

HB

B

2B

4B

6B

Pencil grade and line H pencils are for fine line and detail, and the higher numbers are mainly used by architects and illustrators. The soft B pencils are most useful for drawing and for graded tone. The higher the number the more velvety black the tone.

COLOURED PENCILS

Experiment with a minimum set of 12 or 24 colours to see if you enjoy the medium. A vast range of colours as sets or singles is available to cover all areas of drawing, such as landscapes or portraits. Good-quality brands will not fade. Coloured pencils are best for line and you can use one colour on top of another in various ways.

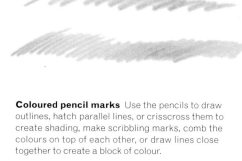

Coloured pencil marks Use the pencils to draw outlines, hatch parallel lines, or crisscross them to create shading, make scribbling marks, comb the colours on top of each other, or draw lines close together to create a block of colour.

GRIP

When you are drawing, keep your wrist supple and sit up straight rather than hunching over the paper. Experiment with holding your pencil or charcoal in different ways – as if you were about to flick a frisbee, for example, when you are shading. See what happens when you hold your pencil firmly and then more loosely, and make big movements with your whole arm to try and free up your style.

Pencil

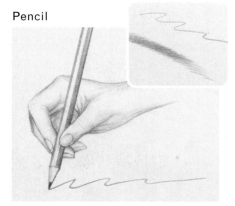

The nearer to the point you hold your pencil, the greater your control and scope for detail. Keep your fingers relaxed. If you hold the pencil further up the shaft, your movements will be freer.

Charcoal

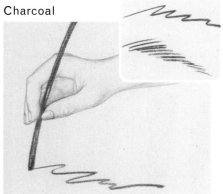

Willow charcoal snaps easily, so hold it gently and press lightly. Break off small pieces and use them on their sides. Compressed charcoal is shorter: cradle it in your palm with relaxed fingers.

Pastel

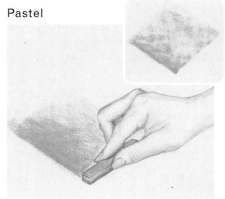

Slide the side of a chalk or oil pastel stick along the surface of the paper to make broad sweeps of colour. The harder you press, the denser the pigment. Use the tip of a pastel to draw lines.

Pens, charcoal, and pastels

After some practice with pencils, try using pens, charcoal, or pastels. Pens are excellent for quick sketches or fine detail and, like pencils, are easy to carry around. Charcoal encourages you to draw more loosely and expressively. Pastels are rich in pigment, which gives them strong, vibrant colours. Hard or soft, waxy or fragile, pastels can be bought individually or in sets.

PEN AND INK

Pen and ink is ideal for line work, but you have to look at your subject closely because you cannot erase marks or change your mind. Using pen and ink demands confident line work, whether you are making a rapid sketch or a tonal study. As well as line, try stippling to create tone.

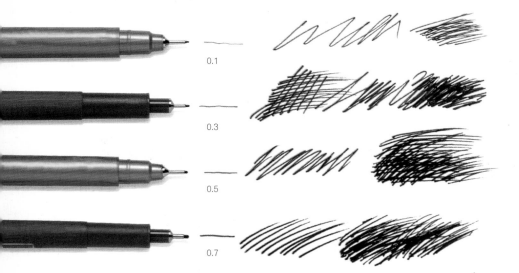

0.1

0.3

0.5

0.7

Technical pens The nibs create lines of uniform width and density. To vary the weight of the line, you need to use different pen sizes – technical pen nibs are measured by width in millimetres.

CONVENIENT PENS

Ballpoint pen

Felt-tip pen

Ballpoint and felt-tip pens are easy to carry around and use. They can produce surprisingly pleasing, spontaneous results, especially for quick, scribbled sketches.

CHARCOAL

Unlike pen, charcoal is easy to rub out and a sweep of an eraser is enough to remove marks. Charcoal responds to pressure and direction, as if it were an extension of your hand, and is superb for loosening tense fingers. Use the tip for lines and the side for sweeps of tone, which you can smudge with a shaper, paper stump (tortillon), cotton bud, eraser, brush, tissue, or your hand.

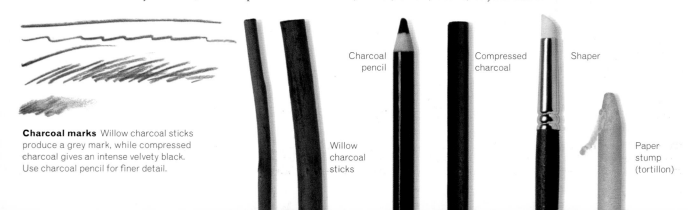

Charcoal marks Willow charcoal sticks produce a grey mark, while compressed charcoal gives an intense velvety black. Use charcoal pencil for finer detail.

Charcoal pencil

Compressed charcoal

Shaper

Willow charcoal sticks

Paper stump (tortillon)

HARD, SOFT, AND OIL PASTELS

Conté crayons and chalk pastels are made from pigment and gum bound into a paste, hence the name. Chalk pastels are powdery and soft; conté crayons are harder and oilier. Oil pastels are bound with oil and wax, which makes them more buttery in consistency. Like charcoal, chalk pastels need to be sprayed with fixative to stop them smudging and losing definition.

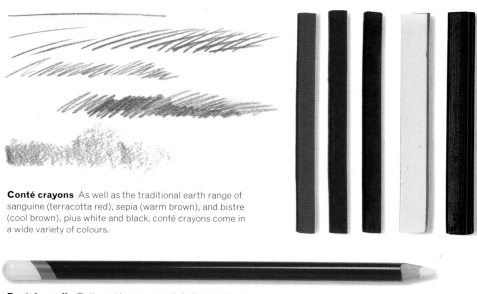

Conté crayons As well as the traditional earth range of sanguine (terracotta red), sepia (warm brown), and bistre (cool brown), plus white and black, conté crayons come in a wide variety of colours.

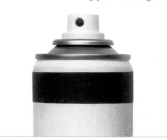

USING FIXATIVE

Fixative is a liquid resin in spray or atomizer form. It glues easily smudged media such as charcoal and pastel to the surface of the paper. Fixative should be applied in a light continuous motion from the top to the bottom of a drawing, which should be held vertically at a distance of about 30cm (12in). It is best to use fixative outdoors or at least in a well-ventilated room. Avoid using too much fixative as this will make your drawing look dull. Hairspray can be used as a suitable alternative for fixing your drawings.

Pastel pencils Both conté crayons and chalk pastels are available in pencil form, which crumbles less, for detailed work. Use pencils alongside the sticks.

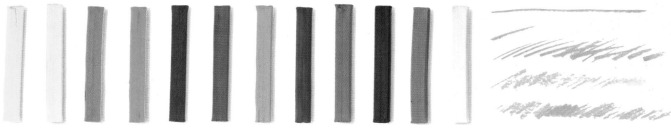

Chalk pastels All pastels come in full-strength pigments with a range of tints (light tones) and shades (dark tones) for each colour. Start with a basic set of 12 or 24 sticks. Chalk pastels are crumbly and respond to light pressure. You can break off pieces and use them on their side to create areas of tone, which can be smudged or blended with your finger or a rag.

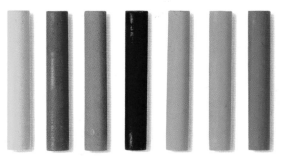

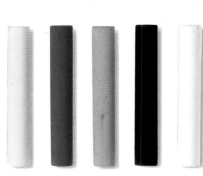

Oil pastels The sticks are chunky, so they are best suited to large-scale drawings and for building up rich colour, rather than for detailed work. Oil pastels are less crumbly than chalk pastels and rarely need fixing but they get sticky with heat, so cool your hands in cold water if necessary. Because oil pastels are waxy, it is easier to layer colours than to blend them.

Paper for drawing

Many sketchbooks contain fine-textured white paper, which is standard for drawing, but you can also buy books with textured paper. Coarse papers are more expensive and range in thickness from charcoal and pastel papers to watercolour surfaces and hand-made paper. Mid-toned paper is interesting to work on, as you can use both dark and light media on it. You can also draw on watercolour paper, which is thicker.

TYPES OF PAPER

For most drawings in black and white or conté crayon, cartridge paper is suitable. It is reasonably smooth and designed to be all-purpose. Ingres paper for charcoal or pastel has a slight tooth (grain). Pastel paper is generally textured so the crumbly pigment has something to cling on to. It is often tinted so that flecks of white paper do not compete with the colours.

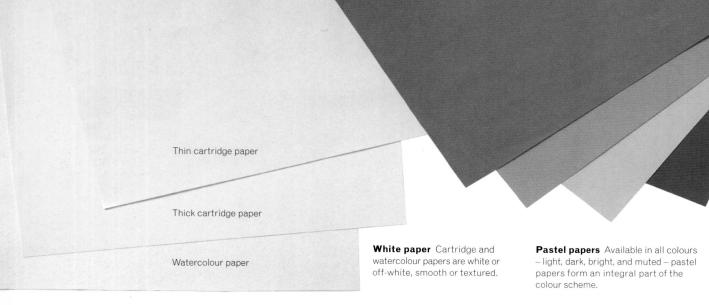

Thin cartridge paper

Thick cartridge paper

Watercolour paper

White paper Cartridge and watercolour papers are white or off-white, smooth or textured.

Pastel papers Available in all colours – light, dark, bright, and muted – pastel papers form an integral part of the colour scheme.

PAPER SIZES

Paper is sold internationally in "A" sizes, each one double the measurements of the last. A4 is the size of writing paper, good for sketching while out and about. A3 or A2 are a better size for drawing on. Buying sheets of A1 and cutting them to size is cheaper than buying smaller sheets or sketchpads.

- A1: 840 x 594mm (33 x 23⅜in)
- A2: 594 x 420mm (23⅜ x 16½in)
- A3: 420 x 297mm (16½ x 11¾in)
- A4: 297 x 210mm (11¾ x 8¼in)

Sketchbooks
Ringbound sketchbooks are convenient to carry and use on the spot. The cardboard backing gives a firm surface.

SMOOTH OR ROUGH?

The type of paper you use affects the appearance of your drawings. A drawing on smooth paper, which reveals every detail, looks different if it is repeated on textured paper, as the rough surface breaks up the marks you make. In colour drawings you can blend pigments more evenly and delicately on a smooth surface, whereas rough papers create more sparkle and contrast.

SMOOTH PAPER

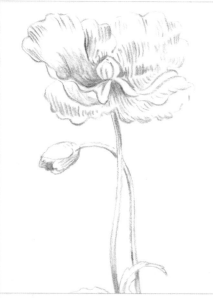

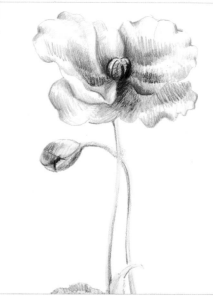

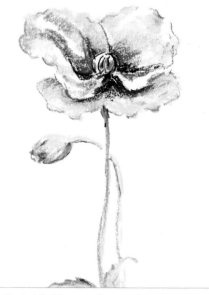

Charcoal On smooth paper the lines are soft and the shading smooth. But charcoal really needs some texture to stick to the paper.

Coloured pencil Smooth paper shows up every detail, such as individual lines of feathering, creating a subtle effect overall.

Pastel It skims over the smooth surface, leaving a light sheen. Like charcoal, it is more suited to rough paper that holds the pigment.

ROUGH PAPER

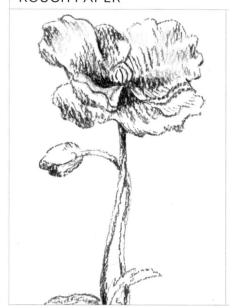

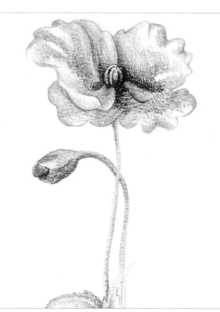

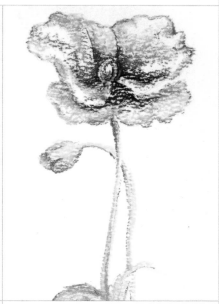

Charcoal Rough paper is better for charcoal, as it adheres to the grain, creating broken lines. This makes a stronger, more dynamic drawing.

Coloured pencil The texture breaks up the lines of pencil and layered colours look darker and more intense. Some detail is still apparent.

Pastel The medium looks striking on textured paper. It is good for loose strokes and blocks of colour applied with the side of the stick.

Using drawing media

Now is the time to try out different media on a pad of cartridge paper. Draw anything that catches your eye, from simple objects at home to details of buildings or landscape. Practise making as many sorts of line as you can think of: outlines, scribbles, spirals, dots, and dashes. You can use line to create shading, too, using hatching (parallel lines) and crosshatching (series of crisscross lines).

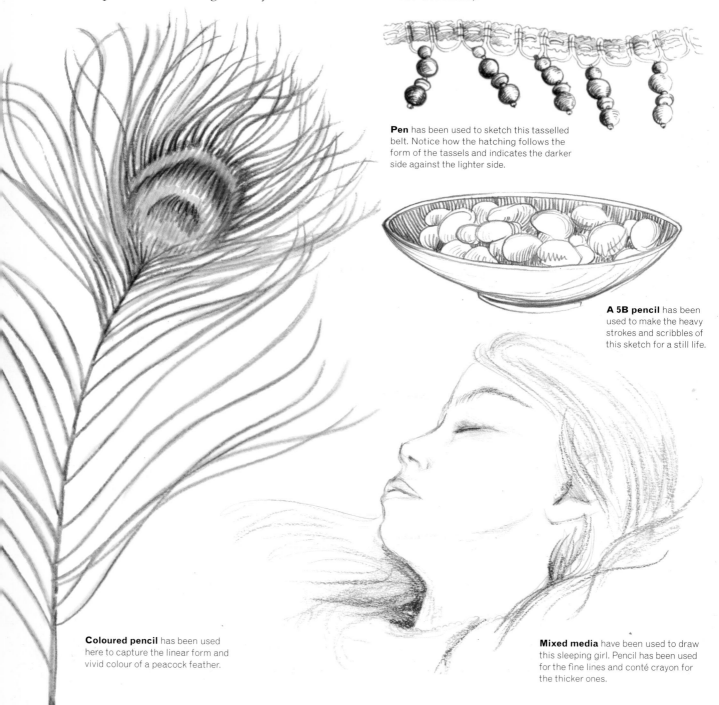

Pen has been used to sketch this tasselled belt. Notice how the hatching follows the form of the tassels and indicates the darker side against the lighter side.

A 5B pencil has been used to make the heavy strokes and scribbles of this sketch for a still life.

Coloured pencil has been used here to capture the linear form and vivid colour of a peacock feather.

Mixed media have been used to draw this sleeping girl. Pencil has been used for the fine lines and conté crayon for the thicker ones.

COMPARING AND CONTRASTING

Drawing the same object in a variety of media will help you to understand their different qualities, especially when they are all on the same paper. Long, curved strokes shape an object, and hatching or dotting adds volume. The pictures below show how an apple looks when drawn on smooth white cartridge paper in black and white media and colour.

PENCIL

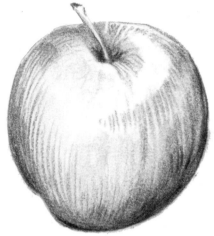

Pencil is finer than charcoal and can be used for delicate silvery hatching and crosshatching that create a mesh of subtly graded tone.

CHARCOAL

With charcoal, the tonal contrast is greater. Charcoal is better for shading than crosshatching. Thick, soft lines merge around the curving apple.

PEN AND INK

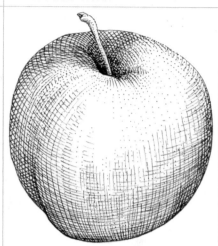

With the even black lines of a fine-nibbed pen, continuous crosshatching builds up density, while dots and dashes speckle the light areas.

CHALK PASTEL

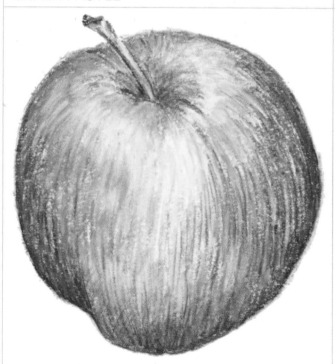

A linear approach is still possible in chalk pastel, here with a limited palette of green, yellow, orange, and red. Rubbing the vertical strokes with an eraser lightens the tone and blends the green areas into the red.

COLOURED PENCIL

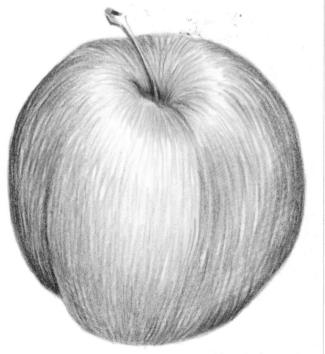

The same colours – yellow, green, orange, and red – laid in lines side by side mix in the viewer's eye and help to shape the apple. Yellow and the bare paper provide the brightest, lightest areas of highlight.

Shape and proportion

To create a realistic drawing, objects need to be a recognizable shape and the right size in relation to each other. You can measure the height and width of one object compared with another quite simply by using a pencil. You can also use the same method to check how far apart objects are. Using a pencil to take measurements, often called sighting, soon becomes second nature when drawing.

TAKING MEASUREMENTS

To check how big things are in relation to other objects, start with a small item, such as the lemon in the drawing below, and use it as the basis for your other measurements. You need to be in the same position for both measuring and drawing, so have your subject matter directly in front of you, so that you do not need to peer over or around your paper to look at it.

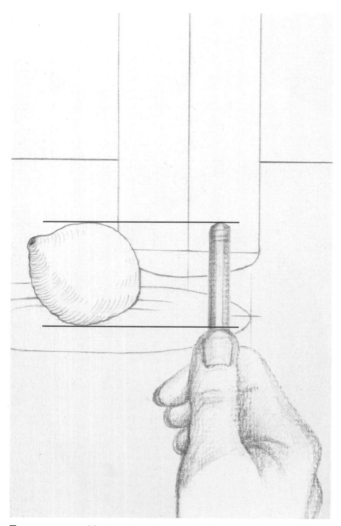

To measure an object, such as the lemon in the picture above, hold the pencil upright between your thumb and fingers, at arm's length and keeping your arm straight. Close one eye, then move the pencil until the top of it is level with the top of the lemon. Slide your thumb up the pencil to mark how far down the pencil the bottom of the lemon comes.

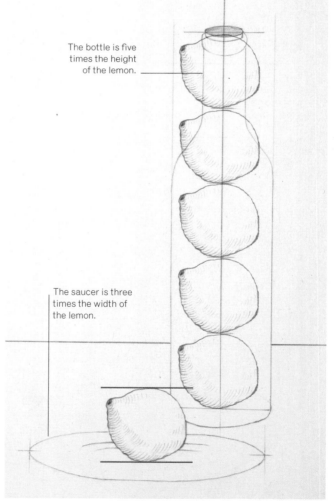

The bottle is five times the height of the lemon.

The saucer is three times the width of the lemon.

Keeping your thumb in the same place, measure how many times the height of the lemon fits into any other object you are drawing, such as the bottle. Measure the width of the lemon in the same way, holding the pencil horizontally, and use this to work out the width of the saucer. You can then map out the objects you are drawing in the correct proportions to each other.

BASIC SHAPES

Once you have worked out the proportions of the objects in a picture, you can rough out the drawing on paper. To make it easier, look at the objects carefully and break them down into basic geometric shapes, such as squares, circles, triangles, rectangles, and ovals.

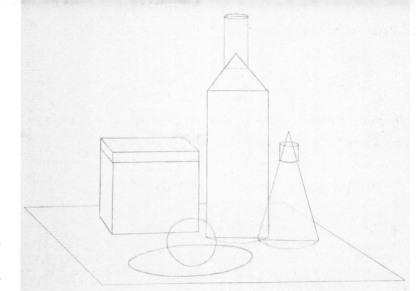

In the preparatory sketch on the right, the bottle has been interpreted as a rectangle with a triangle and tube on top, and the lemon is shown as a circle. If it helps, you can also draw vertical lines through the centre of symmetrical objects to help you match one side to the other.

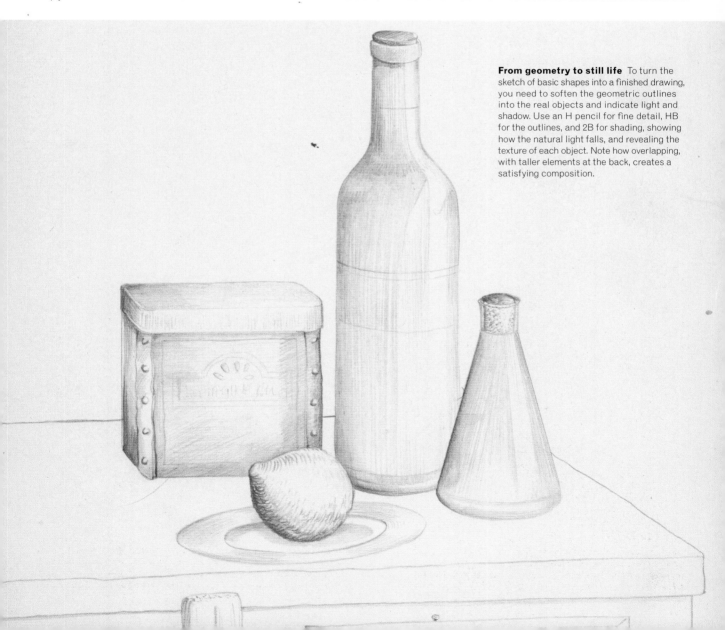

From geometry to still life To turn the sketch of basic shapes into a finished drawing, you need to soften the geometric outlines into the real objects and indicate light and shadow. Use an H pencil for fine detail, HB for the outlines, and 2B for shading, showing how the natural light falls, and revealing the texture of each object. Note how overlapping, with taller elements at the back, creates a satisfying composition.

Drawing shapes and solids

One of the contradictions of drawing is that everything you see is in three dimensions but your paper is in two. You have to translate the weightiness of objects on to a flat surface. There are rules you can apply to help you do this. The most important rule is to forget what your brain has learnt about the external world – minds are adept at overriding visual information with logic. Use your eyes, not your brain.

CONVINCING LINES AND CIRCLES

Drawing straight lines and circles confidently is a matter of practice. Keep the pencil in motion until you have completed the line, as hesitation shows instantly as a kink. When it comes to ellipses – circles flattened in perspective, such as the rim of a cup – the trick is to draw exactly what you see. The shape and slant of an ellipse will vary according to your viewpoint.

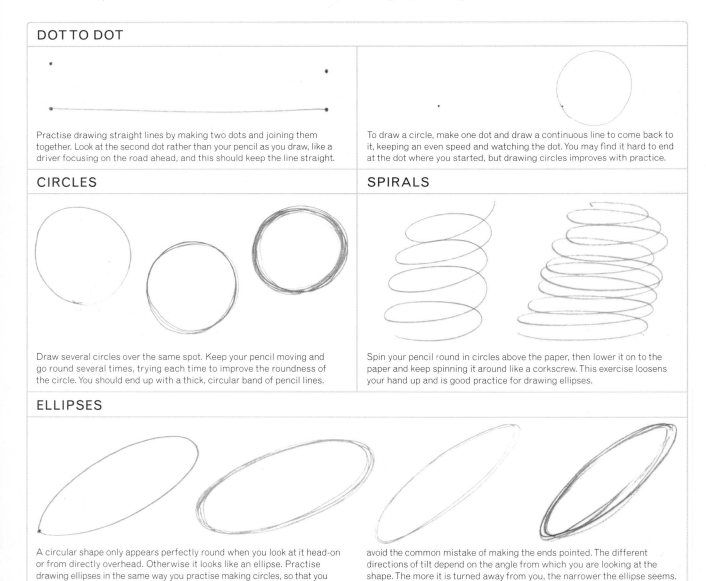

DOT TO DOT

Practise drawing straight lines by making two dots and joining them together. Look at the second dot rather than your pencil as you draw, like a driver focusing on the road ahead, and this should keep the line straight.

To draw a circle, make one dot and draw a continuous line to come back to it, keeping an even speed and watching the dot. You may find it hard to end at the dot where you started, but drawing circles improves with practice.

CIRCLES

Draw several circles over the same spot. Keep your pencil moving and go round several times, trying each time to improve the roundness of the circle. You should end up with a thick, circular band of pencil lines.

SPIRALS

Spin your pencil round in circles above the paper, then lower it on to the paper and keep spinning it around like a corkscrew. This exercise loosens your hand up and is good practice for drawing ellipses.

ELLIPSES

A circular shape only appears perfectly round when you look at it head-on or from directly overhead. Otherwise it looks like an ellipse. Practise drawing ellipses in the same way you practise making circles, so that you avoid the common mistake of making the ends pointed. The different directions of tilt depend on the angle from which you are looking at the shape. The more it is turned away from you, the narrower the ellipse seems.

DRAWING GEOMETRIC SHAPES

If you look at a cube head-on or from directly above it appears flat. But as soon as you can see more than one side, horizontal lines appear to slant. The way to make a cube look like a cube and not a square is to faithfully copy the angle of the slant as you see it. Use your pencil to take measurements. The only lines that stay horizontal are the ones on your eye level.

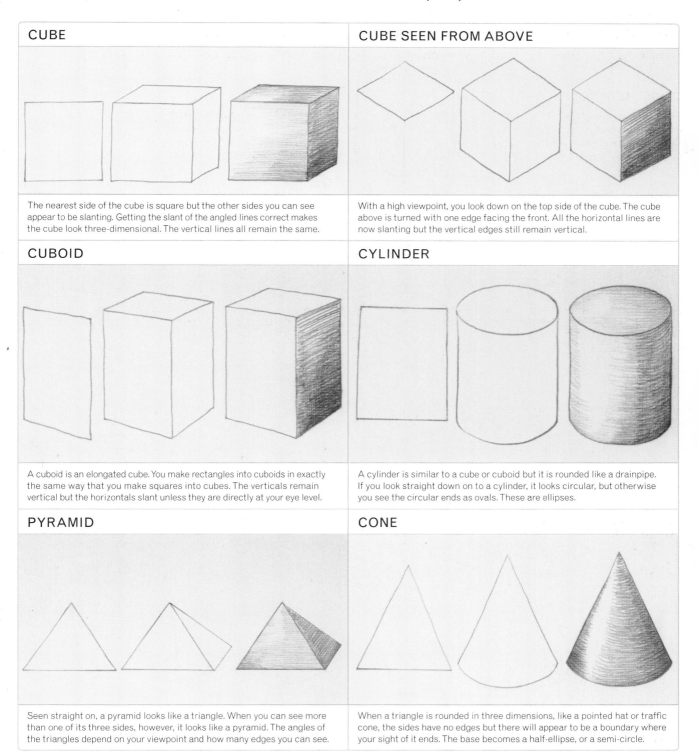

CUBE

The nearest side of the cube is square but the other sides you can see appear to be slanting. Getting the slant of the angled lines correct makes the cube look three-dimensional. The vertical lines all remain the same.

CUBE SEEN FROM ABOVE

With a high viewpoint, you look down on the top side of the cube. The cube above is turned with one edge facing the front. All the horizontal lines are now slanting but the vertical edges still remain vertical.

CUBOID

A cuboid is an elongated cube. You make rectangles into cuboids in exactly the same way that you make squares into cubes. The verticals remain vertical but the horizontals slant unless they are directly at your eye level.

CYLINDER

A cylinder is similar to a cube or cuboid but it is rounded like a drainpipe. If you look straight down on to a cylinder, it looks circular, but otherwise you see the circular ends as ovals. These are ellipses.

PYRAMID

Seen straight on, a pyramid looks like a triangle. When you can see more than one of its three sides, however, it looks like a pyramid. The angles of the triangles depend on your viewpoint and how many edges you can see.

CONE

When a triangle is rounded in three dimensions, like a pointed hat or traffic cone, the sides have no edges but there will appear to be a boundary where your sight of it ends. The base becomes a half-ellipse, or a semi-circle.

Building a drawing

Many objects, both natural and man-made, are geometric in basic shape. Visually breaking down what you see into squares, circles, and other familiar shapes can help you to observe things more accurately, relate one part to another, and draw what you see. Start by drawing the overall shapes, then break the object down into smaller shapes before adding shading and detail.

OBJECTS AROUND THE HOME

Start with inanimate objects, which you can place where you want. Sit right in front of your subject, resting your drawing board on the back of a chair, so that you can look up at what you are drawing and then back at your paper without changing eye level. Use an HB pencil on cartridge paper. Don't worry about drawing the background: just concentrate on the subject.

CHAIR

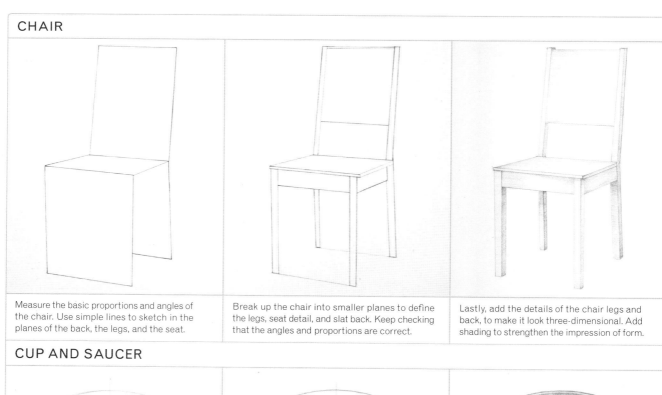

Measure the basic proportions and angles of the chair. Use simple lines to sketch in the planes of the back, the legs, and the seat.

Break up the chair into smaller planes to define the legs, seat detail, and slat back. Keep checking that the angles and proportions are correct.

Lastly, add the details of the chair legs and back, to make it look three-dimensional. Add shading to strengthen the impression of form.

CUP AND SAUCER

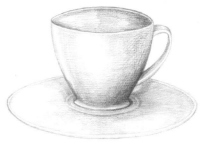

Draw an axis for the centre of the cup rim and the saucer. Measure the height and depth of them, then draw the two matching ellipses.

Draw the two ellipses on the saucer where the cup rests. Look closely at the cup, then sketch its sloping sides and the curve of the base.

Draw the rim of the saucer and the handle of the cup, then any other small details. Add shading last of all, to create a sense of form.

PEOPLE

You can simplify the human form in just the same way as objects. Measure the proportions of the figure and seat with a pencil and work out the scale on a rough sketch first, so that you can fit the whole figure on to your piece of paper without cropping off its head or feet or leaving it floating in space. Your first outlines will look like a stick figure, but all the proportions will be correct.

FIGURE

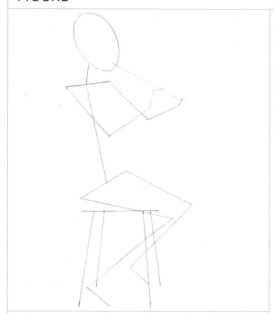

Plot how the basic shapes and lines relate to each other: the oval for the head and the angles of the arms and legs, and position the body so that it is centred over the stool.

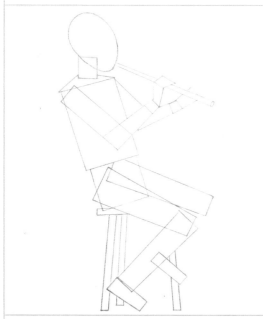

Draw a cone for the neck, a triangle for the shoulders, a rectangular torso, and long, tapering rectangles that are joined at right angles for the arms and legs.

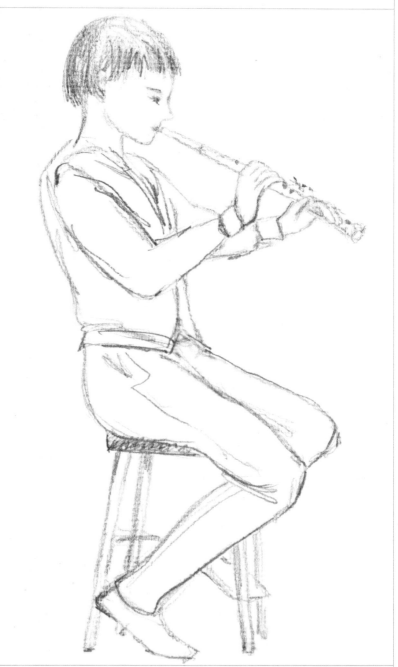

Using the geometric shapes as positional guides, start drawing the figure properly, modifying the shapes according to what you see. Keep checking back to your model as you work, and use an eraser to rub out the original sketch marks once you have corrected them.

Adding tone to drawings

Tone is how pale or dark something is. The play of light and shade is what gives objects form and weight, so adding tone makes a picture look three-dimensional. When it comes to drawing, light, shade, and your subject matter are all equally important. How you apply tonal shading depends on the medium that you are using as well as the texture and colour of the paper that you are drawing on.

DRAWING A SPHERE

Some objects, such as cubes, can appear three-dimensional because of linear perspective. With a circle, however, the only way to give it volume and turn it into a sphere is to add shading.

All the spheres below were drawn on the same rough off-white watercolour paper. The method of shading, however, varied according to the medium used.

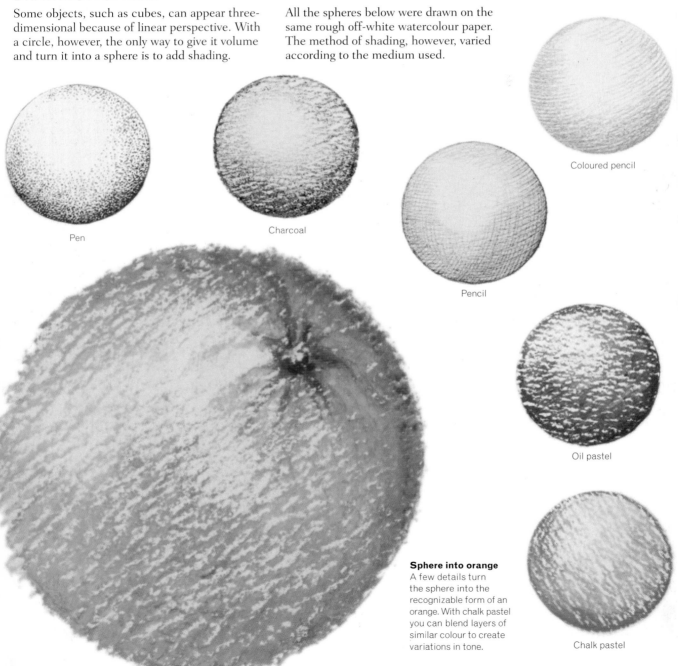

Pen

Charcoal

Pencil

Coloured pencil

Oil pastel

Chalk pastel

Sphere into orange
A few details turn the sphere into the recognizable form of an orange. With chalk pastel you can blend layers of similar colour to create variations in tone.

TEXTURE

Showing texture is like drawing tone in more detail: it involves capturing the play of light and shadow on every speck of the object's surface, rather than just on the overall shape. To convey texture, imagine handling the surface of the object and draw the sensation that touching the object evokes. Below are different treatments in different media of the same subject matter.

PENCIL

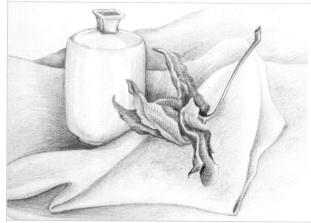

H and 2H pencils were used on smooth white cartridge paper to draw the fine outline and hatching on the jar. These hard pencils create a faint but sharp line.

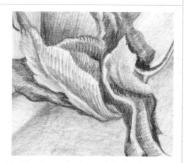

For the denser texture of the leaf, a B pencil was used with varying pressure to alter the weight of the line. A 3B pencil was used to create the soft tones of the fabric behind.

PEN

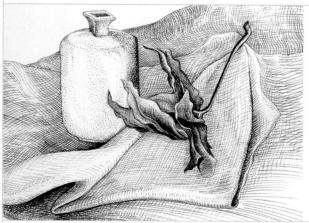

Here, on the same smooth paper, stippling marks were made with a pen. The close dots produced the bottle's shadow and areas of paper were left bare for the highlights.

The texture of the cloth was brought out by crosshatching. Total black coverage in the shadows and looser coverage in the areas of light created the curves of the leaves.

CHALK PASTEL

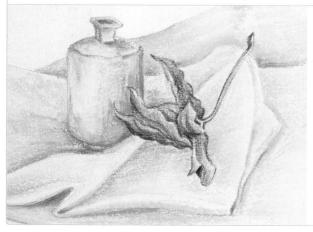

In this version pastel paper and a looser style were used with the powdery medium of pastel. Grey pastel was blended with a finger for the smooth surface of the bottle.

Different tones of brown were used to reveal the form of the leaves. Their clear outline suggests their crisp, papery texture against the soft folds of the fabric.

Using perspective

The way to create an illusion of three dimensions on a flat sheet of paper is to use perspective. Objects in the distance may not really be smaller than they would be in the foreground, but they look as if they are. Perspective makes parallel lines going into the picture space appear to converge. The spot where they meet is called a vanishing point, and you can use it to calculate the angles of other lines in the drawing. The only lines that do not join the vanishing point are horizontals at your eye level and verticals.

ONE-POINT PERSPECTIVE

A classic example of linear perspective is a road or railway in the centre of a picture converging to a point in the background. Indoors, you can see linear perspective by looking down a corridor. Walls appear to converge, the floor seems to rise, and the ceiling to lower, all to a single point. This one-point perspective only works when the subject is head on: if you imagine the sheet of paper as a pane of glass, the road or railway has to pierce it at right angles.

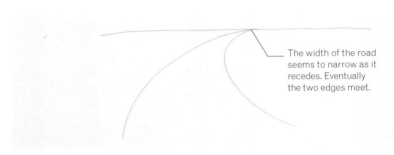

The width of the road seems to narrow as it recedes. Eventually the two edges meet.

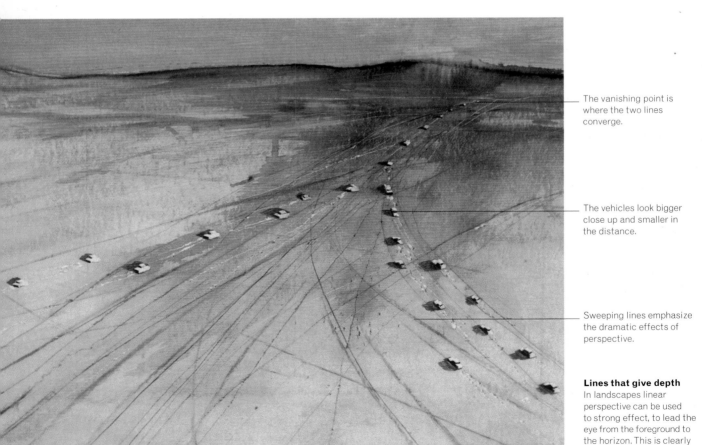

The vanishing point is where the two lines converge.

The vehicles look bigger close up and smaller in the distance.

Sweeping lines emphasize the dramatic effects of perspective.

Lines that give depth
In landscapes linear perspective can be used to strong effect, to lead the eye from the foreground to the horizon. This is clearly demonstrated in this dramatic picture of two roads literally converging.

TWO-POINT PERSPECTIVE

One-point perspective applies when parallel lines go straight into the picture, but often a subject is viewed at an angle. In this case horizontal lines converge at two vanishing points, one on each side of the drawing. Two-point perspective often comes into play with buildings and other objects with straight sides. Use it as a guiding principle for realistic drawing.

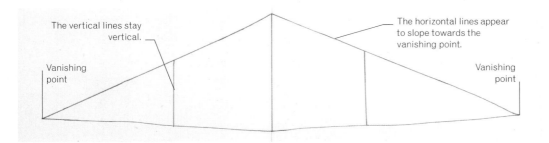

The vertical lines stay vertical.

The horizontal lines appear to slope towards the vanishing point.

Vanishing point

Vanishing point

House in perspective
Two sides of the house are visible. The principal lines of the building converge at vanishing points on the horizon line either side of the drawing (beyond the edge of the paper). Starting with a simple perspective diagram helps to plot the structure of the house.

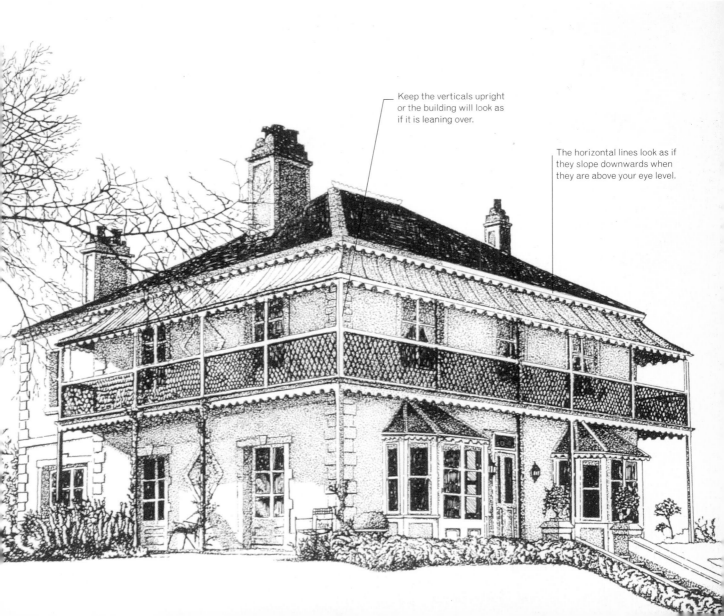

Keep the verticals upright or the building will look as if it is leaning over.

The horizontal lines look as if they slope downwards when they are above your eye level.

Composition

As the artist, you have to decide what to include in your picture and what to leave out, where to position each element, and how the different parts interact to form a whole. You want a viewer to look at the entire picture, but the eye cannot take in everything at once. The key to good composition is to give the viewer visual stepping stones around the picture, and to include a centre of interest for the eye to focus on.

USING A VIEWFINDER

To help work out the best viewpoint on a scene, use a viewfinder. Cut out two L-shaped pieces of cardboard and paint them black, the least distracting colour. Hold them up against the given scene – whether it is a landscape, a still life, or a figure study – and you have an automatic picture frame. The viewfinder makes it much easier to visualize what a composition will look like on paper.

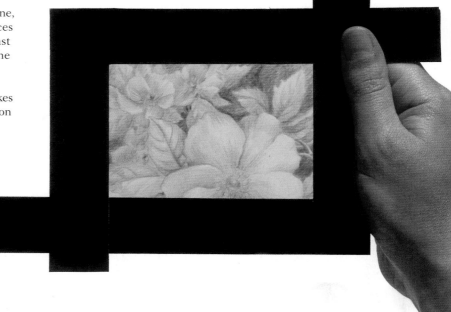

Change the size and shape of the composition by moving the frames closer together or further apart.

CHOOSING A FORMAT

Before you firm up the composition, you need to decide what size you are working at and what shape (format) the paper is. If it is rectangular you can have the short sides top and bottom (portrait format) or sideways (landscape format), or alternatively you can work to a square.

Portrait

Landscape

Often used for landscapes, a wide shape can give a satisfying ratio of sky to land. It is a good choice for many compositions.

The tall format is called portrait as it is a convenient shape for head and shoulders or a figure. It suits other tall shapes too.

Square

Although a square format encourages a well-balanced composition, it can make your drawing look static and lifeless. Use with caution.

APPLYING THE RULE OF THIRDS

The centre of interest in a picture is called a focal point because it immediately attracts the eye. Where you put the focal point is crucial and there is an easy way to give it maximum effect. Divide the paper into thirds and place the focal point on any of the intersections. Based on mathematical proportions, the rule of thirds can give a picture harmony and visual impact.

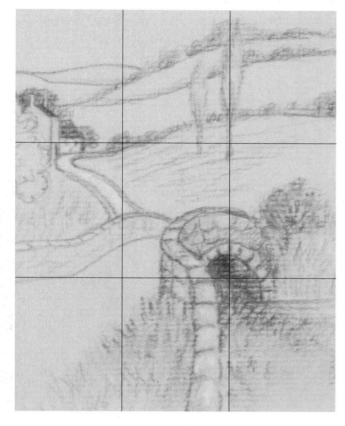

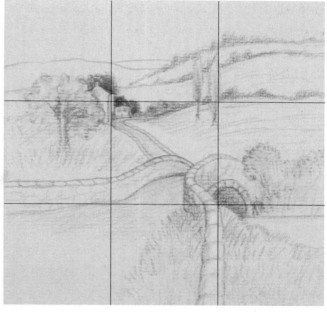

In a square format you can apply the rule of thirds just as for a rectangular composition. The curve and masonry of the bridge fall on one intersection and a secondary focal point, the house, on its diagonal opposite.

In a portrait format the bridge dominates on the lower right intersection. Notice how the road leads the eye from the bridge to the house, which is now less important, but provides middle-ground interest and a visual break.

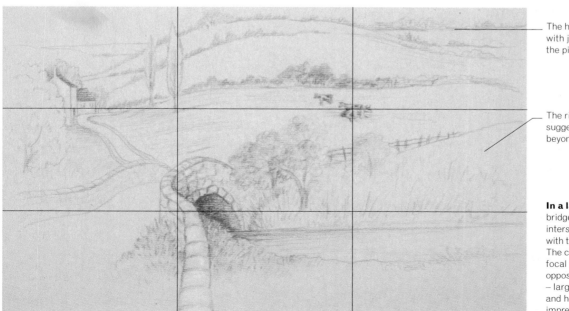

The horizon line is high, with just enough sky to put the picture in context.

The river and open field suggest more landscape beyond the picture frame.

In a landscape format the bridge falls on the front left intersection, directly in line with the upright tree behind. The cows form a secondary focal point diagonally opposite. The relative sizes – large bridge, small cows and house – emphasize the impression of depth.

Seizing the moment

The best way to improve your drawing is to practise. Try to do five to ten minutes sketching every day rather than, or as well as, a longer session once a week. Whatever you draw will improve your powers of observation, so choose what interests you. Leave out or simplify any elements that cause your attention to wander. Avoid talking while you draw, as it will distract you, and immerse yourself in the moment.

KEEPING A SKETCHBOOK

Carry a sketchbook and a pencil or pen around with you everywhere so you can sketch at any opportunity. Regard your sketchbook as a visual diary: don't show it to anyone and use it to make a quick record of anything that interests you. If you are drawing people in public, it is better to remain unobserved, to stop them peering over your shoulder and adding their comments.

Trains give you plenty of practice drawing objects based on geometric shapes. If you wait at a station you can sketch passengers as well as the trains themselves, which are easier to draw when stationary at the platform.

Portable sketchbooks need to be small. A5 is handy for quick sketches but A4 is a better size if you can carry it. The hard back means you don't need a drawing board, and you can use a clip to hold the page in place.

Rehearsals are a brilliant opportunity to study people, as they are too wrapped up in their work to feel self-conscious about your presence. Ask if you may sit on the sidelines of your local group of actors, musicians, or dancers – like Degas drawing pastels of ballerinas off-stage.

FINDING SUBJECTS

Whether indoors or outdoors, you don't need to travel far to find inspiration. Make still lifes at home from kitchen utensils – a table laid for a meal helps you get to grips with the ellipses of plates and glasses. All types of furniture are a lesson in linear perspective. Persevere and taking measurements will become second nature. Start with shapes and shadows before adding detail.

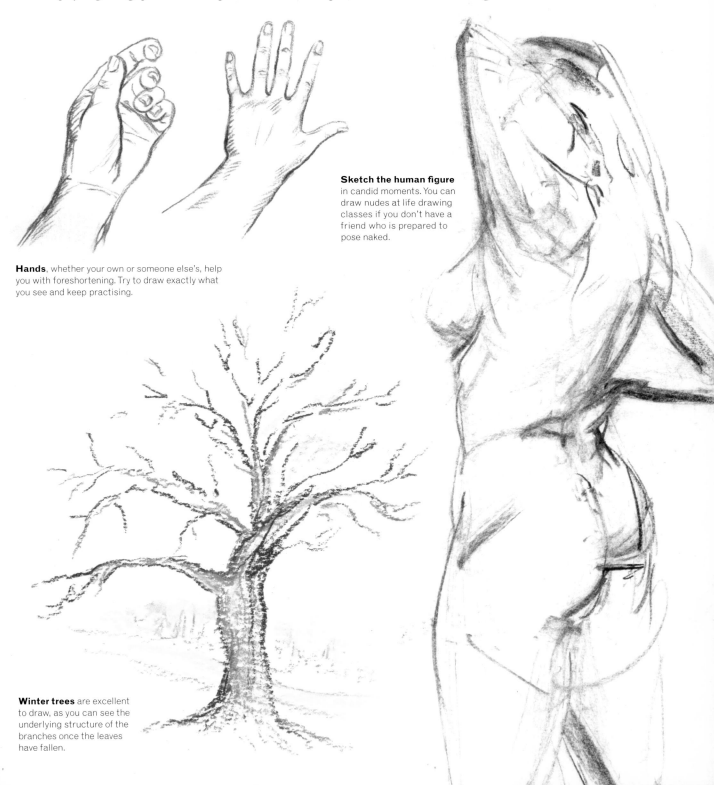

Sketch the human figure in candid moments. You can draw nudes at life drawing classes if you don't have a friend who is prepared to pose naked.

Hands, whether your own or someone else's, help you with foreshortening. Try to draw exactly what you see and keep practising.

Winter trees are excellent to draw, as you can see the underlying structure of the branches once the leaves have fallen.

Capturing movement

When you are drawing something that is moving, you have to work fast. Forget about details and jot down the essentials. You will develop your own style of drawing shorthand, as individual as your handwriting.

Set yourself a time limit, and try to distil the energy of your subject. You can also train your memory by concentrating on looking more than on drawing. You can then try to recreate the image on paper later on.

QUICK SKETCHES

The easiest actions to pin down on paper are the repetitive ones. Someone swimming, a child on a trampoline, people rowing down a river, a tractor harvesting in a field, aeroplanes taking off, or pouring rain, all of these things make rhythmic movements that you can study. Multiple or sudden actions, such as children at play or a bird taking off, are more challenging to draw.

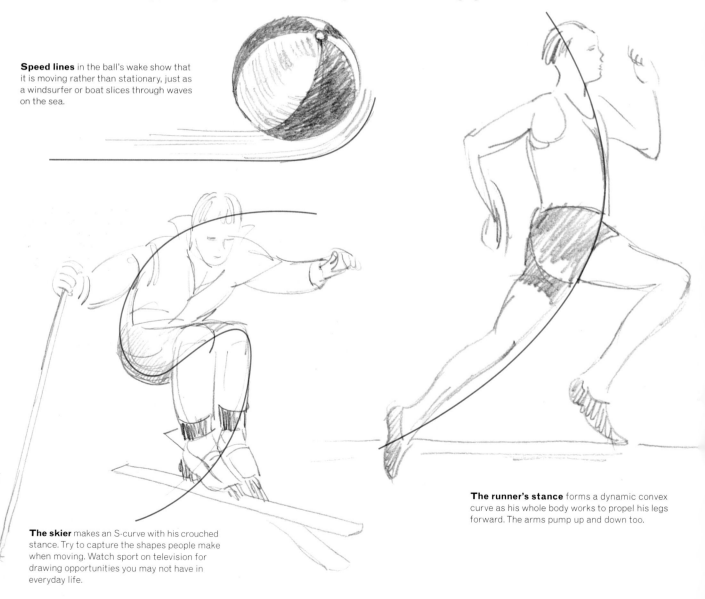

Speed lines in the ball's wake show that it is moving rather than stationary, just as a windsurfer or boat slices through waves on the sea.

The skier makes an S-curve with his crouched stance. Try to capture the shapes people make when moving. Watch sport on television for drawing opportunities you may not have in everyday life.

The runner's stance forms a dynamic convex curve as his whole body works to propel his legs forward. The arms pump up and down too.

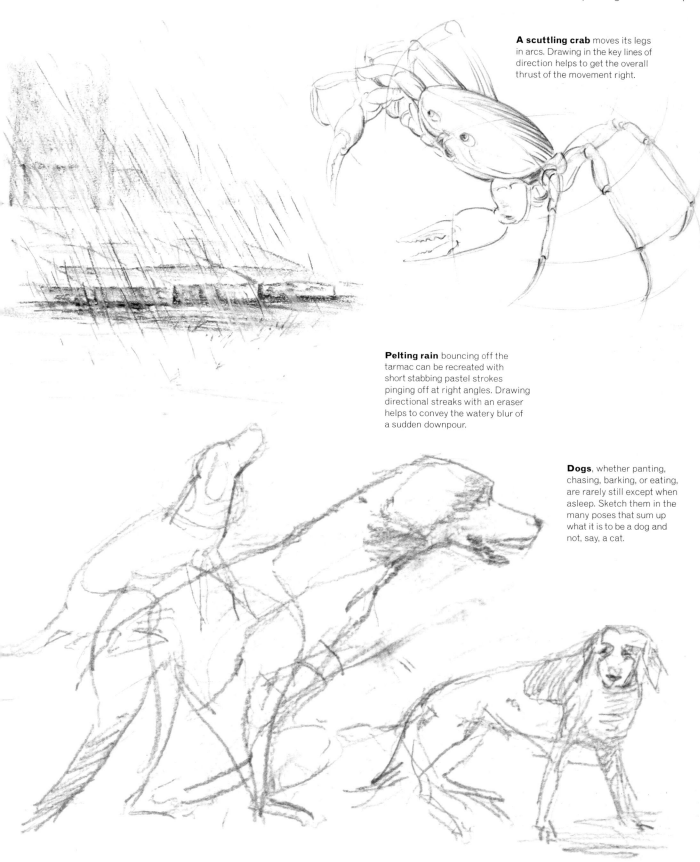

A scuttling crab moves its legs in arcs. Drawing in the key lines of direction helps to get the overall thrust of the movement right.

Pelting rain bouncing off the tarmac can be recreated with short stabbing pastel strokes pinging off at right angles. Drawing directional streaks with an eraser helps to convey the watery blur of a sudden downpour.

Dogs, whether panting, chasing, barking, or eating, are rarely still except when asleep. Sketch them in the many poses that sum up what it is to be a dog and not, say, a cat.

Using colour

Colour has an emotional impact, and it is important to know how different colours react with each other. You cannot make a colour brighter than it already is, but you can make it duller by adding another colour.

Dull in this sense does not mean dreary; it is just the opposite of bright. In drawing media, paler and darker tones, or brighter and duller versions, tend to come in separate sticks or pencils.

MIXING COLOUR ON PAPER

Increasing your understanding of the relationship between colours will help you use them better. As well as buying materials in different colour tones and brightnesses – for instance, blues from midnight navy to baby powder blue – you can mix colours on the paper. Layering involves applying one colour over another so that the bottom one affects the top colour. Alternatively, you can create an optical mix by using colours close together. For a fuller explanation of the relationship of colours to each other see the entry on the colour wheel on pages 138–139.

SCUMBLING

Blue over pink

Pink over blue

Blue over yellow

Yellow over blue

The technique of scumbling is a way of building up pastel in layers. Lightly draw the side or blunted tip of a soft pastel across the paper to create the first layer of colour. Do the same with a second colour to veil but not obscure or lift the previous layer. The broken colour sparkles, and the randomness of the marks adds textural interest. The order in which you apply the colours greatly affects the final appearance.

LAYERING COLOUR

Conté crayons and all types of pastel stick can be used on their side in broad strokes to create flat areas of single or layered colour, in this case blue over yellow and blue over orange. Where the pastels overlap they mix optically to create a third green or brown colour.

CROSSHATCHING

With coloured pencils, pastel pencils, and the tips of pastel sticks, you can use linear techniques. Make parallel lines with one colour (hatching), then add another set of lines across them at a different angle (crosshatching).

FEATHERING

Interlock fine lines so that the two colours shimmer and you can still see the individual marks. Feathering is another linear technique, useful for pencils, in which the colours blend visually rather than on paper.

COLOURED PENCIL DRAWINGS

Once you have experimented with the range of linear marks you can make with coloured pencil, try using them in a finished drawing. Different techniques work in different places. In the drawing below a full range of coloured pencil techniques is used. The brightest colours are in the foreground, with more muted application towards the background.

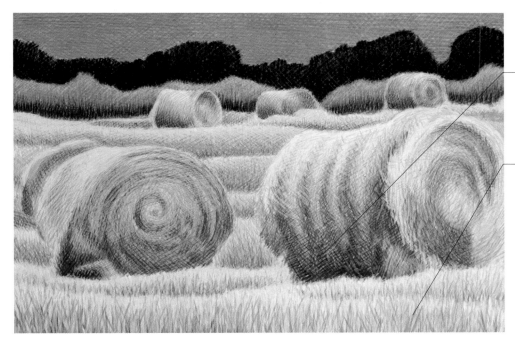

Crosshatching captures the close texture of the bales of hay.

Feathering makes the stalks glimmer and gleam.

Hay bales
The same colour scheme is used throughout, which unifies the drawing. Red predominates and advances in the foreground, with touches of green. In the background the colour balance shifts to mainly green with an underlayer of red.

PASTEL ON DIFFERENT COLOURED PAPERS

All pastel papers come in a range of tints and mid tones, and strong bright or dark colours. The colour of the paper has a marked effect on the drawing, as seen below. You can also use pastel on watercolour paper, which is thicker. The more texture the paper has, the more pastel it will hold, so you can layer colours and completely cover the underlying surface if you wish.

Watercolour paper

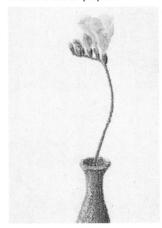

The image looks weak because the white of the paper deadens the colours of the flower and vase. This is why it is preferable to use tinted or coloured rather than white paper.

Purple paper

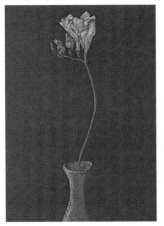

The flower and stem look luminous against the contrasting background. As blue and purple are next to each other on the colour wheel, the vase and the paper harmonize.

Red paper

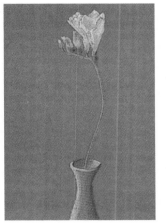

The red and green contrast and vibrate so that the image looks extremely bright. The paper is such a strong colour that the background insists on attention.

Peach paper

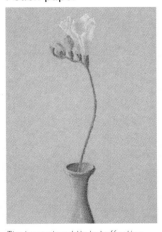

The image is subtle but effective. The paper colour mellows the blue of the vase but it is dark enough to highlight the flower, which would be lost on white paper.

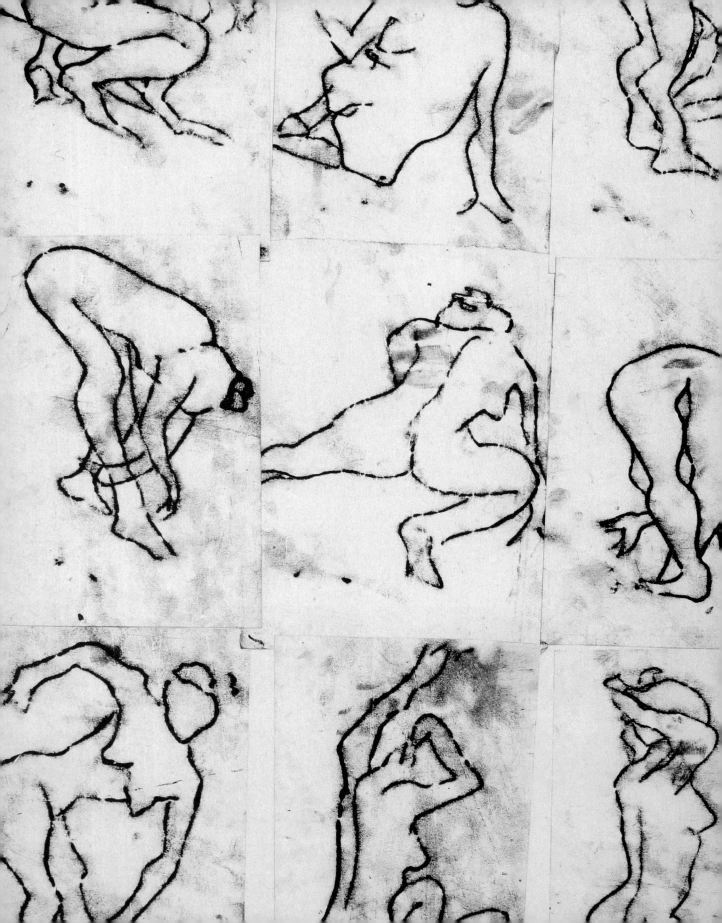

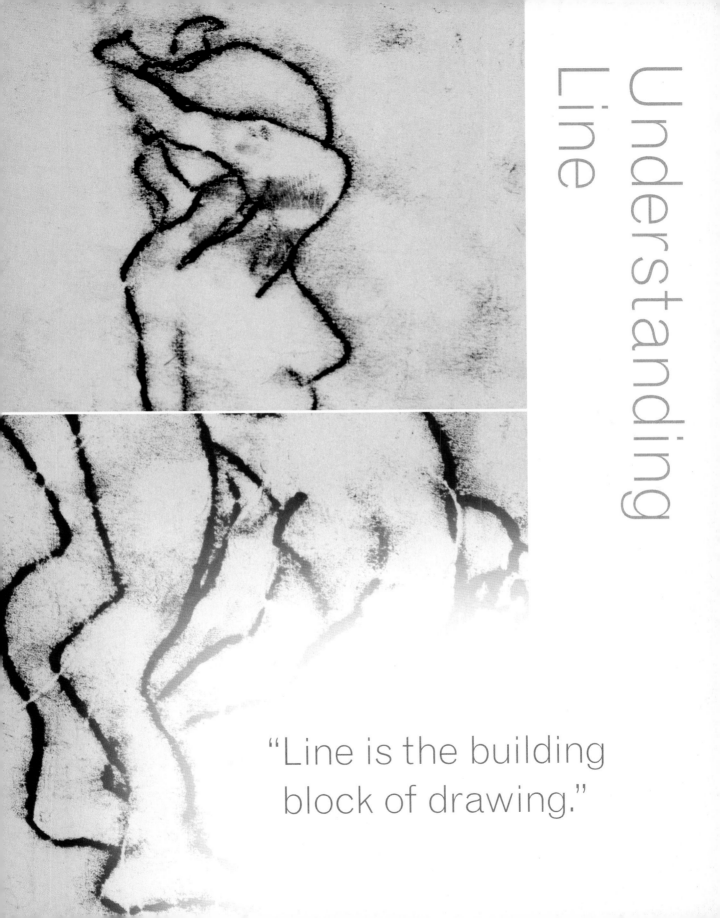

"Line is the building block of drawing."

The power of line

The Swiss-born artist Paul Klee described drawing as "taking a line for a walk". Line is the fundamental drawing technique and you can use it to produce pictures of the utmost sophistication or simplicity. Pencils, pens, and coloured pencils are all ideal for line work. You can work in outline alone, called contour drawing, in which case you concentrate on shape. You can combine outline with hatching to create a tonal drawing or you can simply vary the weight of line to indicate volume and substance.

DIFFERENT TYPES OF LINE

With pencil or charcoal you can explore the full expression of line – thin, thick, bold, delicate, broken, continuous, dark, light. With a technical pen you have a consistent line. No one type of line is better than another: each has its place. Try sketching with different sorts of line, adapting the treatment to the subject matter, and see how it improves the character of the drawing.

Pen outline

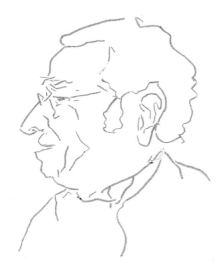

A fine-nibbed pen creates regular lines that are ideal for a rapid sketch. This distinctive profile has been captured in just a few seconds, using very few lines.

Pencil for shading

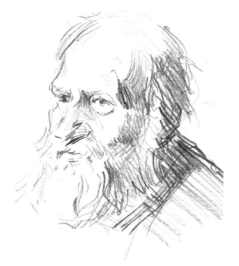

Here soft pencil has been used for dense, crayon-like lines and a harder pencil for crisp lines. The lines follow the contours of the old man's features and beard. Several sketch lines have been added alongside hatching for a mid tone and crosshatching for a dark tone.

Pencil outline

Gentle, fluid lines emphasize the curves of the fruit, their stems, and cores. A sense of form has been created by pressing harder where the two apples on the left meet, while in other places the line has been broken for a delicate touch.

Light and dark pencil lines

The lighter weight of line in the distance implies receding space. The detail also fades – the people along the beach are mere squiggles. This rule of dark, crisp foreground and pale, hazy background lines is called aerial perspective.

USING NEGATIVE SPACE

Every line that you draw creates two edges. The edges may be a boundary between one object and another or they may show the object and a gap. The gaps between positive forms are called negative space and, despite the dismissive name, are highly important for a good composition. Drawing negative space rather than the subject can free you up and strengthen the drawing.

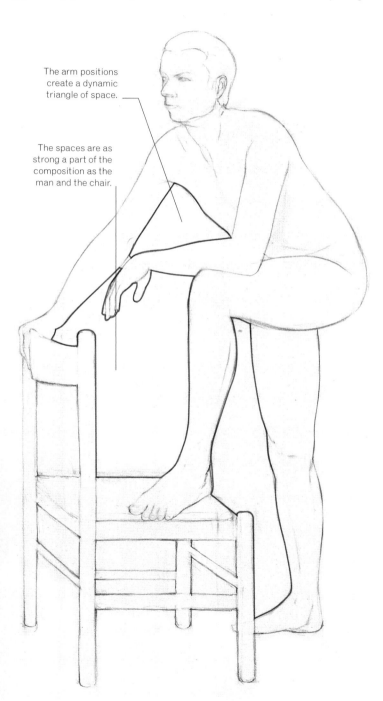

The arm positions create a dynamic triangle of space.

The spaces are as strong a part of the composition as the man and the chair.

In figure drawing the angles of arms and legs often form strong negative spaces. Linear objects based on geometric shapes, such as chairs, are also a gift in terms of negative spaces. Here the combination of a figure and a chair sets up a series of intriguing spaces.

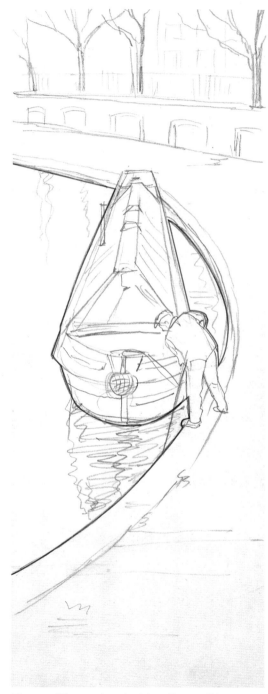

The arc of the canal creates interesting negative space around the boat, setting curves against straight lines. The arches between the trees in the background and the holes pierced into the wall make patterns of negative space.

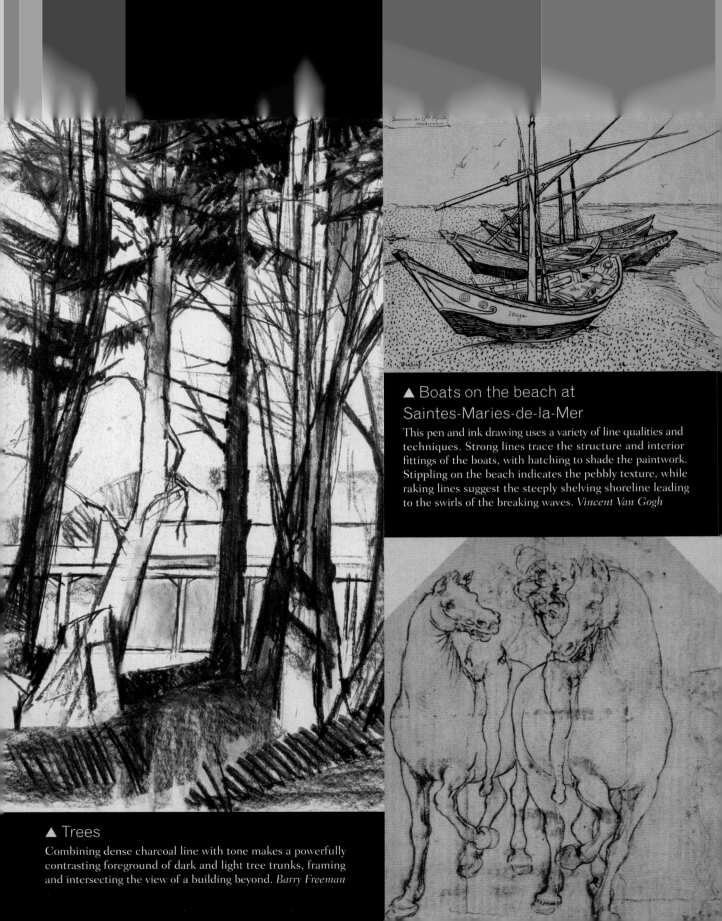

▲ Boats on the beach at Saintes-Maries-de-la-Mer

This pen and ink drawing uses a variety of line qualities and techniques. Strong lines trace the structure and interior fittings of the boats, with hatching to shade the paintwork. Stippling on the beach indicates the pebbly texture, while raking lines suggest the steeply shelving shoreline leading to the swirls of the breaking waves. *Vincent Van Gogh*

▲ Trees

Combining dense charcoal line with tone makes a powerfully contrasting foreground of dark and light tree trunks, framing and intersecting the view of a building beyond. *Barry Freeman*

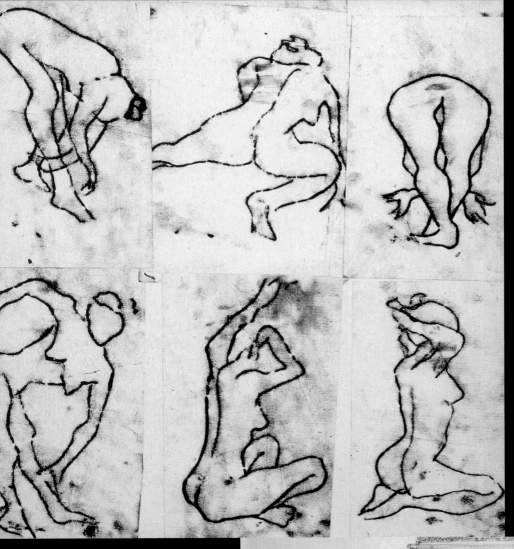

◄ Keep moving

Made by piecing together a series of fast sketches of a live model in various poses, the drawings for this monoprint are purely in outline, concentrating on dynamic movement and the play of positive form and negative spaces. *Lindi Kirwin*

Arc de Triomphe ►

The people, trees, and cars are in darkest ink because they are nearest. Their size gives a sense of the enormous scale of the triumphal arch. Multiple faint lines suggest the pattern of the decoration on the arch without sharply focused detail, which would be overpowering at that distance. *Franklin McMahon*

◄ Horses and knights

Despite the moving subject and rapid charcoal drawing, the wrinkles in the horses' necks describe the turn of the head and the depiction of equine leg action is extraordinarily precise. *Leonardo da Vinci*

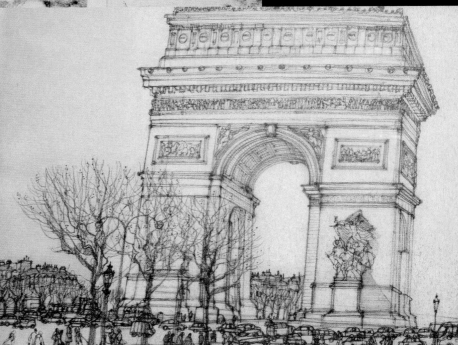

1 Overlapping leaves

This project will help you to focus attention not just on the lines of the subject you are drawing, in this case some sycamore leaves, but also on the shapes that are created in the gaps between and around them – the negative spaces. The relationship between form and space is important when planning a composition, as all the lines and shapes have to relate to the whole. Negative space also helps you position the individual elements of the subject in correct relationships to one another when working on the initial outline of the drawing.

EQUIPMENT
- A4 heavyweight cartridge paper
- HB pencil

TECHNIQUES
- Using negative space
- Drawing outlines
- Varying strength of line

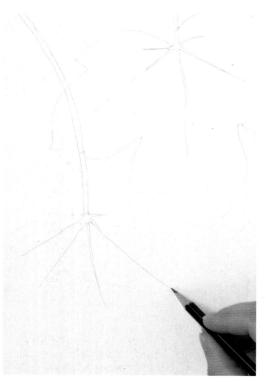

1 Carefully map the position of the sycamore leaves with a faint outline, using the negative spaces to help with accuracy. Lightly sketch in the stems and the leaf veins.

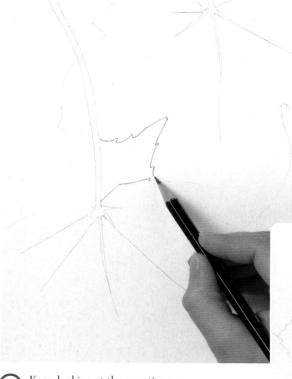

2 Keep looking at the negative spaces – you may find these easier to draw than the positive leaf shapes. Once you are happy with the outlines, darken them by pressing harder with the pencil.

BUILDING THE IMAGE

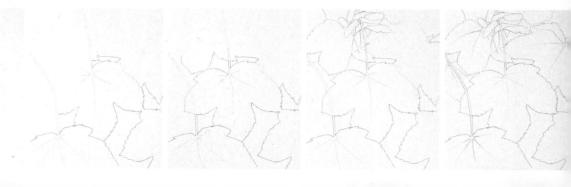

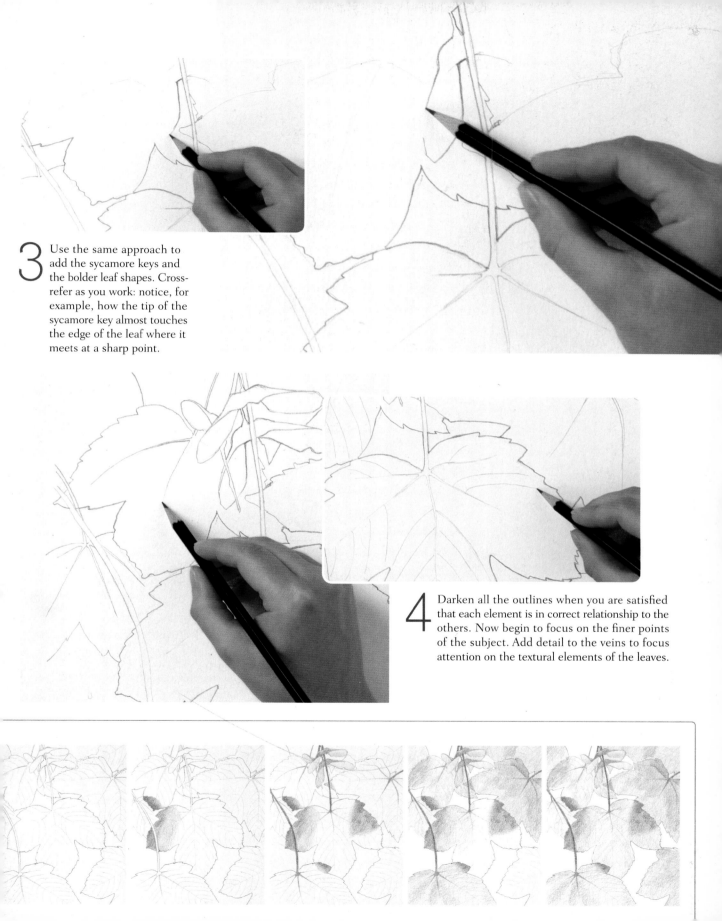

3 Use the same approach to add the sycamore keys and the bolder leaf shapes. Cross-refer as you work: notice, for example, how the tip of the sycamore key almost touches the edge of the leaf where it meets at a sharp point.

4 Darken all the outlines when you are satisfied that each element is in correct relationship to the others. Now begin to focus on the finer points of the subject. Add detail to the veins to focus attention on the textural elements of the leaves.

5 When all the lines are in place, use the side of the pencil lead to lightly shade in areas of tone where the leaves overlap. Start gently and then press harder in the places where the shadows are darker.

"The balance of positive shapes and negative space creates harmony."

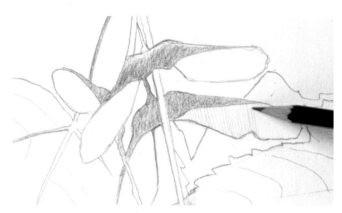

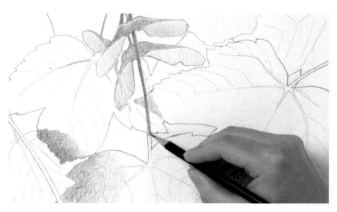

6 Shade in the sycamore keys using the point of the pencil and pressing harder, because these have darker tones than those found on the leaves. Hatch the underside of the keys very lightly, to contrast with the darker tone.

7 Carry on using the point of the pencil to add definition to the long, slender stems. Press hard to create the darkest tone here, lightening the pressure as the stems lead into veins. The stems are the heaviest structural element.

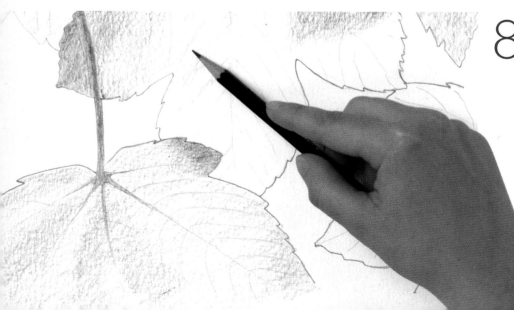

8 Balance the overall design by lightly shading all over the leaves. This harmonizes the structural and tonal elements of the composition, and contrasts with the unshaded negative spaces, to achieve a visually pleasing balance between the two.

Overlapping leaves ▶

The two-dimensional leaves help you to concentrate on negative space and outline. The clear, bold shapes of randomly overlapping leaves create a natural and simple pattern of form and space with which to work.

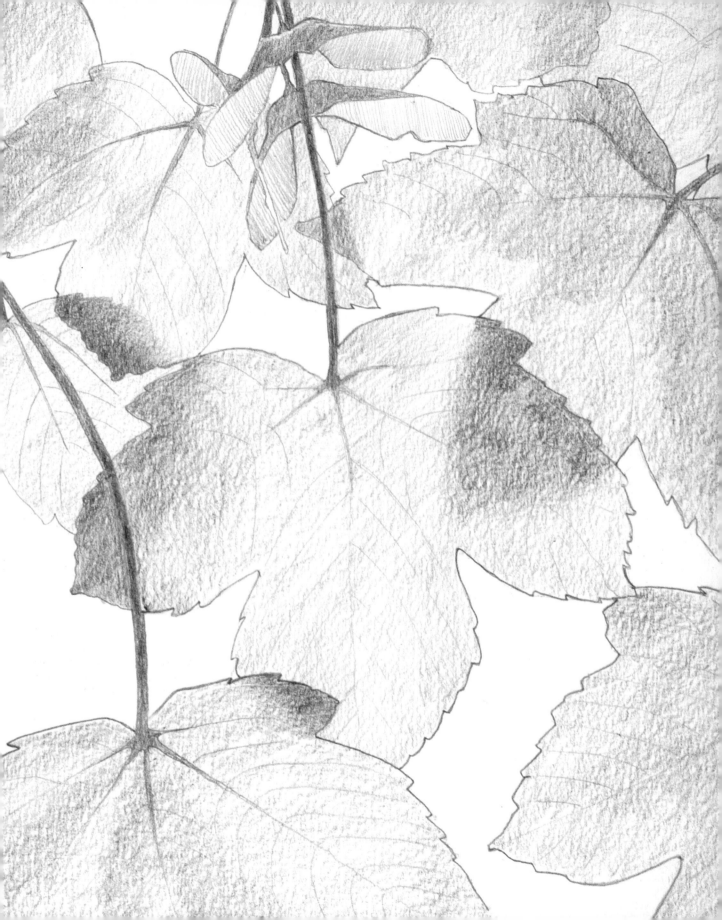

2 Books on a table

Varying the weight, quality, and nuance of line brings a drawing to life. But first you need to block out your composition, with the subject right in front of you, at eye level. This deceptively simple still life of books under natural light challenges your powers of observation. Take a few minutes to study how the books are arranged. You will need to take careful measurements, consider vanishing points, use negative space, and draw straight lines. Once the structure of the drawing is in place, you can start to explore different strengths of line.

EQUIPMENT
- A3 smooth white cartridge paper
- H, HB, and 4B pencils
- Plastic eraser
- Sheet of A4 paper

TECHNIQUES
- Measuring with a pencil
- Drawing geometric shapes
- Using negative space
- Thin and thick lines to show depth and form

1 Mark off the paper into thirds, using the HB pencil. Use a ruler to measure if need be. As you gain experience, this grid will become instinctive and the lines imaginary. For now, the grid will help you to position objects and place focal points.

2 Start with the focal point, the little book, and draw it on the bottom right third line. The spine of one upright book falls approximately on the opposite third. Use sketchy lines to build the composition rather than rubbing out mistakes.

3 Use the spine of the little book as your base measurement (*see p.24*). Calculate the length of the longer lines: the height of the upright books is about twice as long; the bottom book is about 3½ times as long, from corner to opposite corner.

BUILDING THE IMAGE

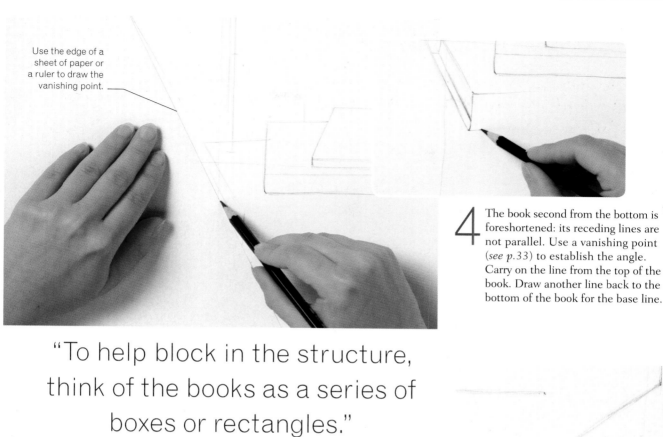

Use the edge of a sheet of paper or a ruler to draw the vanishing point.

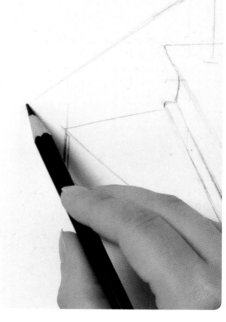

4 The book second from the bottom is foreshortened: its receding lines are not parallel. Use a vanishing point (*see p.33*) to establish the angle. Carry on the line from the top of the book. Draw another line back to the bottom of the book for the base line.

"To help block in the structure, think of the books as a series of boxes or rectangles."

5 Draw the line of the table to anchor the objects. Draw the two bottom books. They create negative space that helps set the angle of the upright book. When you no longer need the vanishing points and grid of third lines, rub them out.

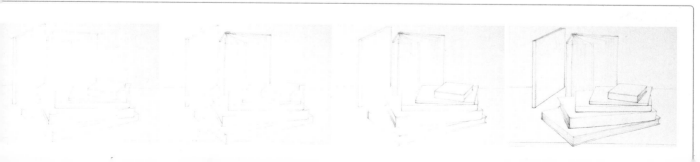

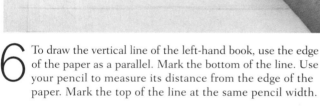

Measure from the paper's edge with your pencil.

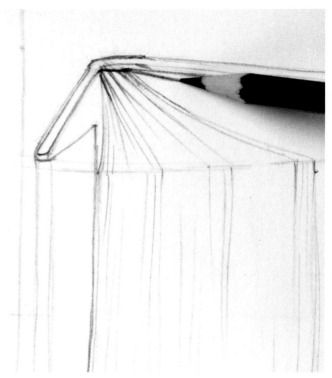

6 To draw the vertical line of the left-hand book, use the edge of the paper as a parallel. Mark the bottom of the line. Use your pencil to measure its distance from the edge of the paper. Mark the top of the line at the same pencil width.

7 Use the H pencil to start drawing the fine lines. Draw crisp, sharp lines to indicate individual pages of the upright book. Lighten the pressure as the lines come forward. Use the HB pencil to draw the covers of the books.

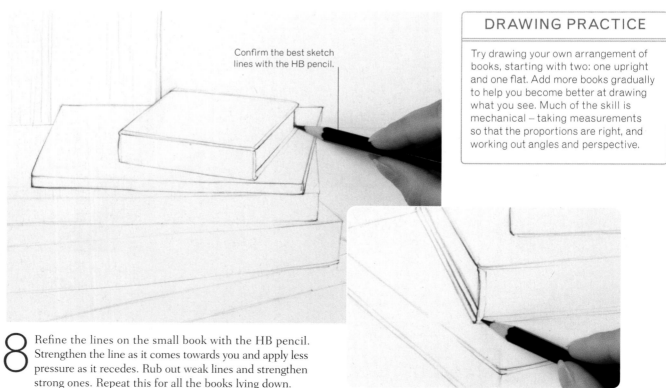

Confirm the best sketch lines with the HB pencil.

DRAWING PRACTICE

Try drawing your own arrangement of books, starting with two: one upright and one flat. Add more books gradually to help you become better at drawing what you see. Much of the skill is mechanical – taking measurements so that the proportions are right, and working out angles and perspective.

8 Refine the lines on the small book with the HB pencil. Strengthen the line as it comes towards you and apply less pressure as it recedes. Rub out weak lines and strengthen strong ones. Repeat this for all the books lying down.

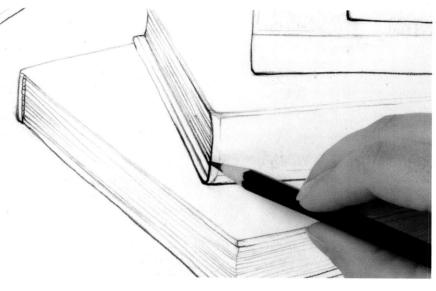

9 Use the 4B pencil for the darkest, thickest line of the nearest books. Draw a heavy 4B shadow line underneath the book to ground it. Use the H pencil for the dash lines of the pages. Stabilize the table with a base line of 4B and verticals to suggest a leg and drawers.

▼ Books on a table

Drawing books will use all your technical skills and let you exploit the variety of lines that can be made with just three pencils. Shapes are repeated in the geometric composition: the arc of pages in the upright book echoes the fan of books lying down.

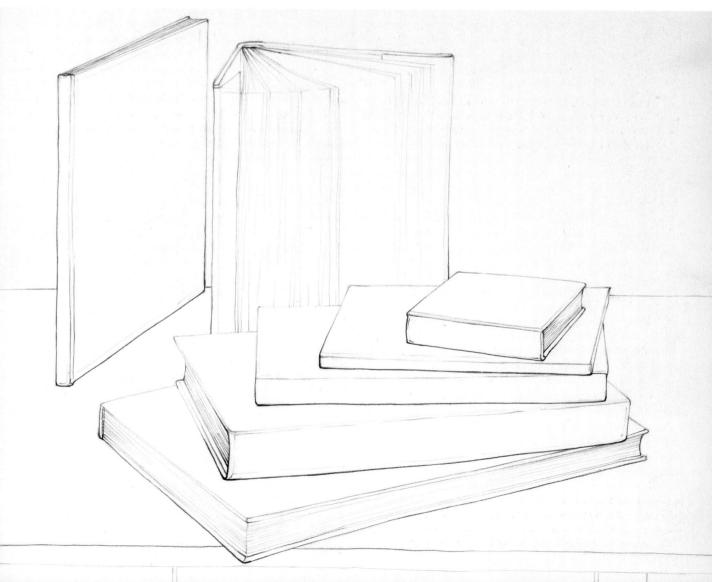

③ Country road

In this graphic landscape the view, punctuated by a large house in the middle ground, makes use of leading lines to create an impression of recession from the foreground to the low hills in the distance. The banks along the road draw the eye along the sweep of tarmac towards the house and beyond. Aerial perspective, whereby distant objects are drawn more faintly than they would appear in real life, has been used to increase the sense of depth. Charcoal, with its capacity for intense velvety blacks as well as light greys, is ideal for the purpose.

EQUIPMENT
- A3 cartridge paper
- Charcoal pencil
- Compressed charcoal stick
- Willow charcoal stick
- Soft watercolour brush

TECHNIQUES
- Using leading lines
- Using aerial perspective
- Hatching line
- Blocking in tone

1 Using the charcoal pencil, sketch in the main lines of the scene to establish the composition. Only press very lightly with the pencil at this stage, as these first lines are intended as guides and you may find that you want to alter things later.

2 Once happy with the structure, think of tone. Screwing up your eyes while looking at a scene helps to define areas of light and tone and see them as clear, bold shapes. Build up tonal areas with hatched lines using the charcoal pencil.

3 Switch to the compressed charcoal stick and strengthen the darkest areas on the roadside bank. Work around the indications of shrub stems, which remain as bare paper. Heightening definition here will bring the bank forward.

BUILDING THE IMAGE

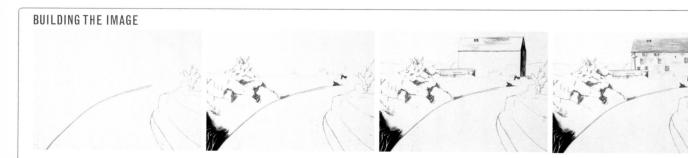

4 Soften any dark tones that seem to overpower the overall composition using gentle stokes with a soft brush. The brush also helps to smooth the charcoal evenly over the paper – and you can use it to remove any unwanted marks.

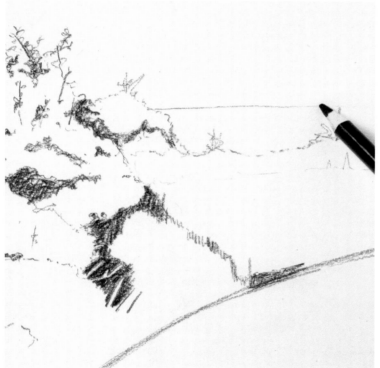

"Use the boldest lines in the foreground of a landscape."

5 Lightly define the background details, using the charcoal pencil again. Keep the lines for the distant hills delicate so that they seem far away, compared with the intense charcoal foreground.

6 Add some tone to the roof of the building with the side of the willow charcoal stick. Areas of tone made with willow charcoal are lighter and softer than those made with compressed charcoal.

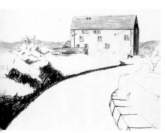
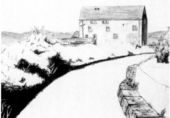
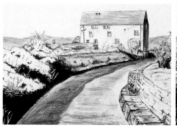
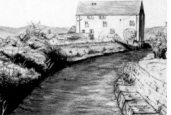

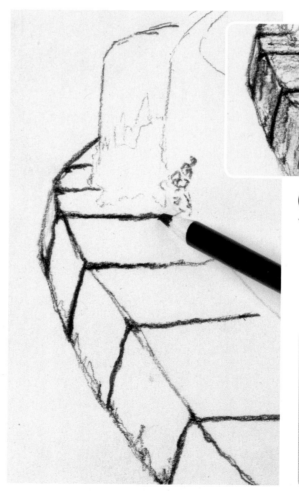

7 Using the point of the charcoal pencil add finer details, such as the windows, drainpipes, the sloping shed roof, and the triangle of wall half hidden by foliage in front of the house.

8 Define the background hills in soft tones with gentle sweeps of the side of the willow charcoal stick. This hazy shading will create the effect of aerial perspective and give the landscape a sense of depth.

9 Using the charcoal pencil again, define the lines of the blocks on the right side of the road. The stone- and brickwork bring a strong sense of recession to this side and a structural element echoed in the house beyond.

LEVELS OF DETAIL

Charcoal is a good medium for landscape, as you can work in detail with the pencils and in broader swathes with willow and compressed sticks. You need to include enough detail to engage viewers' attention but leave some things to the imagination.

10 Build up tone in the road by drawing gentle horizontal strokes with the willow charcoal held on its side. Let the paper show through where the light falls; this also helps to make the paving stones stand out.

▼ Country road

Achieving a smooth progression from foreground to distance is one of the challenges of landscape drawing. Aerial perspective helps, particularly if the landscape has features such as a road or river to lead the eye into the scene.

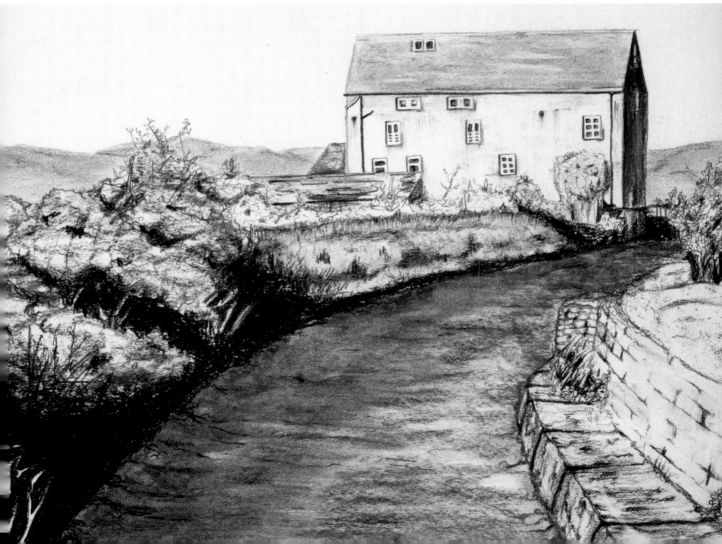

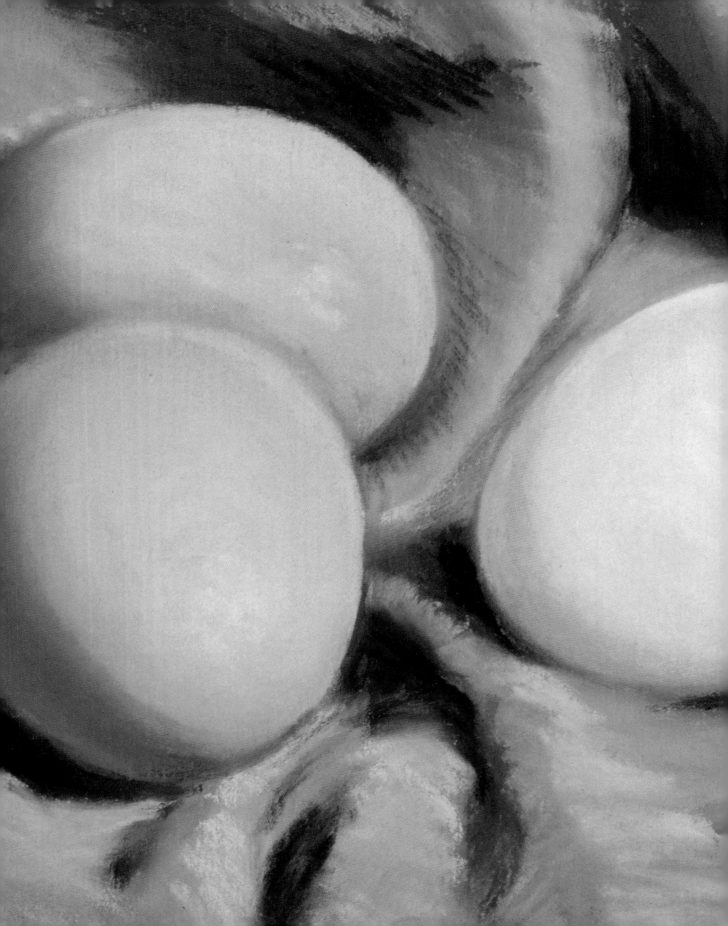

Drawing with Tone

"Use light and
shade to create
depth and volume."

Light and dark

When you are sketching outdoors you work under natural light, whether it is sunny or overcast, summer or winter, midday or twilight. Indoors, you have more control. Artists' studios traditionally face north to provide a constant light. Using artificial light, however, allows you to take your time and forget about changing levels of light. Showing how light falls and using tone to create shadows and highlights, makes everything you draw, whether objects, people, animals, or landscapes, look three-dimensional.

THE EFFECTS OF LIGHTING

A single bright light creates a contrast of light and shade that accentuates the form of things. A movable light such as an anglepoise lamp provides strong directional light. The play of light varies depending on where you place the light. You can use the direction of lighting to alter the mood of a drawing. Indoors, natural lighting is more gentle and diffused than artificial lighting.

FRONTLIGHTING

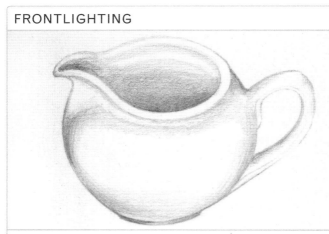

When an object is lit from the front, it looks bleached out, like a face photographed using just flashlight. Although pale, the object is rimmed in shadow, like the jug above.

SIDELIGHTING

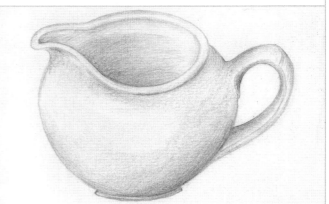

Often the best lighting for a still life, sidelighting strengthens the contrast of light and shade and shows up form well. The transition from light to shade may be gradual or sharp depending on how bright the light source is.

BACKLIGHTING

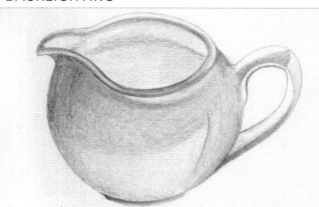

When an object is backlit, it is in shadow, often with a halo of light around it once you add background. Outdoors, drawing subject matter against the sun creates the same effect and can look dazzlingly effective.

THREE-QUARTER LIGHTING

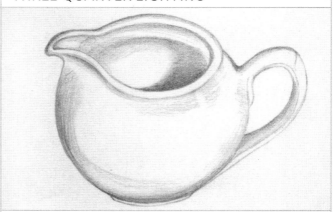

The light is shining from the right foreground, over the artist's shoulder, so both the inside and outside of the jug have a mixture of light and shadow. Three-quarter lighting is flattering for portraits.

USING TONE

Strongly contrasting areas of tone are eye-catching, whereas more subdued tone fades into the background. In black and white drawings dark shading on white paper looks striking, while grey tone recedes. You can use this knowledge to add depth and solidity to your drawings. Combine tone with line or use it on its own. Charcoal and pastel are good for tonal drawing.

Stippling

There are many ways to apply tone and one of them is stippling – dots. How closely you space the dots and how big you make them varies the density of tone.

Tone in colour

Colours are dark or light in tone, just as pencil or charcoal are. One way to make a colour look paler is to apply less pigment, as on the right of the drawing above. Screwing your eyes up helps you see how light or dark colours are in relation to each other.

Line or tone?

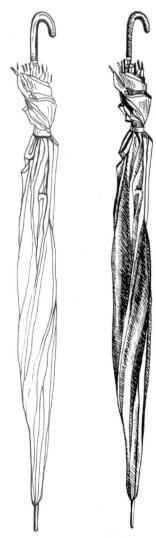

The first umbrella is drawn entirely in line; the second one is drawn in line with hatched shading to show clearly the folds of the fabric. Both have their strengths: which you prefer is a matter of choice.

Drawing part of a picture in detail and leaving the rest of it sketchy creates a focal area of interest. Here the sparing lines of bedding lead the eye to the head of the sleeping figure. The vertical of the corner and hatching scribbled on to a section of wall give context. Note how a single pencil is used to create different depths of tone.

Selective tone

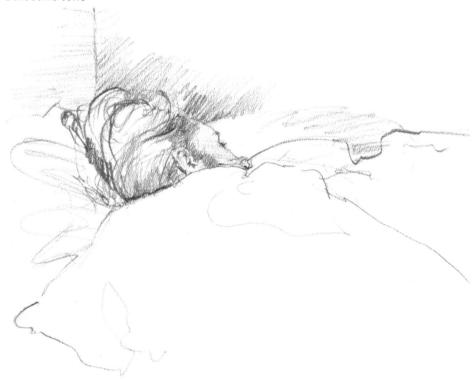

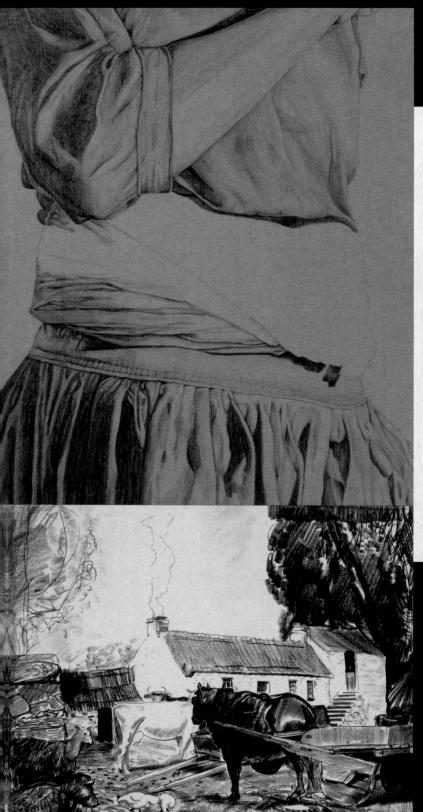

◄ Fabric study
Creative cropping of the figure focuses attention on to the pencilled fabric. Light catches the ridges of material under the waistband, while folds retreat into shadow, making the texture tangible. *Liane Holey*

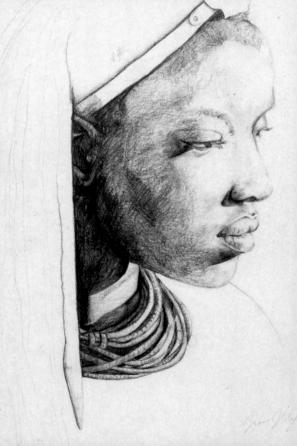

▲ Profile of a young woman
Bathing the features in light reinforces the thoughtful expression of the model. The pencil tone deepens from the cheeks to the neck and hairline and stands out against the white headgear. A sliver of crosshatching indicates the cheekbone. *Liane Holey*

◄ Farmyard
Conté crayon tone and composition work hand in hand as the dark shape of the horse leads the eye towards the white form of the cow, pointing up the steps to the house and ushered back down by the darkly hatched tree, set against the pale sky. *George Wesley Bellows*

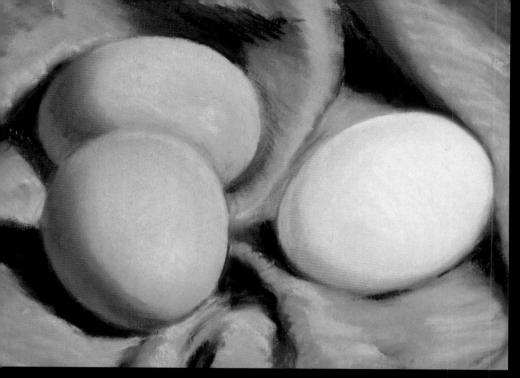

◄ Eggs
Tone is equally important in colour. Soft chalk pastels capture the matt surface of egg shells, with the lilac of the fabric reflected in the shadows. *Jennifer Mackay Windle*

▼ Seated nude
Light falls on the woman's breasts, stomach, forearms, and thighs in this subtly erotic study. Bands of scribbled and blended tone in conté crayon are counteracted by a secondary light source illuminating the model's back. *Isabel Hutchison*

▼ En marche (Walking)
Conté crayon is a superb medium for purely tonal drawings. Haloed in light, the figure emerges from the background in the monochrome equivalent of the artist's dotted pointillist oil-paintings. *Georges Seurat*

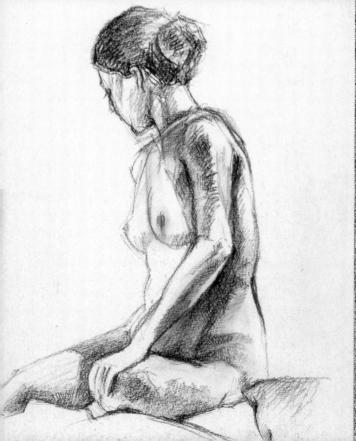

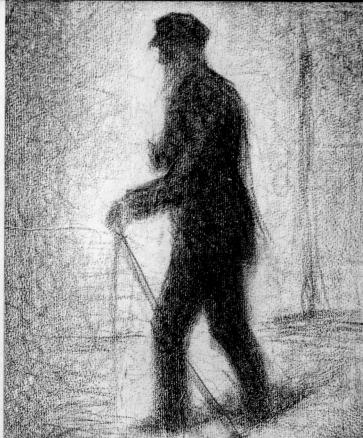

4 Group of shells

In this still life hard and soft graphite pencils are used on mid-toned paper to capture the smooth and nubbly textures of a group of shells, and light and shade are emphasized to create the impression of solidity and depth. Working on textured paper with a slight tooth adds definition to the areas of tone and enhances the sense of three-dimensional form on the flat surface of the paper. To make the composition more interesting, the shells are strongly lit from one side by a single light, which casts dramatic shadows over the simple arrangement.

EQUIPMENT
- A4 peach-toned paper with a slight tooth
- Putty eraser
- 2H, H, B, HB, 2B, and 4B graphite pencils

TECHNIQUES
- Hatching lines to express tone and form
- Drawing out highlights with a putty eraser

1 Lightly sketch the outlines of the shells with the HB pencil, rubbing out any mistakes. Use the negative spaces between and around the shells to help define their contours and position them correctly. Strengthen the best lines with the 2B pencil.

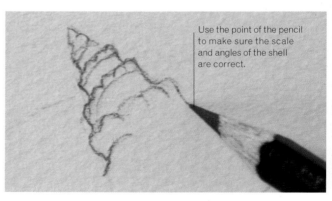

Use the point of the pencil to make sure the scale and angles of the shell are correct.

2 Add detail to the front shell with the HB pencil. Use light pressure to create delicate lines at this stage, so that you can rub out any lines that you are not happy with. Use your pencil to keep checking that the angles are correct.

3 Start to define more intricate details of pattern and structure with the 2B pencil, still keeping the pressure light so that you can change things if you like. Spend time getting the drawing stage right before you shade anything.

BUILDING THE IMAGE

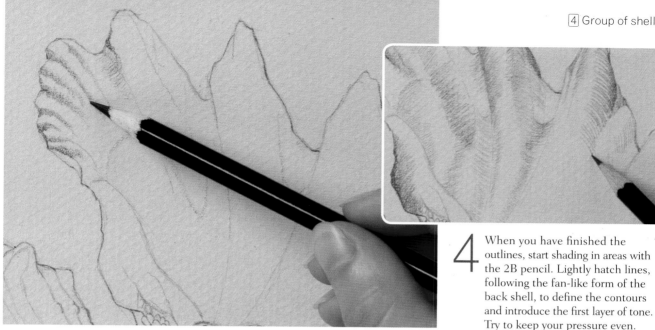

4 When you have finished the outlines, start shading in areas with the 2B pencil. Lightly hatch lines, following the fan-like form of the back shell, to define the contours and introduce the first layer of tone. Try to keep your pressure even.

"It is important to feel happy with the outline before adding detail."

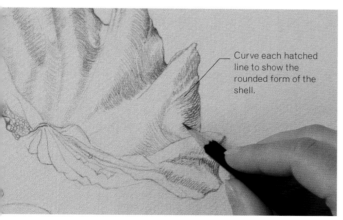

Curve each hatched line to show the rounded form of the shell.

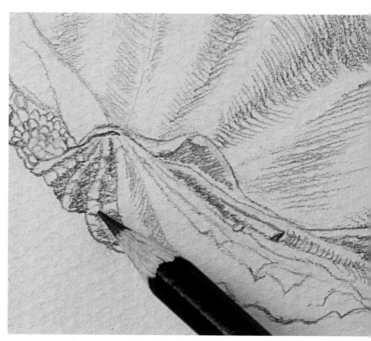

5 Add another layer of hatched lines with the 2B pencil. Carry on following the contours of the shell, but apply slightly firmer pressure where the shadows are darkest. Use the H pencil to add any sharper details.

6 Continue using the H pencil to define the intricate little ridges of the underside of the back shell. Switch to the softer B pencil to darken the areas of hatched tone between the ridges. This will seem to add depth to them.

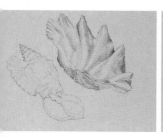

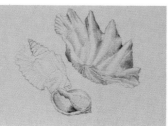

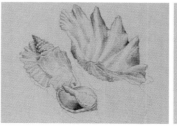

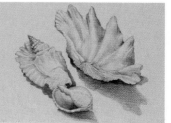

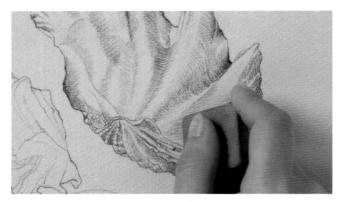

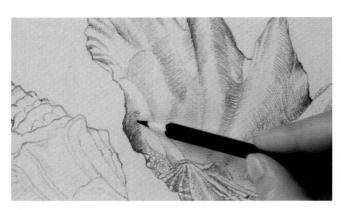

7 To model the shape of the large shell on the right, make gentle downward strokes along the ridges of the shell with the corner of the putty rubber. This will erase parts of the drawing and create areas of highlight.

8 To finish the shell, study it closely to see where the darkest shadows are, then strengthen these areas of tone by adding further layers of close hatching with the 2B pencil. The deep shadows provide a strong contrast with the highlights.

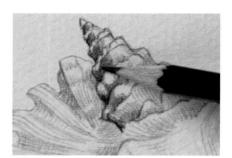

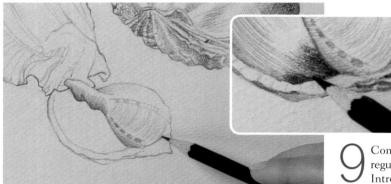

TIPS ON TONE

Screw up your eyes when looking at your subject to help you see where the areas of light and shade are. When you add tone, place a piece of paper under your hand to stop you from smudging.

9 Complete the small shell in the foreground by adding regular hatched lines with the 2H pencil to model its form. Introduce darker shading with HB on the interior of the shell and use the 2B pencil for the darkest areas of shadow.

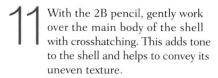

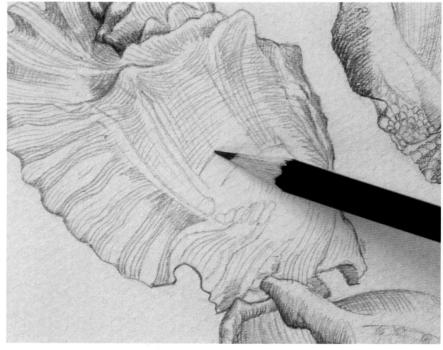

10 With the HB pencil, carry on adding detail to the larger shell on the left, paying particular attention to its texture. Notice how the strong side lighting emphasizes the form of the shell and the tonal contrasts.

11 With the 2B pencil, gently work over the main body of the shell with crosshatching. This adds tone to the shell and helps to convey its uneven texture.

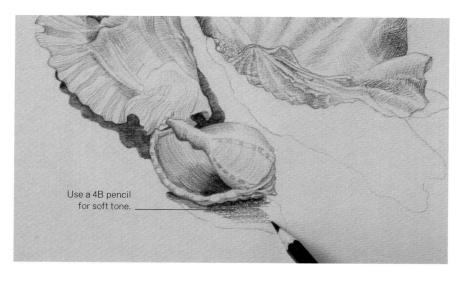

Use a 4B pencil
for soft tone.

12 Lightly draw the outlines of
the shells' shadows with the H
pencil. Shade in the darkest
areas of shadow beneath the
shells with the side of the 4B
pencil. Use the 2B pencil for the
areas of more diffused shadow.

▼ Group of shells

Simple hatching in a range of pencils has
been used to make the shells look three-
dimensional and give them texture. The
dramatic side lighting has emphasized
the contrast between light and shade
and made the composition stronger.

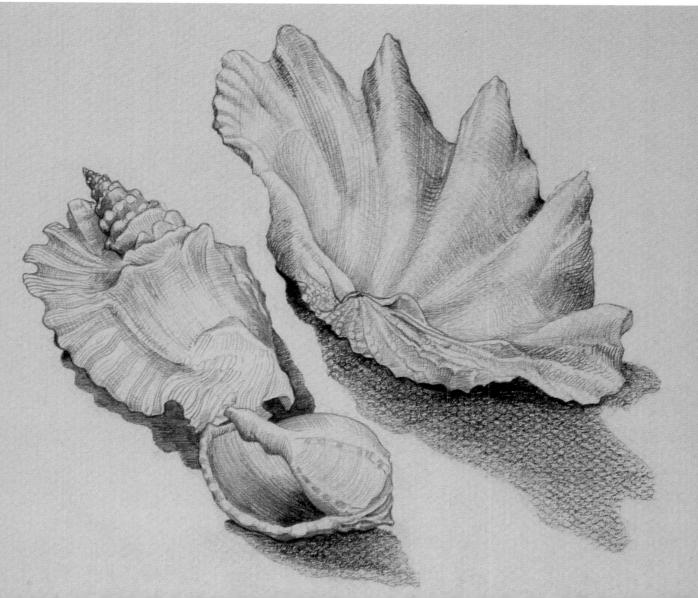

5 Portrait of a young woman

This monochrome study in conté crayon is drawn on tinted paper, which provides the mid-tone in the drawing. The portrait is drawn from a three-quarters viewpoint, perhaps the most interesting angle from which to view a face and common in traditional portraits. The main source of light is on the model's left, and there is a second light above her. The artist is looking up at the model and this low viewpoint, together with the strong contrast between light and dark tones, emphasizes the sculptural nature of the head and evokes a sense of drama.

EQUIPMENT

- A3 tinted pastel paper
- Black and white conté crayons
- Shaper
- Plastic eraser

TECHNIQUES

- Blending with a shaper, eraser, and finger
- Following the form of the subject
- Touching in highlights

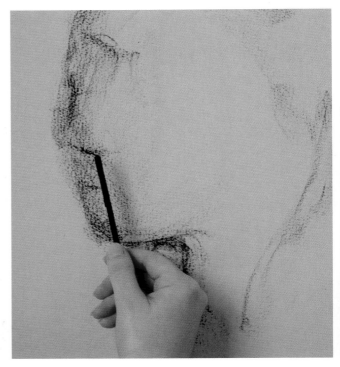

1 Lightly block in the shape of the head with the side of the black crayon. Working in faint tone rather than line will make it easier for you to fit the whole head on to your page. Make the left side of the face darker to show where the light falls.

2 Use the stick end of the shaper to measure from the chin to the bottom of the nose, the length of the nose, and the distance from the top of the nose to the hairline. Lightly mark the points you have measured in black line.

BUILDING THE IMAGE

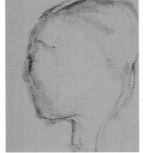
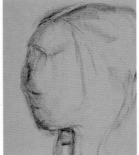
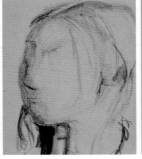
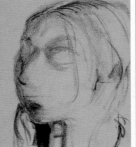
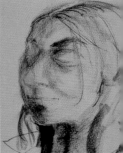

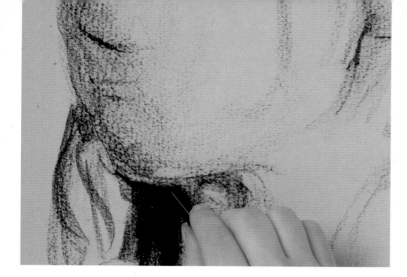

Portrait of a young woman | 71

3 Draw the hair below the chin on the left side of the face. Work in mid-tone, pressing lightly until you are happy that it is in the right place, then work over it, strengthening the tone.

POSITIONING FEATURES

When you are at the same eye level as your model, the eyes will be halfway up the head in a portrait. Lowering the viewpoint, so that you look up at the model, affects the position of the features. Trust your eyes and your measurements and draw the eyes, nose, mouth, and ears exactly where you see them.

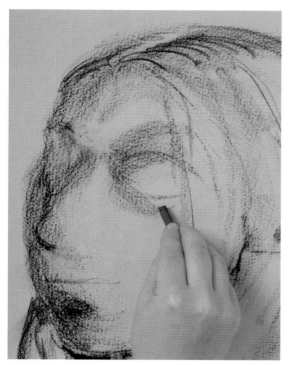

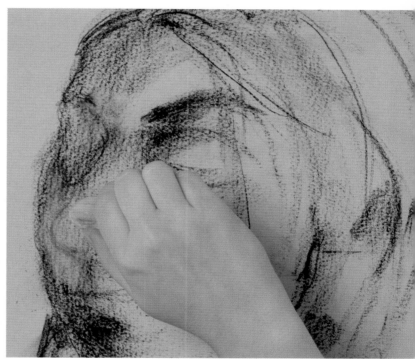

4 Use the point of the crayon to draw strands of hair that follow the shape of the head. Lightly indicate the curves of the eye sockets and cheeks, using the broad edge of the crayon.

5 Check that the distances from the mouth to the nose and the nose to the eyes are correct, as well as the distance from the top to the bottom of the head. Correct any mistakes by rubbing out the crayon with kitchen towel or the eraser.

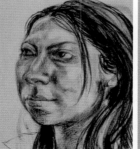
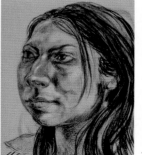

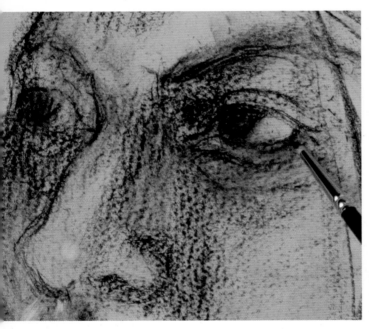

6 The mouth is about a third of the way up the face. Draw the outline of the lips in black, then use white to indicate the highlights below the nose and on the lips. The white will be a reminder, as you will add the highlights last of all.

"Taking away tone is as important as adding it."

7 Draw the details of the eyes, the eyelids, and the eyebrows in black crayon. Use the shaper, which is like an eraser on a pencil, to blend in the different tones around the eyes. Rub the shaper clean on kitchen towel.

8 Rub out a highlight on the forehead and smudge it with your finger to blend it in. Rub out and smudge highlights on the browbone and cheekbones in the same way. Now you have light tones, as well as dark and mid-tones.

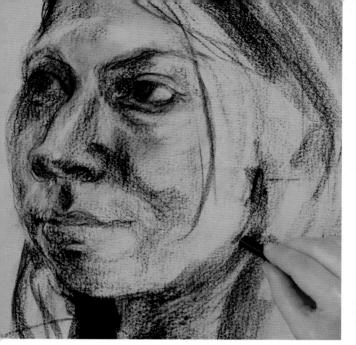

9 Stroke black crayon under the chin, following the contours of the face, to bring the head forwards visually. Build up tone, using similar curved strokes rather than lines, to draw the areas of the cheeks and neck that are in shadow.

10 Use the black crayon on its side to block in the hair and add volume to the top of the head. Hair often moves so leave most of the detail to the end. Start to refine tone, adjusting light and dark areas over the whole picture.

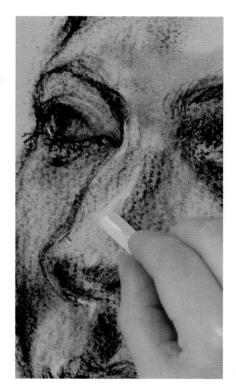

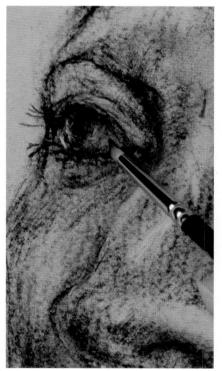

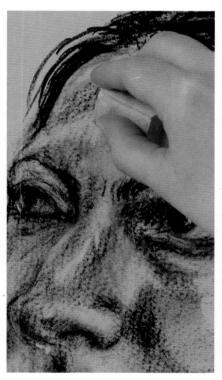

11 With the eraser, rub out the crayon tone down the bridge of the nose. Draw a highlight line down the nose. Dab a highlight just under the nose, halfway between the nostrils.

12 Use the shaper to adjust the details around the eyes. Rub out highlights above and below the eyes to indicate the eye sockets. Erase tone to create highlights in the whites of the eyes.

13 Use the eraser to get back to the bare paper for larger areas of mid-tone on the forehead. Lightly draw the eraser over the model's right cheek to adjust the tone. Keep checking where the light falls.

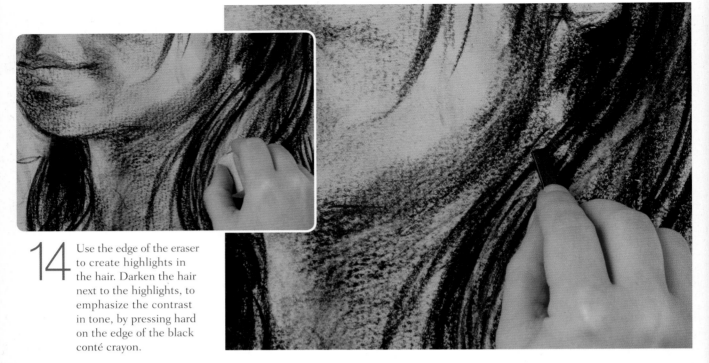

14 Use the edge of the eraser to create highlights in the hair. Darken the hair next to the highlights, to emphasize the contrast in tone, by pressing hard on the edge of the black conté crayon.

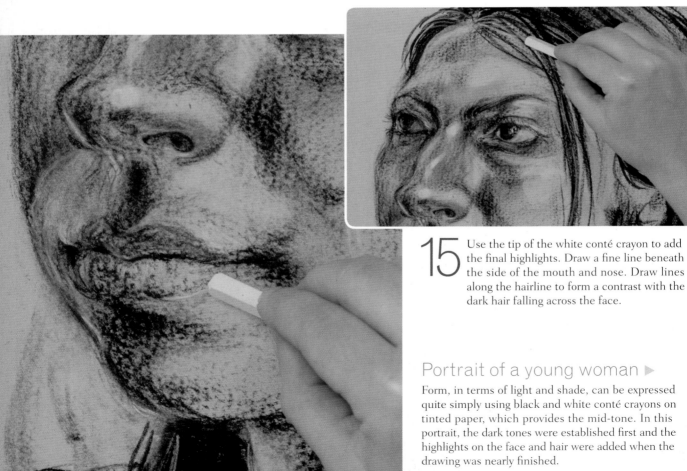

15 Use the tip of the white conté crayon to add the final highlights. Draw a fine line beneath the side of the mouth and nose. Draw lines along the hairline to form a contrast with the dark hair falling across the face.

Portrait of a young woman ▶

Form, in terms of light and shade, can be expressed quite simply using black and white conté crayons on tinted paper, which provides the mid-tone. In this portrait, the dark tones were established first and the highlights on the face and hair were added when the drawing was nearly finished.

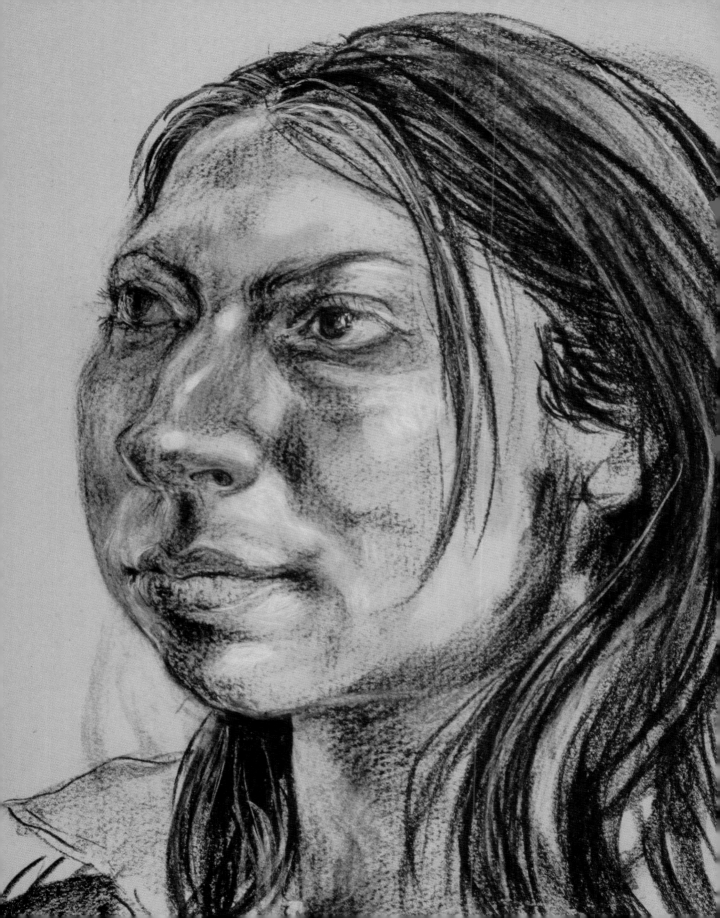

6 Parrot study

In this complex line drawing a range of four technical pens is used to vary the density of line employed to draw the parrot's feathers and to produce a range of tones suggesting its underlying shape. Hatching, stippling, and even scribbled strokes are all used to great effect to depict the different types of plumage and the physical weight and form of the parrot's body beneath. Notice how the tones are built up gradually, after an initial pencil sketch, to convey the soft, plump mass that is an intrinsic characteristic of the subject.

EQUIPMENT
- A4 medium-weight cartridge paper
- HB pencil
- Technical pens 0.1, 0.3, 0.5, 0.7

TECHNIQUES
- Hatching and crosshatching
- Creating lines of different strength
- Stippling

"Light and shade are all you need to show nuances of texture and form."

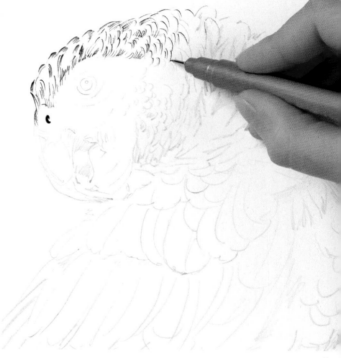

TECHNICAL PENS

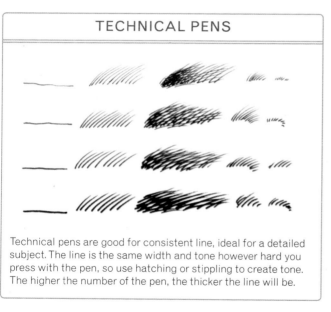

Technical pens are good for consistent line, ideal for a detailed subject. The line is the same width and tone however hard you press with the pen, so use hatching or stippling to create tone. The higher the number of the pen, the thicker the line will be.

1 Lightly sketch the outline of the bird and the contours of its feathers using the HB pencil. Starting with the head, use the sketch as a guide for your first ink marks with the 0.1 pen. Make small feathering strokes that follow the plumage.

BUILDING THE IMAGE

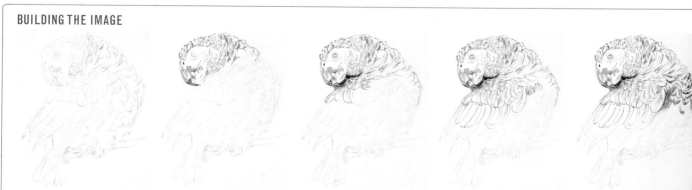

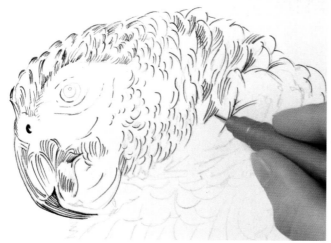

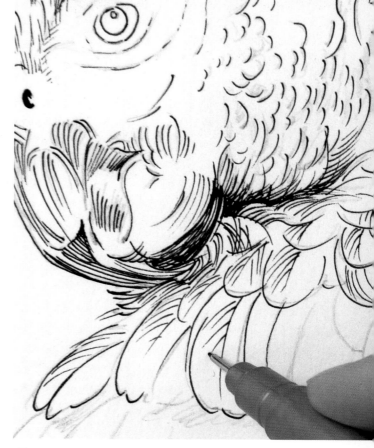

2 Using the same pen, hatch the first layer of shading, working downwards from the head to the neck. Make the hatched lines closer together to increase the density of tone where necessary. Curve the lines to follow the contours.

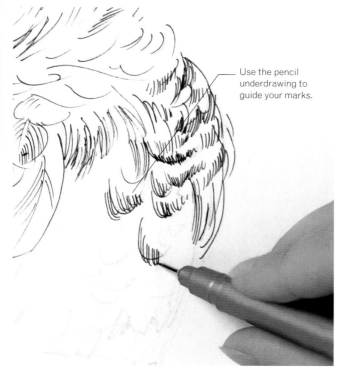

Use the pencil underdrawing to guide your marks.

3 Work methodically over the whole of the bird, following the natural downward growth of the feathers. Use small directional strokes with the 0.3 pen to draw the larger feathers on the back.

4 Create the smooth, curved appearance of the breast feathers by repeating the small downward strokes with the 0.3 pen, but hatching them closer together to strengthen the darker tones.

PENCIL FIRST

When doing a detailed pen drawing, make a sketch in pencil first. Pencil mistakes are easy to rub out, but pen marks are there to stay.

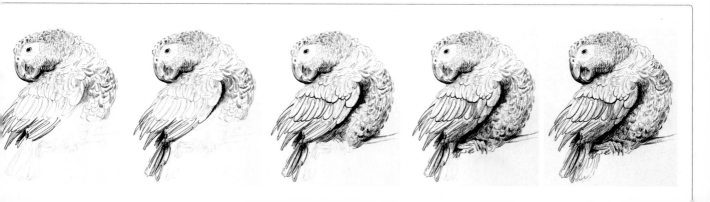

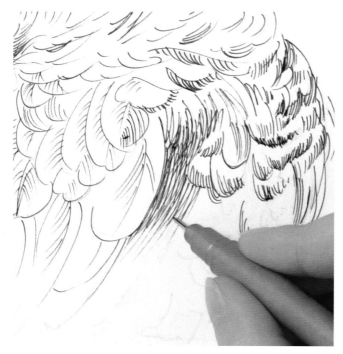

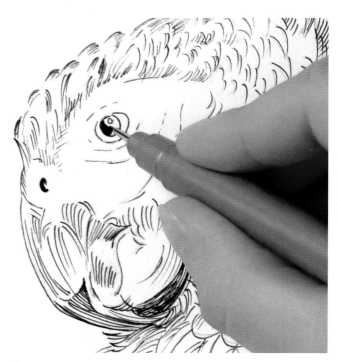

5 Start defining the area of shadow between the wing and the breast, using regular downward sweeping strokes with the 0.5 pen tip. This will be the darkest shadow in the picture.

6 Fill in the detail of the eye with the 0.3 pen tip but leave a spot of highlight – the white of the paper. The highlight enlivens the eye and makes it look shiny.

LIGHT OR DARK

The bare paper is a valuable foil to the pen marks when working in the consistent monotone of technical pen. It provides highlights and contrast.

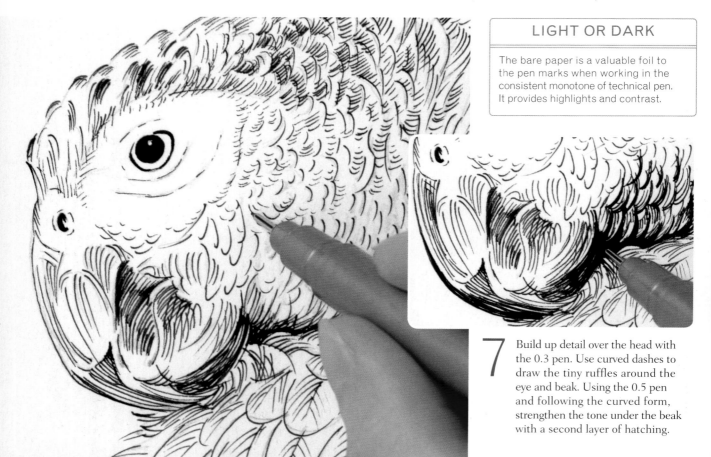

7 Build up detail over the head with the 0.3 pen. Use curved dashes to draw the tiny ruffles around the eye and beak. Using the 0.5 pen and following the curved form, strengthen the tone under the beak with a second layer of hatching.

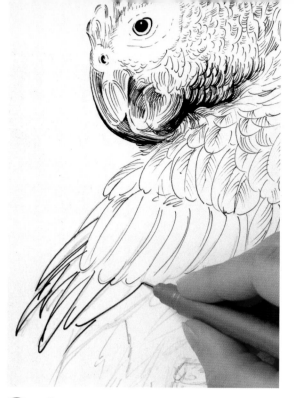

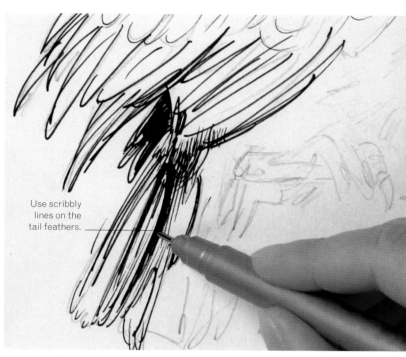

Use scribbly lines on the tail feathers.

8 Follow the outlines of the large individual wing feathers on the bird's back, using the 0.3 pen to emphasize their strong, linear pattern.

9 The tail feathers are more ruffled. Keeping your hand relaxed, hatch lines upwards and downwards with the 0.5 pen to depict the subtle variation of light and dark tone in this area.

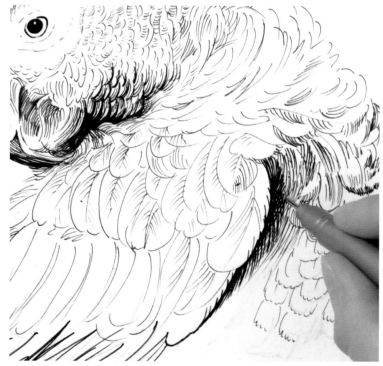

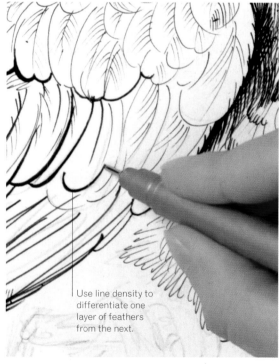

Use line density to differentiate one layer of feathers from the next.

10 Using the 0.5 pen, add a layer of crosshatching with the lines close together to strengthen the shadow under the wing. This dense shadow helps to bring the wing forwards from the body.

11 Carry on drawing the surface of the wing, boldly defining the contours of the individual feathers with the 0.7 pen. This will achieve the layering effect of the feathers on the wing.

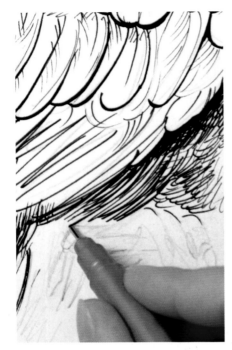

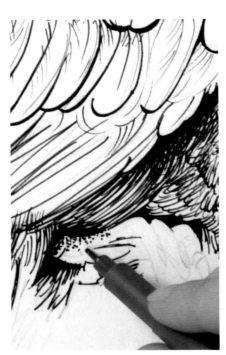

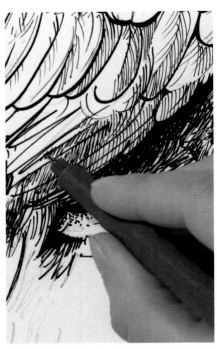

12 Finish the shading under the wing. Layer hatched lines, using downward strokes with the 0.3 pen to increase the tone in this darkest area. Totally cover the paper with ink around the perch.

13 Use a different technique of stippling (dotting) with the 0.3 pen to shade the perch and distinguish it from the bird. The closer the dots are placed together, the darker the tone.

14 Add small, regular, hatched lines to add tone to the feathers that are in shade, in this case on the bottom edge of the wing. This hatching will help to make the wing look as if it is curved.

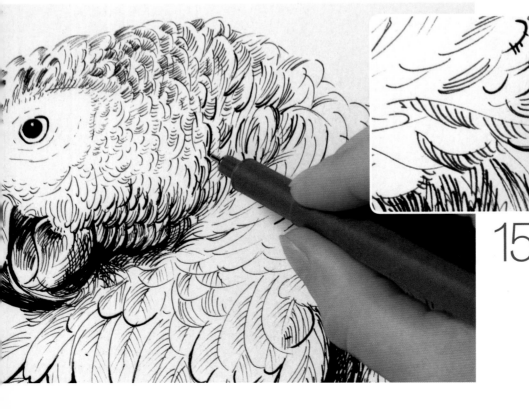

15 To finish the drawing, strengthen areas of fine detail where necessary. Emphasizing the contour line around individual feathers with the 0.7 pen helps to create the distinctive ruffled effect of the parrot's plumage.

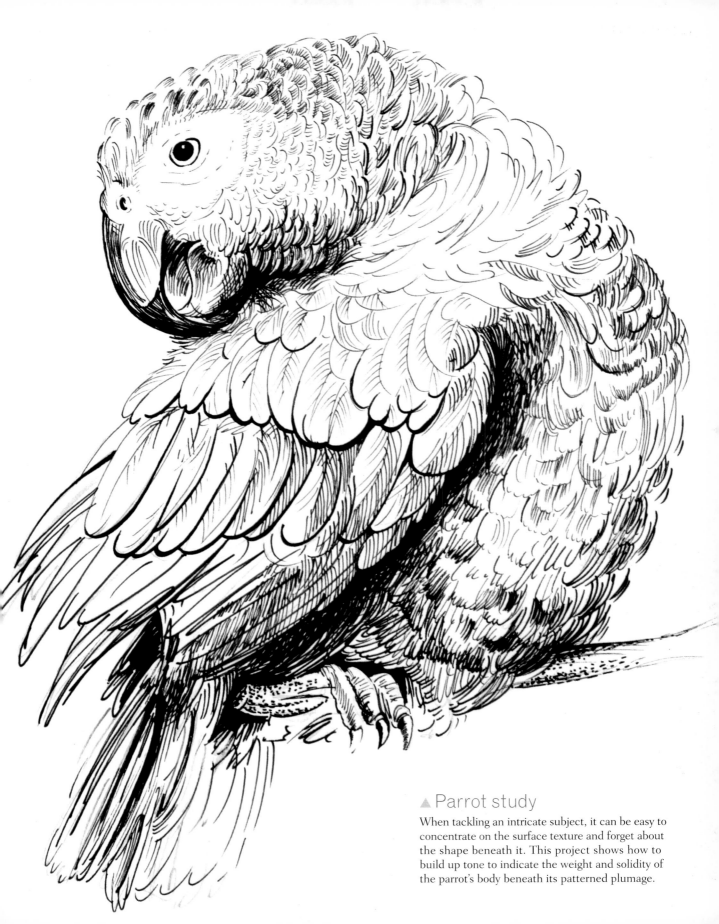

▲ Parrot study

When tackling an intricate subject, it can be easy to
concentrate on the surface texture and forget about
the shape beneath it. This project shows how to
build up tone to indicate the weight and solidity of
the parrot's body beneath its patterned plumage.

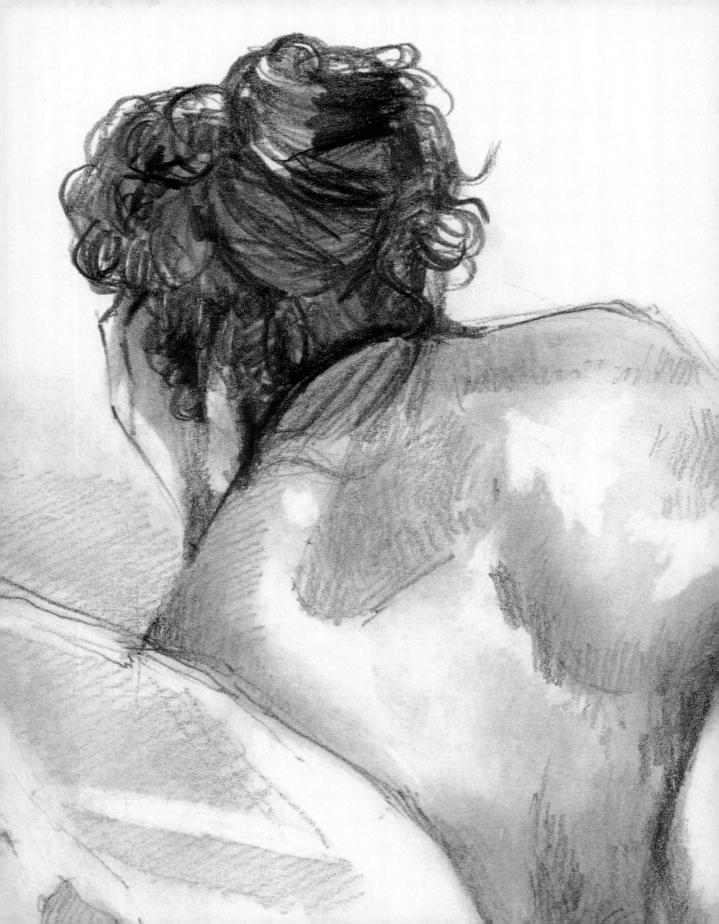

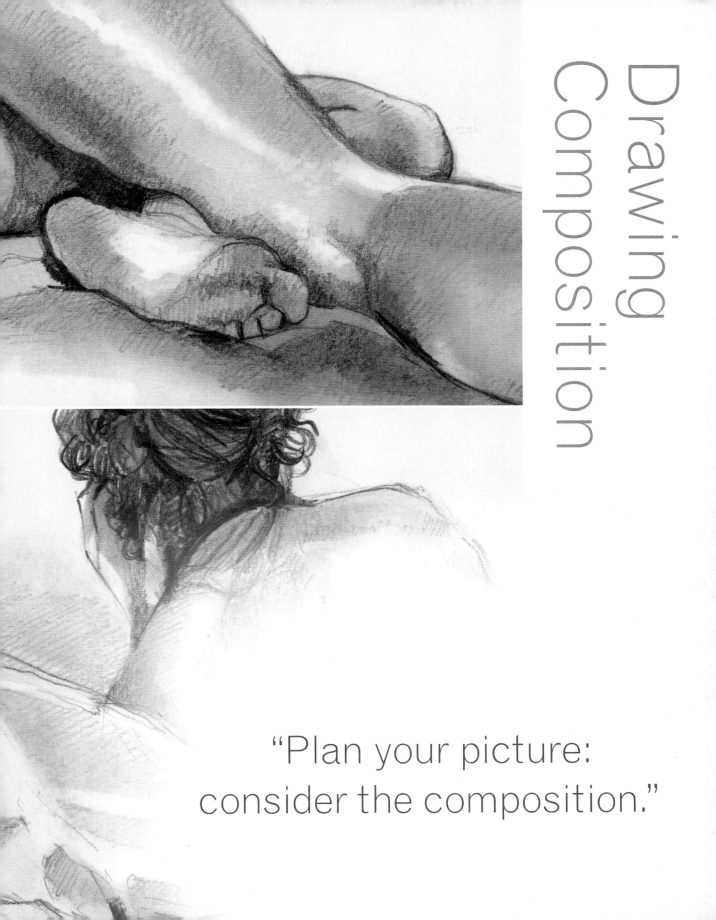

"Plan your picture:
consider the composition."

Planning a picture

When you set up a static arrangement such as a still life or portrait, you can organize the composition yourself. But even outdoors, when you find a composition in a landscape or moving subject, you need to think about what you place where and how all the parts of the picture work together. There are ways to make the picture interesting by leading the eye from one part to another without leaving the paper. Editing the scene, leaving things out or moving them, can help to make a more dynamic composition.

ARRANGING A STILL LIFE

There are do's and don'ts when it comes to still lifes. Include something with height, if necessary using a hidden platform. Avoid placing objects in a row. Instead, overlap objects to give depth but don't obscure small items with large ones. Think about negative spaces – the composition should look just as strong upside down, when the shapes are unrecognizable.

Choosing objects

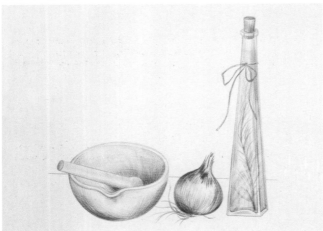

Although the objects are well chosen, providing a variety of sizes and shapes, placing them in a row puts the composition on one plane and is unexciting.

Giving depth

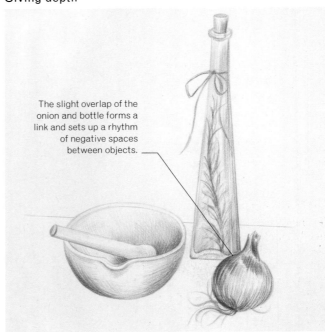

The slight overlap of the onion and bottle forms a link and sets up a rhythm of negative spaces between objects.

Moving the bottle to the back creates a strong composition with height and depth. The pestle leads the eye in and points towards the bottle.

Zooming out

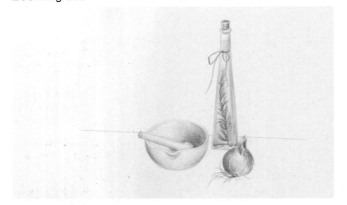

The still life looks stranded in a sea of paper: better to fill the page with the objects so that they sit comfortably in the size and format chosen.

Zooming in

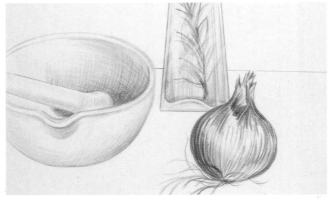

The elements fill the picture space. You do not have to include entire objects. Cropping can create interesting shapes and ideas.

CHOOSING A VIEWPOINT

After selecting the size and format of your paper, the next decision is what viewpoint to take. Scenes look reassuringly familiar and normal when you draw them at eye level. If you wish to look afresh, choose a low viewpoint (sitting on the floor or lying down), which makes things appear to loom over you. A high viewpoint makes objects look smaller.

Straight on

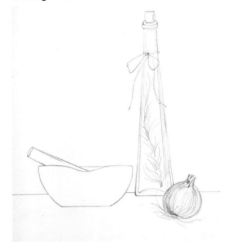

The safest, simplest view for you and the viewer is on your eye level when sitting down (or standing up if you prefer to draw this way).

Low viewpoint

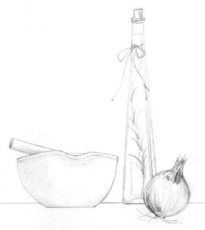

Looking up at your subject matter gives it extra importance. It can be effective for portraits, making a person look dominating and powerful.

Bird's eye view

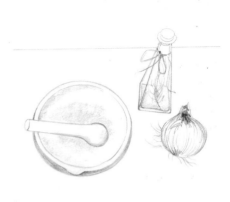

An overhead view gives you the chance to look into things rather than through them. Even a slightly high viewpoint reveals the tops of objects.

LANDSCAPES

To choose the best view of a landscape you often need to walk around, making several rough sketches to find the best composition. You are not taking a photograph – there is no need to record everything you see. Leave out any details that distract, and move things around to look balanced and pleasing to the eye. Framing the scene often creates an interesting composition.

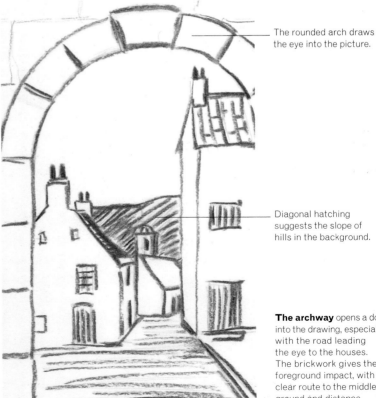

The rounded arch draws the eye into the picture.

Diagonal hatching suggests the slope of hills in the background.

The archway opens a door into the drawing, especially with the road leading the eye to the houses. The brickwork gives the foreground impact, with a clear route to the middle ground and distance.

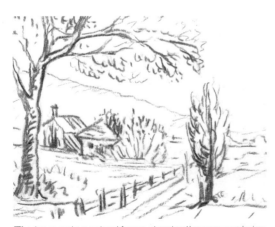

The trees make a natural frame, stopping the gaze wandering off the sides of the picture. The house tucks in cosily under the branches. The trees balance each other, but at the same time the asymmetry of the large and small trees is more stimulating to the eye than equal sizes.

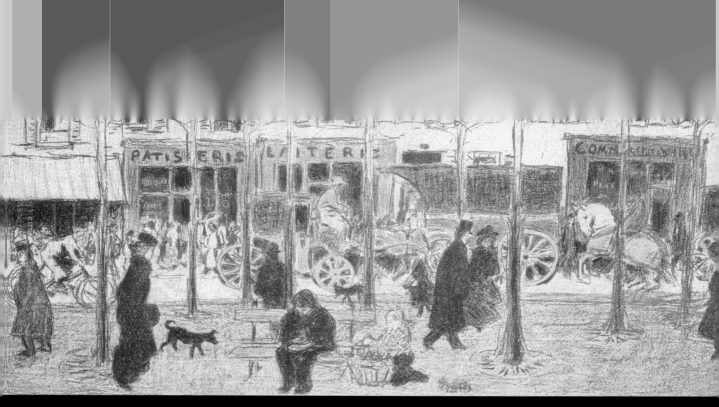

▲ Street scene in Paris

The truncated verticals break up the unusually wide format – itself like a street – into a series of cameos. Colour divides the composition widthways into two distinct horizontal bands. *Henri de Toulouse-Lautrec*

▼ Nude study

Working on the diagonal creates dynamism even in a static pose. In a figure, such a composition creates foreshortening so that the foot is represented as larger than the head. Soft pencil shading puts a sheen on the curves of the body. *Isabel Hutchison*

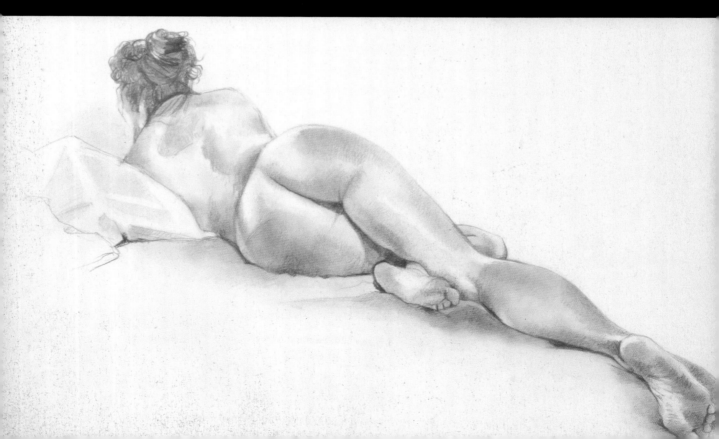

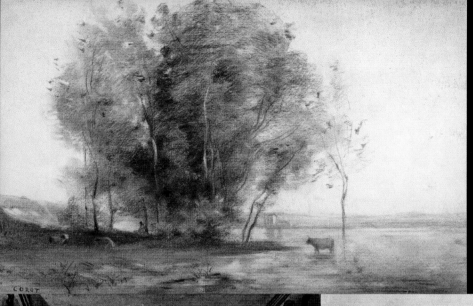

◀ Landscape with cow

Charcoal creates a soft and silvery scene in which the central tree mass dominates. The spindly tree on the right makes a frame for the cow, which leads the eye to the figures scattered under the tree. The building just visible on the far shore balances the cow and creates a sense of distance. *Jean Baptiste Camille Corot*

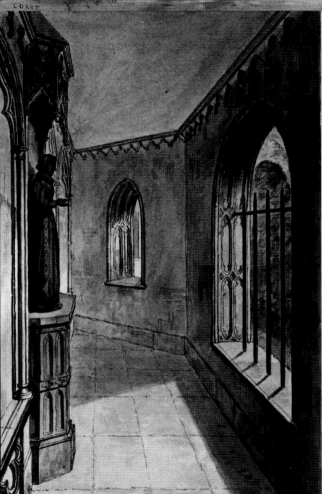

▲ Hallway at Strawberry Hill

Lines of perspective lead the eye along the flagstones and arouse curiosity as to what is round the corner. The statue in a recess and the window opposite frame and balance the composition widthways. *Horace Walpole*

▲ Hare

The serenity of a centrally placed image in pencil is enlivened by the diagonal of the hare's back, turned head, and ears. The triangle formed by the animal solidly grounds it despite only a suggestion of context. *William Morris*

7 Kitchen still life

These household items were chosen for their bold, simple shapes, and were arranged in a group so that they overlap. The resulting layers create a sense of depth, and help focus the eye on the relationships between the different shapes. The bottles' straight sides contrast with the rounded casserole, the focal point, which in turn echoes the curves of the lemon squeezer. The use of complementary colours, orange and blue, describes the objects' reflecting surfaces and enlivens and unifies the picture. Well-planned composition and colour go hand in hand.

EQUIPMENT
- A3 textured pastel paper
- Willow charcoal stick
- Blue, green, yellow ochre, dark brown, terracotta, and white chalk pastels
- Fixative
- Clean rags or kitchen towel

TECHNIQUES
- Arranging a still life with height and depth
- Blending pastels with rag and finger

Use directional strokes to echo the play of light.

1 Starting with the largest object, the casserole, start drawing the outlines in willow charcoal. Note the different ellipses on the casserole, the base of the bottles, and the lemon squeezer. Keep the outlines light so that you can alter them easily if necessary.

2 Shade in the darkest areas of tone on the bottles, casserole, and lemon squeezer, using the side of a blue chalk pastel. Follow the curving forms of the objects. Half-close your eyes if necessary, to make it easier to see the areas of dark tone.

3 Repeat this process with the areas of lightest tone, using yellow ochre and light green to introduce some colour contrast to the still life. Work over the background as well as the objects, as this is an integral part of the composition.

BUILDING THE IMAGE

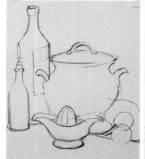
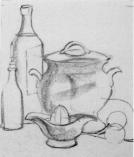
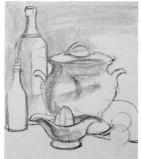
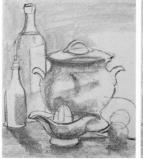
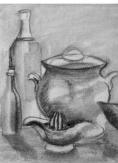

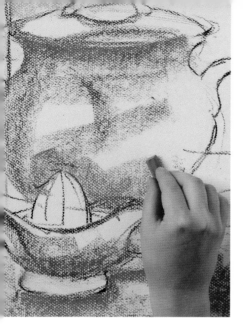

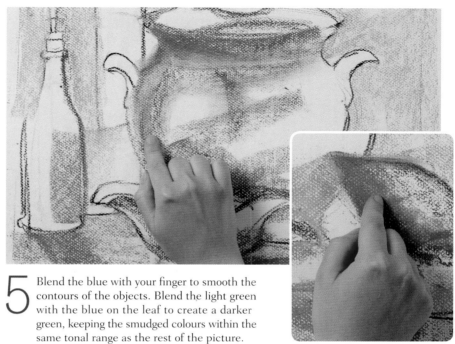

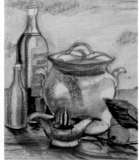

4 With the dark and light tones established, add a mid-tone in terracotta. With three basic tones in place, the objects start to look solid and weighty.

5 Blend the blue with your finger to smooth the contours of the objects. Blend the light green with the blue on the leaf to create a darker green, keeping the smudged colours within the same tonal range as the rest of the picture.

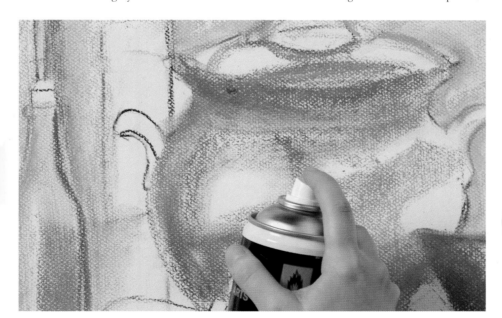

KEEPING CLEAN

Always wash your fingers or wipe them on a clean rag in between smudging one area of pastel and the next, so that you don't make the colours muddy.

6 Spray a light layer of fixative over the picture. This will prevent the pastels from smudging and prepare the surface for the next layer of pastel you apply.

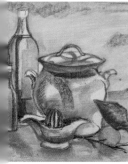
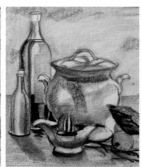
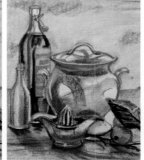
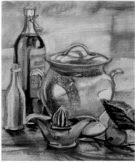

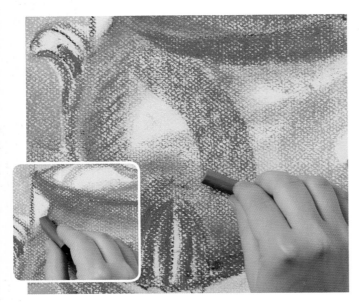

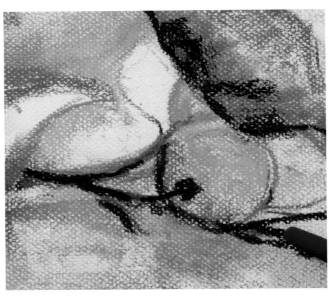

7 In blue, strengthen the outlines to make a feature of the negative space and to separate the objects from the background. Use the pastel on its side to emphasize the contrast in tones and create a pattern of repeated shapes.

8 Use the tip of the dark brown pastel to draw the angles of the twig, working over blue to make a strong line. Notice how the straight lines of the twig echo the sides of the bottles, sandwiching the curves of the objects in the centre.

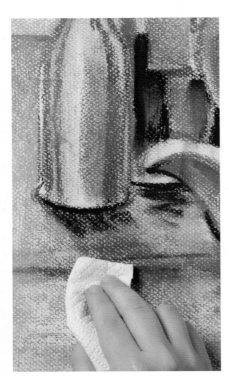

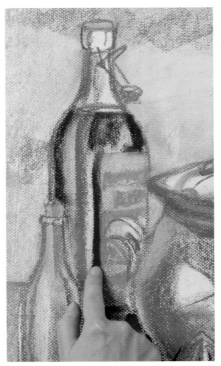

11 Use the tip of a white chalk pastel to add definition to the brightest areas of highlight on the reflective surfaces of the objects.

Kitchen still life ▶

Drawing a small group of everyday objects allows you to focus on their shape and form. Overlapping them is an easy way to make the picture look three dimensional. By treating the background and the objects as a whole, the picture is unified and a sense of depth is created.

9 Use a clean rag or some kitchen towel to blend and soften areas of dark tone that would otherwise appear too overpowering. Let the texture of the paper show through the pastel by building and blending layers lightly and gradually.

10 Work over the surface with your finger to blend areas of tone and give the objects a soft, smooth texture. Wash your finger in between colours. Leave some areas unblended so that the picture stays fresh and lively.

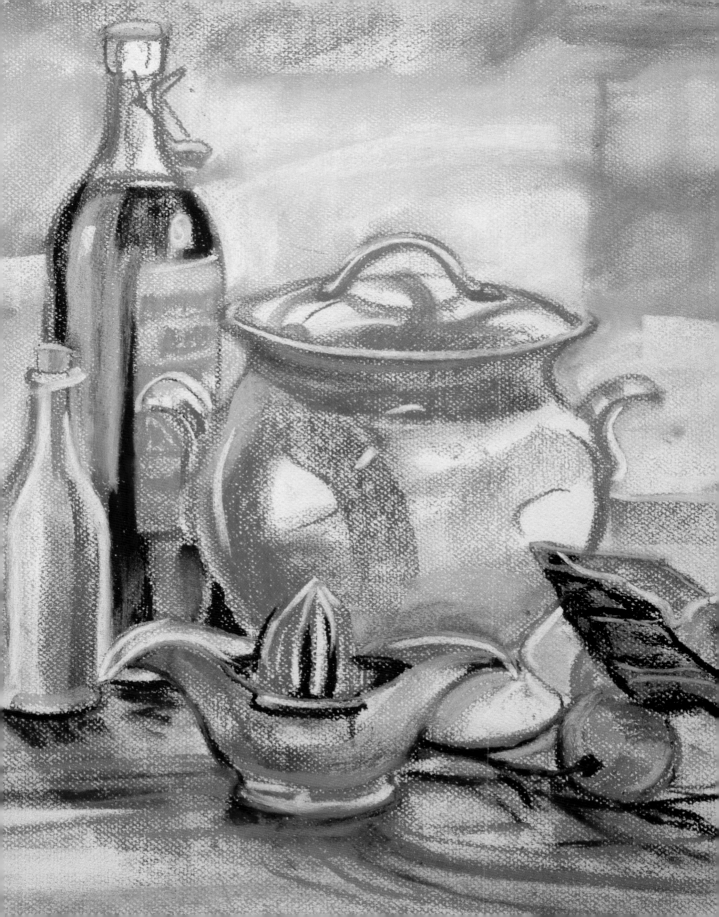

8 View of a watermill

In this attractive pencil drawing the main elements of the composition are organized around the focal point, the watermill in the distance. The horizontal band of buildings leading towards the mill and the line of the water's edge draw your eye into the picture and create a powerful feeling of depth. After making thumbnail sketches, this viewpoint has been selected because the arch of the bridge and the railings frame the scene like an oval window, increasing the sense of perspective and focusing your attention on the watermill.

EQUIPMENT
- A3 medium-weight cartridge paper
- B and 2B pencils
- Plastic eraser
- Sharpener or knife

TECHNIQUES
- Using a viewfinder
- Measuring angles with a pencil
- Framing a scene
- Hatching and crosshatching

1 Turn the sheet of paper to landscape format and lightly sketch in the main shapes of the bridge and and buildings beyond, using the B pencil. Only press lightly at this stage.

2 If necessary, hold the pencil up as for measuring (*see p.24*) to assess the angles of the building roofs. When you have sketched the main elements, stand back and check that everything is in the right place, then strengthen the lines.

BUILDING THE IMAGE

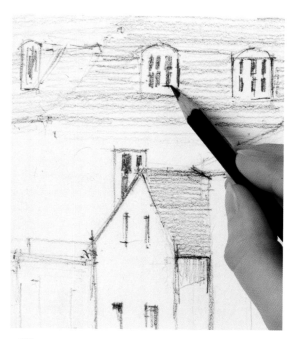

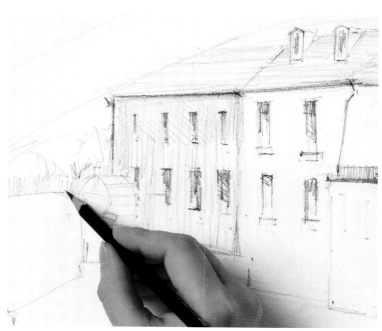

3 Still using the B pencil, start to build up the first layer of tone on broader areas with light hatching. Use the sharp point of the pencil lead to draw the finer details in the windows.

4 Carry on using soft hatching for shading and the sharp point for detail over the entire drawing, keeping the tones light. Keep the drawing sketchy so you can make changes – it can be worked up later.

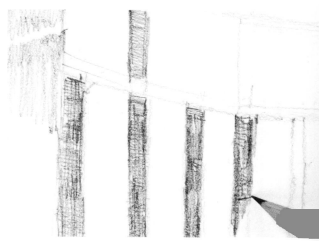

5 Use the side of the pencil lead to create long vertical lines of hatching that describe the pillar on the bottom left, and to add light tone and emphasize the vertical direction of the buildings on the right.

6 Shade the posts of the railings, pressing a little harder with the pencil. Use crosshatching to darken the tone and help suggest the rounded form of the railings.

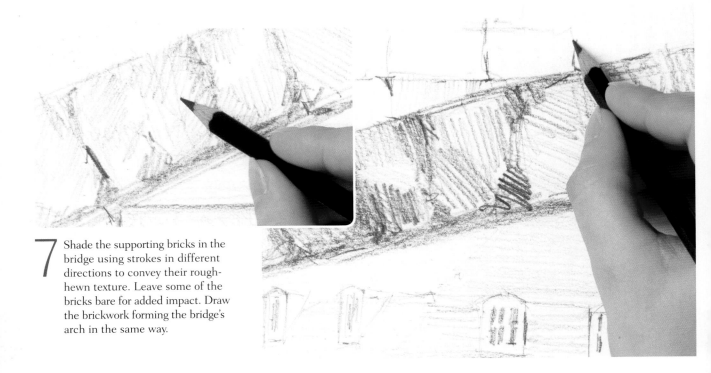

7 Shade the supporting bricks in the bridge using strokes in different directions to convey their rough-hewn texture. Leave some of the bricks bare for added impact. Draw the brickwork forming the bridge's arch in the same way.

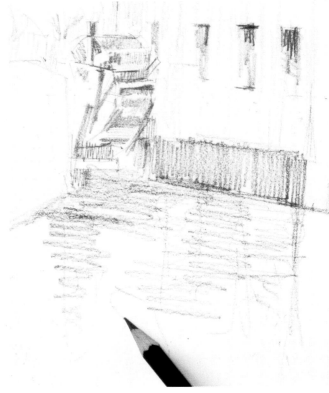

"Quick hatching in different directions is good for creating texture."

8 Use the 2B pencil to shade in the vertical reflections of the buildings in the canal. Apply a spiral scribble of shading over the top, varying your pressure on the pencil to capture the variety of light and dark tones.

9 Still using the 2B pencil, strengthen the darkest shadows by pressing a little harder. Keep your pencil leads sharp throughout. Using a knife rather than a pencil sharpener enables you to create a longer lead that is good for shading.

10 Complete the picture by drawing attention to the focal point. Sharpen the tip of the 2B pencil, then strengthen and darken the details of the watermill.

▼ View of a watermill

This drawing focuses the eye on an interesting, though distant, focal point: the watermill. The unusual top and bottom frame creates a striking composition and the buildings lead the eye along the river. The variety of lines and textures of the architectural features combine to create a sense of depth.

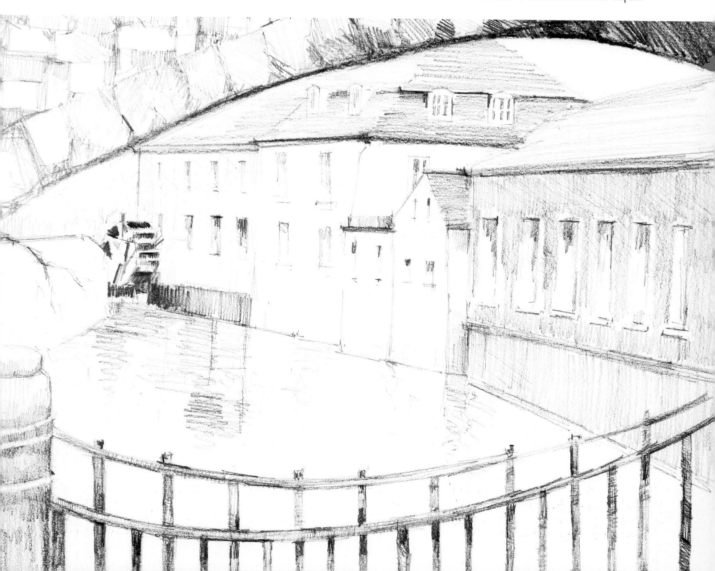

9 Lounging figure

Composition and planning are the key to successful life drawing. Here, after making four quick sketches, a simple but imposing composition has been chosen as a base for a longer study. The figure has been placed centrally, dividing the paper vertically from the head, through the torso, and down through the left leg, then horizontally through the right arm and right leg to create a cross-like composition. In the final drawing dark tones in charcoal have been used in conjunction with highlights drawn out with an eraser to create a powerful image.

EQUIPMENT
- A3 heavyweight cartridge paper
- Pencil
- Willow charcoal stick
- Compressed charcoal
- Putty eraser

TECHNIQUES
- Foreshortening limbs
- Smudging tone

QUICK POSES

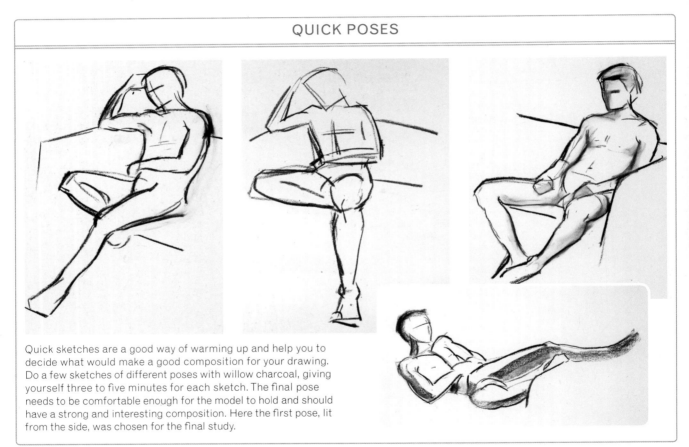

Quick sketches are a good way of warming up and help you to decide what would make a good composition for your drawing. Do a few sketches of different poses with willow charcoal, giving yourself three to five minutes for each sketch. The final pose needs to be comfortable enough for the model to hold and should have a strong and interesting composition. Here the first pose, lit from the side, was chosen for the final study.

BUILDING THE IMAGE

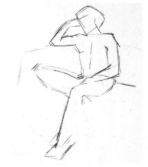
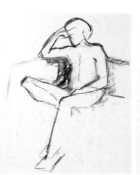
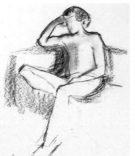
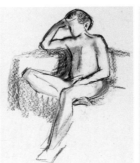
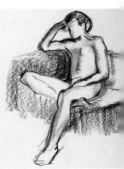

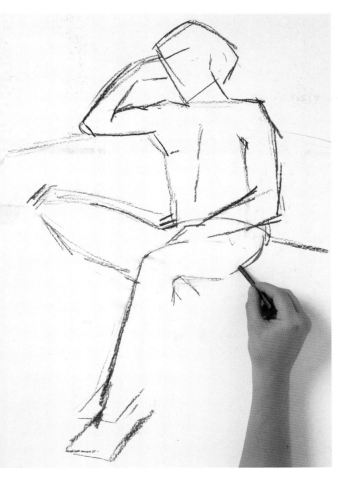

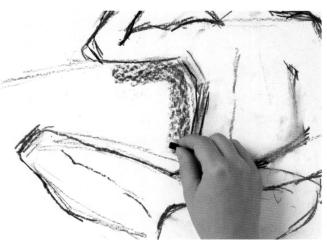

1 Use a pencil to take measurements (*see p.24*) and mark key points on the figure, so you get the proportions right and can place it on the paper without cropping off the head or the foot. Sketch the outline of the figure with willow charcoal.

2 Draw the spaces between the different parts of the body to help position the arms and legs. When you are satisfied that they are in the right places, use the willow charcoal on its side to shade in the negative spaces around them.

"Marking key points on the figure first helps you to position it on the paper."

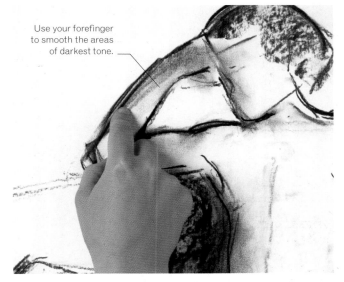

Use your forefinger to smooth the areas of darkest tone.

3 Identify the dark areas of tone on the figure. Gently smudge the outline of the drawing, following the direction of the arms and legs with your finger. The smudged tone creates the first layer of shading and a sense of solid form.

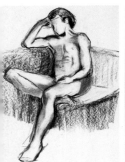
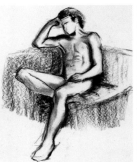
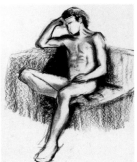
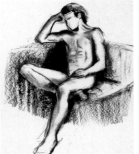
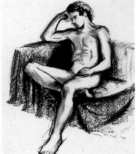

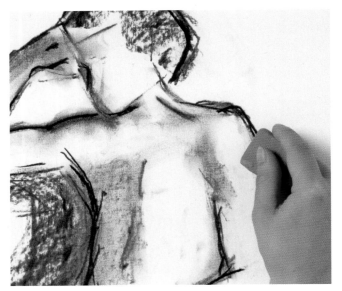

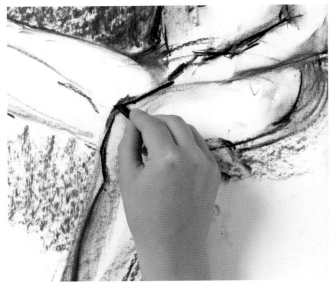

4 Now look at the main highlighted parts of the figure. Holding the putty eraser at a slight angle, press on it gently to draw broad areas of highlight out of the charcoal tones. Rub the putty eraser clean on a piece of scrap paper.

5 Go over the outlines of the figure with the point of the willow charcoal stick, constantly checking back to the life model. Use broken lines around the knee, to vary the outline to suit the weight distribution of the figure.

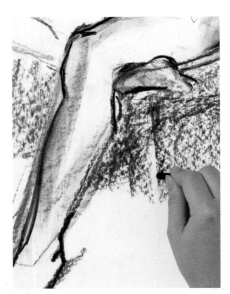

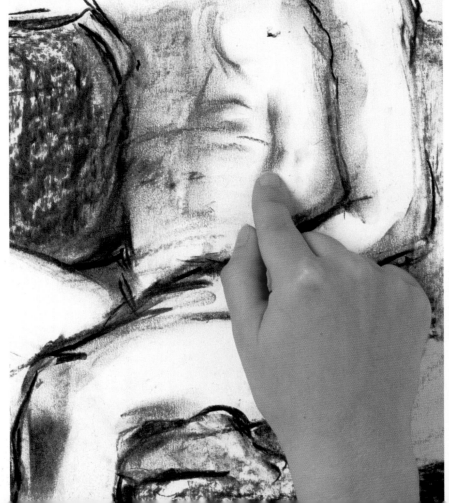

6 Start blocking in areas of tone on the seat to stop the figure from appearing to float in space. Make regular, light, downward strokes with the side of the willow charcoal stick.

7 Add tone to define the groups of muscles, smudging with your finger to keep the drawing soft. The tonal areas are all relative – as you darken one area, you see where another one needs to be strengthened.

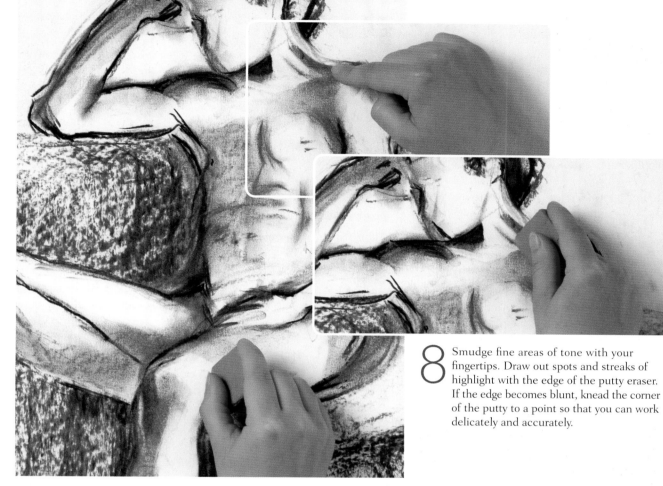

8 Smudge fine areas of tone with your fingertips. Draw out spots and streaks of highlight with the edge of the putty eraser. If the edge becomes blunt, knead the corner of the putty to a point so that you can work delicately and accurately.

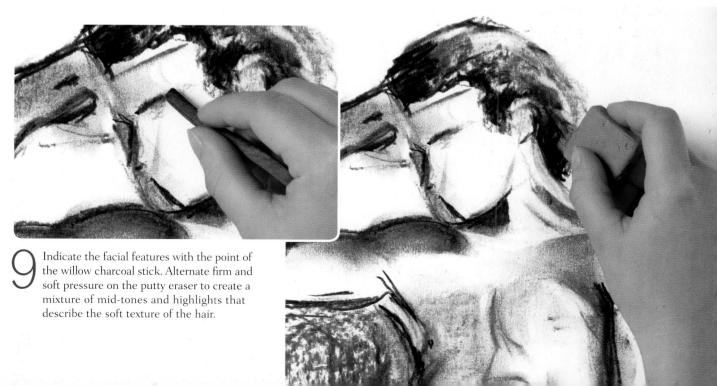

9 Indicate the facial features with the point of the willow charcoal stick. Alternate firm and soft pressure on the putty eraser to create a mixture of mid-tones and highlights that describe the soft texture of the hair.

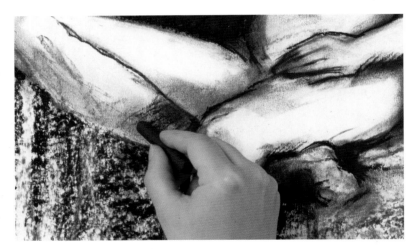

10 Use the compressed charcoal, which is denser and blacker than the willow, to strengthen the darkest areas of tone. Increasing the contrast between light and dark tones creates a greater sense of depth in the drawing.

SIDE LIGHTING

The pose chosen for this drawing is strongly lit from the side. Side lighting creates deep shadows, which emphasize the muscular structure of the body in a nude figure study.

11 Use the compressed charcoal sparingly to draw hatched lines that follow the smooth, curved form of the lower leg and shoulder. This makes the figure seem more three dimensional and strengthens the areas of darkest shadow.

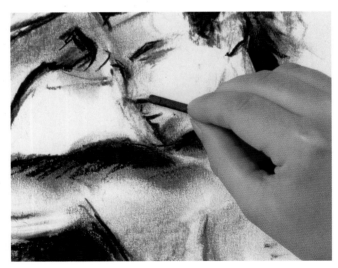

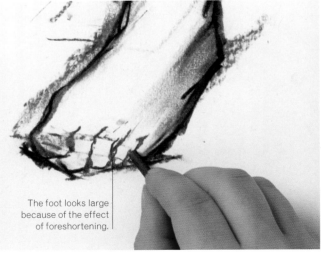

The foot looks large because of the effect of foreshortening.

12 Use the more delicate willow charcoal stick to refine the eyes, nose, and mouth. There is no call for huge detail, as the facial features need to be consistent with the broad treatment of the body and limbs.

13 Stand back and assess the drawing, adding finishing touches such as the lines separating the toes on the front foot. Ground the foot with a smudged shadow along the inside of it and behind the heel.

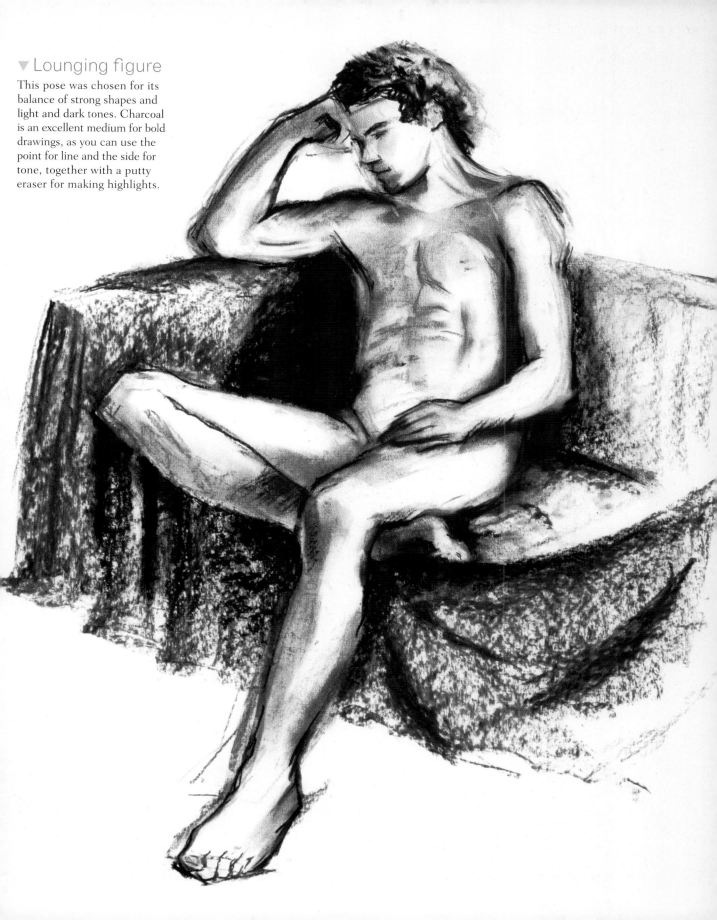

▼ Lounging figure

This pose was chosen for its balance of strong shapes and light and dark tones. Charcoal is an excellent medium for bold drawings, as you can use the point for line and the side for tone, together with a putty eraser for making highlights.

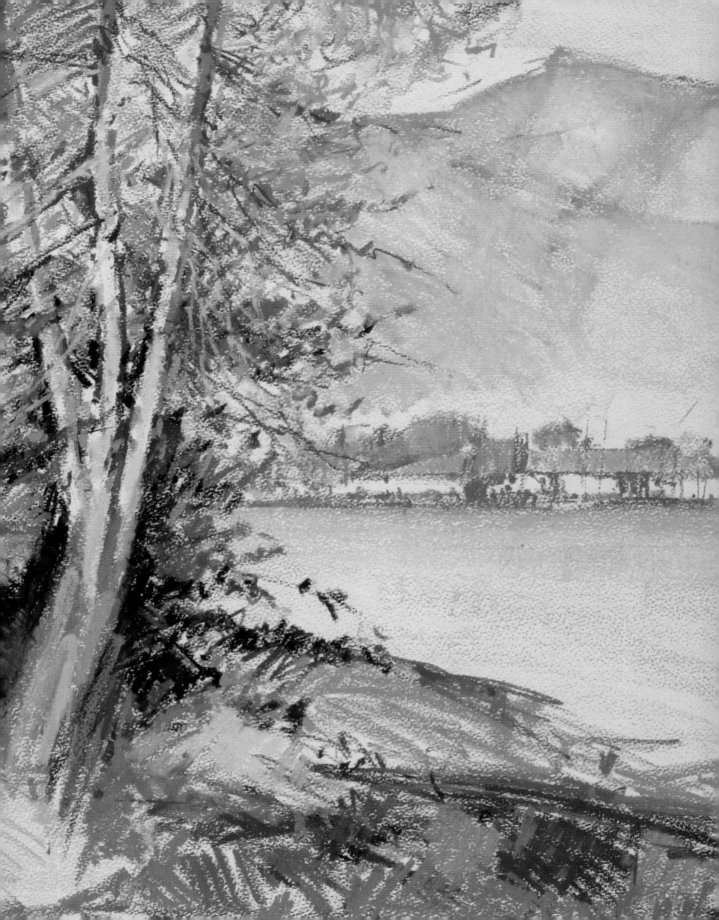

Using Colour in Drawing

"Be selective with
colours to create
a vibrant picture."

Vibrant colour schemes

Both pastels and coloured pencils come in a huge range of colours because, unlike paints, you cannot mix them before you apply them to the paper. Tempting as it is to use all the colours, pictures are often more successful with a limited choice.

Bright colour stands out all the more for being used judiciously. As with composition, what you leave out is as important as what you put in. And every colour is affected by the others on the paper: the scheme needs to work as a whole.

WARM AND COOL COLOURS

The colours of sun and fire – reds, yellows, and oranges – are described as warm. And the colours of sea and ice – blues – are known as cool. Warm colours seem to leap forward in a drawing. Cool colours appear to go backwards into the picture. You can use this knowledge of warm colours advancing and cool ones receding to add distance and balance.

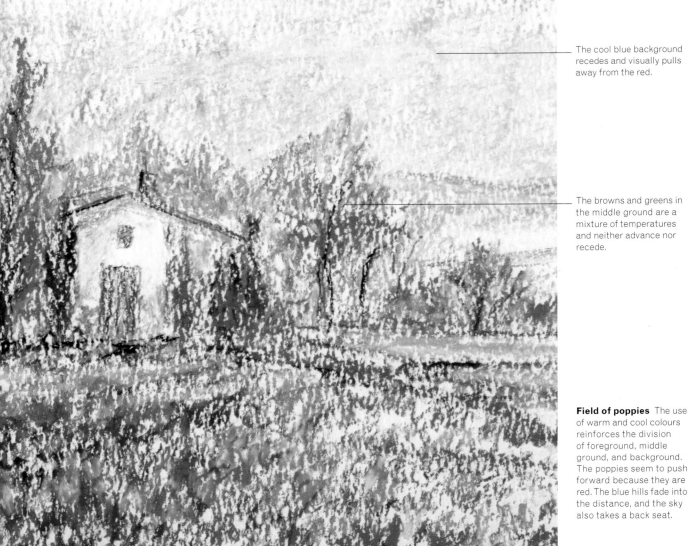

The cool blue background recedes and visually pulls away from the red.

The browns and greens in the middle ground are a mixture of temperatures and neither advance nor recede.

Field of poppies The use of warm and cool colours reinforces the division of foreground, middle ground, and background. The poppies seem to push forward because they are red. The blue hills fade into the distance, and the sky also takes a back seat.

USING CONTRASTING COLOURS

On the colour wheel (*see pp.138–139*), each colour is opposite another. Opposite pairs – red and green, blue and orange, yellow and purple – are called complementary colours. You cannot make red any redder, but you can make it seem brighter by putting it next to green. By using complementary colours together you can make your drawings more vibrant.

Blue and orange

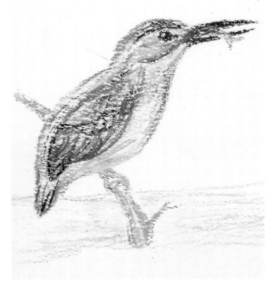

The kingfisher's plumage is made even more striking by the pairing of complementary blue and orange.

Red and green

A red rose looks even richer on its green stem. Nature's few high-intensity notes are all the stronger against the predominant greens and earth colours.

Yellow and purple

Yellow notes in the foreground leap out against the complementary purple of the mountains. The use of yellow in the sky and valleys unites the foreground, middle ground, and background.

Gallery

As much care has to go into choosing colours as arranging composition. Colour is all the stronger for being applied with restraint and thought.

Trees by water ▶

Intense soft pastel colour in the tree and patch of ground makes the foreground stand out. Notes of blue in the tree relate to the cool pale blue of the receding mountains across the lake. *Barry Freeman*

▼ Study of plants

In a largely monochrome drawing, the slightest hint of colour can alter the mood. The addition of coloured pencil lets a few buds and petals represent the delicate blooms of the many. *Lynne Misiewicz*

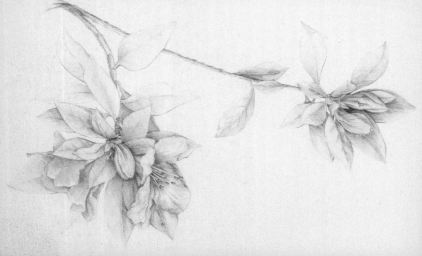

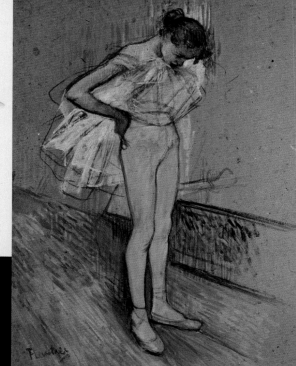

A dancer adjusting her leotard ▶

Against the mid tone of the paper and streaked blue floor, the white and pink pastel shines out. Black outline contains the colour and the skirting board counterbalances with darks. *Edgar Degas*

Country scene ▶

Soft pastel gives the colours a chalky unity.
Blending allows subtle differentiation of
cool blue-greens, warm yellow-greens, and
darker green shadows in the vegetation.
Jennifer Mackay Windle

▼ Pastel expressions

The harmonious scheme of limited, related
colour concentrates the eye on the rapt
pose and strongly lit face. *Mark Topham*

▲ Flowers

Layering pastel gives the flowerheads
a jewel-like intensity. The pigment is
built up thickly, obscuring the paper
beneath. The fuzziness of the edges,
often breaking through the outlines,
accentuates the shimmer of colour.
Odilon Redon

10 Exotic flower

Flowers provide an excellent opportunity to work with a truly vibrant palette. Here a single flower head creates an explosion of colour that almost fills the sheet of paper. Despite its impact, only a limited selection of oil pastels has been used. Oil pastel is a particularly flexible medium for coloured drawing, as it can be applied in many ways to achieve different effects. One layer can be added to another. The layers can then be smudged and blended on the paper, or scratched and scraped through with a scalpel blade or knife to define detail if necessary.

EQUIPMENT
- Mid-toned, textured pastel paper
- Willow charcoal stick
- Mid- and dark pink, orange, maroon, purple and deep purple, dark, bright, and pale green, black, bright blue, and deep red oil pastels
- Rag or tissue
- Scalpel

TECHNIQUES
- Layering and blending
- Using bright colour against dark
- Scraping back

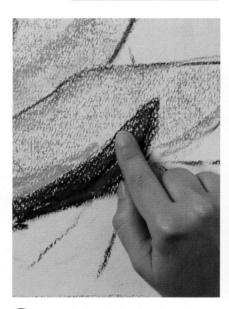

1 Sketch the outlines of the flower head in charcoal. You can draw boldly and make as many marks as you like because all the charcoal will be covered by oil pastel. Using the mid-pink oil pastel on its side, block in the background colour of the petals.

2 Carry on blocking in the largest areas of colour over the whole flower head. Use orange as a second colour over the mid-pink. Both of them are warm colours that seem to come forward. Cool blues applied later will stop them vying for attention.

3 Use a darker shade of pink on the underside of the petals. To make this even darker, apply maroon pastel over the top of it and blend the two colours together with your finger. The main light and dark tones of the flower are now established.

BUILDING THE IMAGE

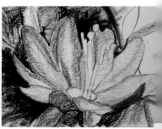

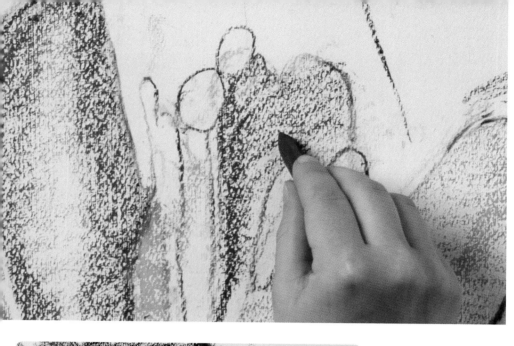

4 Begin applying a light layer of darker tone in purple, following the curved edges of the petals. Let the texture of the paper show through in places so that the colours really stand out.

PAPER WEIGHT

The best paper for oil pastel is relatively heavy, and should have enough tooth to withstand layers of colour and scraping back.

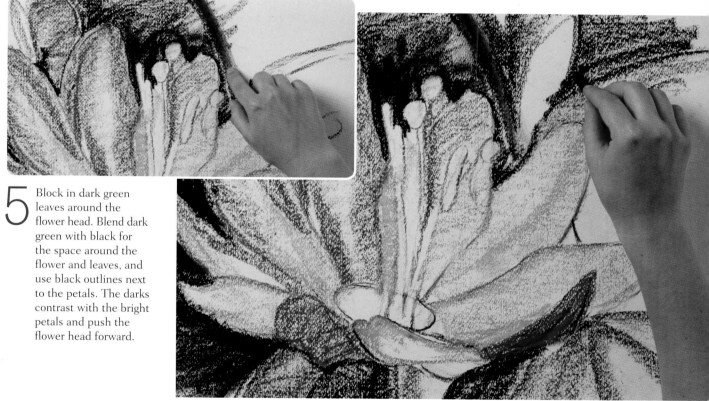

5 Block in dark green leaves around the flower head. Blend dark green with black for the space around the flower and leaves, and use black outlines next to the petals. The darks contrast with the bright petals and push the flower head forward.

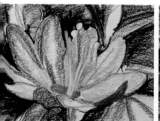
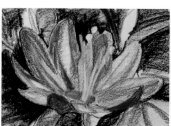
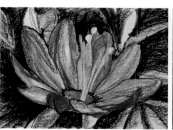
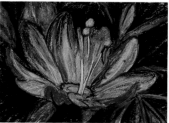

6 Returning to the inside of the flower, begin to add bright accents, using the point of the orange pastel for the tops of the stamens. Drive the pigment into the paper by pressing hard so that here you can't see the underlying texture of the surface.

"Oil pastel is heavy so push and pull it to smudge it."

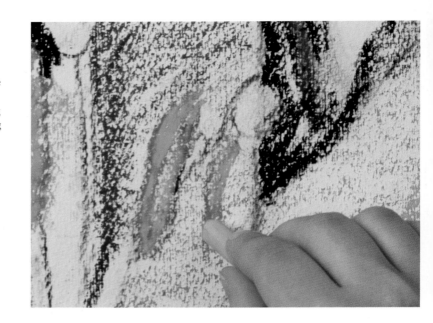

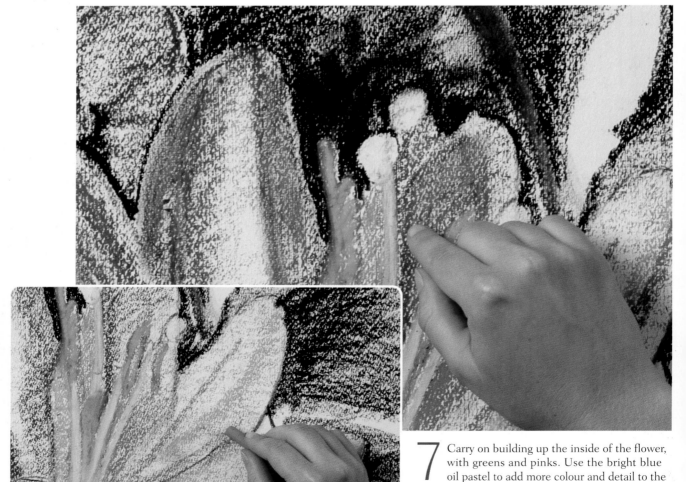

7 Carry on building up the inside of the flower, with greens and pinks. Use the bright blue oil pastel to add more colour and detail to the petals. Once you have laid down all the main colours, start to blend them together by gently rubbing them with your finger.

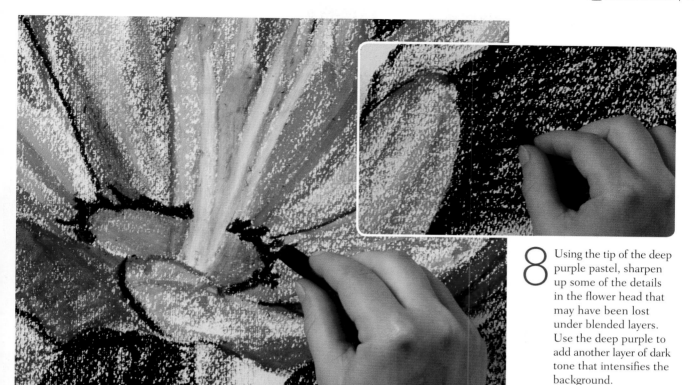

8 Using the tip of the deep purple pastel, sharpen up some of the details in the flower head that may have been lost under blended layers. Use the deep purple to add another layer of dark tone that intensifies the background.

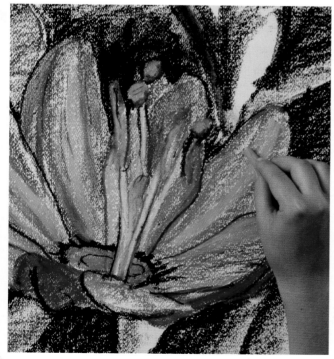

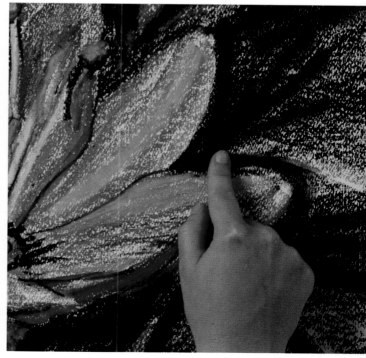

9 Using the ground colours as a guide, work up thicker layers by pressing harder with the oil pastels. Laying down more pigment strengthens the colour, which increases the depth of the picture and the contrast between bright and dark.

10 Use the bright green over the top of the dark green ground on the leaves and blend the two together with your finger. The texture of the paper will begin to disappear as the oil pastel is pushed into its grain.

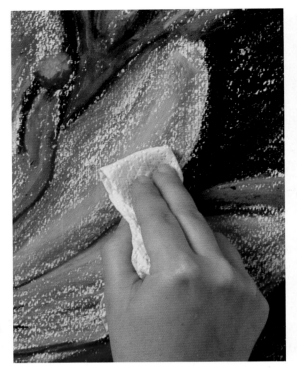

11 Blend larger areas of colour together using a clean rag or kitchen towel. Blending creates areas of smooth texture and lifts off any excess oil colour, so that you can add another layer of colour if you want to.

12 Pick out the edges of the petals in deep red and blend them into the neighbouring colour with your finger. Wash your finger before you carry on drawing or blending.

SCRAPING BACK

A scalpel or craft knife is very useful for artists. If you have used many layers of oil pastel, you have to scrape back the pigment, taking care not to gouge the paper, before you can apply highlights. If not, the pastel will just slip over the top of the underlying layers.

13 Using the flat edge of a scalpel blade, scrape back the layers of oil pastel to sharpen definition around the outlines of the petals. This will reveal the layers of colour underneath and create bright linear marks.

14 Lift some of the colour off the green rounds of the stamens to get back to the paper. Add pale green to create highlights. Use dark green in the background around the stamens to create a contrast between dark and light.

▼ Exotic flower

Oil pastel works best with a confident, spontaneous approach. Here it is the uninhibited use of colour and boldness of composition that give this picture its dramatic visual impact.

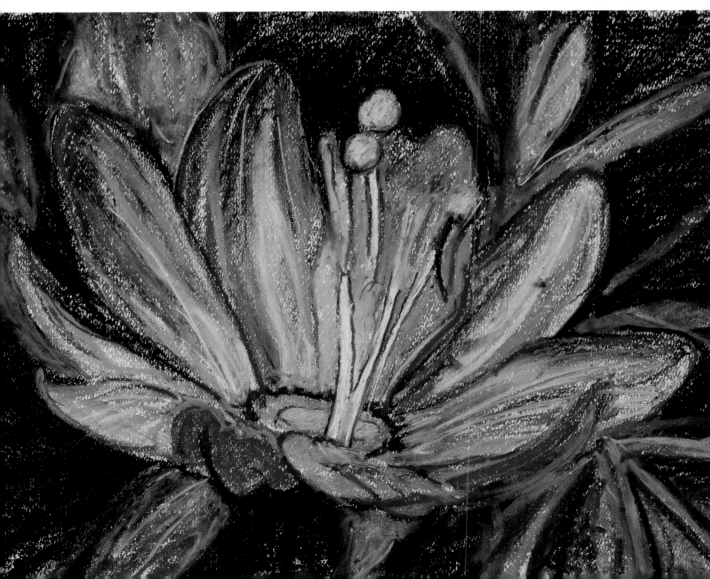

11 Market stall

When faced with an enticing array of colours and textures, as in this vegetable stall, it can be hard to know where to start, but this picture has been drawn quickly and decisively. Vigorous strokes of coloured pencil in complementary colours have been juxtaposed with each other: red with green, and blue with orange. Colour pencil cannot be blended easily, so it has to be used in a linear way. Here the pencil strokes are applied in many different directions to emphasize the contrasts in form and texture between the different vegetables.

EQUIPMENT
- A3 cartridge paper
- 2B pencil
- Flesh, dark blue, orange, light green, dark green, burnt umber, light grey, dark grey, yellow, mid-brown, light red, dark red, dark plum, dark orange coloured pencils

TECHNIQUES
- Juxtaposing complementary colours
- Crosshatching with two colours

1 Lightly sketch the main features of the market stall and its background with the 2B pencil. Then start colouring in the stallholder's face and arms, using light diagonal strokes with the flesh pencil.

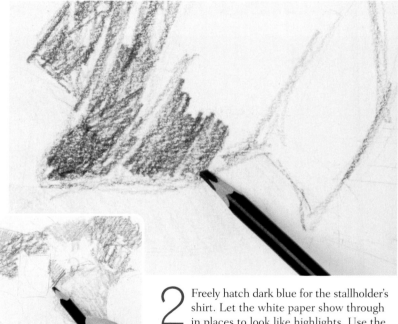

2 Freely hatch dark blue for the stallholder's shirt. Let the white paper show through in places to look like highlights. Use the same hatching technique to draw the vegetables: use orange for the carrots and the light and dark green for the broccoli, leeks, and lettuce.

BUILDING THE IMAGE

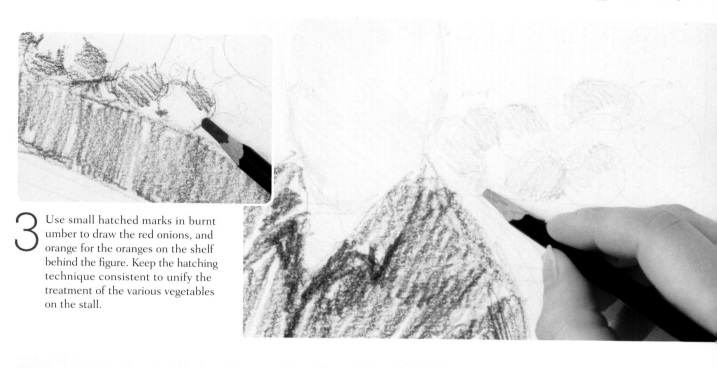

3 Use small hatched marks in burnt umber to draw the red onions, and orange for the oranges on the shelf behind the figure. Keep the hatching technique consistent to unify the treatment of the various vegetables on the stall.

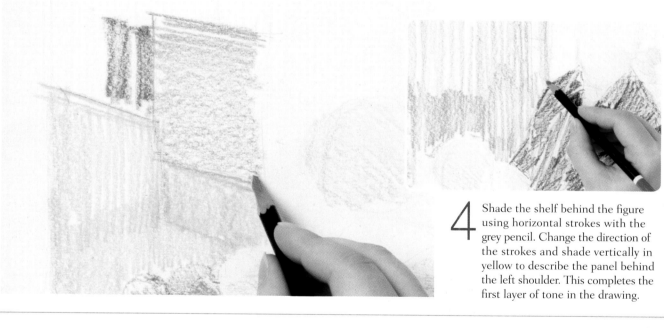

4 Shade the shelf behind the figure using horizontal strokes with the grey pencil. Change the direction of the strokes and shade vertically in yellow to describe the panel behind the left shoulder. This completes the first layer of tone in the drawing.

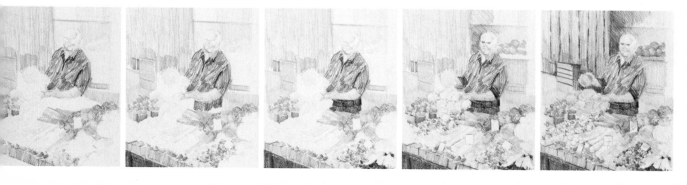

5 Begin the second layer of shading to introduce more detail to the scene. Using small, even strokes with the mid-brown pencil, add tone to the areas of shadow on the face. Layer the tone consistently across the drawing.

6 Crosshatch darker colours over lighter ones to define the shaded areas and shapes of the vegetables. Overlay brown with dark green in the right foreground, and dark over light red to contrast shadow and highlight on the radishes.

7 Add further definition to the face with dark grey, working up the eyebrows and the hollows of the eyes.

9 Use broken lines of dark grey to suggest planks of wood. Strengthen the colour with dark blue and brown.

8 Use the dark plum colour to add shadows to the radishes. Shade the underside of the oranges stacked behind the stallholder with the dark orange, letting the paper show through to create highlights.

Market stall ▶

In this picture complementary colours are used next to each other, making them look more vibrant, and there is a lively contrast between the neutral tones of the background and the vivid vegetables in the foreground.

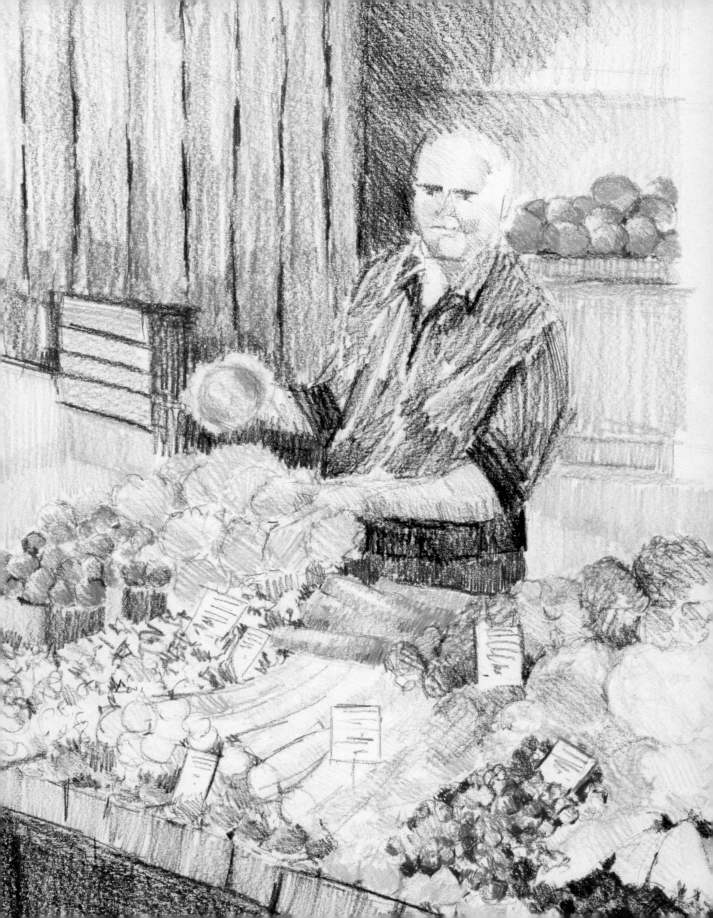

12 Girl on the beach

A holiday beach scene provides an excellent opportunity to work with vibrant colours in dazzling natural light. The bikini and beach rug provide vivid touches of colour, and these are set against the softer earth tones of the girl's skin and the sand, and the pastels of the sea and sky. Soft chalk pastels are easy to blend, so you can create tone easily. Here they have been used on dark paper to emphasize the brilliance of the colours and create a composition that captures the warmth of the afternoon and the glow of the sun as it sinks towards the horizon.

EQUIPMENT
- A3 dark-toned, textured pastel paper
- Pale pink and turquoise pastel pencils
- Raw umber, burnt sienna, light blue, bright green, raw sienna, dark purple, pale ultramarine, strong pink, light lilac, bright blue, mid-lilac, light orange, lime green, pea green, bright orange, pale pink, dark brown, turquoise, bright red, coral pink, dark blue chalk pastels

TECHNIQUES
- Blending pastels
- Juxtaposing bright and earth colours

1 Lightly sketch in the composition using the pale pink pastel pencil, taking the foreshortening into account. Loosely block in shadow, using raw umber for the ground and burnt sienna for the warmer dark tones on the figure.

2 Use light blue to draw the sea, pressing hard to cover the paper grain. Add a stripe of bright green below it where the sea meets the shore. Tone down the green with raw umber. Block in the sand and light skin tones with raw sienna.

BUILDING THE IMAGE

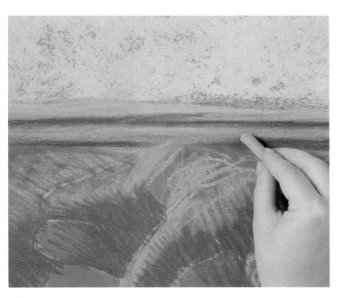

3 Add further detail to the sea where the waves break on the shore. Use dark purple to create lines of shadow set against a line of pale ultramarine to capture the rippled light effect on the surface of the water.

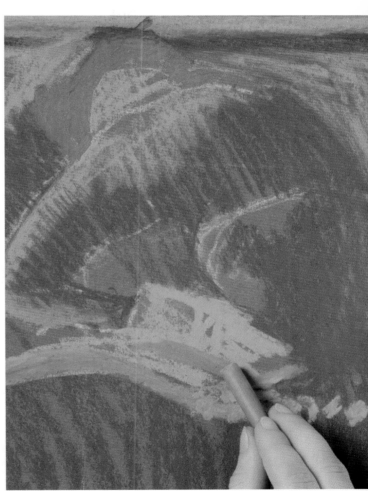

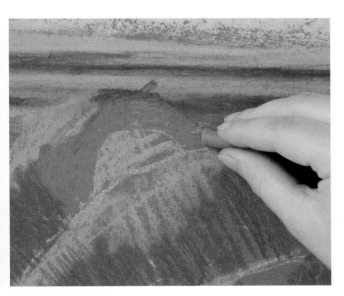

4 Using a very strong pink, boldly draw the girl's bikini, pressing hard with the tip of the pastel so that you cover the paper well. Just a small area of such a bright, hot colour will stand out.

5 Use the same pink to add details to the beach rug. Add the light lilac. Over this, blend bright blue with pale ultramarine for the first stripe. Use two shades of lilac beneath the girl's head, the lighter one first.

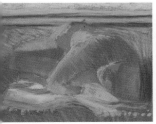

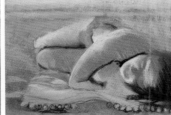
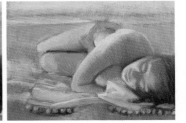

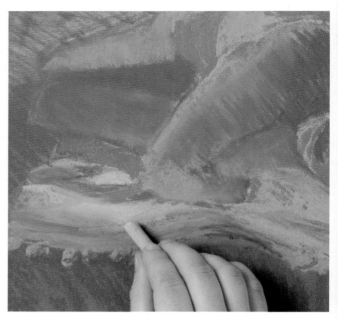

6 Use bright orange to add warm highlights to the exposed skin. Smudge the orange with your finger, following the line of the arm, and blend it into the layer of raw sienna below. Add the bright blue tassels on the rug.

7 Add more bright accents to the beach rug: light orange, and lime green blended over the top of pea green. Add a light layer of raw umber over the bright blue to tone down the colour of the tasselled fringe.

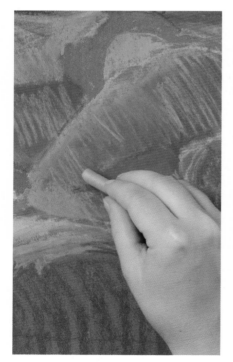

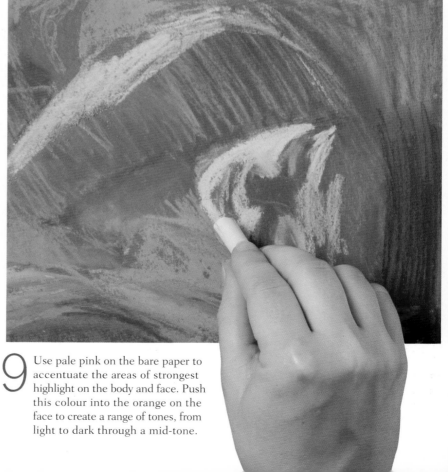

8 Lightly hatch lines over the girl's body and face with a bright orange pastel, to add warmth to the skin. Gently smudge the hatching lines with your finger to blend the colours in smoothly.

9 Use pale pink on the bare paper to accentuate the areas of strongest highlight on the body and face. Push this colour into the orange on the face to create a range of tones, from light to dark through a mid-tone.

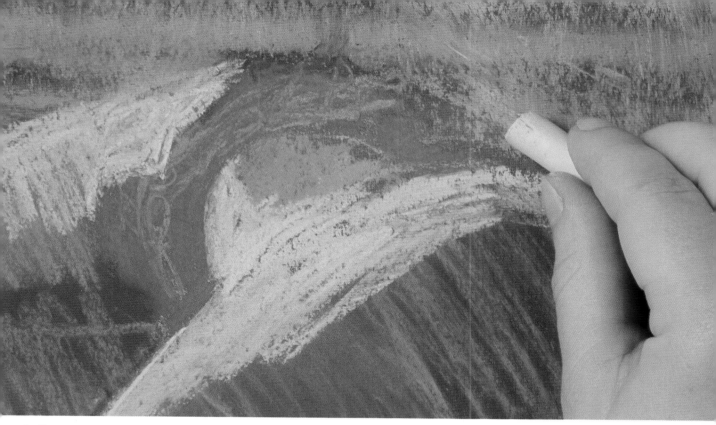

10 Scumble (*see p.40*) a veil of pale pink pastel over the background. Adding the paler tones here helps to create a sense of distance and links the pale tints in the drawing.

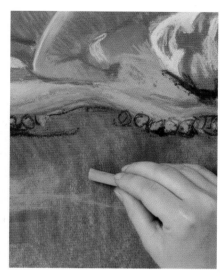

11 Add dark brown beneath the head and use it to outline and underline the tassels. Use raw sienna and turquoise on their sides to block in cooler tones in the foreground.

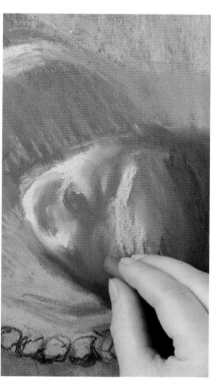

12 Create the glow of late afternoon sunlight by adding touches of bright red pastel around the eyes and mouth. This warm colour brings the face forward visually.

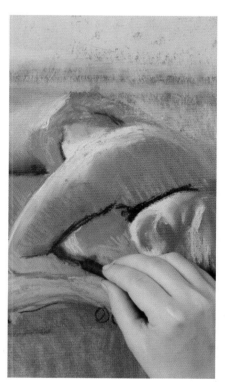

13 Add definition to the body with the dark brown pastel. Smudge the line with your finger to blend it in and to soften the effect over the natural curves of the figure.

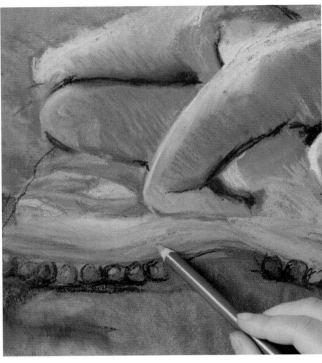

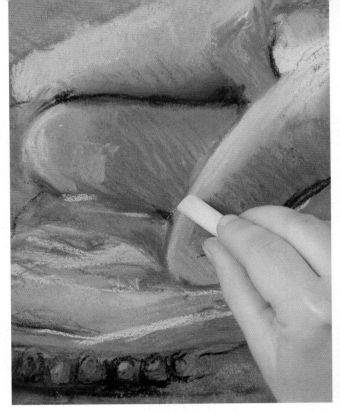

14 Use the turquoise pastel pencil to define areas of sharper detail that may have been lost under layers of blending. The pencil gives you more control and enables you to add detail without disturbing surrounding colour.

15 Add some cool contrast to the skin tones with the same light blue as the base layer of the sea. Add highlights that contrast with the warmer areas of brown tone and suggest the reflective quality of the skin.

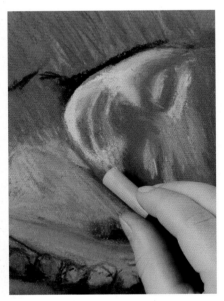

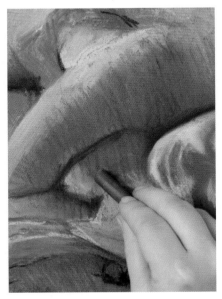

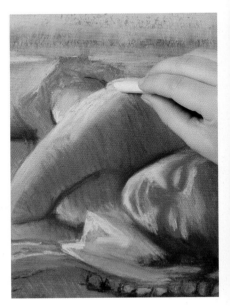

16 Tone down the red accents on the face with burnt umber, then stroke coral pink on to the face and upper arm. Keep checking back to the model so that you consider the overall effect when adding late details.

17 Tone down and soften the brown shadow lines between the arms with dark blue. Define the upper shoulder with raw sienna and dark blue scribbles. Bring the blue around the shoulder and on to the body.

18 Emphasize the highlight on the shoulder with the pale pink pastel. Use this colour again to accentuate the lightest areas of sand in the foreground and background, harmonizing the overall tones of the drawing.

19 Add a final light layer of raw sienna over the foreground. Blend it in with gentle circular sweeps of the palm of your hand. Add some long, loose strokes of turquoise around the knees. This cool colour will help to make the knees stand out against the background.

▼ Girl on the beach

This figure on a beach is an ideal subject in which to explore how to use colour to create a sense of perspective. The cool blues and violets of the sea recede into the distance, while the rosy highlights on the girl's skin stand out as if in the foreground.

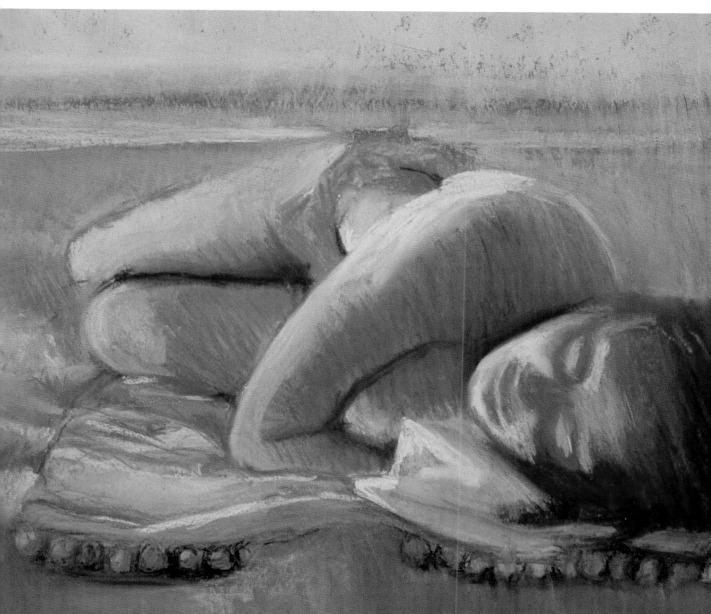

Watercolour Workshop

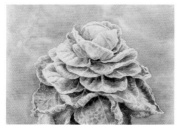 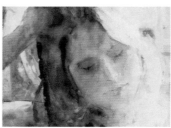 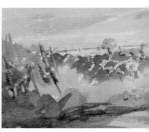

Introduction to watercolour

Watercolour has a translucency and luminosity that is unmatched by any other type of paint. The white paper shows through the brushstrokes, making the painting shine from within, and allows you to breathe life into portraits with glowing skin tones, or to capture the effects of scudding clouds, rain, or sunshine in skies and landscapes.

When mixed with water, watercolour paints will continue to shift and change until they have dried out completely, and you can use this fluidity to create an expressive range of marks and textures. For subjects which require a sensitive approach, you can use soft, blended strokes. At other times you may choose to paint "wet on dry", leaving each application of paint to dry before adding the next, each shimmering layer creating veils of colour, allowing for precise and highly detailed work. Alternatively, you can think in colour and compose with the paint, drawing with broad, loose, personal strokes. When you work quickly and boldly, using strokes economically, the medium responds with a pleasing clarity.

While many effects can be planned, watercolours sometimes react unpredictably. This spontaneity may at first seem daunting, but you can turn it to your advantage. If you exploit the effects of the accidental spread of the watercolour rather than creating every

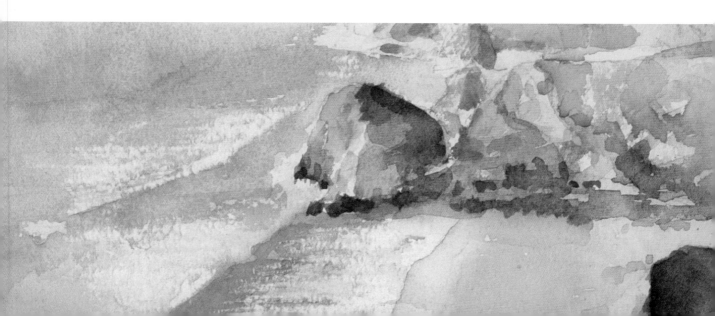

mark yourself, the medium will reward you with fresh and original paintings. There are many ways to work in watercolour and the right method is the one that suits your mood, experience, and subject matter. Just experiment to find your own style.

This section will provide a foundation for painting in watercolour, with advice on the key elements of picture-making and the techniques specific to this exciting medium. You can follow the section as a beginners' course from start to finish, as each part builds on the one before. Alternatively, you can dip in and study the individual subjects or techniques that particularly interest you. Either way, the hands-on approach means that you paint from the start and produce appealing images with just a few strokes. Because painting with watercolours and using colour go hand in hand, the four chapters that follow on from materials and techniques each introduce an increasingly sophisticated way of using colour, supported by a gallery of inspirational examples, both old and new. The 12 projects make use of the basic techniques you have practised and give you the opportunity to learn new ones as you are led, step by step, to finished paintings on a range of subjects. As your confidence with watercolour grows, so will your appreciation of its radiance and versatility.

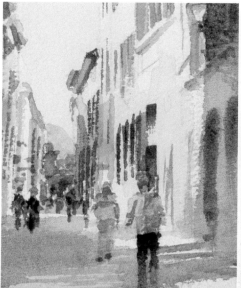

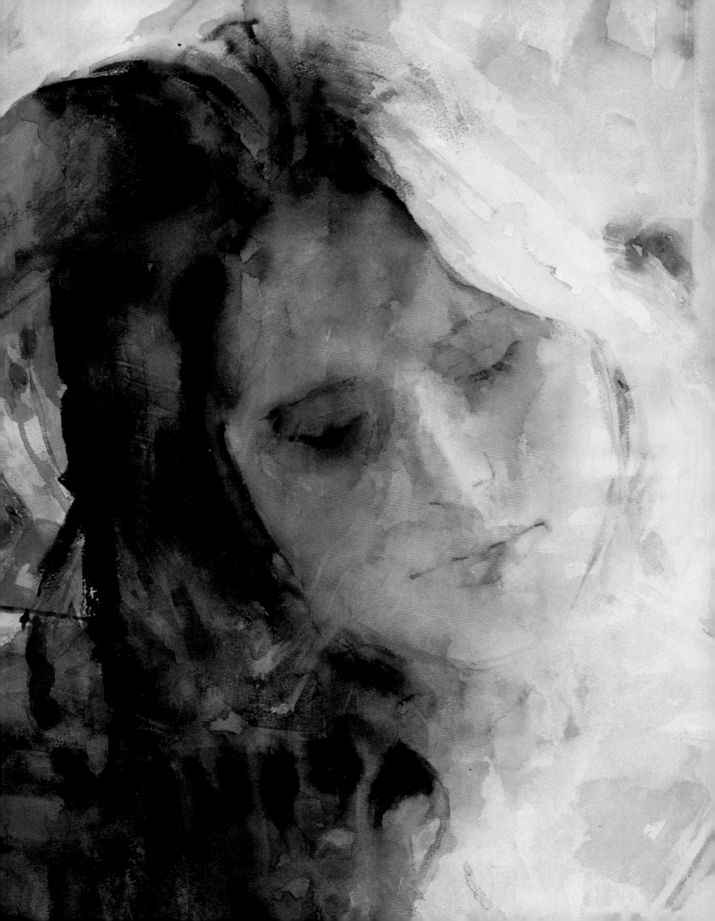

Watercolour
Materials and Techniques

Paint and other materials

You can buy watercolour paints in a vast array of colours, which can vary in form and quality. The two main forms of watercolour paint are tubes of fluid pigment and solid blocks called pans. "Artists' colours" are the highest quality watercolour paints.

These contain greater quantities of fine pigment than "Students' colours" and are more transparent so create more luminous paintings. It is a good idea to limit the range of colours that you buy to start off with and invest in the more expensive Artists' colours.

RECOMMENDED COLOURS

The ten paints below make up a good basic starter palette. You do not need to buy a larger selection because these paints can be successfully mixed together to create a wide range of colours.

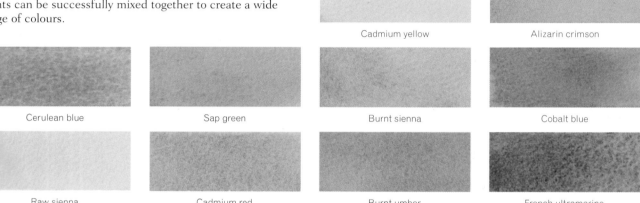

Cadmium yellow · Alizarin crimson · Cerulean blue · Sap green · Burnt sienna · Cobalt blue · Raw sienna · Cadmium red · Burnt umber · French ultramarine

TYPES OF PAINT

Tubes of paint are usually stronger than pans. They squeeze easily on to a palette and are quick to mix, making them good for large washes.

Half-pans, and the larger pans, can be bought individually or in paintboxes. They are small and portable, so useful for painting outdoors.

Paintboxes are a convenient way of storing and transporting half-pans or pans. The lids can be used as palettes.

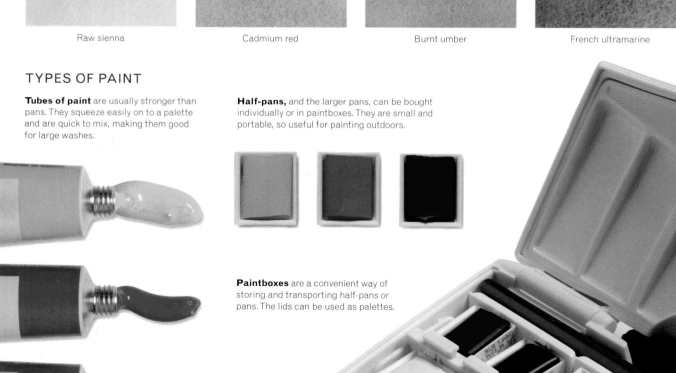

OTHER MATERIALS

There is no need to buy a huge number of brushes to paint with; the range below will enable you to create a wide variety of effects. Apart from paints, paper, and brushes, keep kitchen towel to hand for mopping up spills and blotting out mistakes, and jars of water for mixing paints and cleaning brushes. You may also find some of the additional equipment below useful.

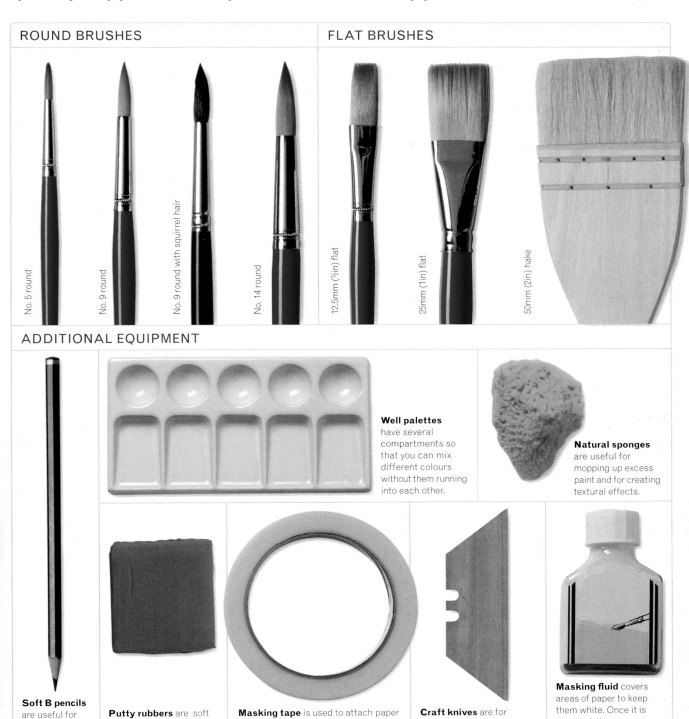

ROUND BRUSHES

No. 5 round

No. 9 round

No. 9 round with squirrel hair

No. 14 round

FLAT BRUSHES

12.5mm (½in) flat

25mm (1in) flat

50mm (2in) hake

ADDITIONAL EQUIPMENT

Well palettes have several compartments so that you can mix different colours without them running into each other.

Natural sponges are useful for mopping up excess paint and for creating textural effects.

Soft B pencils are useful for preliminary drawings.

Putty rubbers are soft and don't damage the surface of paper.

Masking tape is used to attach paper to a drawing board and give a painting a crisp edge.

Craft knives are for sharpening pencils and making highlights.

Masking fluid covers areas of paper to keep them white. Once it is removed, the paper can be painted as normal.

Paper for watercolour

Paper is made from linen or cotton fibres or wood pulp. To make paper less absorbent and create a surface that can hold washes and brushstrokes, size is added. Lighter weight papers have less size so may need to be stretched first to prevent them buckling. You can buy paper with a variety of surfaces and in a range of weights, so it is best to buy single sheets of paper until you have decided which type suits you.

TYPES OF PAPER

There are three main types of paper surface: hot-pressed paper has a hard, smooth surface; cold-pressed or NOT paper has a slight texture; and rough paper has been allowed to dry without pressing. Paper weights are given in gsm (grammes per square metre) or lbs (pounds per ream). The choice ranges from light paper, which weighs 190gsm (90lb), to heavy 638gsm (300lb) paper.

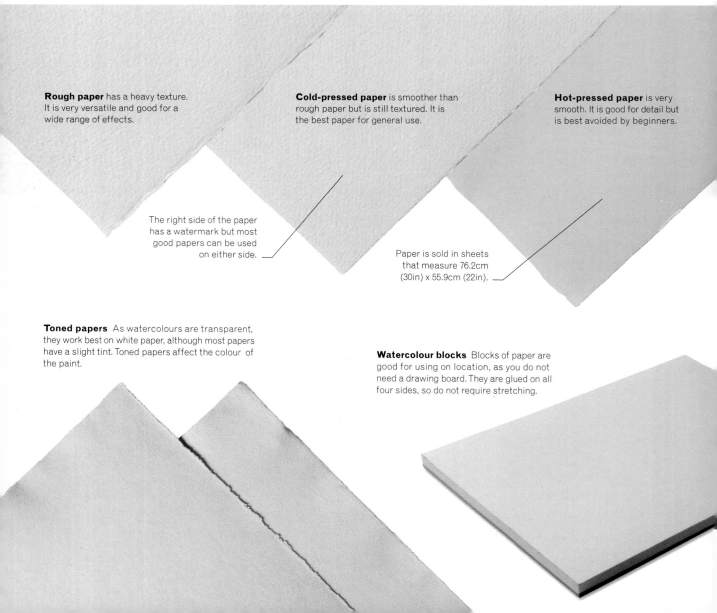

Rough paper has a heavy texture. It is very versatile and good for a wide range of effects.

Cold-pressed paper is smoother than rough paper but is still textured. It is the best paper for general use.

Hot-pressed paper is very smooth. It is good for detail but is best avoided by beginners.

The right side of the paper has a watermark but most good papers can be used on either side.

Paper is sold in sheets that measure 76.2cm (30in) x 55.9cm (22in).

Toned papers As watercolours are transparent, they work best on white paper, although most papers have a slight tint. Toned papers affect the colour of the paint.

Watercolour blocks Blocks of paper are good for using on location, as you do not need a drawing board. They are glued on all four sides, so do not require stretching.

PAINT ON PAPER

The type of paper you use has a marked effect on a painting. These three sunset paintings were all created using the same techniques, but were painted on the three different types of paper: hot-pressed, cold-pressed, and rough. As a result, the finished paintings look quite different from each other.

The washes have a hard edge.

Hot-pressed paper Washes are difficult to control on this paper and tend to dry with hard edges on the top of the slippery surface. This paper is better for a more linear subject.

Cold-pressed paper This is the easiest paper to use as the surface is good for broad, even washes. This type of paper is also suitable for paintings with fine detail and brushwork.

Even gradation and smooth marks.

Rough paper This paper can be quite difficult to use but reacts well to a bold approach. Washes are often broken by the paper's surface, which is useful when a textured effect is desired.

The wash breaks up on the pitted surface.

STRETCHING PAPER

Lay the paper, right side up, on a strong wooden board. Squeeze clean water from a sponge on to the paper so that it is thoroughly wet. Tip the board to let any excess water run off.

Stick each side of the paper down with damp gummed tape, overlapping it at the corners. Smooth the tape with a sponge. Let the paper dry naturally so it becomes flat. Keep the paper on the board until your painting is finished.

Brushes for watercolour

Traditional watercolour brushes are made from soft hair and those made from sable are considered the best. Sable brushes are expensive, however, so when buying a first set of brushes look for synthetic and synthetic/sable blends, which have been developed to mimic pure sable. Whatever a brush is made from, it should point well and hold its shape, be able to hold a generous amount of paint, and be supple and springy.

ROUNDS AND FLATS

Round brushes are conical and can be shaped into a fine point. They are numbered: the larger the brush, the higher its number. Flat brushes are wide and have straight ends. Their size is given by a metric or imperial measurement. Use the rounds and flats in the recommended brush selection (see p.131) to enable you to create a wide range of strokes from fine lines to broad washes, as below.

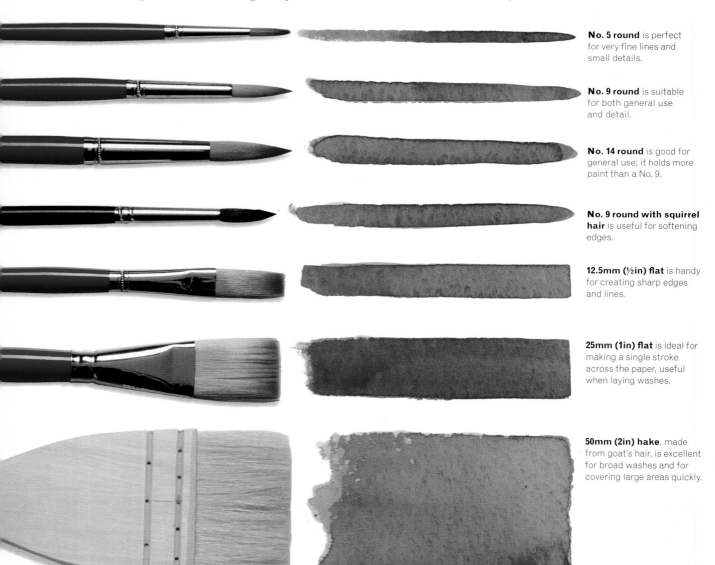

No. 5 round is perfect for very fine lines and small details.

No. 9 round is suitable for both general use and detail.

No. 14 round is good for general use; it holds more paint than a No. 9.

No. 9 round with squirrel hair is useful for softening edges.

12.5mm (½in) flat is handy for creating sharp edges and lines.

25mm (1in) flat is ideal for making a single stroke across the paper, useful when laying washes.

50mm (2in) hake, made from goat's hair, is excellent for broad washes and for covering large areas quickly.

BRUSHSTROKES

Watercolour brushstrokes should be smooth and flowing. Practise relaxing your hand and wrist so that you can make continuous strokes, letting the brush do the work. Try using the brush at different angles and speeds. All the brushstrokes below were made with a No. 14. It is a good idea to use a large brush for as long as possible in your paintings to avoid creating fussy brushmarks.

Upright brush

To make the thinnest possible line, hold the brush upright and only use the point.

Slanting brush

To create a medium-width line, lower the angle of the brush to use the centre of the hairs.

Low brush

To produce the widest possible mark, press down so that you are using the full width of the brush.

Varying strokes

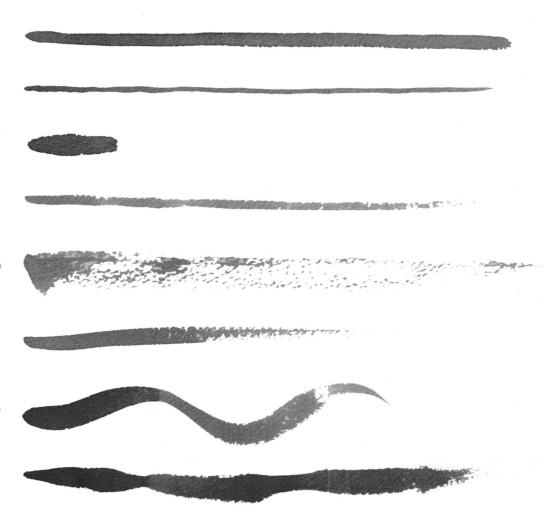

To create a long, solid stroke, move the brush slowly over the paper, letting the paint flow.

To make a fine, continuous line, hold the brush upright and just use the tip.

To make a petal-like mark, press the whole shape of the hairs down on to the paper.

To gradually lighten a mark, slowly lift off the brush as you move across the paper.

To create a broken, textured effect, drag the side of the brush quickly over the paper.

To make an expressive mark, speed up. Fast strokes are often straighter than slow ones.

To produce an undulating stroke, twist the brush rhythmically as you draw it across the paper.

To create this pattern, vary the pressure of your stroke as you cross the paper.

Brushstrokes

Try holding your brushes at different angles and varying the speed and pressure of your brushstrokes to create a variety of marks, as below. This will improve your brush control so that you become more relaxed and confident when painting. Trying out different brushstrokes will also help you to discover the range of effects you can make using round or flat brushes.

VISUAL EFFECTS

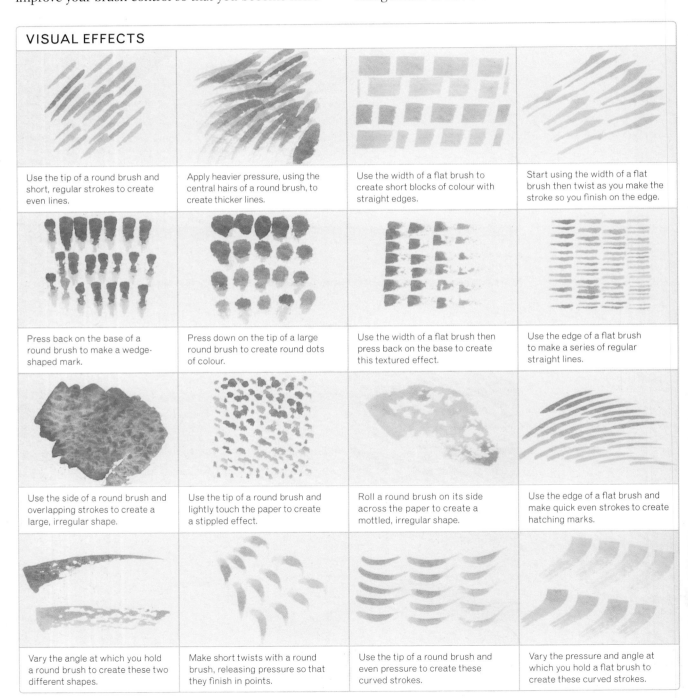

Use the tip of a round brush and short, regular strokes to create even lines.

Apply heavier pressure, using the central hairs of a round brush, to create thicker lines.

Use the width of a flat brush to create short blocks of colour with straight edges.

Start using the width of a flat brush then twist as you make the stroke so you finish on the edge.

Press back on the base of a round brush to make a wedge-shaped mark.

Press down on the tip of a large round brush to create round dots of colour.

Use the width of a flat brush then press back on the base to create this textured effect.

Use the edge of a flat brush to make a series of regular straight lines.

Use the side of a round brush and overlapping strokes to create a large, irregular shape.

Use the tip of a round brush and lightly touch the paper to create a stippled effect.

Roll a round brush on its side across the paper to create a mottled, irregular shape.

Use the edge of a flat brush and make quick even strokes to create hatching marks.

Vary the angle at which you hold a round brush to create these two different shapes.

Make short twists with a round brush, releasing pressure so that they finish in points.

Use the tip of a round brush and even pressure to create these curved strokes.

Vary the pressure and angle at which you hold a flat brush to create these curved strokes.

APPLYING STROKES

It is easy to create simple images with just a few brushstrokes. Try out the individual marks that are painted on this page, then put them together to make a flower, a penguin, and a fish.

Use a flat brush and a controlled sweep to paint the long leaves, then press the whole shape of a round brush on to the paper to form the petals. Finally use the tip of the round brush for details.

Use a round brush to make the long strokes of the penguin's body and wings, petal-like shapes for the feet, and stippling detail.

Make a curved stroke to suggest the fish's body, then use a fine brush for stippling and to create the long strokes of its whiskers.

Colour wheel

The colour wheel is a classic device that shows how the six main colours – red, purple, blue, orange, green, and yellow – relate to one another. The colour wheel contains the three primary colours and three secondary colours. Primary colours – red, yellow, and blue – cannot be mixed from any other colours. Secondary colours – orange, purple, and green – are mixed from two primary colours. The colours between the primary and secondary colours on the wheel are known as intermediate colours.

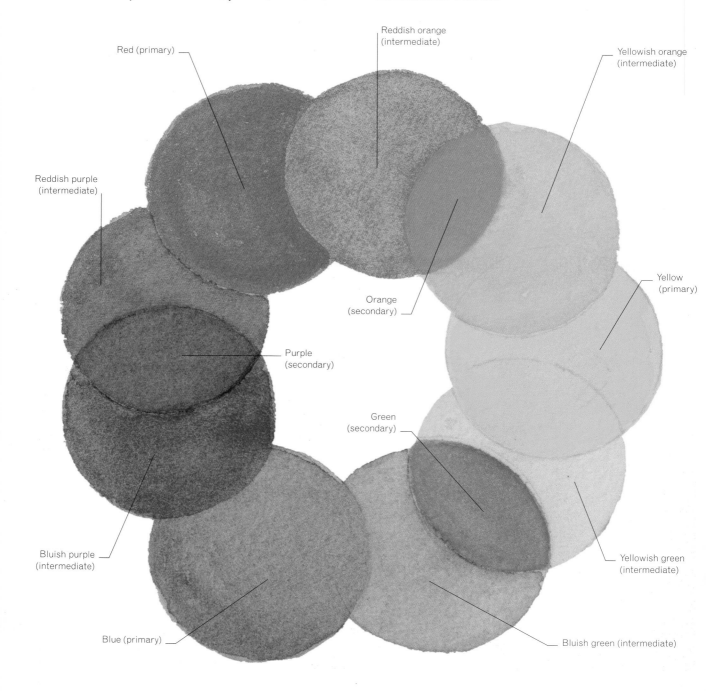

Red (primary)

Reddish orange (intermediate)

Yellowish orange (intermediate)

Reddish purple (intermediate)

Yellow (primary)

Orange (secondary)

Purple (secondary)

Green (secondary)

Bluish purple (intermediate)

Yellowish green (intermediate)

Blue (primary)

Bluish green (intermediate)

PRIMARY COLOURS

Red is one of the strongest hues and can easily overpower other colours.

Yellow is the lightest tone, so appears to recede when placed next to other colours.

Blue is a very dominant colour and will not be overpowered.

SECONDARY COLOURS

Green is made from yellow and blue, so it neither appears to dominate or recede.

Purple is made from red and blue, so is strong but doesn't overpower other colours.

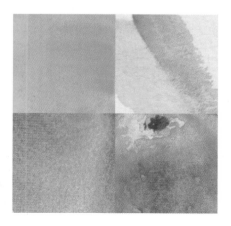

Orange is made from red and yellow, so will lighten any colour it is mixed with.

Colour mixing

It is easy to mix watercolour paints to make new colours, both in a palette and on paper. The recommended basic palette of ten colours (*see p.130 and below*) includes the three primary colours, green, and browns, so you will be able to mix a wide range of colours. There are several shades of some colours; for example, there are two reds: cadmium red and the bluer alizarin crimson. The different shades of a colour react differently when mixed with other colours, increasing the range of colours you can create.

LIGHTENING COLOURS

By varying the amount of water you add to paint you can create a range of different shades from light to dark. If you want the paint to retain its translucency you should always make colours lighter by adding water rather than white paint, which makes colours opaque.

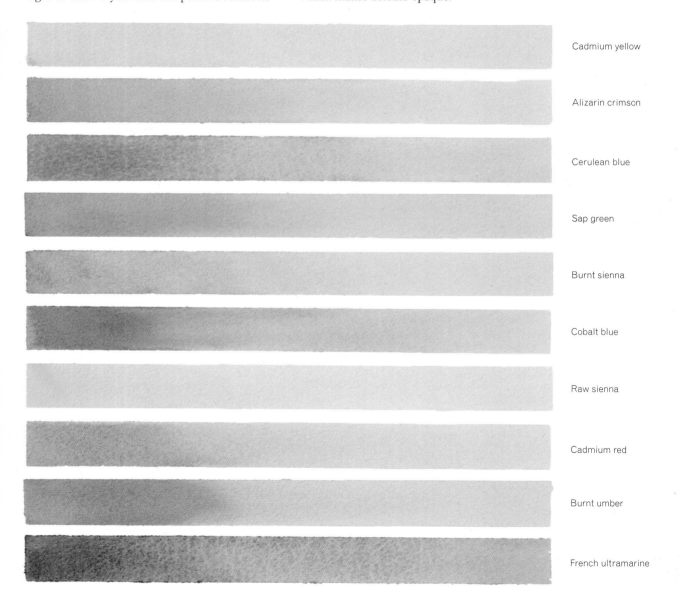

Cadmium yellow

Alizarin crimson

Cerulean blue

Sap green

Burnt sienna

Cobalt blue

Raw sienna

Cadmium red

Burnt umber

French ultramarine

MIXING COLOURS ON A PALETTE

Squeeze a small amount of paint from a tube on to your palette. Dip a brush into a jar of clean water then mix the water with the paint. Add more water until you have the colour you want.

Watercolours look lighter when dry, so it is a good idea to test colours on a spare piece of paper, or around the edge of your colour test sheet (see p.37), before using them in a painting.

Rinse your brush after mixing each new colour and keep the water in your mixing jar clean. To blend two colours, mix the dominant colour with water, then gradually add the second colour.

Make sure the dish or palette you are using has room to dissolve the pigment in a smooth puddle.

Use a white palette or dish, or a glass plate with white paper underneath, so you can see the colour you are mixing.

MIXING COLOURS ON PAPER

Mix two different colours with water in separate wells in your palette. Paint the first colour on to your paper with a clean brush. While this is still wet, add the second colour and it will mix on the paper to create a new colour. Sometimes when you mix two colours they will look grainy. This granulation occurs when the paints mixed have different weight pigments from each other. Try mixing colours to see which ones granulate. The effect is good for creating textures.

GRANULATION

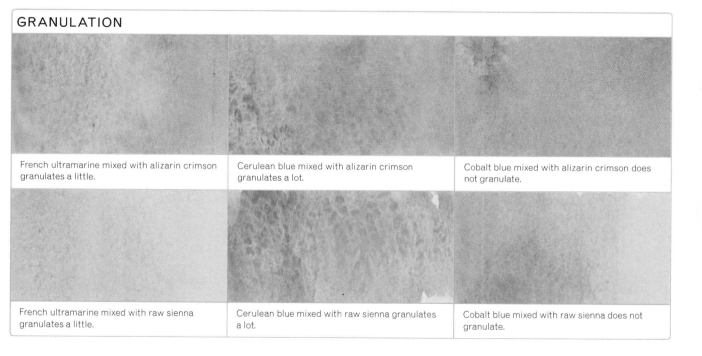

French ultramarine mixed with alizarin crimson granulates a little.

Cerulean blue mixed with alizarin crimson granulates a lot.

Cobalt blue mixed with alizarin crimson does not granulate.

French ultramarine mixed with raw sienna granulates a little.

Cerulean blue mixed with raw sienna granulates a lot.

Cobalt blue mixed with raw sienna does not granulate.

Useful colour mixes

Some colours look better if you make them by mixing your paints rather than attempting to buy a tube or pan of the colour. Greens are often the colour painters have most trouble with but you can mix them very successfully. Skin colours may also seem difficult but you can make a wide range of realistic skin tones for any skin colour with mixes of just four colours from your basic palette.

MIXING GREENS

The range of greens that appears in the natural world is vast. However, there are few sources of green pigment and many of the manufactured green paints that you can buy are strong and lack the subtlety of natural greens. To expand your range of greens, mix bought greens with blue or yellow, or create your own by mixing blue and yellow or blue and orange.

GREEN VARIATIONS

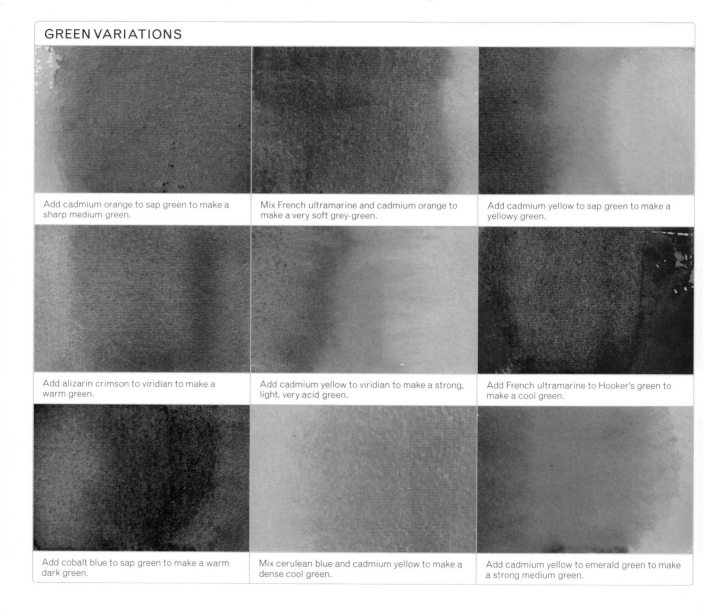

Add cadmium orange to sap green to make a sharp medium green.

Mix French ultramarine and cadmium orange to make a very soft grey-green.

Add cadmium yellow to sap green to make a yellowy green.

Add alizarin crimson to viridian to make a warm green.

Add cadmium yellow to viridian to make a strong, light, very acid green.

Add French ultramarine to Hooker's green to make a cool green.

Add cobalt blue to sap green to make a warm dark green.

Mix cerulean blue and cadmium yellow to make a dense cool green.

Add cadmium yellow to emerald green to make a strong medium green.

SKIN TONES

All skin tones, from the palest to the darkest of complexions, are made up of a combination of three colours: red, yellow, and blue. Therefore, it is possible to mix all skin colours with a very limited selection of paints: raw sienna, alizarin crimson, cerulean blue, and cadmium red. When you paint skin remember it is reflective so will also be affected by the colours around it.

Raw sienna and alizarin crimson make a soft, even skin tone, which can be used for all skin types.

Cool down a raw sienna and alizarin crimson mix with cerulean blue to help model a face.

Raw sienna and cadmium red make a strong colour suitable for tanned or dark skin.

Layering colours wet on dry creates luminous skin tones, which can be softened with water, as on the right-hand side.

Pure colours

Raw sienna

Alizarin crimson

Cerulean blue

Cadmium red

Colour mixes

Raw sienna and alizarin crimson

Raw sienna and cerulean blue

Alizarin crimson and cerulean blue

Raw sienna, alizarin crimson, and cerulean blue

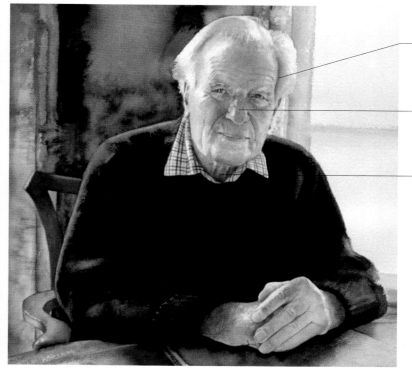

Alizarin crimson is used on the side of the face.

Warmer colours are used down the centre of the face.

Dark tones mixed from pink, yellow, and blue look soft.

Portrait of a man This face has been painted using raw sienna, alizarin crimson, cerulean blue, and cadmium red. The colours have been built up slowly from light to dark to create a radiant face.

Colour blends

Practise mixing the ten colours in your basic palette to see how many new colours you can make. Try mixing combinations of two and three colours: don't use more than three colours as the end result will be muddy. It is a good idea to mix the paints on paper and label the colour swatches that you create, as below, so that you have a record of which colours mix together well.

MIXING TWO COLOURS

As you experiment with your paints you will see that some colours mix together more successfully than others. For example, French ultramarine mixed with alizarin crimson produces a pleasing warm mauve but if you use cadmium red instead of alizarin crimson you get a muddy purple. Here you can see examples of some of the best mixes that can be made from your basic palette.

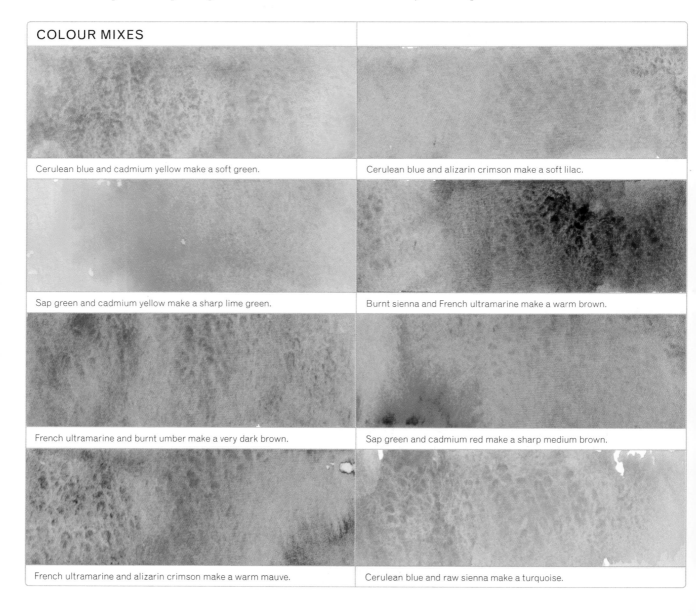

COLOUR MIXES

Cerulean blue and cadmium yellow make a soft green.

Cerulean blue and alizarin crimson make a soft lilac.

Sap green and cadmium yellow make a sharp lime green.

Burnt sienna and French ultramarine make a warm brown.

French ultramarine and burnt umber make a very dark brown.

Sap green and cadmium red make a sharp medium brown.

French ultramarine and alizarin crimson make a warm mauve.

Cerulean blue and raw sienna make a turquoise.

BLACKS AND BROWNS

There is no need to buy black watercolour paint, as you can make dark brown and black by mixing red, blue, and yellow. By using different shades of the primary colours you can make a range of dark colours.

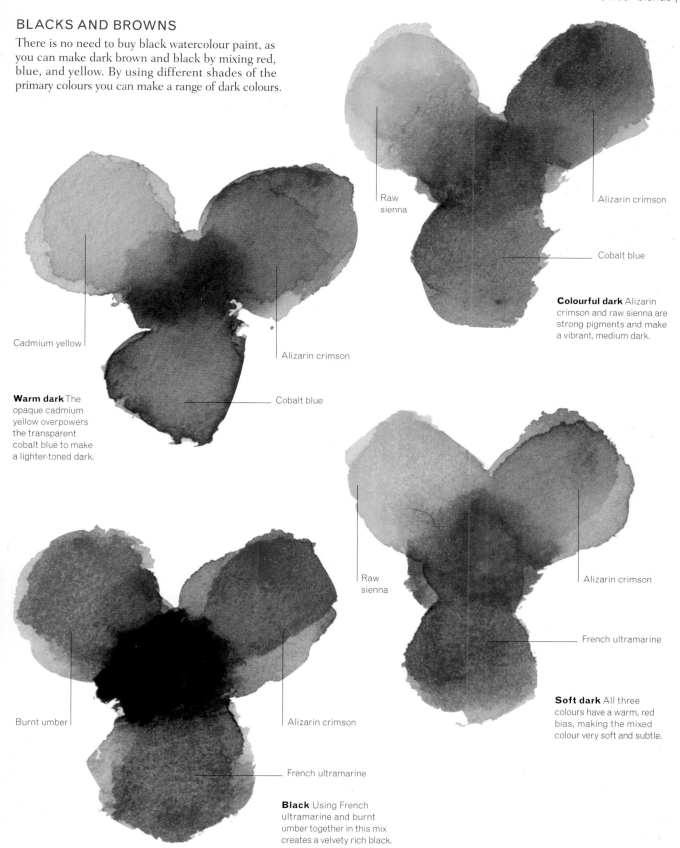

Raw sienna

Alizarin crimson

Cobalt blue

Colourful dark Alizarin crimson and raw sienna are strong pigments and make a vibrant, medium dark.

Cadmium yellow

Alizarin crimson

Cobalt blue

Warm dark The opaque cadmium yellow overpowers the transparent cobalt blue to make a lighter-toned dark.

Raw sienna

Alizarin crimson

French ultramarine

Soft dark All three colours have a warm, red bias, making the mixed colour very soft and subtle.

Burnt umber

Alizarin crimson

French ultramarine

Black Using French ultramarine and burnt umber together in this mix creates a velvety rich black.

Washes

Washes are the foundation of watercolour painting, as they are the first application of paint to the paper, whether as a tinted ground or a large painted area. Laying a wash, therefore, is a vital technique to master. Once you have practised producing a smooth, flat wash in a single colour, you can vary the basic technique to create graded washes, variegated washes, and broken washes.

FLAT WASH

Dampen the paper and tilt your drawing board slightly. With a large flat brush, paint a band across the top of the paper.

Starting at the other side of the paper, paint the next band so that it overlaps the first. Repeat to the bottom of the paper. Dry with the paper tilted.

In a flat wash, the bands of paint blend together while they are still wet to create a smooth wash of uniform colour.

GRADED WASH

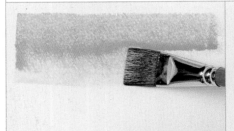

Dampen the paper and lay a wash across the top. Immediately add water to the paint and add another band of paint at the base of the first band.

Add more water to your paint and repeat. Continue to dilute the paint for each band of paint, until you reach the bottom. Allow to dry.

A graded wash becomes progressively lighter towards the bottom, as each band of paint is more diluted than the previous one.

VARIEGATED WASH

Paint two bands of a wash at the top of the damp paper. Load your brush with a different colour and paint this below the first colour.

Let the bands of paint blend on the paper. To produce a more colourful result, introduce a different colour with each new stroke.

BROKEN WASH

Hold your brush low on the paper so that you drag the colour over the surface, letting the paper's texture break up the bands of paint.

You can vary the position of the broken marks by letting the brush glance across the paper in different places to create texture.

USING WASHES

Below you can see some of the many different ways in which washes can be used. While a flat wash is good for painting large areas and backgrounds, more complex washes can express mood or be used for natural elements. Graded washes, for example, give skies a sense of depth. Variegated washes, on the other hand, are excellent for colourful sunsets.

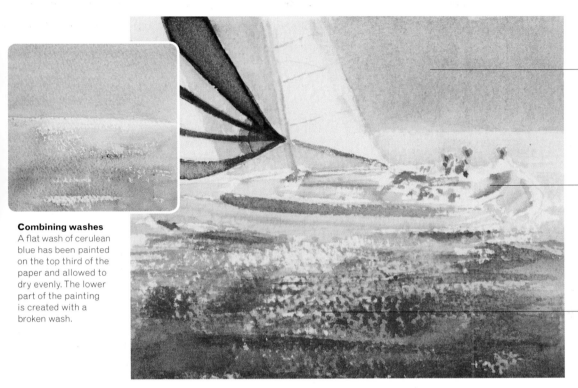

The flat wash of cerulean blue has created a calm background sky.

Addng a few details to the boat brings action and purpose to the scene.

The texture of the broken wash is good for sea and contrasts with the calm sky.

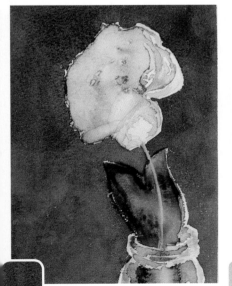

Combining washes
A flat wash of cerulean blue has been painted on the top third of the paper and allowed to dry evenly. The lower part of the painting is created with a broken wash.

Flat wash

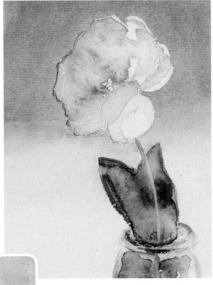

The flat background wash makes the colours of the flower really stand out in contrast.

Graded wash

The neutral, graded background wash is pale at the bottom, making the leaves and jar stand out.

Variegated wash

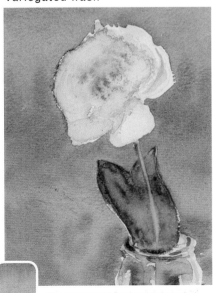

The variegated background wash is colourful and suggests an area of interest behind the flower.

Building a painting

Watercolour paintings can be built up by adding layers of paint either to paint that has already dried – wet on dry – or to colour that is still wet – wet-in-wet. Laying down paint wet on dry produces vivid colours with strong edges. You can paint wet on dry with a high level of accuracy so it is a good technique to choose when painting detail. Wet-in-wet is more immediate and the results, produced as the colours blend, are softer and less predictable. Wet-in-wet is useful for backgrounds and the early stages of a painting.

WET OR DRY?

Try out these two techniques to see the effects they produce. Practising will also help you to judge how wet or dry your paper is, which helps you to anticipate the effect your painting will produce. If paint is added to a wash before it is completely dry, particularly on smooth paper, it may cause backruns as the second colour runs into the first and dries in blotches with hard edges.

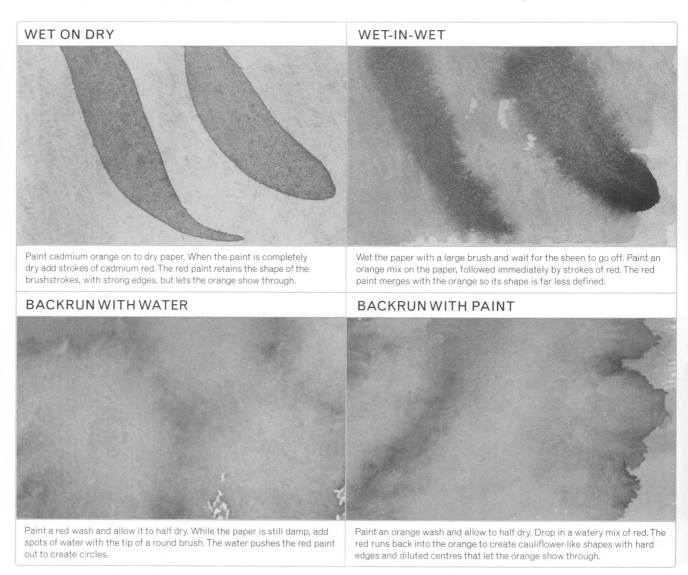

WET ON DRY

Paint cadmium orange on to dry paper. When the paint is completely dry add strokes of cadmium red. The red paint retains the shape of the brushstrokes, with strong edges, but lets the orange show through.

WET-IN-WET

Wet the paper with a large brush and wait for the sheen to go off. Paint an orange mix on the paper, followed immediately by strokes of red. The red paint merges with the orange so its shape is far less defined.

BACKRUN WITH WATER

Paint a red wash and allow it to half dry. While the paper is still damp, add spots of water with the tip of a round brush. The water pushes the red paint out to create circles.

BACKRUN WITH PAINT

Paint an orange wash and allow to half dry. Drop in a watery mix of red. The red runs back into the orange to create cauliflower-like shapes with hard edges and diluted centres that let the orange show through.

WET-IN-WET STUDY

As painting wet-in-wet is not predictable, it is a good idea to practise studies whenever you can. Here the method has been used to quickly capture the head of a tiger and paint the soft texture of its thick, colourful fur.

The background is painted with raw sienna

The strong mix of burnt sienna creates the texture of the fur.

The stripes of burnt umber are added when the paint has dried a little.

BACKRUN STUDY

Backruns sometimes appear by mistake but you can use them to enhance your paintings. Because of their spontaneity, use backruns when you are free to interpret the marks you end up with. Here cauliflower-like shapes have been made into autumnal leaves.

Washes of raw sienna, alizarin crimson, and sap green are painted side by side.

Once the wash is dry, look for shapes you can interpret.

Water dropped in to the middle of the wash flows out towards the edges.

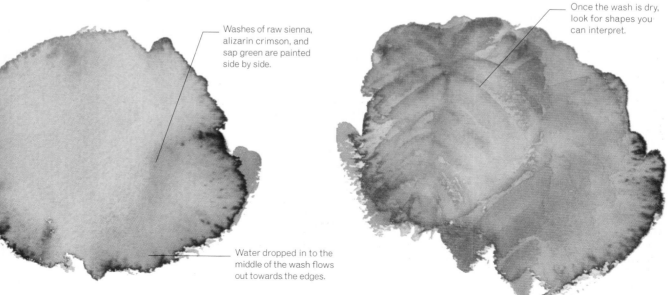

Watercolour paint effects

You can add texture and interest to your paintings with a number of special effects. These include splattering and sponging, and techniques using materials that resist the flow of paint on the paper and make it dry in a striking pattern, as when tin foil or salt are used. As the results of these methods can be unpredictable, have fun experimenting with them and build up the range you can use in your paintings. Try using cling film to create the ripples on water, salt to make snow or ice, and splattering and sponging for foliage.

SPLATTERING ON DRY PAINT

Paint a wash of cerulean blue mixed with sap green and let it dry. Load a brush with Windsor violet, then flick this brush over the wash. The splattered paint dries as rings with hard edges and light centres.

SPLATTERING ON WET PAINT

Paint a turquoise wash and while the paint is wet, flick on Windsor violet to produce soft, mottled blobs with colourful centres. The effect achieved will vary depending on how wet the wash is when the second colour is applied.

FEATHERING

Paint horizontal lines with water. While the paper is still wet, drag a brush with turquoise paint down the paper, across the lines of water. Vary the amount of water and pressure used to make different textures.

GLAZING

Paint a wash of cadmium yellow and let it dry. Paint two bands of translucent colour – a cerulean blue and sap green mix and alizarin crimson – over the yellow and the unpainted paper. The paint glazed on the yellow looks brighter.

USING SALT

Drop salt crystals on to an alizarin crimson wash and let it dry. Brush off the salt to reveal the shapes made by the salt absorbing the paint. The effect will vary depending on how wet the paint is and how much salt you use.

SPONGING

Dip a natural sponge into a wash of alizarin crimson, then press the sponge on to dry watercolour paper. The mottled marks you make will vary depending on the amount of paint used and how hard you press.

USING CLING FILM

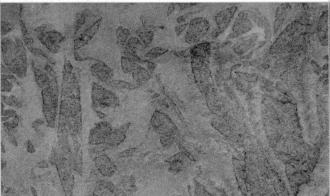

Paint a Windsor violet wash. While it is wet, scrunch up some cling film and press it on to the paper. Let the paint dry before removing the cling film, so that the paint keeps the hard edges formed where the film has touched it.

USING TIN FOIL

Press tin foil into wet paint using the same technique used for cling film. The effect is stronger than that produced by cling film but you cannot see the effect being made while the paint is drying.

SCRAPING BACK

Paint the rough shapes of a loose stone wall using a mix of cerulean blue and burnt umber, letting the colours blend. While the paint is wet, scrape out the shapes of the stones using a plastic strip – such as an old credit card – to remove the wet paint.

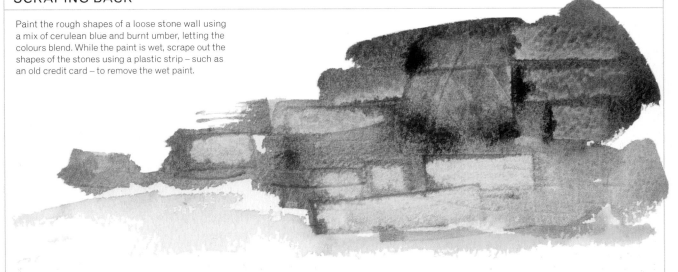

Composition

When planning a painting, you have to decide what you want to focus on in your picture and what you want to leave out. Simplicity is the key to success when you start painting, and editing will strengthen your composition. You will also need to choose where you position the different elements of your painting. In a successful composition they will be placed so that they lead the viewer into the painting.

VIEWFINDER

Use a viewfinder as a framing device that you can move in front of your subject to help you visualize how it will look in a variety of compositions. You can make a simple viewfinder by holding two L-shaped pieces of card to make a rectangle, as shown on the right. You can change the shape and size of the rectangle by moving the pieces of card closer to each other or further apart.

Slide the corners of the card in and out to frame and crop the picture.

FORMAT

Deciding what format – shape of paper – to use is an important part of planning a composition. The three paintings below show how the choice of format can direct attention to different focal points. The formats used for this study are: portrait (a vertical rectangle, higher than it is wide), landscape (a horizontal rectangle, wider than it is high), and square.

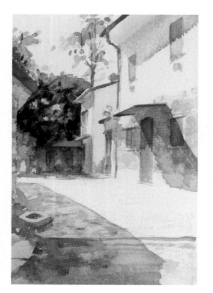

Portrait format The large amount of space given to the foreground in this design leads the eye along the road and into the picture.

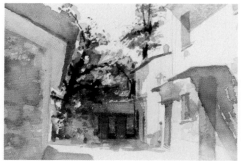

Landscape format The horizontal nature of this picture draws attention to the colourful shed doors and angles of the trees. The building on the left directs the eye to to the centre of the composition.

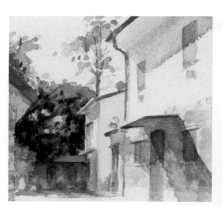

Square format Here the roofs and doorways have been included. The trees on the left act as a counterpoint to this detail on the right and help to create a balanced composition.

USING THE RULE OF THIRDS

To help you plan your composition and give it visual impact, try using the rule of thirds. Divide your paper into thirds both vertically and horizontally to make a nine-box grid. At first you may want to draw these lines on the paper with a pencil, but with practice the grid can be imaginary. For maximum effect, position the main elements of your design on the lines. Place the horizon line, for example, a third up from the bottom or a third down, and use the points where the lines intersect for your areas of interest.

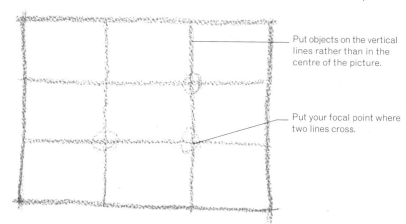

Put objects on the vertical lines rather than in the centre of the picture.

Put your focal point where two lines cross.

The focal point, the face, has been placed where two lines intersect.

Girl in artist's studio This painting of a figure in a clutter of objects and colours could have looked quite chaotic, but because the areas of interest have been placed according to the rule of thirds the composition is well balanced and pleasing to the eye.

The lines of the chair draw the eye into an otherwise empty area.

Sketching

Simple sketches are very useful when planning a watercolour painting. You can develop rough ideas, sketched in pencil, into compositions, and use watercolour sketches to help you plan the colours you want to use and to practise marks and colour mixes.

Use a sketchbook to keep all your ideas together and to record things you see that inspire you, so that you build up your own valuable reference. Copy out developed compositions on to watercolour paper and use the pencil lines as a guide when you begin painting.

USING SKETCHBOOKS

Many sketchbooks contain cartridge paper with a smooth surface. This is fine for pencil sketches, but if you want to use soft pencils, graphite sticks, and watercolour to sketch with, choose a sketchbook that contains paper with a slightly rough surface. It is a good idea to buy a pocket-size sketchbook and carry this around so that you can sketch whenever you are inspired.

Project sketch

The drawing is done lightly, as it will remain under the washes and brushmarks of the finished painting.

Don't use watercolour paper for planning sketches, as alterations and erasings will damage the paper's surface.

A sketch for the Cherries project (see pp.52–55) was copied on to watercolour paper before painting began.

Quick colour sketch

Quick colour sketches, such as this one of a lemon, are a good way to experiment with different colour combinations and techniques.

Planning a composition

This sketch has been used to plan which colours to use in a painting. Just a few brushstokes are sufficient.

COLOUR TEST SHEETS

This page from a sketchbook shows the marks and sketches that were made when planning the Cherries project *(see pp.170–173)*. Colour mixes were tested and techniques such as wet-in-wet and softening were practised to help discover the best way of painting the cherries. Test sheets often influence the final design of a painting, as they highlight interesting and successful effects.

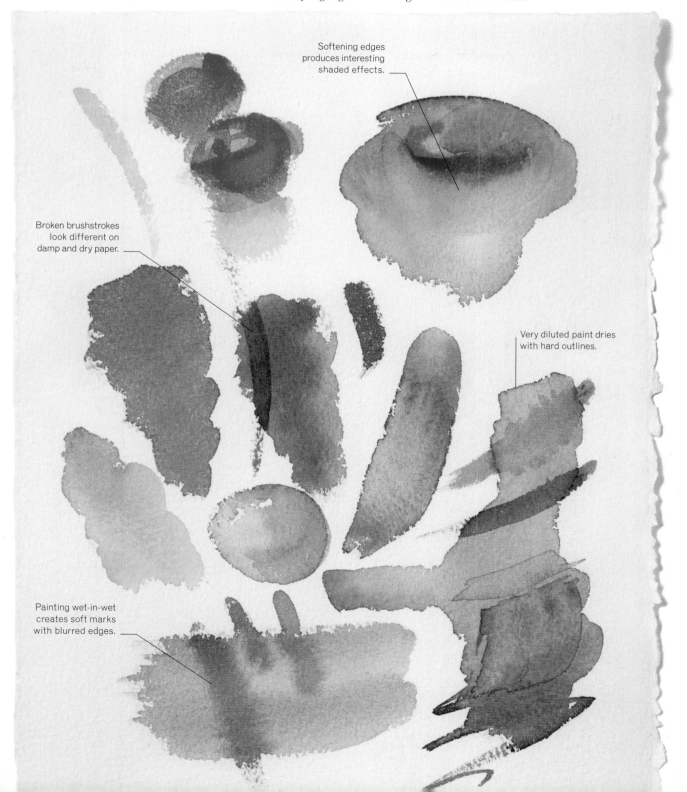

Softening edges produces interesting shaded effects.

Broken brushstrokes look different on damp and dry paper.

Very diluted paint dries with hard outlines.

Painting wet-in-wet creates soft marks with blurred edges.

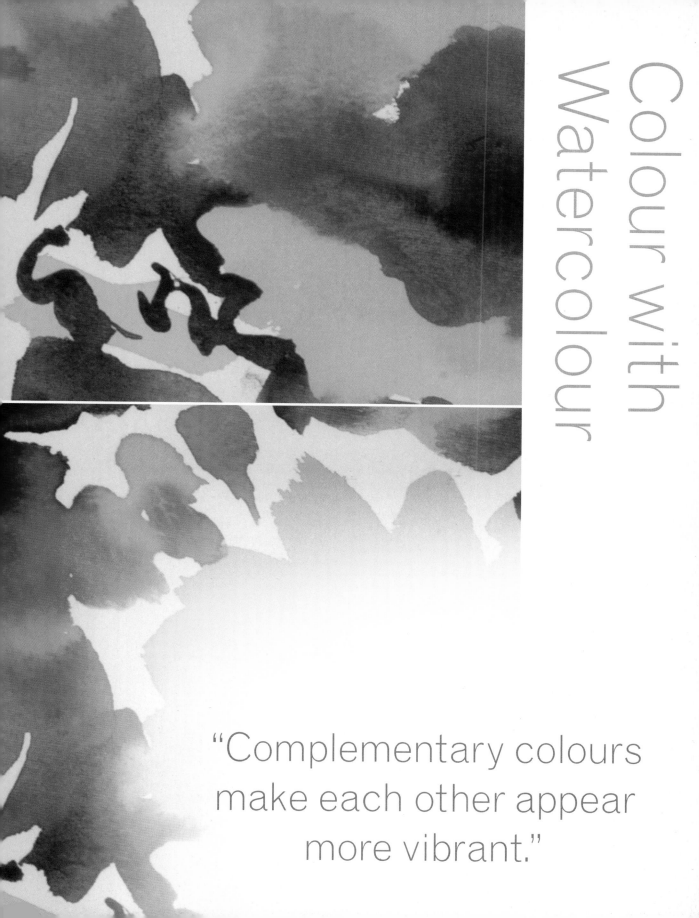

Colour with
Watercolour

"Complementary colours
make each other appear
more vibrant."

Vibrant colours

To create a really vibrant painting, you need to plan which colours to use. If you try to reproduce all the colours you see in front of you, they end up vying with each other, rather like all the instruments in an orchestra playing at once. If, on the other hand, you try limiting the colours you use in a painting to complementary opposites, such as red and green, you will find that the colours make each other appear more vibrant. The reds will look much more red and the greens will appear more intensely green.

COMPLEMENTARY COLOURS

There are three primary colours: red, yellow, and blue. These are colours that can't be made by mixing other colours together. Green, orange, and purple are called secondary colours. Each of these is made by mixing two primary colours together. Green, for example, is made by mixing blue and yellow together. Complementary colours are pairs of colour that are opposite each other on the colour wheel. The complementary colour of any secondary colour, therefore, is the primary colour it does not contain.

Yellow and red make orange, so blue is the complementary of orange.

Blue and yellow make green, so red is the complementary of green.

Red and blue make purple, so yellow is the complementary of purple.

COLOURFUL NEUTRALS

If you mix two complementary colours together in equal proportions, they produce a neutral colour. By varying the proportions of the mix, you can create a harmonious range of neutral greys and browns. These neutrals are far more luminous and colourful than ready-mixed greys and browns, and are excellent for creating areas of tone. If your painting is based around red and green, for example, the areas of tone would be made from varying mixes of red and green.

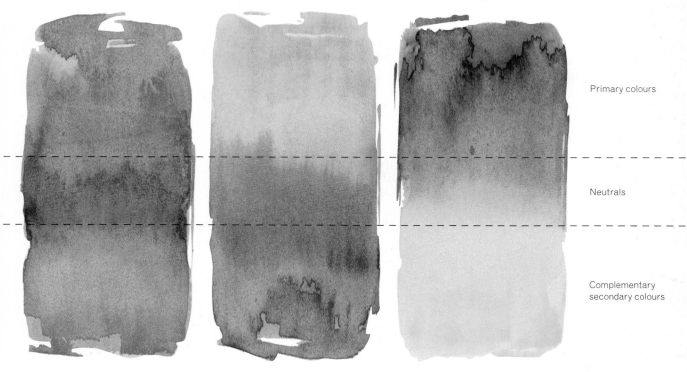

Primary colours

Neutrals

Complementary secondary colours

HARMONIOUS PAINTINGS

Colour is one of the most direct ways of expression available to you when you paint. The instant you use colours together they form an association with one another that helps to suggest the mood of the painting. Limiting colours to complementary opposites enables you to create simple, vibrant paintings with a range of harmonious tones.

Red and green

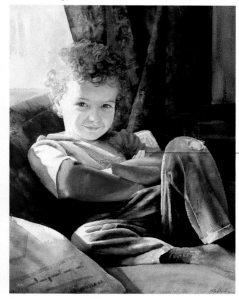

The reflective yellow contrasts with the dark purple.

The green body of the T-shirt makes the red arms stand out.

Red is a forceful colour and is made more vibrant here by its proximity to green. The boy's pose is relaxed but the liveliness of the red hints at his boisterous nature.

Yellow and purple

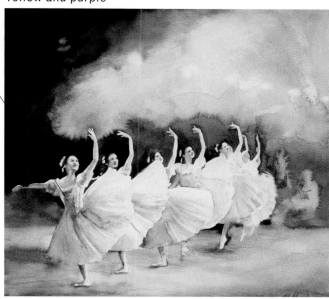

Yellow is a reflective colour and here it is used in the dancers' skirts to reflect the glare of strong stage lighting. Counterbalancing the yellow with purple highlights the illuminated skirts and helps to ground the dancers' feet.

Blue and orange

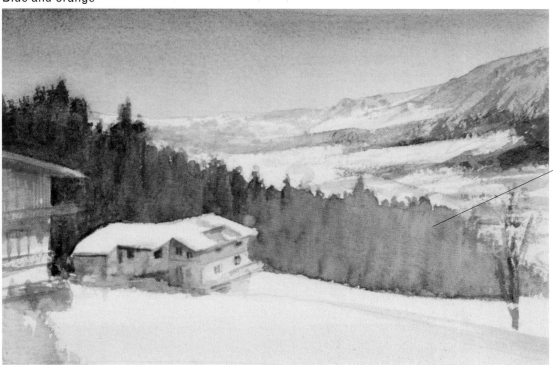

Orange and blue have been mixed together to create a range of green neutrals for the trees.

The dominance of blue in this scene suggests cold, still mountain air, in contrast with the orange areas that suggest sunshine and warmth.

Complementary colours make each other appear more vibrant and can be used to create simple, harmonious paintings.

▲ Corn

Painting the orange-yellow ear of corn in the foreground against a complementary blue sky makes it really stand out. The use of yellow and purple, and red and green elsewhere adds vibrancy. *Peter Williams*

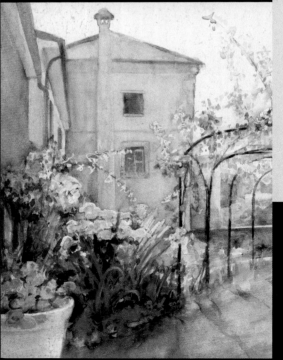

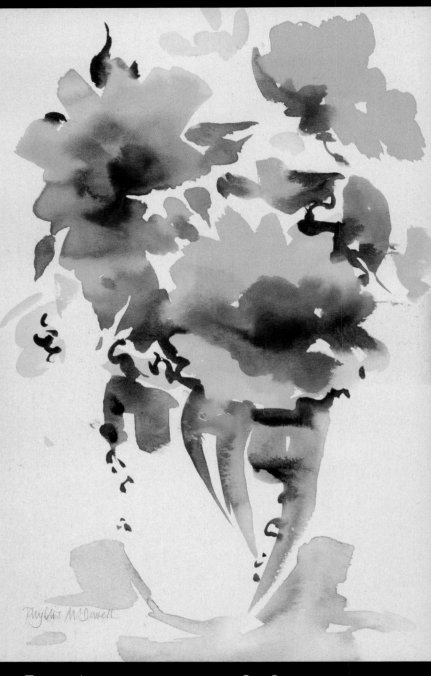

◄ Tuscan house

The orange and yellow house is surrounded by complementary blues and lilacs. The use of complementary blue for the window draws attention through the foreground to the house. *Glynis Barnes-Mellish*

▲ Sunflowers

This bold, loose painting shows a controlled use of complementary colours. The strong splash of yellow is heightened by the flowers' purple centres, and the green leaves balance the reds. *Phyllis McDowell*

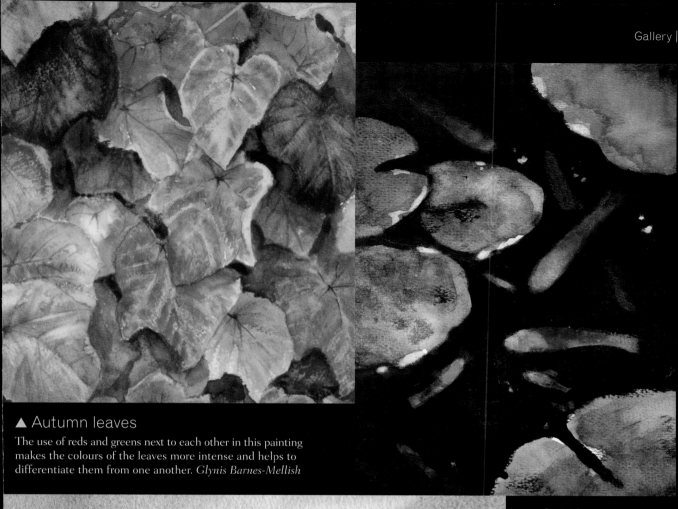

▲ Autumn leaves

The use of reds and greens next to each other in this painting makes the colours of the leaves more intense and helps to differentiate them from one another. *Glynis Barnes-Mellish*

▲ Goldfish pond

While the composition of this painting is simple, the use of complementary colours means that it is anything but dull. The bright red goldfish appear stunningly vibrant, a result of them being positioned among strong green lilies. *Robert McIntosh*

◀ Church in field

This atmospheric scene makes use of two sets of complementary colours. The soft use of blues and purples in this painting suggests cloud and mist and is balanced by the complementary yellows and oranges of winter sunlight. *Phyllis McDowell*

13 Tuscan landscape

At first sight, landscapes look both colourful and rather complex, especially if they are made up of many different shades of green. In this painting, however, orange and blue – complementary colours – are used not only to create a dramatic and vibrant composition, but are also mixed together to make a harmonious range of neutral greens and greys. The sky makes up two thirds of the painting and a basic flat wash is used to great effect to capture the appearance of a deep blue sky on a still, hot summer's day.

EQUIPMENT

- Cold-pressed paper
- Masking tape
- 4B pencil
- Brushes: No. 14, 25mm (1in) flat, hake, squirrel
- Kitchen towel
- Cobalt blue, cadmium orange, French ultramarine, cadmium red, burnt sienna

TECHNIQUES

- Flat wash
- Graded wash

PREPARATION

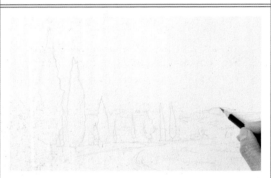

Lightly sketch the outlines of the composition with a soft (4B) pencil, to act as a guide for your painting.

Stick masking tape around the edges of the picture area. This will define the edges of the painting and will help to keep them clean.

1 Use the hake brush to wet the paper in horizontal lines, starting at the top of the picture area and working down to the horizon line. Mop up any excess water with clean kitchen towel.

2 Mix a generous amount of cobalt blue on your palette, enough for a wash. When the wet paper has lost its sheen, load the 25mm (1in) flat brush with cobalt blue and apply a flat wash of colour for the sky.

BUILDING THE IMAGE

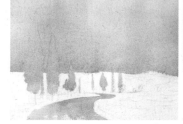
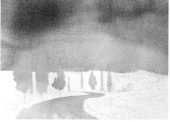

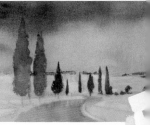

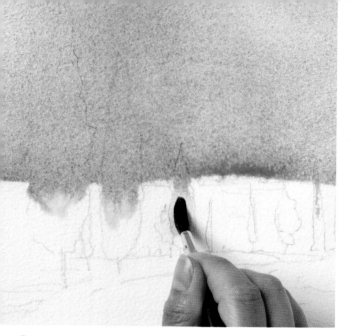

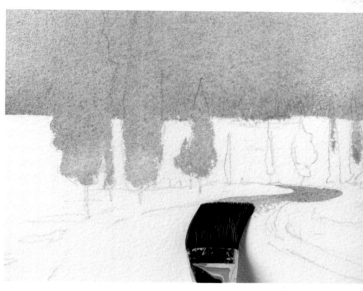

3 Use a squirrel brush that has been dipped in water to soften the lower edge of the wash and to bring the blue down on to the trees along the road.

4 Load the 25mm (1in) flat brush with the cobalt blue that is already mixed on your palette. Use this paint to create the curving road.

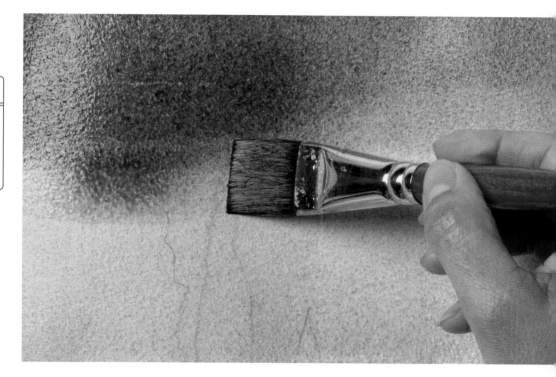

GRADED WASH

As the cobalt blue is still wet, the second wash of French ultramarine, which is darker, blends into it, creating a graded wash.

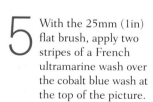

5 With the 25mm (1in) flat brush, apply two stripes of a French ultramarine wash over the cobalt blue wash at the top of the picture.

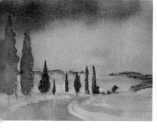
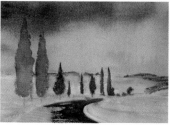

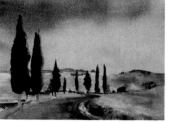

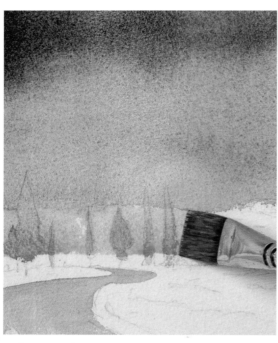

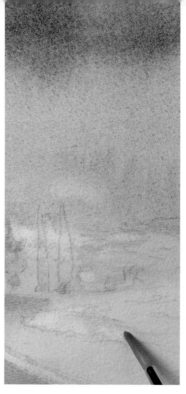

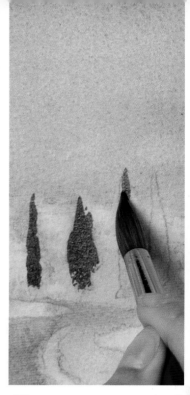

6 When the trees and road are dry to the touch, apply a wash of cadmium orange below the blue wash of the sky with the 25mm (1in) flat brush. The trees and road will look green where you have painted over them.

7 Wait for the orange paint to dry a little and lose its sheen. Using a soft brush, gently dab water on to the orange paint to push it away. This will add texture to the fields.

8 Mix French ultramarine and cadmium orange to make a soft green for the trees. Don't overload your brush so the strokes break up slightly to create the trees' texture.

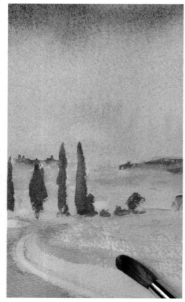

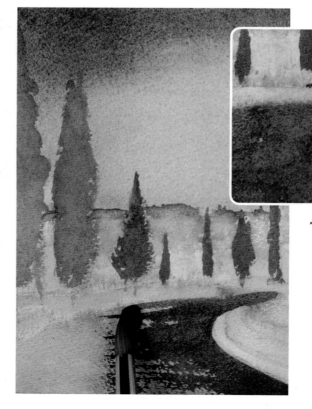

9 Paint trees on the horizon with the green mix and soften them. When the orange wash is dry, add cadmium orange mixed with a little cadmium red to brighten the fields.

10 Paint the road with a mix of burnt sienna and French ultramarine. Add cadmium red and cobalt blue to make grey, and strengthen some areas by mixing in French ultramarine on the paper.

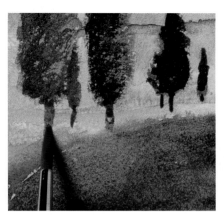 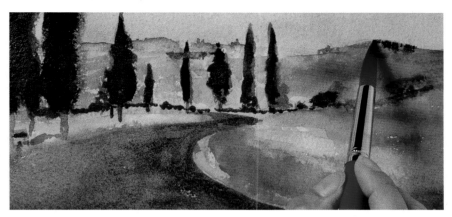

11 Mix cadmium red and cobalt blue for the tree trunks. Darken the foliage with a burnt sienna and French ultramarine mix. Paint the shadows with a mix of cobalt blue, cadmium red, and cadmium orange, and then soften them.

12 Add a mix of cobalt blue and cadmium red to the horizon, to create depth. Paint grass in the foreground of the picture, then strengthen the colour between the trees with touches of cadmium orange.

▼ Tuscan landscape

The complementary washes of orange and blue create a colourful final painting. Simple mixes of these colours produce the greens for the trees and a range of harmonious tones for the finer details.

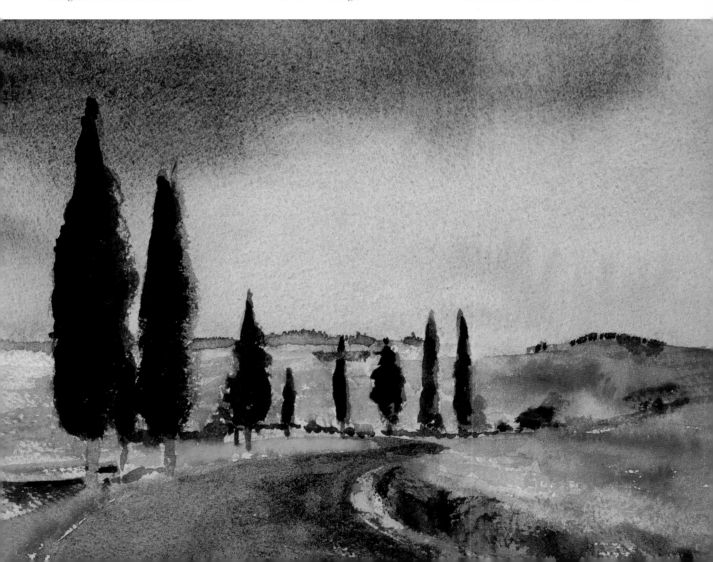

14 Ballet shoes

In this painting the golden tones of the ballet shoes and barre are set against a predominantly neutral background. Applying the background wet-in-wet as different shades of cool lilac creates a complementary, harmonious combination of colours. The lilac is also reflected in the satin surface of the ballet shoes, which helps to emphasize their soft sheen. Although there are some warm colours used in the background, they recede in comparison with the rich gold of the ballet shoes, and this helps to bring the shoes right to the front of the painting.

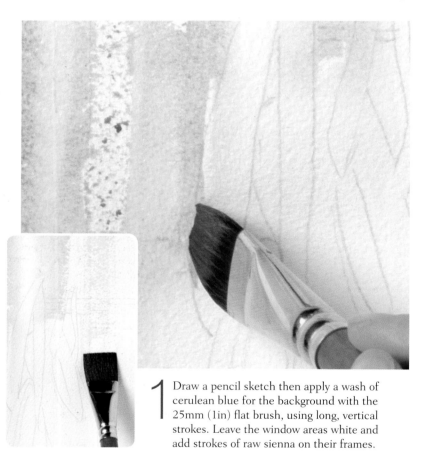

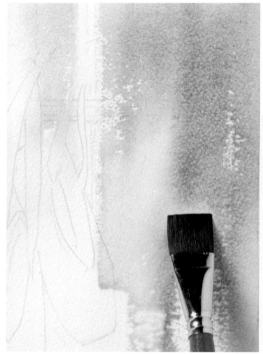

EQUIPMENT
- Rough paper
- Brushes: No. 5, No. 14, 25mm (1in) flat
- Cerulean blue, raw sienna, Windsor violet, burnt sienna, cadmium orange, cadmium red, cadmium yellow

TECHNIQUES
- Wet-in-wet

1 Draw a pencil sketch then apply a wash of cerulean blue for the background with the 25mm (1in) flat brush, using long, vertical strokes. Leave the window areas white and add strokes of raw sienna on their frames.

2 Paint vertical strokes of diluted Windsor violet on the right-hand side of the picture with the 25mm (1in) flat brush. The Windsor violet will run into the wet raw sienna, keeping the edges soft.

BUILDING THE IMAGE

3 Use raw sienna to paint the wooden barre and the ballet shoes, letting the colour run into the purple background. Strengthen the cerulean blue, keeping the white areas of paper clear.

4 Mix cerulean blue and raw sienna for the barre supports. Add a burnt sienna and Windsor violet mix to the background. Strengthen the barre with raw sienna and a touch of cadmium orange.

5 Use a cerulean blue and Windsor violet mix to paint horizontal lines on the left. Darken the back wall with a burnt sienna and cerulean blue mix. Paint inside the shoes with a mix of burnt sienna and Windsor violet.

6 Strengthen the colour of the shoes with raw sienna mixed with a little cadmium orange. Paint vertical lines of cerulean blue to create their satin sheen. Add Windsor violet wet-in-wet, then lines of burnt sienna.

STRENGTHENING COLOURS

As paint dries, colours tend to become paler. If the dried result is too pale, you can strengthen the colour by adding further layers of paint.

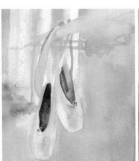
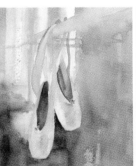
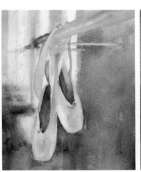
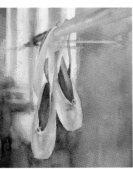

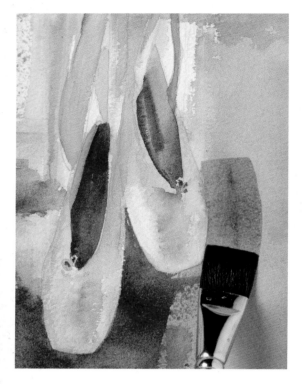

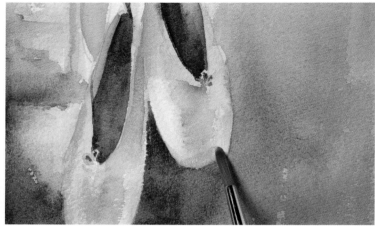

7 Paint the shoe ribbons with a mix of cerulean blue and raw sienna and add definition with a mix of Windsor violet and raw sienna. Strengthen the background around the shoes with the mix of Windsor violet and raw sienna. This helps to bring the shoes forward.

8 Add raw sienna to the background on the right side. Warm up the shoes with a mix of cadmium red and raw sienna. Strengthen the dark parts of the shoes with the mix of Windsor violet and burnt sienna. Paint the block toes with raw sienna.

9 Paint the front part of the barre with a mix of burnt sienna and raw sienna, so that it appears to be coming forward. Paint the receding part of the barre with the cooler mix of Windsor violet and burnt sienna.

10 Add a wash of Windsor violet to the right-hand side of the picture, to create a contrast with the yellow shoes. Paint the shoe ties with the mix of Windsor violet and burnt sienna. Add raw sienna and cadmium yellow to the fronts of the shoes to make them more vibrant.

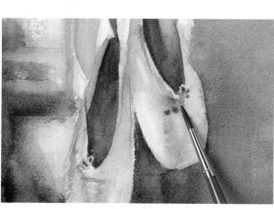

Ballet shoes ▶

A dynamic picture has been created from the relationship between the bold main image and the wash of colours behind it. The build-up of golden tones and the strength of the complementary lilac has produced a luminous and striking image.

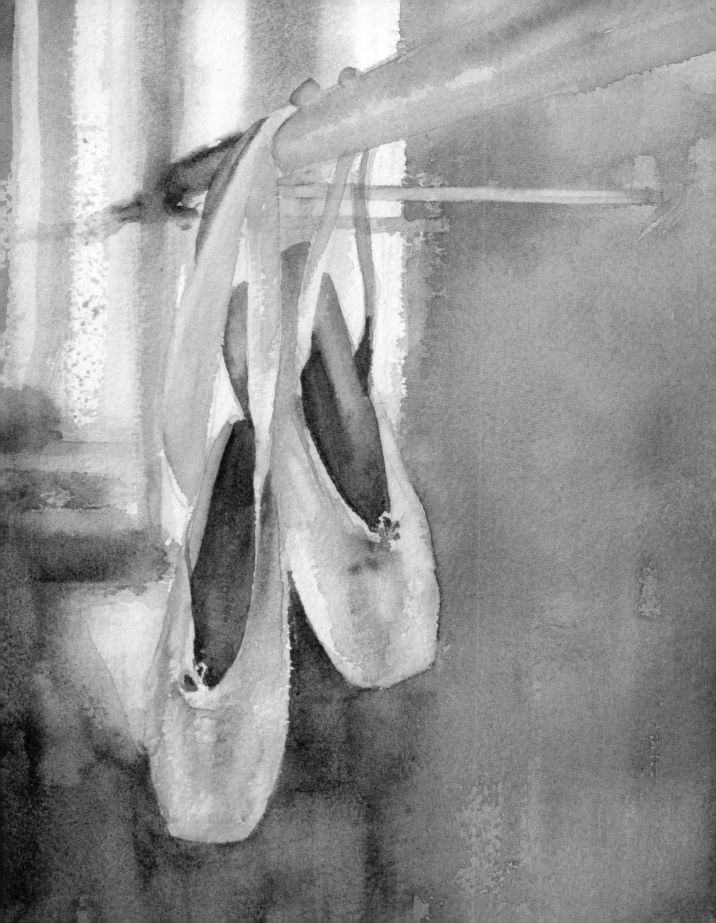

15 Cherries

Close studies can make highly rewarding paintings. By cropping in tightly on a small bunch of cherries in this straightforward study, attention is focused on the fruit and there is no need for unnecessary detail. In order to emphasize the vibrant red of the cherries, its complementary colour – green – is used for the rest of the painting. The soft, loose washes of different greens create a calm, recessive background, which throws the vivid scarlet of the cherries into relief so that they appear to come forward and completely dominate the painting.

EQUIPMENT
- Cold-pressed paper
- Brushes: No. 5, No. 9, 12.5mm (½in) and 25mm (1in) flat
- Alizarin crimson, cadmium red, cadmium yellow, burnt umber, French ultramarine, viridian, Windsor violet, emerald green, cerulean blue

TECHNIQUES
- Wet-in-wet
- Softening edges

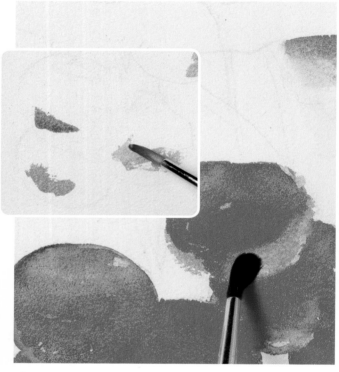

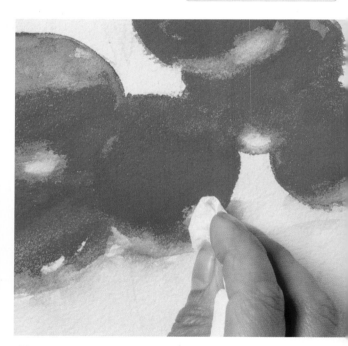

1 Use touches of alizarin crimson to paint the lighter areas of the cherries, taking care not to overload your brush. Paint the rest of the cherries cadmium red and soften the edges with water to remove some paint.

2 Remove a little of the wet cadmium red by dabbing it with a clean tissue. This takes you back to the alizarin crimson that was covered by cadmium red in step 1. The contrast between the two colours makes the cadmium red look brighter.

BUILDING THE IMAGE

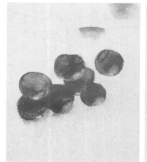
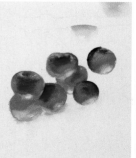
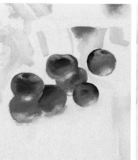
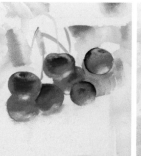
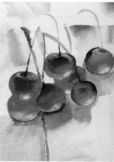

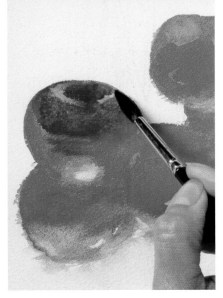

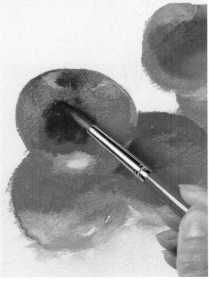

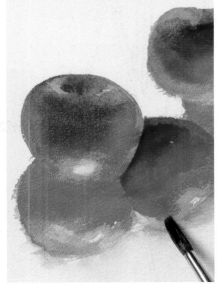

3 Create shadows with Windsor violet then add another layer of cadmium red to strengthen the colour of the cherries. Use a wet brush to soften some areas to create highlights. Strengthen the alizarin crimson.

4 Mix cadmium red and burnt umber to make a dark red and paint this on to the cherries while the cadmium red is still wet. This darker mix creates the shadows of the cherries that are furthest away.

5 Use pure Windsor violet to outline part of the cherries and separate them from each other. Strengthen the red again, to push back the darker colours, and soften the edges to show where the light falls on them.

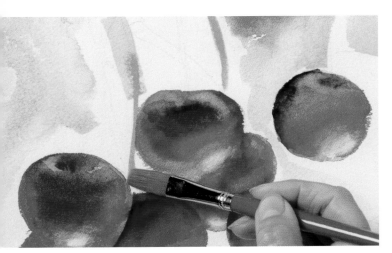

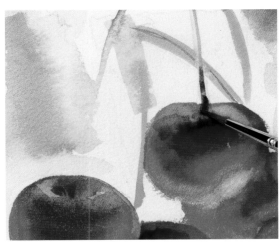

6 Paint washes of emerald green, cadmium yellow, and cadmium red wet-in-wet in the background. Keep the colours loose and wet so that they appear to recede. Use the side of the 12.5mm (½in) flat brush to paint fine green lines for the stems of the cherries.

7 When the cherries are dry, paint the leaf with emerald green and cerulean blue. Use a mix of French ultramarine and burnt umber to indicate where the stalks meet the cherries.

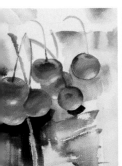
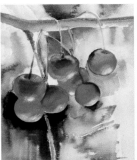

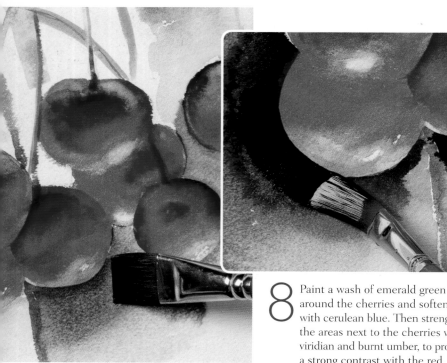

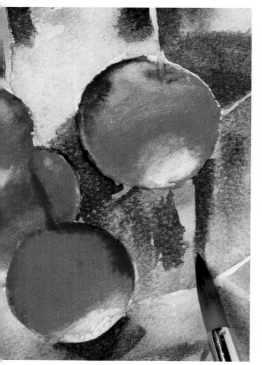

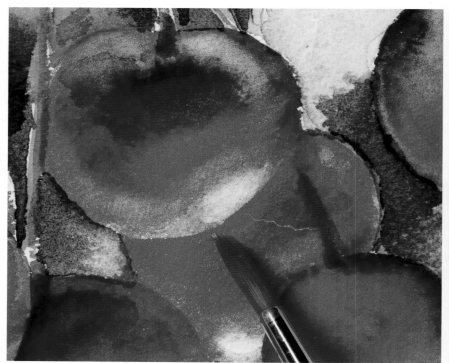

8 Paint a wash of emerald green around the cherries and soften it with cerulean blue. Then strengthen the areas next to the cherries with viridian and burnt umber, to provide a strong contrast with the red.

9 Paint the branch above the cherries with burnt umber, using the side of the No. 5 brush. The paint will granulate naturally, helping to create the mottled appearance of the bark on the branch.

10 Fill in the background with broad washes of greens. Paint the leaf with a mix of cerulean blue and cadmium yellow, then add strokes of cerulean blue and viridian to create the leaf veins.

11 Paint the shadows on the cherries with a mix of cadmium red and alizarin crimson. Strengthen the colour of the branch with burnt umber and add Windsor violet in the darkest places.

Cherries ▶

The dramatic effect of the finished painting is achieved by the striking contrast between the scarlet cherries and the complementary washes of green around them.

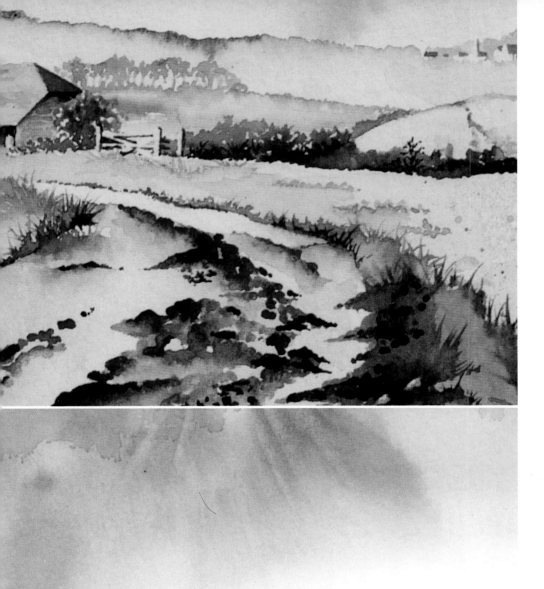

Effective Watercolour Tone

"Plan your colours:
limit your palette."

Light and dark

Tone – the relative lightness or darkness of colours – is the most important building block for all painting. It creates pattern and shape, movement and design. Colour, depth, and focus are all diminished without good, clear use of tone. A painting in which all the colours are of a similar tone looks dull because there are no high notes or low notes – nothing stands out. To create subtle paintings full of energy and interest, it is best to limit the colours you choose and to use neutrals to create a varied range and depth of tone.

LIMIT YOUR PALETTE

Working with a limited range of colours that are close together on the colour wheel holds a painting together and gives it unity. The colours can be based around any one of the primary colours and will each contain a certain amount of that colour. Including one complementary colour in your selection will enable you to create a range of harmonious neutrals and semi-neutrals that also unify the painting. Using a very small amount of the pure complementary colour in your painting will give emphasis to the composition and make the colours sparkle.

In the colour wheel all the colours are equal in tone, so no one colour stands out.

Limited palette of yellow-green, green, blue-green, and complementary red.

Limited palette of blue-green, blue, blue-purple, and complementary orange.

Limited palette of blue-purple, purple, red-purple, and complementary yellow.

— Dark tone

— Medium tone

— Light tone

SELECTING TONES

Using a simple range of close tones in your painting will help to hold all the different elements of your composition together. Most paintings only need a range of three close tones, accented by a few very dark tones and the white of the paper to create drama and focus. Make sure that you have identified all the tones in a scene before you decide where to simplify them. To help you see the tone of an object, compare it with the colours surrounding it. You may also find it useful to hold a piece of white paper next to the tone to see how light or dark it is when compared with white.

PAINTING WITH A LIMITED PALETTE

Before beginning a painting, try making a preliminary sketch of your subject. Use the sketch to help you work out which range of colours and tones to use to create a strong composition.

The simple watercolour sketch on the right was made in preparation for the painting below and many of the tones used were corrected, to create a more dynamic painting. In the finished painting the palette is limited, with green as the dominant colour. Using a range of greens has made the foliage interesting even though it is not very detailed. The tonal range of the neutral colours gives the painting structure, and the small amount of complementary red makes the painting more vibrant.

Preliminary sketch

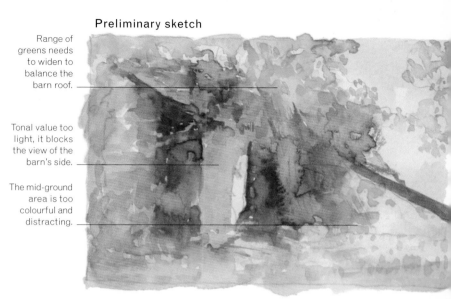

Range of greens needs to widen to balance the barn roof.

Tonal value too light, it blocks the view of the barn's side.

The mid-ground area is too colourful and distracting.

Finished painting

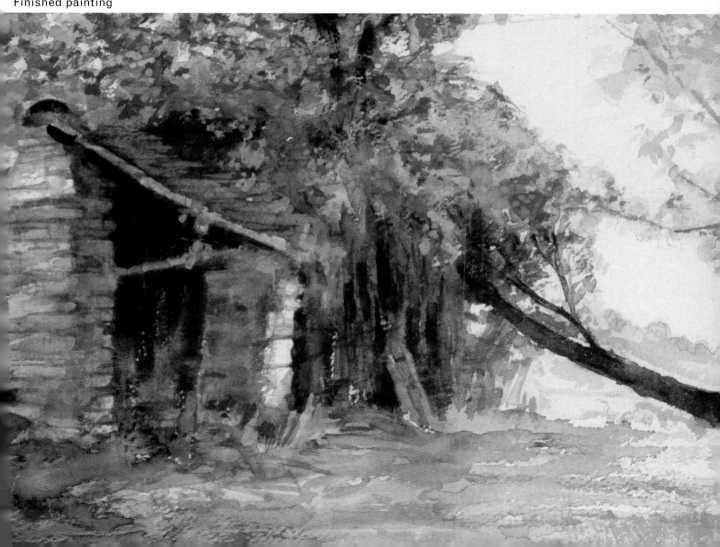

Gallery

Subtle paintings can be created by limiting the number of colours used and incorporating a variety of tones to create pattern and highlight interest.

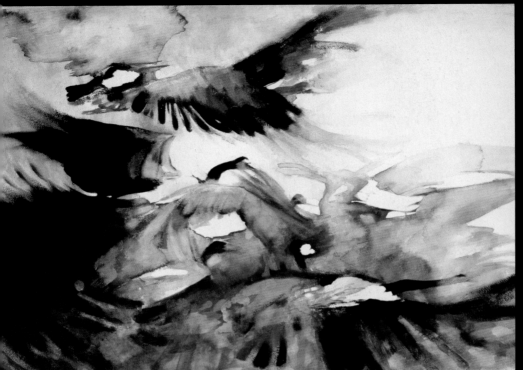

◄ Canada geese

The overall tone of this painting groups the birds together. The detail of the geese and their flapping wings has then been created through tonal contrast. A limted use of bright colours adds areas of interest. *Glynis Barnes-Mellish*

▼ Sprouted brussels

This painting makes use of a limited blue-green palette and harmonious soft, yellow neutrals. The subtlety of the mid-tone range draws the eye to the delicate details and areas of focus. *Antonia Enthoven*

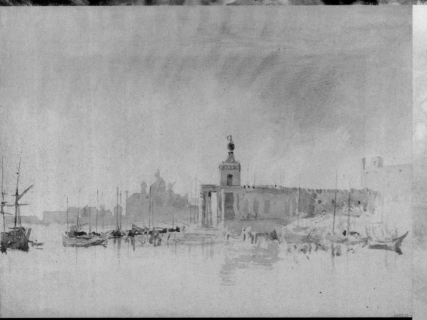

▲ Venice, Punta della Salute

This harmonious painting makes very effective use of a limited palette of colours that are all close to one another on the colour wheel. A subtle use of tone gives the painting structure, and the tonal contrast of the boats on the left leads the eye into the distance. *J.M.W. Turner*

◄ Between the showers

The sky is the main area of interest in this picture and is painted a muted blue to suggest rain. If bright colours were used elsewhere they would vie for attention, so the tones used for the land have been deliberately held back. *Peter Williams*

Startled ►

Colour and tonal range have been limited in this painting. The use of pure colour and contrasting dark tones on the hat and coat of the young woman helps to focus attention on her. *Winslow Homer*

◄ Wall, Siena

A limited palette has been used here to control the area of interest. The contrast of the small amount of red with the unifying blues makes the window the clear focus. *Nick Hebditch*

16 Geese in the park

The setting for this painting is a hot summer's day with brilliant back lighting. To help create this effect, the whites and palest tones are preserved by slowly building up layers of colour around them. A limited palette is used, with yellow as the dominant colour. While this is mixed with other colours in the yellow-green background, the yellow and orange of the chicks are carefully layered, to keep them clean and bright. The muted blues and violets used to define the geese help to emphasize the bright, warm colours used in the rest of the painting.

EQUIPMENT

- Cold-pressed paper
- Brushes: No. 5, No. 9, 25mm (1in) flat
- Cadmium yellow, cerulean blue, Windsor violet, cadmium orange, burnt sienna, cadmium red, emerald green, French ultramarine, burnt umber, alizarin crimson

TECHNIQUES

- Layering
- Wet-in-wet

TRYING OUT COLOURS

A colour test sheet is a good way to plan which colours to use. Trying out strokes and blocks of different colours will give you a good idea of what they will look like when they are mixed together wet-in-wet on the paper rather than on your palette.

"Layering keeps colours pure and vibrant."

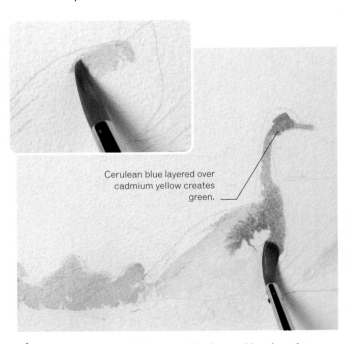

Cerulean blue layered over cadmium yellow creates green.

1 Paint the chicks and the geese's bodies and heads cadmium yellow, using the No. 9 brush. Then paint the geese's heads and necks cerulean blue and their chests Windsor violet.

BUILDING THE IMAGE

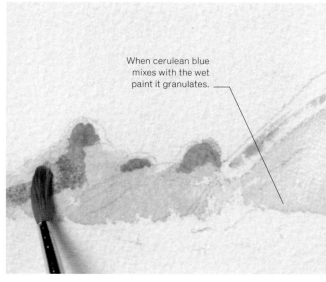

When cerulean blue mixes with the wet paint it granulates.

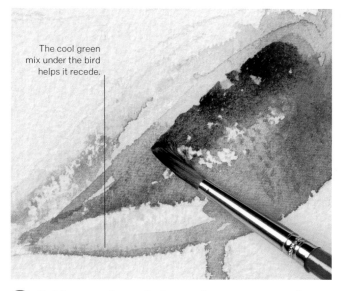

The cool green mix under the bird helps it recede.

2 Add cerulean blue to the lower parts of the geese to create cool shadows. When the paint on the chicks has dried, add dashes of cadmium orange to their heads and cerulean blue to their bodies.

3 Build up more layers of colour on the geese, using cerulean blue, Windsor violet, burnt sienna, cadmium red, and cadmium yellow. Finish by using a mix of burnt sienna and Windsor violet to paint the wing feathers.

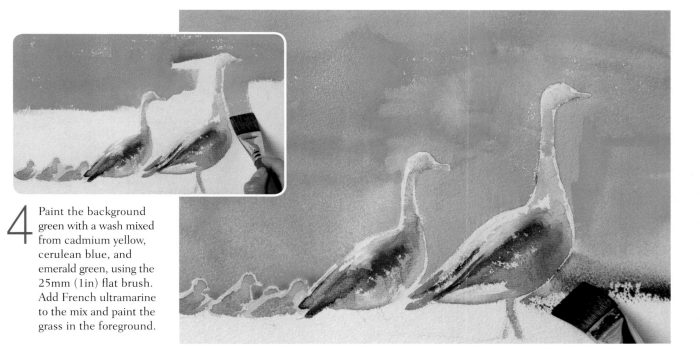

4 Paint the background green with a wash mixed from cadmium yellow, cerulean blue, and emerald green, using the 25mm (1in) flat brush. Add French ultramarine to the mix and paint the grass in the foreground.

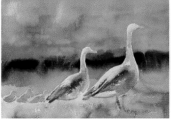
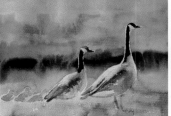
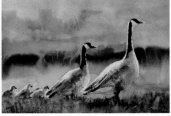

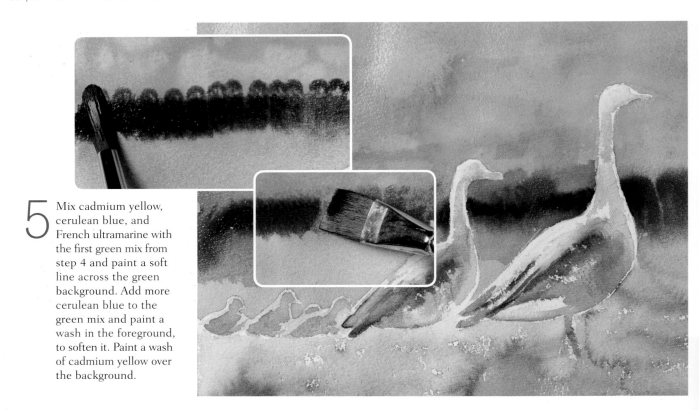

5 Mix cadmium yellow, cerulean blue, and French ultramarine with the first green mix from step 4 and paint a soft line across the green background. Add more cerulean blue to the green mix and paint a wash in the foreground, to soften it. Paint a wash of cadmium yellow over the background.

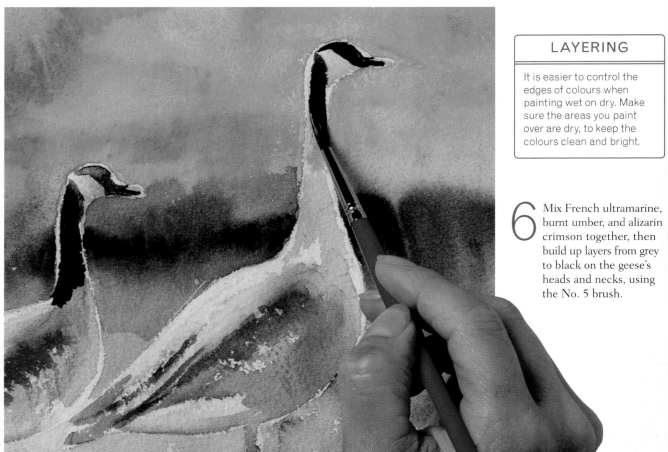

LAYERING

It is easier to control the edges of colours when painting wet on dry. Make sure the areas you paint over are dry, to keep the colours clean and bright.

6 Mix French ultramarine, burnt umber, and alizarin crimson together, then build up layers from grey to black on the geese's heads and necks, using the No. 5 brush.

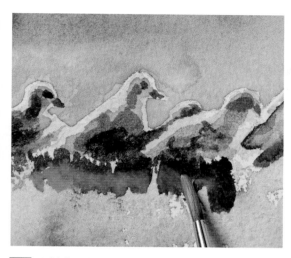

8 Soften the dark green with cadmium yellow. Use cerulean blue to tone down the white edges of the geese, add the geese's legs, and paint the shadows on the grass.

7 Add details to the chicks with cerulean blue and burnt umber. Paint lines of dark green and yellow below the birds to help anchor them firmly in place against the loose background.

▼ Geese in the park

The clean, sharp shapes and bright colours of the geese and chicks have been created by building up layers of paint. The neutral tones convey the softness of the geese's feathers and the use of contrasting bright colour brings the chicks into focus.

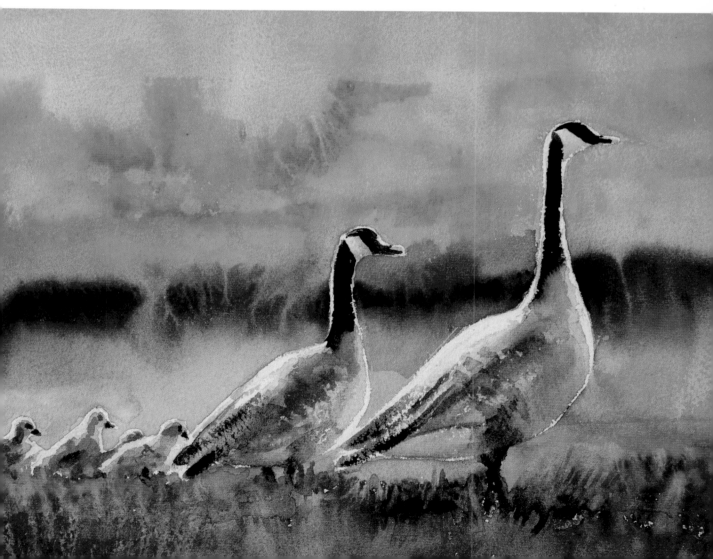

17 Peony in a jar

A single flower can be an absorbing and rewarding subject to paint, and gives you the chance to study one thing in detail. Much of the peony in this painting is in shade, which gives you a certain amount of free rein when painting the colours. Lifting out lines of colour to create details in the areas of shadow creates soft, light marks rather than stark, white highlights. This subtle treatment of the leaf and stamens provides a strong visual contrast to the brightly lit, sharp edges of the petals, which sparkle with vibrant colour.

EQUIPMENT
- Cold-pressed paper
- Brushes: No. 5, No. 9, 25mm (1in) flat
- Raw sienna, alizarin crimson, permanent mauve, cadmium red, emerald green, cerulean blue, French ultramarine, burnt sienna, burnt umber

TECHNIQUES
- Lifting out
- Painting glass

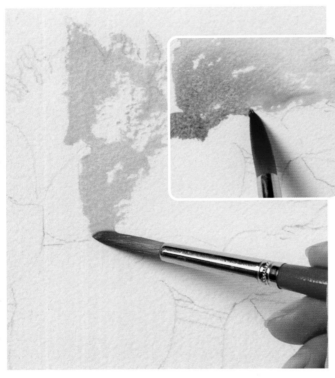
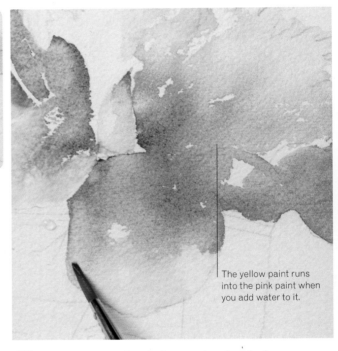

The yellow paint runs into the pink paint when you add water to it.

1 Paint the centre of the flower in raw sienna with the No. 9 brush. Mix pink from alizarin crimson and permanent mauve, then paint the petals pink while the raw sienna is still wet, so that the pink and yellow paint run together.

2 Rinse your paintbrush then use it to brush clean water along the edges of some of the petals, to soften the pink and create highlights. Adding water to the yellow paint makes it run into the pink paint.

BUILDING THE IMAGE

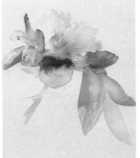
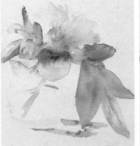
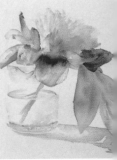

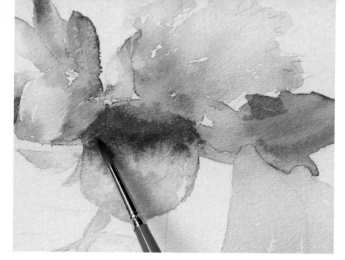 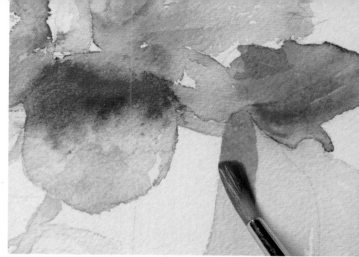

3 Paint the stem and leaves with raw sienna. Add permanent mauve and alizarin crimson to the petals while they are still wet. Soften some areas with a clean brush to vary the tones.

4 Add cadmium red to the petals and the tips of the stamens. Mix raw sienna and permanent mauve to create a neutral tone for the stamens and paint the leaves emerald green.

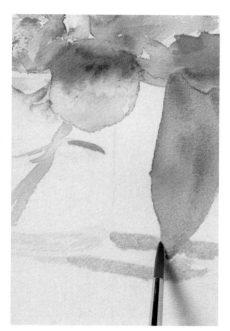

5 Mix grey from cerulean blue, pink, and raw sienna and paint the top of the glass. Use cerulean blue to paint the lines of shadow next to the glass.

6 Add raw sienna to the shadows and green to the flower stem. Paint strokes of cerulean blue to create the effect of bubbles inside the glass.

7 Mix cerulean blue and permanent mauve together to make a neutral colour. Use this to paint the shadow around the bottom of the glass.

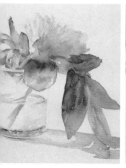 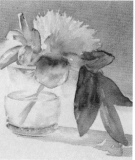 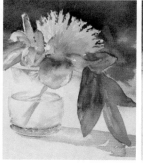 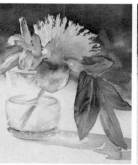 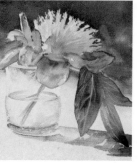

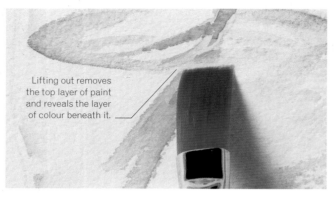

Lifting out removes the top layer of paint and reveals the layer of colour beneath it.

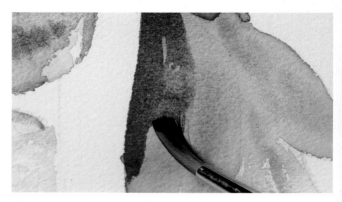

8 Paint the surface of the water in the glass with raw sienna. Draw a clean, wet flat brush across the flower stem to lift out some of the green paint and show how the water distorts the stem.

9 Strengthen the colour of the petals with pure alizarin crimson and permanent mauve. Mix emerald green and French ultramarine together to make a darker green and use this to paint the tops of the leaves.

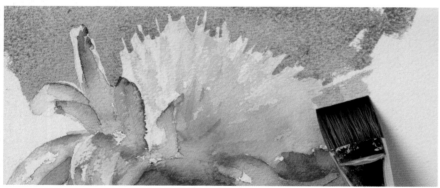

10 Mix cerulean blue and burnt sienna together. Paint a light wash behind the flower with the 25mm (1in) flat brush and soften the edges with a little water.

11 Mix French ultramarine and burnt umber and paint it over the background wash while still wet. Use a No. 5 brush to draw the colour down between the stamens.

12 While the paint on the leaves is damp, lift out lines of paint with a clean 25mm (1in) brush, to create the veins of the leaves. Lift lines of paint from the leaf stem in the same way. Add dark green to the tip of the lower leaf.

LIFTING OUT

Be careful not to use too much pressure when lifting out. Use a clean, damp brush and blot the paper between lifting strokes.

Peony in a jar ▶

Removing paint by lifting out colour has been used as an effective technique here to add detail both to the flower stem and the leaves. The veins of the leaves are soft, in direct contrast to the sharp edges of the flower's petals and stamens.

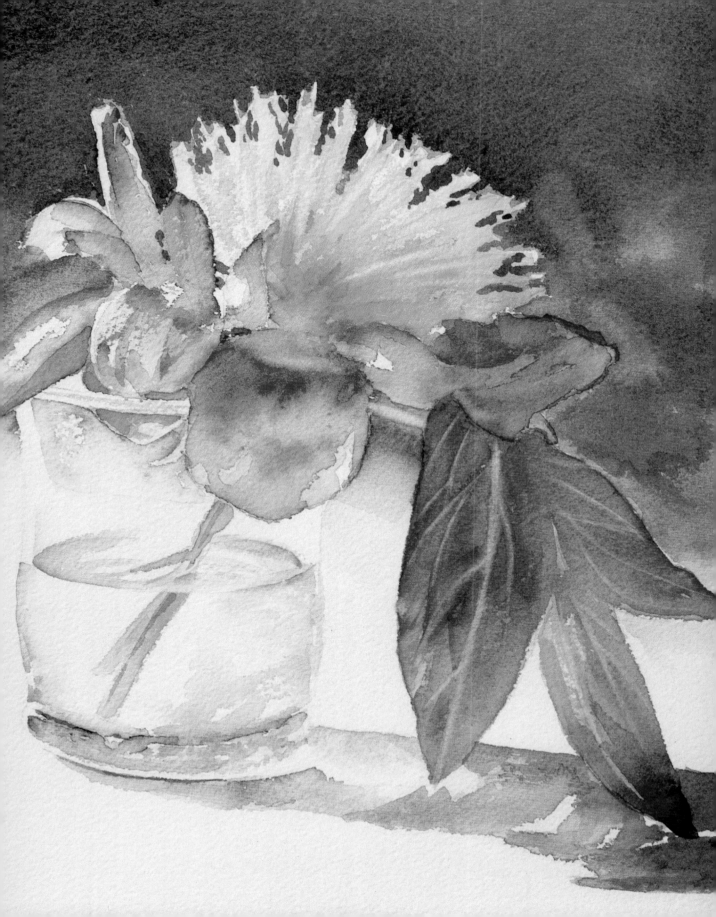

18 Boats on the canal

In this painting of two small boats on a Venetian canal, orange is both the dominant and the underlying colour. Because the first layer of orange paint shows through subsequent layers of colour in the reflections and shadows, it unifies the different elements of the picture. Lifting out colour with a clean damp brush reinstates light areas accidentally lost in the first few washes. This is particularly useful here, as the lighter tones created by lifting out are gently tinted rather than white, so do not detract from the layers of colour used to depict the boats.

EQUIPMENT

- Cold-pressed paper
- Brushes: No. 5, No. 9, 12.5mm (½in) and 25mm (1in) flat
- Raw sienna, cadmium yellow, light red, cadmium red, cerulean blue, burnt sienna, French ultramarine, Windsor violet, burnt umber, alizarin crimson

TECHNIQUES

- Creating shadows
- Lifting out
- Layering

The broken wash will help to reflect the colour of the brickwork.

1 Paint the brickwork and water with a raw sienna wash. Make vertical strokes with the 25mm (1in) flat brush, letting the wash break in places. Brighten the brickwork with cadmium yellow, then add vertical stokes of light red and soften with water.

2 Mix cadmium red and cerulean blue to make grey for the stairs. Mix cerulean blue and yellow for the water, and paint the ripples on the water with the edge of the 25mm (1in) flat brush. Use cerulean blue to define the edges of the building.

BUILDING THE IMAGE

3 Paint the railings with cerulean blue and a mix of light red and cerulean blue. Add burnt sienna to the bricks. Use cerulean blue and burnt sienna for the steps and the dark water. Mix French ultramarine and light red for the alley and the low bricks next to the water. Tone down the white areas with raw sienna.

"Adding layers of complementary paint makes the colours look more muted."

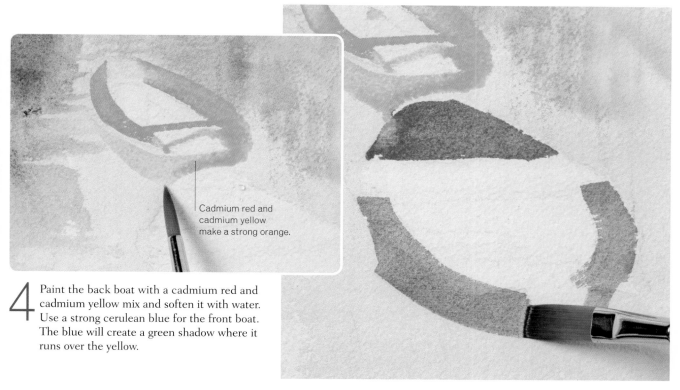

Cadmium red and cadmium yellow make a strong orange.

4 Paint the back boat with a cadmium red and cadmium yellow mix and soften it with water. Use a strong cerulean blue for the front boat. The blue will create a green shadow where it runs over the yellow.

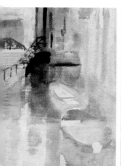
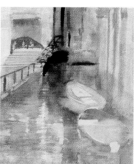
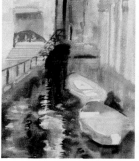
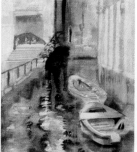

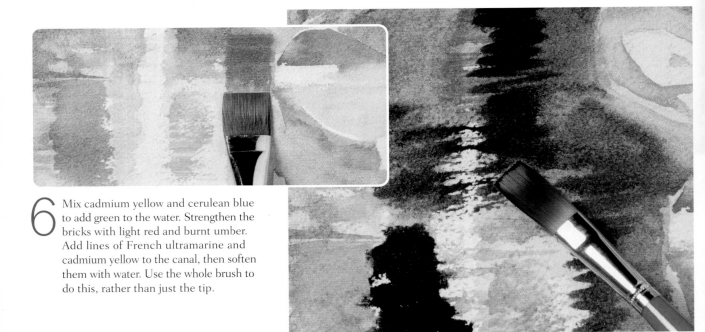

5 Paint the canal with vertical strokes of watery cerulean blue, using the 25mm (1in) flat brush. Use short lines rather than long strokes. Mix Windsor violet and burnt umber for the darkest parts of the water and to paint the area beneath the bridge. You do not need a green for the darker areas of the water.

6 Mix cadmium yellow and cerulean blue to add green to the water. Strengthen the bricks with light red and burnt umber. Add lines of French ultramarine and cadmium yellow to the canal, then soften them with water. Use the whole brush to do this, rather than just the tip.

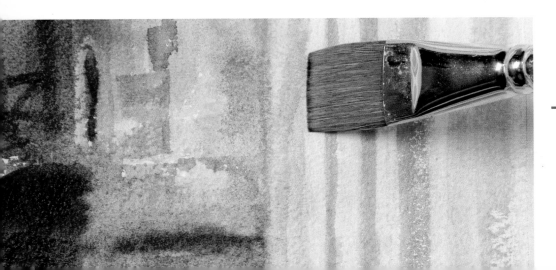

7 Darken the lower part of the building with the mix of Windsor violet and burnt umber. Using a clean, wet stubby brush, lift out narrow, vertical lines of colour from the walls to create the effect of windows.

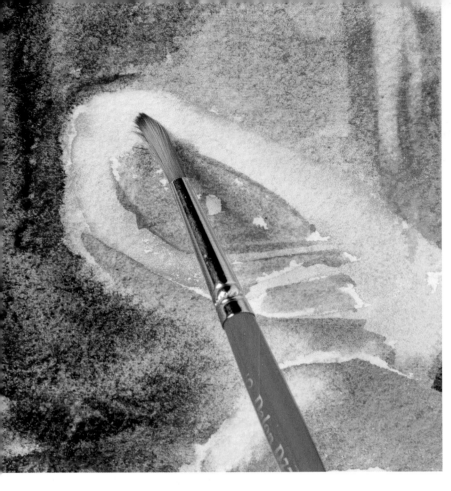

8 Paint shadows on the orange boat with French ultramarine and lift out some orange at the front of the boat to create a highlight. Paint details on the blue boat with a mix of cerulean blue and cadmium yellow. Use burnt umber for the shadows.

SHADOW COLOURS

Painting over a colour with its complementary colour, even if this colour is lighter, will create a neutral tone that you can use to paint shadows.

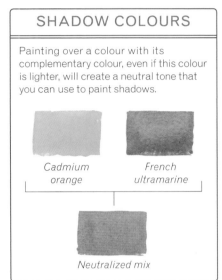

Cadmium orange *French ultramarine*

Neutralized mix

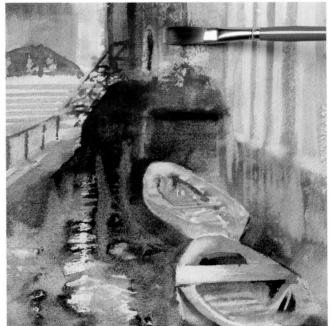

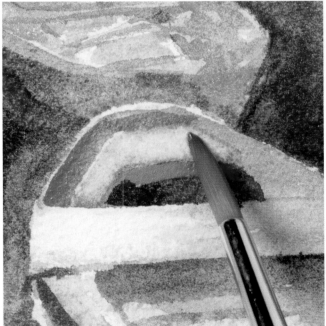

9 With the side of the 12.5mm (½in) brush, add detail to the bricks with burnt umber and paint Windsor violet over the green of the water. Paint the dark shadow beneath the blue boat with a mix of Windsor violet and burnt umber.

10 Paint a line of undiluted cerulean blue around the bow of the blue boat to strengthen the colour. Then lift out some of the blue with a clean, wet brush to create the effect of shadows and highlights.

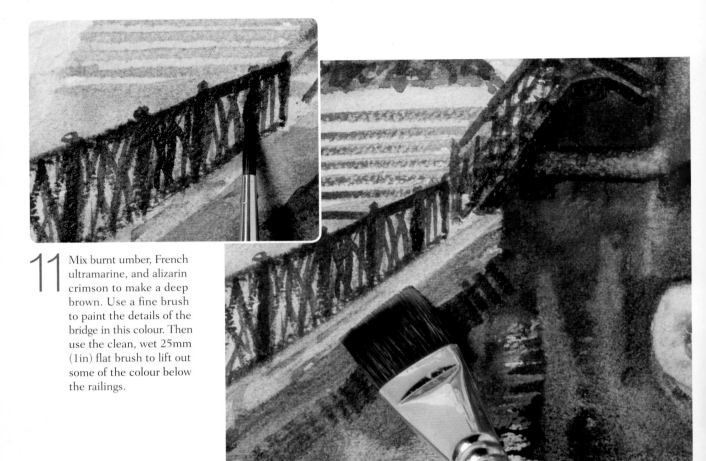

11 Mix burnt umber, French ultramarine, and alizarin crimson to make a deep brown. Use a fine brush to paint the details of the bridge in this colour. Then use the clean, wet 25mm (1in) flat brush to lift out some of the colour below the railings.

12 Add a mix of cadmium yellow and cadmium red to the orange boat to strengthen the colour. Paint details in dark brown then add a line of cerulean blue (a complementary colour) to create a shadow at the back of the boat.

Boats on the canal ▶

The eye is drawn into the finished painting by the vertical lines of the buildings and the reflections in the canal. The limited palette of neutral tones used in the water emphasizes the vibrant colour of the boats, making the composition stronger.

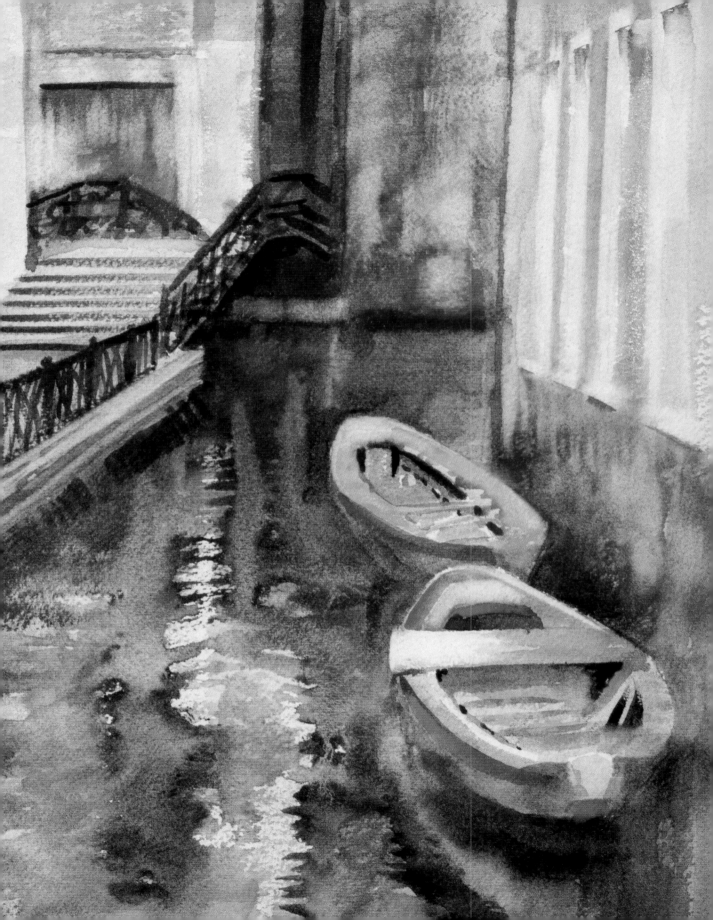

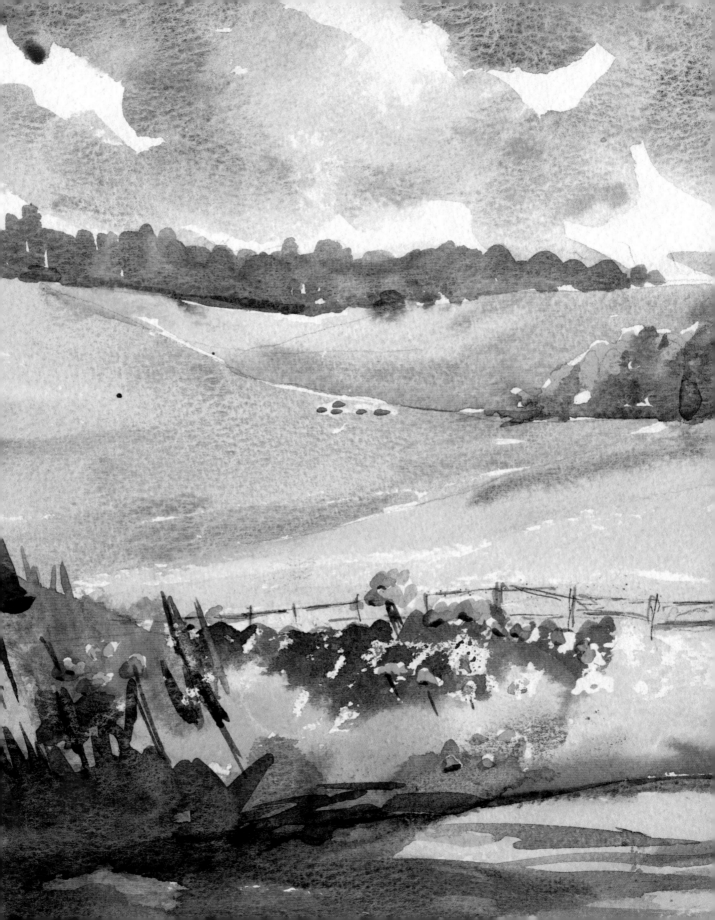

Creating Perspective with Watercolour

"Red is in front,
blue is behind, and
green is in between."

Creating depth with colour

The colours of objects appear to change depending on how near or far they are from you, because of atmospheric conditions. In the foreground, colours are at their warmest and strongest and have the widest range of tones. With distance, colours lose their intensity, becoming bluer and lighter with less tonal variation. To create a sense of perspective in your paintings, forget what colour you think an object is and paint it the colour you actually see. This will be determined by how near or far away the object is.

RED COMES FORWARD

The coloured grid on the right shows how the warmth, or lack of warmth, of a colour affects where it sits in a painting. Warm colours such as reds and oranges appear to come forward, cool blue colours seem to recede, and greens sit in the middle distance.

By positioning warm and cool colours carefully, you can create a sense of depth in the scenes you paint. A simple landscape of green fields with red poppies in the foreground and a distant blue sky immediately has a sense of perspective. On a smaller scale, you can make individual objects look more solid if you paint the part of the object closest to you with warm colours and use cooler colours on the sides of the object, as these are further away from you.

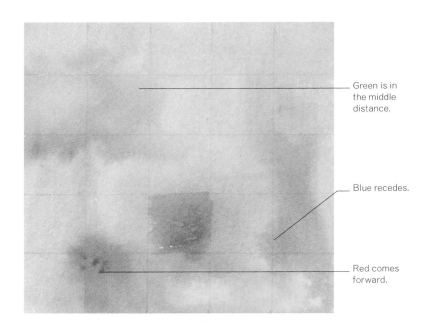

Green is in the middle distance.

Blue recedes.

Red comes forward.

WARM AND COOL PALETTES

Paints are described as warm or cool depending on whether they have a reddish or bluish tone. This varies according to the pigment used to make them. A warm colour such as red, for example, can appear in the cool palette if the pigment used to make it has a bluish tone, as with alizarin crimson. Selecting colours from both palettes in your paintings will help you create perspective.

Warm colour palette

1. cadmium yellow 2. burnt sienna 3. cadmium red 4. emerald green 5. cadmium orange 6. raw sienna 7. burnt umber 8. sap green 9. French ultramarine 10–18. neutral mixes.

Cool colour palette

1. cobalt blue 2. raw umber 3. alizarin crimson 4. lemon yellow 5. Windsor violet 6. yellow ochre 7. permanent mauve 8. viridian 9. cerulean blue 10–18. neutral mixes.

CREATING DEPTH

All paintings, regardless of subject matter, rely on the use of warm and cool colours to create a sense of depth. By understanding how distance and atmosphere change colours and tones you can control the sense of depth in your paintings.

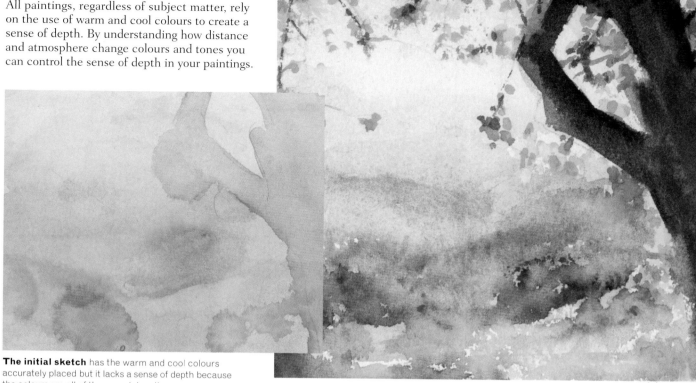

The initial sketch has the warm and cool colours accurately placed but it lacks a sense of depth because the colours are all of the same intensity.

The final painting has the colours carefully positioned and decreasing in intensity towards the horizon, so has a sense of depth.

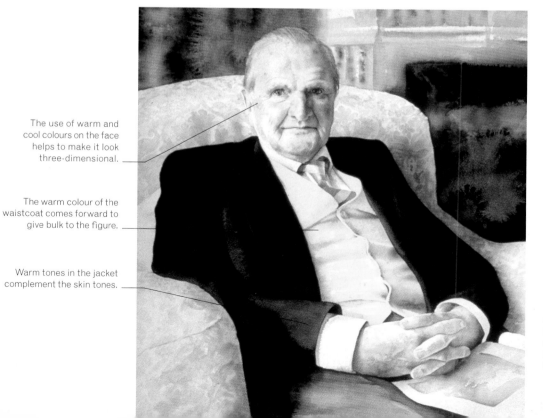

The use of warm and cool colours on the face helps to make it look three-dimensional.

The warm colour of the waistcoat comes forward to give bulk to the figure.

Warm tones in the jacket complement the skin tones.

In this portrait colours have been chosen from both the warm and cool palette. The waistcoat, for example, is a warm yellow but the background yellows are cool. It is this careful use of colour that creates the sense of depth.

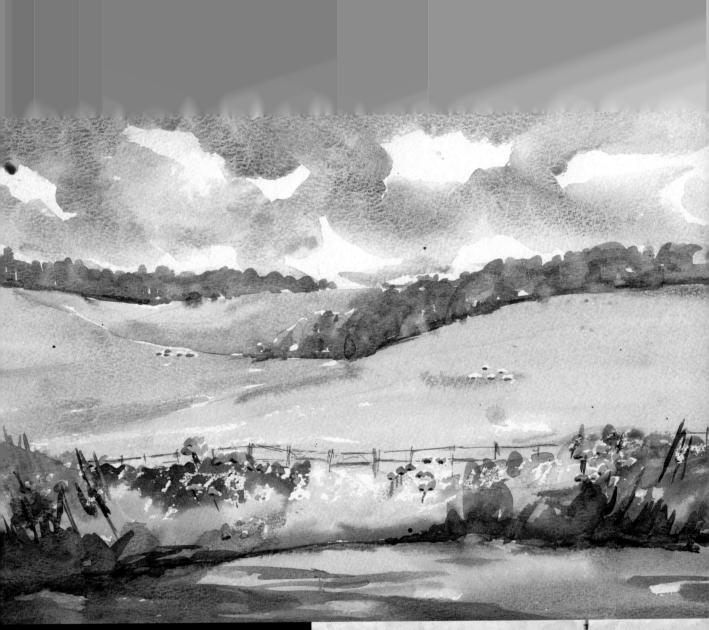

▲ West Dean poppies

This landscape has a real sense of depth due to its careful use of warm and cool colours. The trees become blue towards the horizon, while the foreground is painted with warm reds and yellows.
Sara Ward

Lobster pots at Beesands beach, Devon ▶

The focus in this painting is firmly on the strong red and hot orange boxes in the foreground. Greens in the foliage and neutral baskets hold the middle distance, and the blue at the horizon gives depth.
Robert O'Rorke

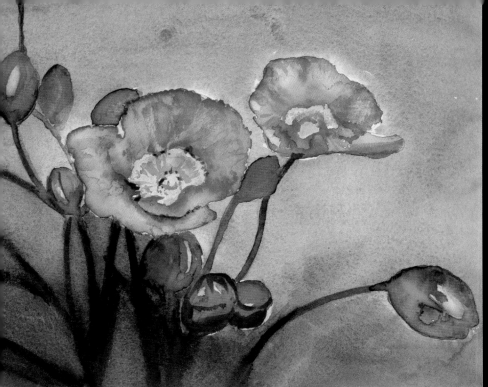

◄ Red poppies

This simple study shows how even in close-up subjects warm and cool colours can be used to create depth. Here the reds of the petals and warmer greens come foward, while the background is pushed back with a blue wash. *Glynis Barnes-Mellish*

▼ Young girl

This painting is quite abstract but its use of warm and cool colours gives it form. The hot colour in the centre of the face brings it forward, while the sides of the face and hair are cooler so they appear to recede. *Glynis Barnes-Mellish*

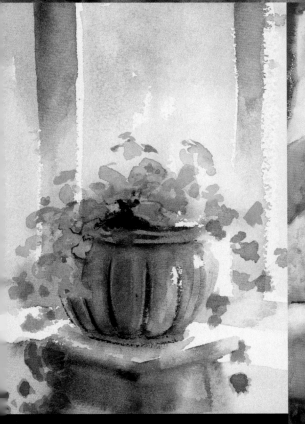

▲ Ivy

The foliage and glazed pot in this painting are both green but a sense of depth has still been created because a range of greens from warm to cool has been used. *Glynis Barnes-Mellish*

19 Field gate

A characterful old farm gate, made from rough, weathered wood, is the focal point of this painting. Using soft, loose washes of warm and cool colours for the surroundings sets the gate in its environment without creating any distracting detail. The gate itself is then painted using the dry brushwork technique, which is perfect for building up texture and conveying the rugged nature of the wood. Using rough paper breaks up the brushmarks and adds to the textural quality of the gate, as well as letting glimpses of the underpainting show through.

EQUIPMENT
- Rough paper
- Brushes: No. 9, No. 14, 12.5mm (½in) and 25mm (1in) flat
- Cadmium yellow, emerald green, cerulean blue, French ultramarine, burnt sienna, cadmium red

TECHNIQUES
- Dry brushwork
- Splattering
- Layering

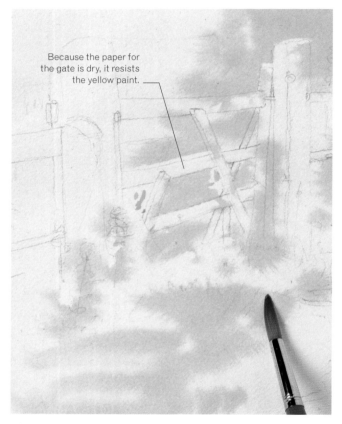

Because the paper for the gate is dry, it resists the yellow paint.

"Dry brushwork creates a textural effect."

1 Use a wide flat brush to wet the paper everywhere except for the gate itself, as you want it to remain white. While the paper is still damp, paint all the areas of grass and leaves cadmium yellow, using the No. 14 brush.

2 Mix a lime green from emerald green and cadmium yellow and use this to paint more foliage. Paint a wash of pure cerulean blue across the sky and the gate posts, using the 12.5mm (½in) flat brush.

BUILDING THE IMAGE

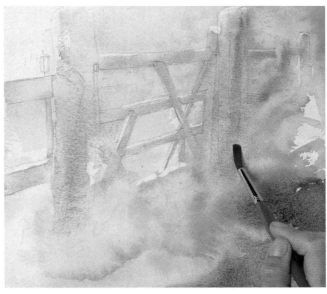

3 Mix French ultramarine and burnt sienna to create a warmer blue wash for the path and bring it into the foreground. Paint this colour on to slightly damp paper.

4 Add a line of burnt sienna to the edge of the road, to give it a little warmth. Using the same colour, drybrush the dry paper of the gate post.

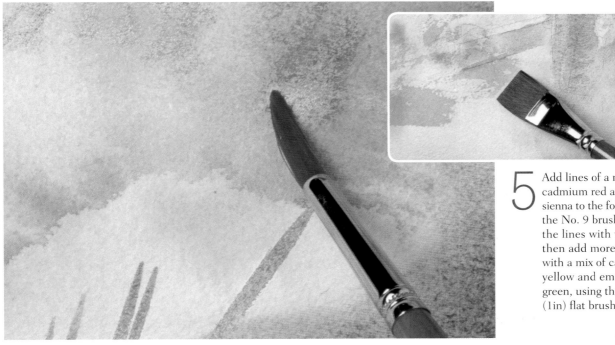

5 Add lines of a mix of cadmium red and burnt sienna to the foliage with the No. 9 brush. Soften the lines with water, then add more details with a mix of cadmium yellow and emerald green, using the 25mm (1in) flat brush.

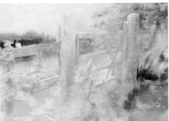
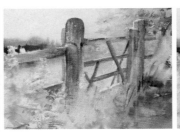
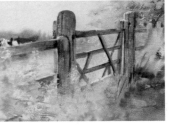

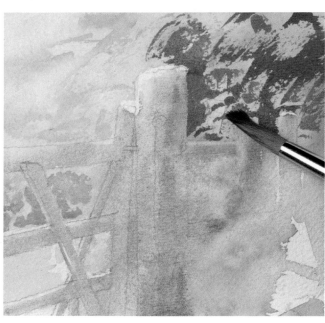

6 Paint water on to the area behind the gate with a clean brush, then add a mix of emerald green and French ultramarine with the No. 14 brush. Use the lime green mix below the post and soften it with water.

7 Drybrush more detail on to the leaves of the tree on the right with a mix of emerald green, cadmium yellow, and French ultramarine. Strengthen the colour of the background next to this tree with cadmium yellow.

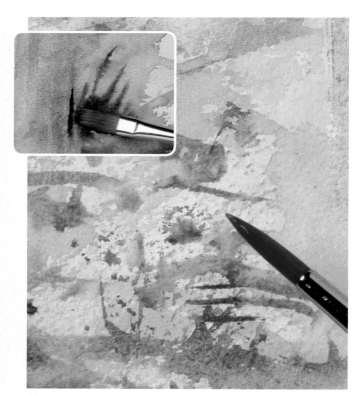

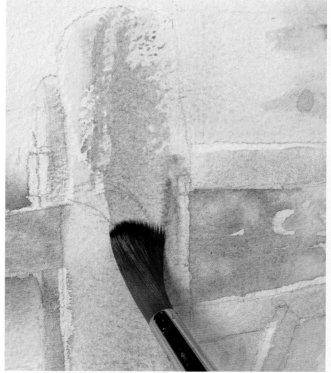

8 Use the side of the 12.5mm (½in) flat brush to paint thin strokes of grass with a mix of French ultramarine, emerald green, and burnt sienna. Create flowers by adding cadmium red with the side of the No. 9 brush then flicking with water.

9 Start adding detail to the gate with dry brushwork. Use a light touch to make broken lines that suggest the texture of the wood. Use a variety of brown tones mixed from French ultramarine and burnt sienna.

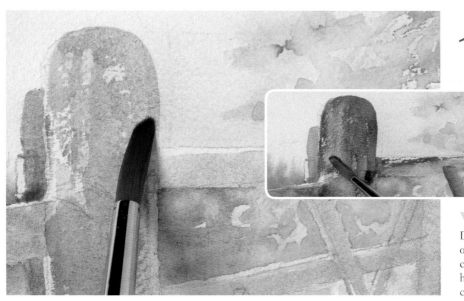

10 Model the shape of the gate post with cerulean blue. Add cadmium red to the front post to add warmth and make it appear to come forward. Add fine, dark details to the gate with a mix of burnt sienna and cerulean blue, using the No. 9 brush.

▼ Field gate

Dry brushwork creates the rough texture of the gate, while the soft, loose washes of cool and warm colour around it convey the hazy warmth of the afternoon sun and create a sense of depth.

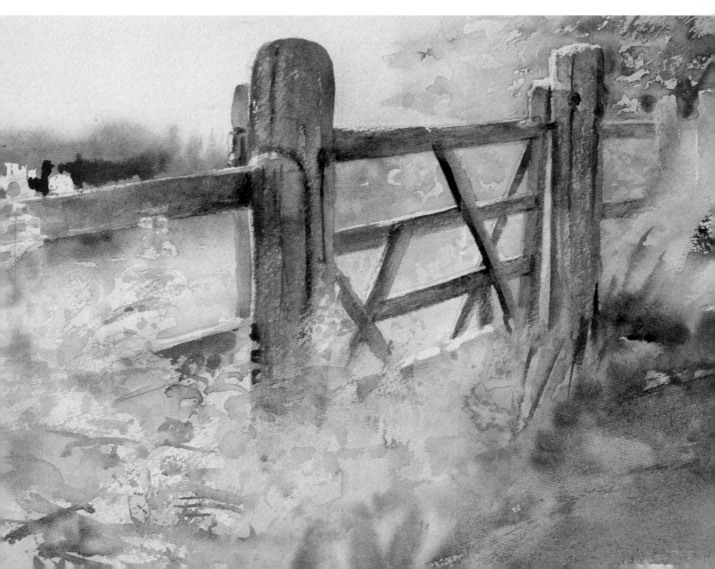

20 Wild hare

The hare in this painting almost fills the picture so that little design space is given to the field behind it, but creating perspective is just as important in close-up studies like this as it is in large landscapes. Using warm and cool colours to paint the hare creates a sense of depth and establishes the personality of the subject, from its quivering nose to its silky ears. Dry brushwork, softened with water, is very useful for painting animals, as it conveys the texture of their coats. Here it captures the essence of the hare's velvety fur.

EQUIPMENT

- Rough paper
- Brushes: No. 5, No. 9, No.14, 12.5mm (½in) flat
- Cerulean blue, alizarin crimson, raw sienna, burnt umber, French ultramarine, Windsor violet, burnt sienna, sap green, cadmium orange, cadmium yellow

TECHNIQUES

- Dry brushwork
- Underpainting

1 Paint the outsides of the hare's ears cerulean blue with the No. 14 brush, then use a mix of alizarin crimson and raw sienna to paint the insides of the ears. With a clean brush, run water down at the bottom of the ears to keep them soft.

2 Paint the front of the hare's face with raw sienna and use the cooler alizarin crimson for the sides. Apply the paint lightly so that the edges of the colours are jagged.

BUILDING THE IMAGE

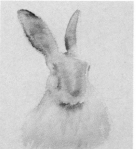
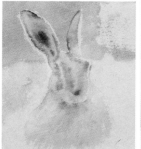
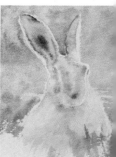

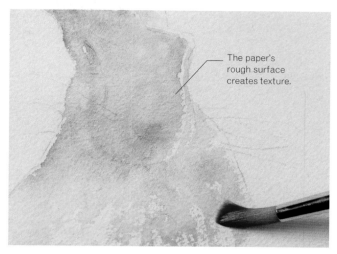

The paper's rough surface creates texture.

3 Add raw sienna while the cerulean blue paint on the ears is still wet, then paint the nose with a mix of alizarin crimson and raw sienna, using the No. 5 brush. Paint a little pure alizarin crimson below the nose.

4 Add cerulean blue to the raw sienna at the side of the face to create soft areas of green. Use water to push the paint away to look like fur. Drybrush a mix of raw sienna and alizarin crimson over the dry paper for the hare's body.

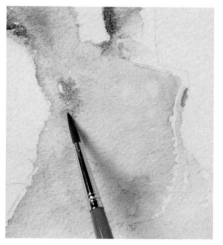

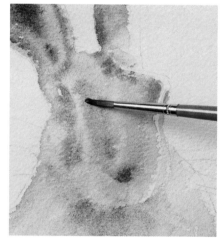

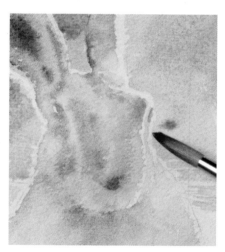

5 Mix burnt umber, French ultramarine, and Windsor violet together to paint shadows on the ears. Use cerulean blue to add the detail of the eye and the shadows under the hare's face.

6 Darken the face with a mix of burnt sienna and cerulean blue. Use a mix of burnt umber and alizarin crimson for the face and ears and Windsor violet for the tip of the nose. Drop in water to help create the fur texture.

7 Add a cool green made from cerulean blue and raw sienna to the background. While this is wet, add dashes of cerulean blue so that it granulates. Brighten the wash with a touch of raw sienna.

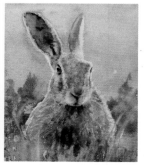

8 Warm up the green at the front of the picture with a mix of French ultramarine and cadmium yellow. Drybrush the colour on using the No. 14 brush.

CREATING A SENSE OF DEPTH

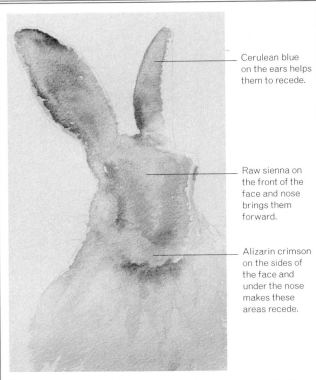

Cerulean blue on the ears helps them to recede.

Raw sienna on the front of the face and nose brings them forward.

Alizarin crimson on the sides of the face and under the nose makes these areas recede.

The head is given aerial perspective by keeping warm colours, which come forward, in the centre of the face, and cool colours, which recede, at the sides. More paint is drybrushed on top, but the initial colours still show through to retain the sense of form.

9 While the foreground is still wet, add touches of detail with alizarin crimson, raw sienna, and a mix of sap green and raw sienna. Leave parts of the paper white, to create the effect of sparkling highlights in the grass.

10 Mix Windor violet and burnt umber to paint around the hare's eye. Use the same colour to add the details of the nose, using water to soften them. Paint the shadows on the nose with cerulean blue.

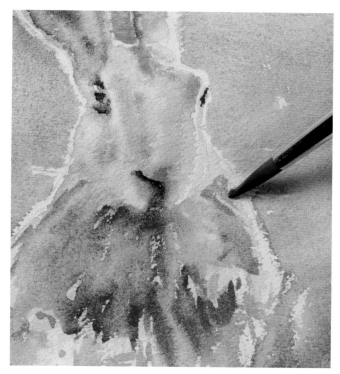

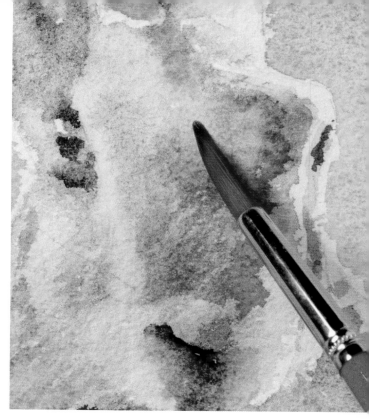

11 Mix a warm dark brown from alizarin crimson, burnt umber, and Windsor violet and paint the fur with the No. 9 brush. Add cerulean blue to the mix and use this on the hare's sides and the dent on the side of its face.

12 Add the mix of burnt umber, alizarin crimson, and Windsor violet to the front of the face, and cadmium orange to the right-hand side. Add dashes of a mix of sap green and raw sienna to create the look of fur.

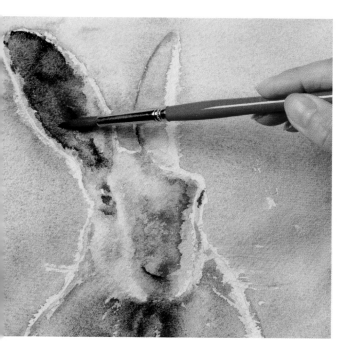

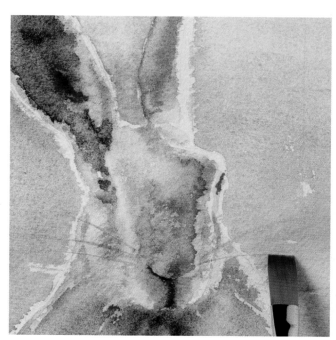

13 Darken the ears with a mix of burnt umber, Windsor violet, and a little alizarin crimson. Add French ultramarine and cerulean blue to this mix and use it to tone down the ears and add the shadow below the head.

14 Make the right ear darker with a mix of cerulean blue and Windsor violet. Use cerulean blue to mark the base of the whiskers. While the background wash is still wet, paint the whiskers with the 12.5mm (½in) flat brush.

15 Use the side and point of the No. 14 brush to paint the dark grass sap green. Use a variety of strokes, making sure the brush is not overloaded with paint. Add alizarin crimson and raw sienna to the grass in the foreground.

16 Drop a mix of alizarin crimson and raw sienna on to the grass while the paint is still wet, then use the clean, wet 12.5mm (½in) flat brush to lift out paint and create the long blades of grass in front of the hare.

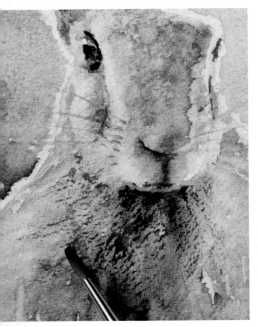

"Loose brush marks suggest movement and life."

18 Finish with some fine details on the face. Use a mix of burnt sienna and raw sienna on the right-hand side to bring it forward and add Windsor violet to the edge of the face.

17 Add strokes of burnt umber to the fur. Use a mix of burnt sienna and Windsor violet to paint the contours of the face and whiskers. Add cerulean blue to the side of the body and use a very dark brown mix to paint the eye.

Wild hare ▶

Using bright underpainting to create the hare's form and adding fine detail with dry brushwork have created a simple, yet effective study. Too much detail would have made the picture static.

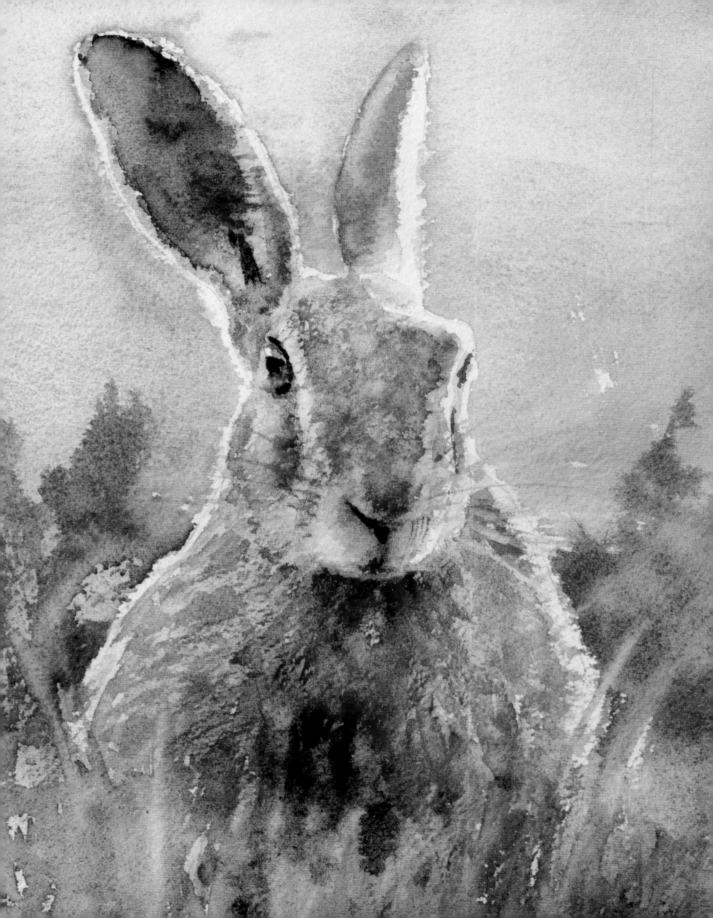

21 Street scene

Deserted street scenes can look a little uninteresting but by adding just a few people, a painting springs to life. Not only do figures add activity, they also create movement in a composition, leading the viewer's eye through the painting. In this scene the buildings are very tall and, due to the amount of shadow they cast, most of the interest is in the top half of the composition. Adding the figures at street level in the lower half of the painting emphasizes the scale of the buildings and helps to anchor them while introducing colour and interest.

EQUIPMENT
- Cold-pressed paper
- Brushes: No. 5, No. 9, 12.5mm (½in) and 25mm (1in) flat
- French ultramarine, cerulean blue, cadmium yellow, emerald green, raw sienna, Windsor violet, cadmium orange, raw umber, viridian, alizarin crimson, cadmium red, burnt sienna, sap green, burnt umber

TECHNIQUES
- Dry brushwork
- Adding figures

1 Using the 12.5mm (½in) flat brush, paint the sky with a graded wash, from French ultramarine at the top to cerulean blue at the bottom. Paint the trees cadmium yellow and let it dry, then drybrush emerald green and French ultramarine for the leaves.

2 Drybrush raw sienna for the buildings. Use a light wash of Windsor violet for the top of the building on the right. Use cadmium orange to paint the underside of the roof, then add fine lines of cerulean blue to create shadows.

BUILDING THE IMAGE

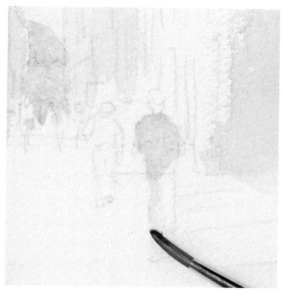

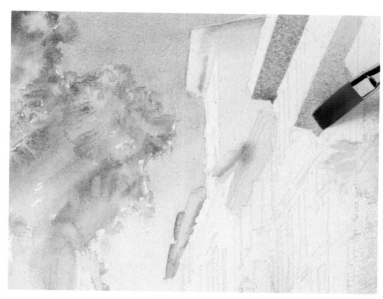

3 Add a mix of French ultramarine and cadmium yellow to the sky at the end of the street, to help the view recede into the distance. Sketch in the shapes of the figures in cerulean blue.

4 Using the 12.5mm (½in) flat brush, paint the shadows on the building and rooftop in Windsor violet. Add cadmium yellow for local colour and use a mix of cerulean blue and raw umber to paint the shadow under the roof.

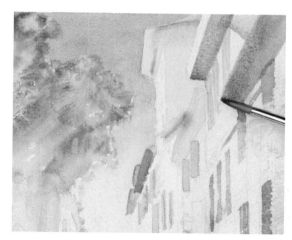

5 Mix viridian and cerulean blue to make turquoise. Paint some of the shutters in this colour and use straight cerulean blue for others. Add French ultramarine to the detail at the far end of the street.

6 Add colour to the shadows by painting the undersides of the balconies in alizarin crimson with the No. 5 brush and then strengthen the colour with cadmium red.

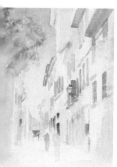
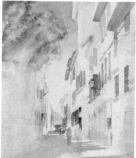
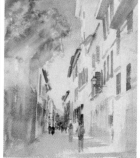
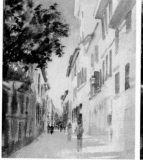
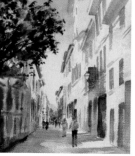

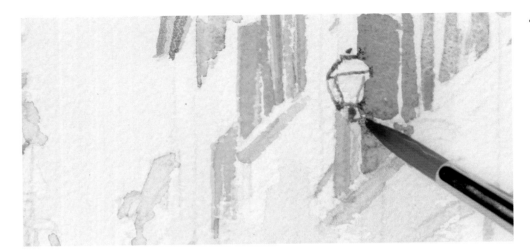

7 Paint the shadows under the windows with raw sienna. Use viridian for the open shutter. Paint the outline of the street lamp in burnt sienna and use the same colour to paint the arches on the building on the right.

"Use the simplest brushstrokes to convey human figures."

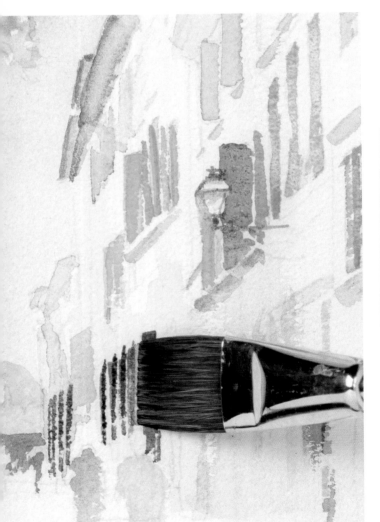

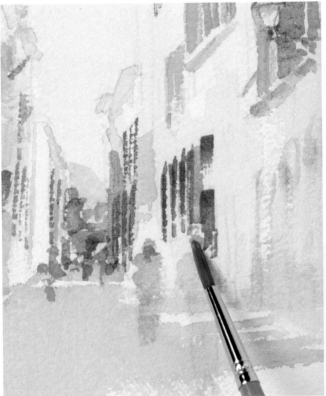

8 Mix burnt sienna, French ultramarine, and Windsor violet to make a deep purple for the shutters and the dark areas of the building on the right-hand side of the picture. Apply this mix with the 25mm (1in) flat brush.

9 Use a light wash of Windsor violet to paint the shadows on the street. Paint the faces of the figures with dots of cadmium red and strengthen the colour of their bodies with French ultramarine.

10 Paint a wash of cadmium orange on the lower half of the wall on the left. Use burnt sienna to paint the people in the distance, then mix burnt sienna and cerulean blue to add detail to the wall on the left.

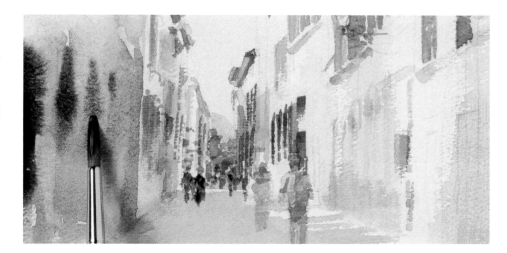

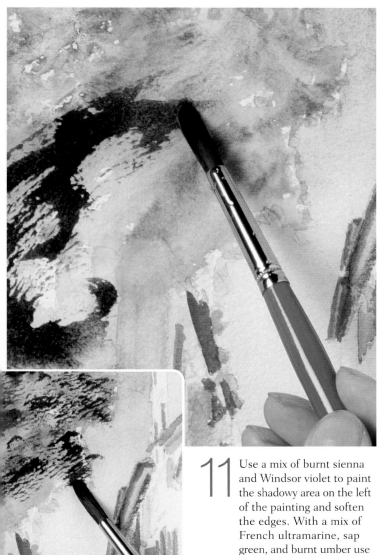

11 Use a mix of burnt sienna and Windsor violet to paint the shadowy area on the left of the painting and soften the edges. With a mix of French ultramarine, sap green, and burnt umber use dry brushwork to paint the leaves on the tree.

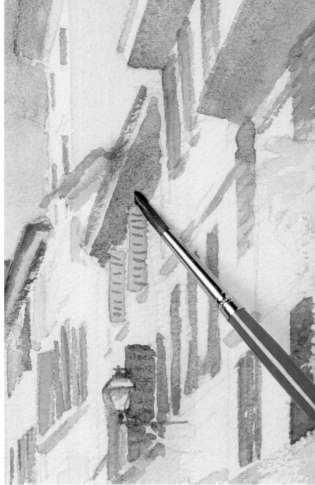

12 Mix burnt umber and Windsor violet, then paint the rooftops of the building on the right with the 12.5mm (½in) flat brush. Switch to the No. 5 brush and Windsor violet to add more detail to the building.

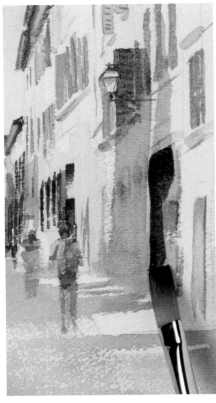

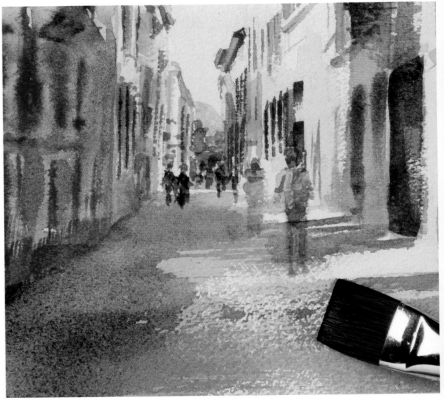

13 Mix burnt sienna and cerulean blue to make a warm neutral for the walls on the right. Add burnt umber for the darker shadows. Drybrush the mix of burnt sienna and cerulean blue on to the road to create shadows.

14 Paint a graded wash of French ultramarine on to the road, making it stronger in the foreground. While it is still wet, add burnt sienna and French ultramarine at the base of the building to create shadows.

PAINTING SHADOWS

Bright light creates light shadows as it spills into areas of shadow and fills them with pools of colour. Remember this when painting sunny scenes so that you don't make the mistake of painting shadows that are very dark and dull.

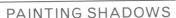

15 Add detail to the front figure with burnt sienna and to the second figure with Windsor violet. The contrast between the two colours will help to bring the front figure forward and make the second figure recede.

Street scene ▶

The painting has been kept loose to capture the liveliness of the scene. Giving the figures only the barest suggestion of form blends them into the landscape where they add more colour, and making the shadows light and colourful helps to create the sunny atmosphere.

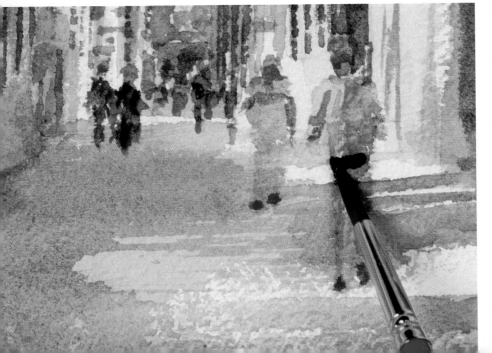

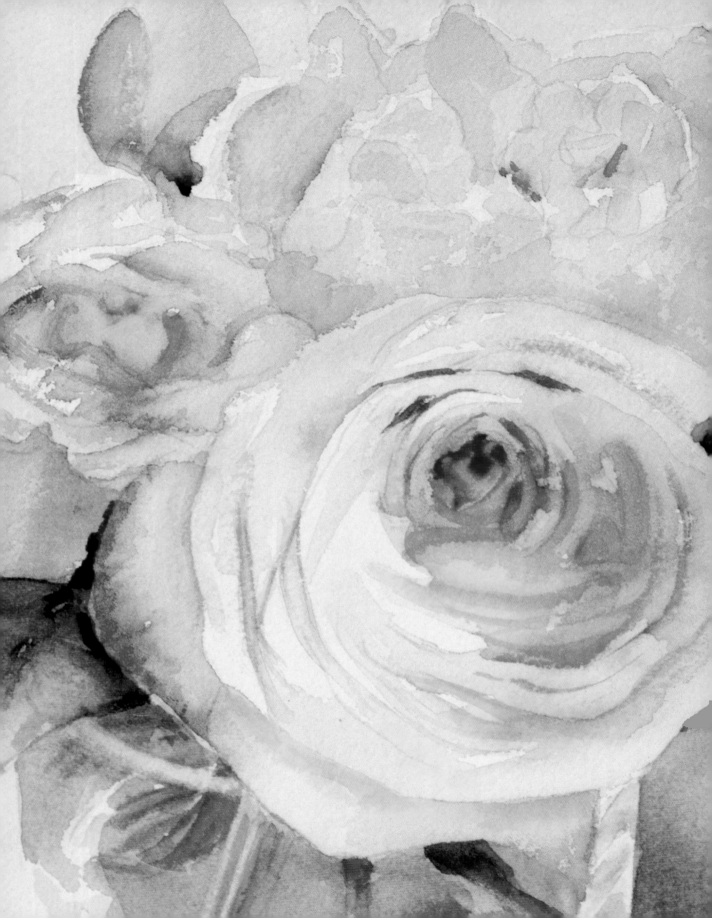

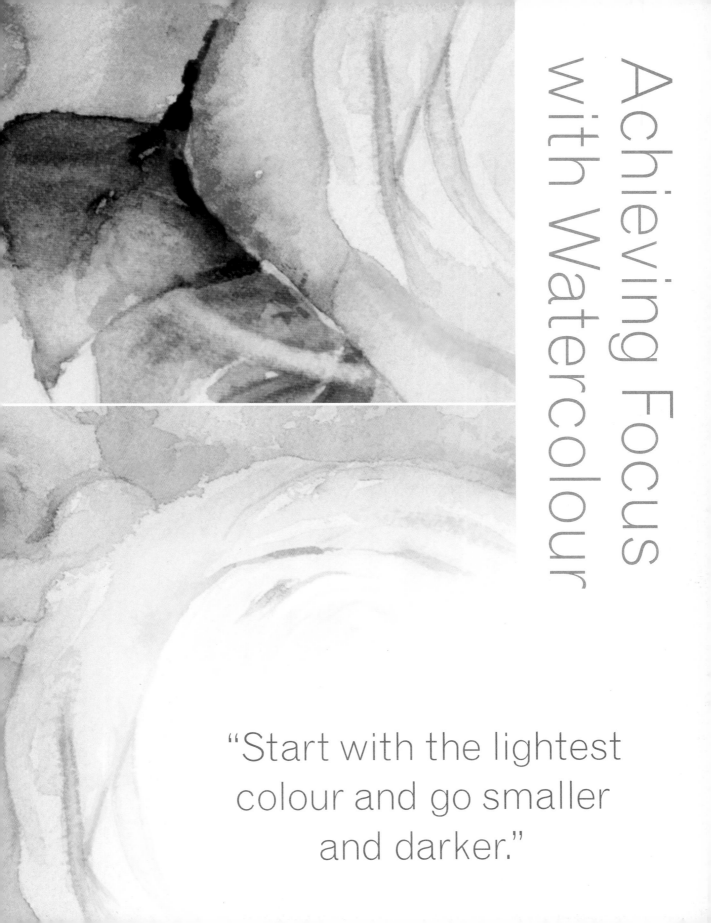

Achieving Focus
with Watercolour

"Start with the lightest
colour and go smaller
and darker."

Focal point

A good painting has a strong focal point that immediately draws your eye to the main area of interest. The focal point of any image is the point where the lightest and darkest marks meet. You can use these tones elsewhere in your painting but they should only be next to each other where you want your viewer to focus. To emphasize the focal point even more, it is a good idea to restrict the range of tones you use for the details around it so that these areas are less defined and do not vie for attention.

LIGHT TO DARK

It is important to decide what your main point of interest is before you begin painting so that you can create a strong composition. Start by identifing the lightest colours in your composition. These colours lie underneath all the subsequent layers of colour, unifying your picture. Block in these large areas of colour first, then begin building up the mid tones to give your painting structure. Next paint smaller, darker details, and finally add tiny amounts of pure bright colour and the darkest tones of all to bring the main area of interest into focus.

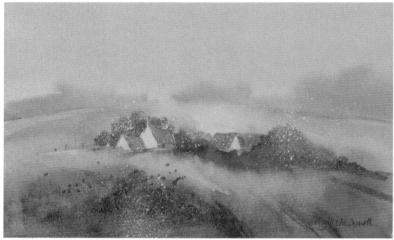

Farm buildings The buildings have been brought into focus in this picture as dark foliage has been painted next to their light stonework. Flicking a small amount of complementary red paint in the foreground creates further interest.

BUILDING LAYERS

This painting of a flowerpot has been built up in layers, starting with the lightest colours and then adding progressively smaller and darker areas of colour so that detail and focus are established.

Light tones

For this painting a mix of raw sienna and cadmium red was used first for the lightest tone.

Mid tones

The mid tones were then added. These create contrasts between objects and give them edges.

Dark tones

Mid dark details were painted, then dark accents added next to the lightest tones to create focus.

EMPHASIZING THE FOCAL POINT

The focal point of this painting of a gymnast is her legs and neck, and this is where the lightest and darkest marks have been placed next to each other. To emphasize this focal point, the distracting detail of the gymnasium has been replaced with a soft background wash. The gymnast's leotard merges into this wash, which also helps to keep attention on the legs.

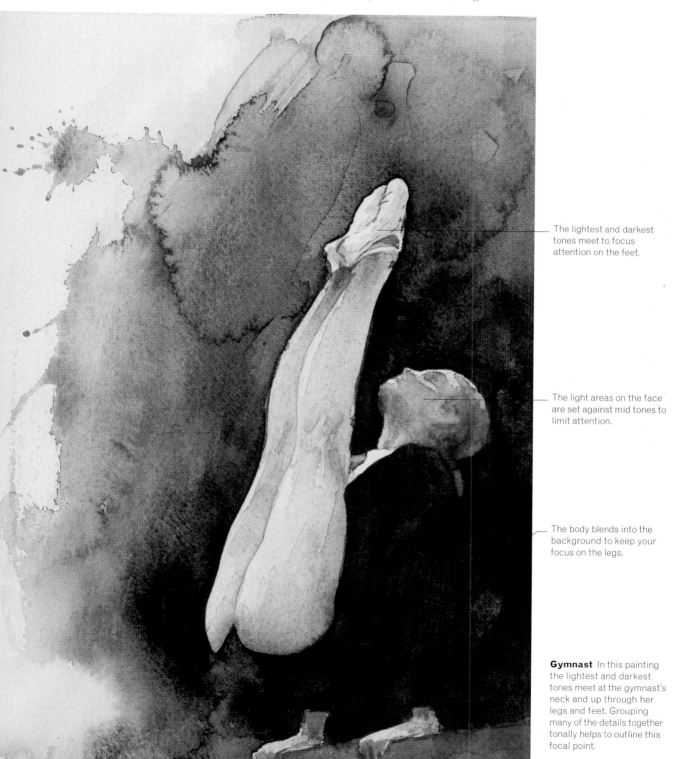

The lightest and darkest tones meet to focus attention on the feet.

The light areas on the face are set against mid tones to limit attention.

The body blends into the background to keep your focus on the legs.

Gymnast In this painting the lightest and darkest tones meet at the gymnast's neck and up through her legs and feet. Grouping many of the details together tonally helps to outline this focal point.

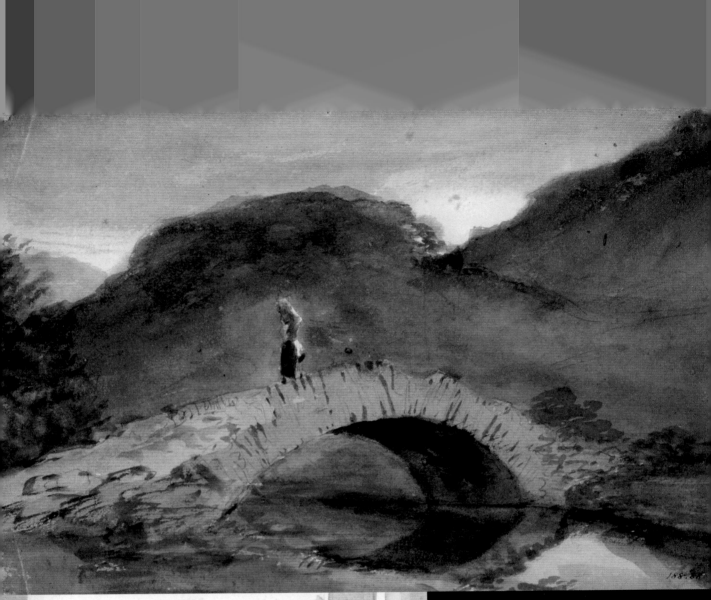

▲ Bridge at Borrowdale

The clear focal point in this muted painting is the figure standing on the bridge. This figure is the only place in the picture where the lightest and darkest tones meet. *John Constable*

Pink roses ▶

The deep central colour of the front rose and the lights and darks on the leaves either side of it, make this rose the focal point. The other blooms melt away without such contrast. *Glynis Barnes-Mellish*

◀ Street market

This busy steet scene contains a lot of detail, but by limiting the combination of light and dark to the two figures in yellow saris they remain the focal point. *Glynis Barnes-Mellish*

◀ A tramp

In this striking portrait the head of the man is set back in shadow while the foreground is quite light in tone. To focus attention on the face, the white shirt has been painted next to a very dark edge of the beard. *John Singer Sargent*

▲ Courtyard, Venice

In this painting the focus created by adjacent light and dark marks occurs in several different places, from the stone slab at the doorway, to the plant pot, to the back wall. This arrangement keeps the eye moving around the scene. *Nick Hebditch*

22 Chair by a window

Bright sunlight spilling on to the chair and floor animates this simple country interior. Resists are used to great advantage in this painting, as they keep parts of the paper white. This means that you can paint the first large areas freely and loosely, capturing the intensity of light coming through the window by using warmer colours closest to the source of light. Once the resists are removed, the contrast and tension between the darkest tones and the unpainted white paper focuses attention on the relationship between the chair and the window frame.

EQUIPMENT
- Cold-pressed paper
- Brushes: No. 5, 25mm (1in) and 12.5mm (½in) flat
- Raw sienna, burnt sienna, Windsor violet, cerulean blue, cadmium yellow, French ultramarine, cadmium red, titanium white acrylic paint
- Masking tape and masking fluid

TECHNIQUES
- Resist

RESISTS

Below you can see three different types of resist – masking tape, masking fluid, and wax candle – and the marks that they make on paper. Masking tape and fluid are used to protect areas that will be painted over once they have been removed. Masking fluid is more flexible in that you can create a more irregular shape with softer edges. Wax cannot be removed.

Paint over masking tape.

Masking tape removed.

Paint over masking fluid.

Masking fluid removed.

Applying wax.

Paint over wax.

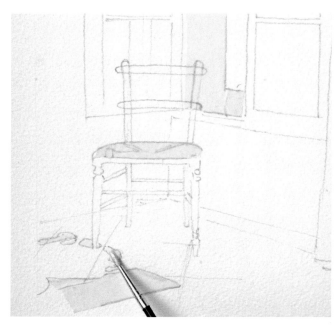

1 Put masking tape over the large areas of the picture that you want to keep white. Paint masking fluid on to the smaller areas. As the fluid is cream, you can see where it is. Use a cheap brush and clean it straightaway. Let the fluid dry completely.

BUILDING THE IMAGE

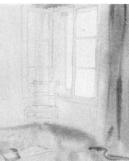
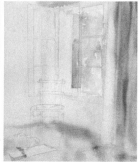
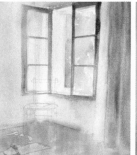
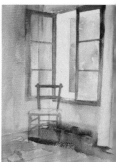

2 Paint the walls with a wash of raw sienna. You can do this freely without having to worry about the areas that will remain white. Paint the window frame raw sienna too.

3 While the paint is still wet, add a wash of burnt sienna to the curtain, the floor, and the wall beneath the window. Paint a line of Windsor violet around the edge of the floor.

4 Use cerulean blue to paint the sky through the window. Add a little cadmium yellow to the lower part of the blue while it is still wet, to create a soft green for the trees outside the window.

5 Soften the edges of the curtains with a little water to suggest light falling on them. Use burnt sienna to add the details of the window frame and skirting board, then brush the paint down to create the effect of a sheen on the floor.

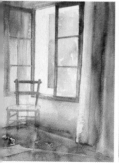
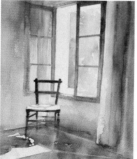
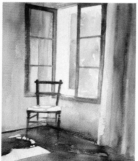
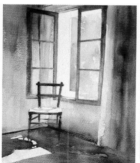

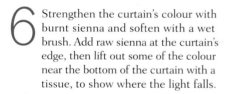

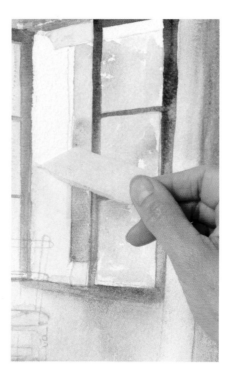

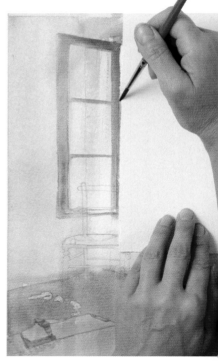

6 Strengthen the curtain's colour with burnt sienna and soften with a wet brush. Add raw sienna at the curtain's edge, then lift out some of the colour near the bottom of the curtain with a tissue, to show where the light falls.

7 Use the Windsor violet and burnt sienna mix to paint the second window frame, then remove the masking tape around the window. This will leave the outside walls, which are in sunlight, white.

8 Use a piece of paper to help you paint a fine straight line of raw sienna all the way along the edge of the open window. Using the paper helps to create a controlled line, which has a soft edge.

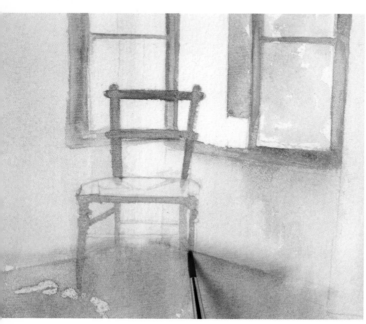

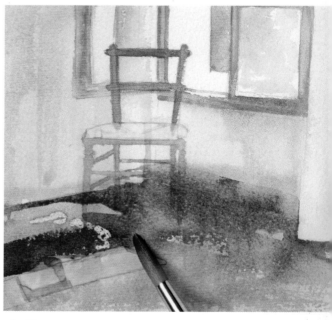

9 Use a mix of burnt sienna, French ultramarine, and Windsor violet to paint the chair back. Drybrush this mix on to the window frame to create a weathered texture. Paint the chair seat and legs with an orange mix of burnt and raw sienna.

10 Add cerulean blue to the orange mix for the shadow on the wall to the left. Mix burnt sienna and Windsor violet for the shadow on the floor and brush on raw sienna and burnt sienna to add texture and contrast.

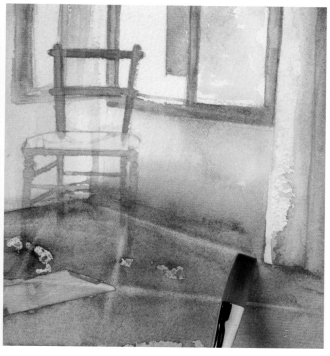

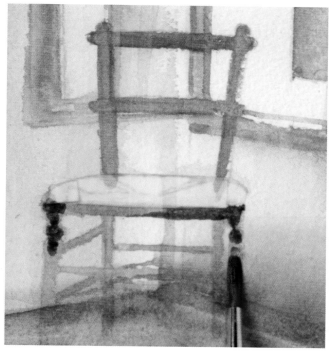

11 Paint the shadows on the wall with burnt sienna and Windsor violet. Keep the wall around the window orange so that it looks light. While the paint on the floor is still wet, lift out fine lines of colour to create interest.

12 Add further interest to the floor by flicking it with water to create backrun effects (*see p.148*). Darken the chair with French ultramarine and burnt sienna, then use Windsor violet to paint shadows on it.

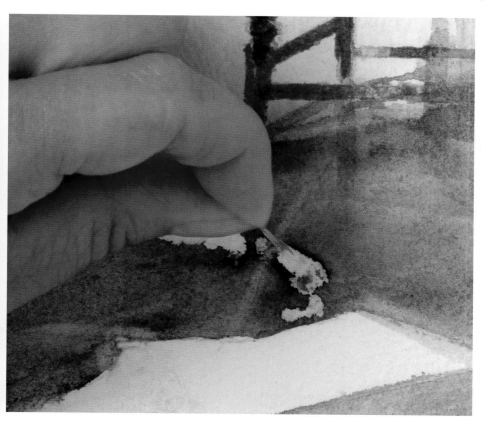

13 Peel off the masking tape on the floor to reveal the white paper where there is a pool of light near the chair. Then, carefully peel away the masking fluid with your fingernails to leave patches of white paper where the light has been broken by the shadows of the chair.

MASKING FLUID

Always make sure that both the masking fluid and paint are completely dry before you remove the masking fluid so that you do not tear the paper.

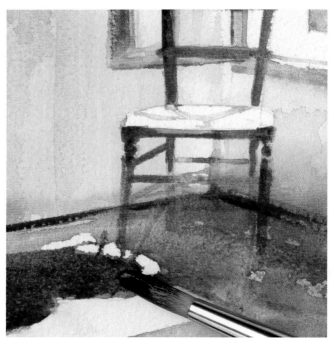

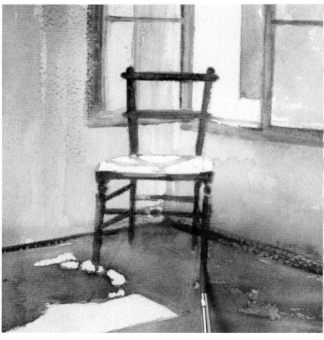

14 Use the Windsor violet and burnt sienna mix to darken the window frame and to paint the shadows of the chair legs. Add cadmium red to the corner for warmth and use Windsor violet for the shadow on the floor.

15 Darken the top of the picture with the burnt sienna and Windsor violet mix. Once the paint around the chair legs has dried, strengthen their colour with the burnt sienna and Windsor violet mix.

"Light can create interest in areas that are otherwise plain and empty."

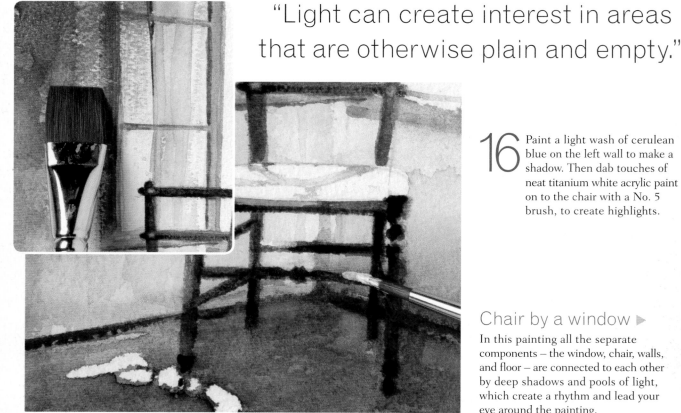

16 Paint a light wash of cerulean blue on the left wall to make a shadow. Then dab touches of neat titanium white acrylic paint on to the chair with a No. 5 brush, to create highlights.

Chair by a window ▶

In this painting all the separate components – the window, chair, walls, and floor – are connected to each other by deep shadows and pools of light, which create a rhythm and lead your eye around the painting.

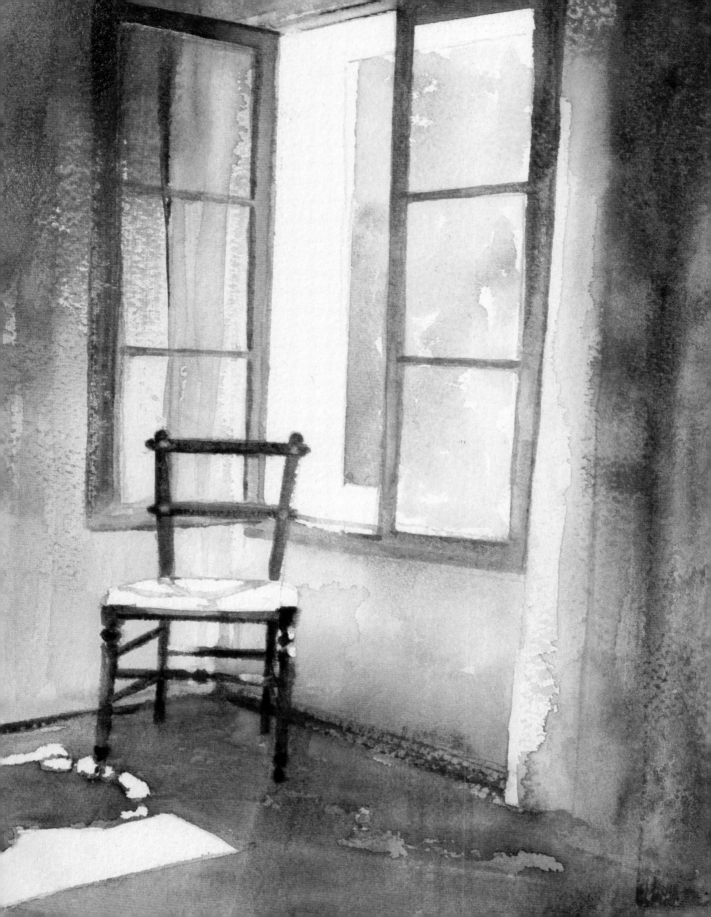

23 Cliffs and beach

This rugged and colourful seascape may look complex, but by identifying the underlying colours that unify the whole scene, it is easy to start work. The first washes create an interplay between the warm and cool colours, which establishes perspective and creates a sense of movement, vital in painting the sea. As you build up the subsequent layers of colour in the seascape, you can strengthen features and refine detail. Finally, using a razor blade to remove some of the paint from the sea produces broken marks that capture the effect of sunlight sparkling on the water.

EQUIPMENT

- Cold-pressed paper
- Brushes: No. 5, No. 14, 12.5mm (½in) and 25mm (1in) flat
- Razor blade
- Burnt sienna, cerulean blue, turquoise deep, Windsor violet, cadmium orange, cadmium yellow, emerald green, French ultramarine, alizarin crimson, sap green, burnt umber

TECHNIQUES

- Scraping back

The white of the paper showing through the dry brushwork suggests the crests of the waves.

1 Wet the paper, then paint the cliffs burnt sienna, using the 25mm (1in) flat brush. Use cerulean blue for the distant sky, blending it into the yellow to create a soft green for the distant hills and the areas of shadow on the cliffs.

2 Paint the sea with a wash of cerulean blue, then drybrush turquoise deep (an Old Windsor colour) over the top with the 25mm (1in) flat brush, to strengthen the colour. Carry the turquoise over on to the beach.

BUILDING THE IMAGE

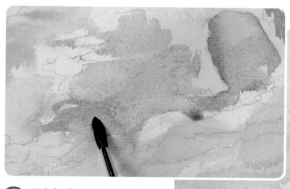

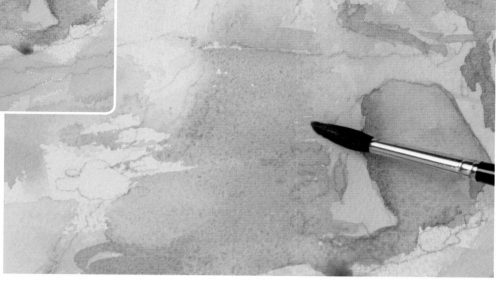

3 While the cerulean blue on the beach is still wet, paint the shadows on the rocks and the beach with Windor violet, using the No. 14 brush. Add cadmium orange for the colour of the sand.

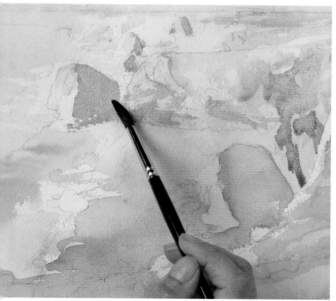

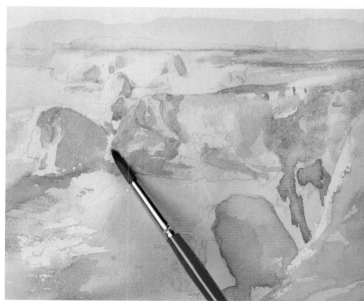

4 Mix cadmium yellow and emerald green and paint the grass, adding cerulean blue for the more distant grass. Add shadows to the rock in the foreground with French ultramarine. Use cerulean blue to paint the distant rock.

5 Strengthen the colour of the sea with turquoise deep, using the No. 5 brush. Paint the mid-range greens on the cliff tops using a lime green mix of emerald green and cadmium yellow, with a little cadmium orange added to it.

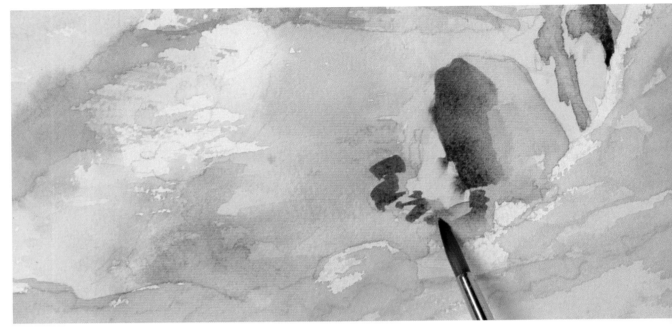

6 Darken the shadows on the rock and paint the pebbles with a mix of burnt sienna and Windsor violet. Paint shadows on the cliffs using the lime green mix with burnt sienna and French ultramarine added to it.

"Keep your painting loose and free."

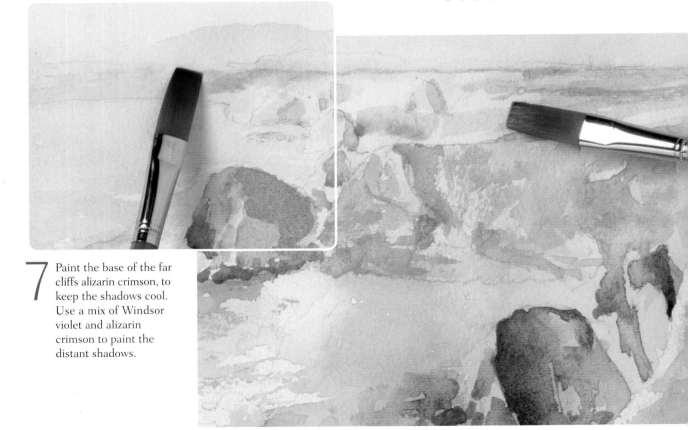

7 Paint the base of the far cliffs alizarin crimson, to keep the shadows cool. Use a mix of Windsor violet and alizarin crimson to paint the distant shadows.

8 Brush the foreground with a clean, wet brush, then paint a mix of sap green and burnt sienna on to the wet paper. While the paint is still wet, add strokes of emerald green and burnt sienna for the grass in the foreground.

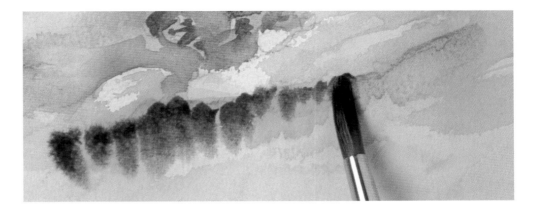

9 Drop clean water on to the foreground to create backrun effects that add interest to the grass. While the paint is still wet, add dashes of alizarin crimson for some local colour.

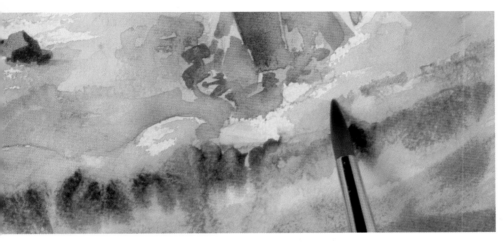

10 Carry on adding detail, using French ultramarine for the shadows on the grass and burnt sienna on the rocks. Mix sap green and cerulean blue to paint the shadows that help to define the cliffs.

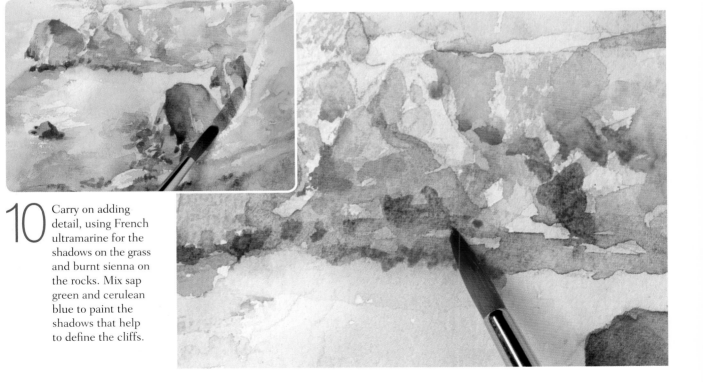

11 Paint the smaller rocks on the beach Windsor violet and add French ultramarine for the shadows. Splatter the foreground with the lime green mix and apply strokes of a mix of burnt umber and sap green for added colour.

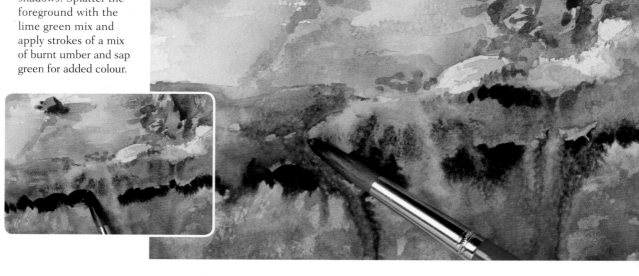

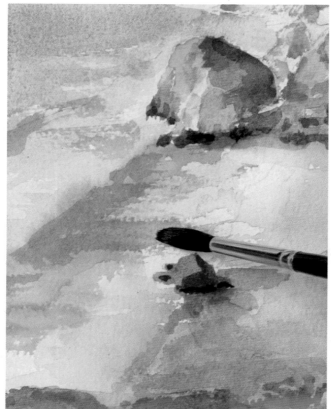

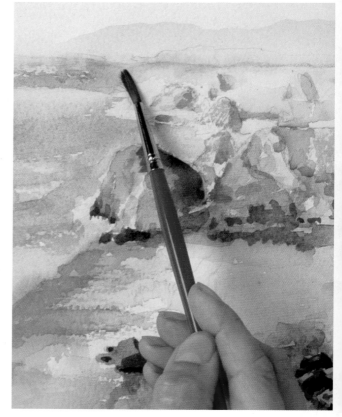

12 Add touches of cadmium orange to the foreground to bring it forward and add cerulean blue to the background to make it recede. Strengthen the colour of the sea with turquoise deep.

13 Add Windsor violet to the far cliffs where they meet the sea to push them back into the distance. Paint the grass on the distant cliffs on the right with a mix of cerulean blue and burnt sienna.

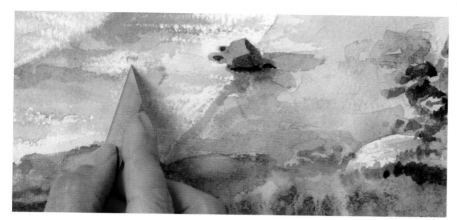

14 When the paint on the sea is completely dry, scrape off some of the paint, using horizontal strokes of a razor blade, to create the effect of the crests of the waves.

▼ Cliffs and beach

This painting is full of colour and light. The layered washes of colour have created a harmonious interplay of light and shade, and scraping away some of the paint has created sparkling highlights in the sea.

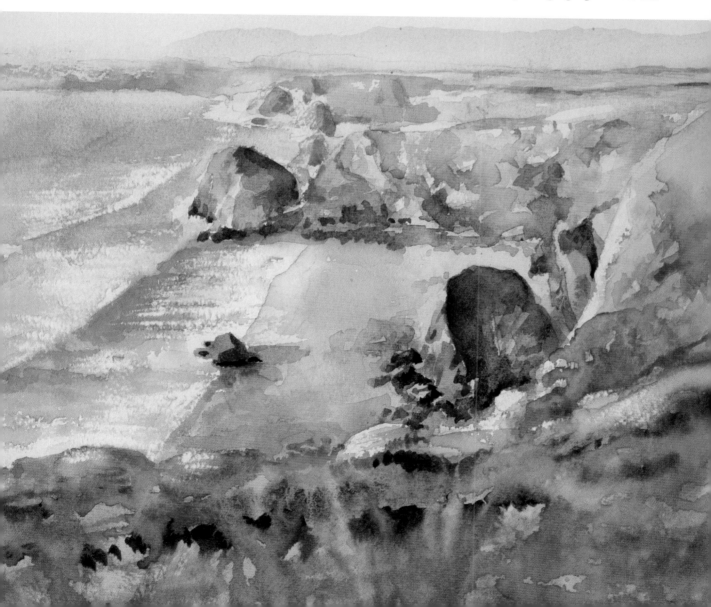

24 Portrait

Painting portraits may seem challenging, but the techniques you have learnt so far can all help to produce vibrant character studies. The main aim of a portrait is to convey someone's personality through softness, texture, and expression. Delicate skin tones work best when they are built up slowly and layered, wet on dry. This keeps the colours luminous so that they hold the features together as further details are strengthened. The contrast between soft skin tones and strong features helps to create a dramatic, vivid portrayal of your subject's personality.

EQUIPMENT
- Rough paper
- Brushes: No. 5, No. 14, 25mm (1in) flat
- Scalpel or razor blade
- Alizarin crimson, raw sienna, cerulean blue, cadmium red light, burnt sienna, Windsor violet, French ultramarine, cadmium red

TECHNIQUES
- Layering
- Scratching out
- Drybrush

1 Mix a wash of alizarin crimson and raw sienna and paint it over the face and neck except for where light hits the forehead. Soften the edges with a clean, wet brush. Add alizarin crimson wet-in-wet to make some areas of the skin a cooler colour.

2 While the paint on the face is drying, mix a light wash of cerulean blue and paint the shirt. Let the wash break in places, leaving white paper, to create the shirt's texture.

BUILDING THE IMAGE

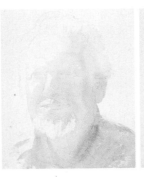
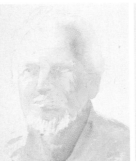
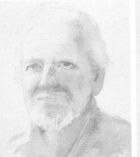
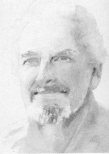

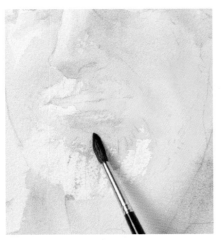

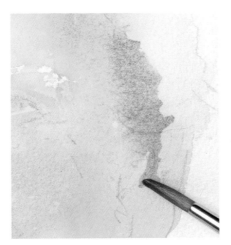

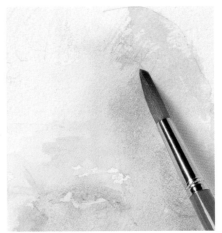

3 When the face is dry, add cerulean blue to the skin mix and use to add shape to the face around the nose. When this layer of paint is dry, add a little alizarin crimson to the centre of the face to bring it forward.

4 Mix alizarin crimson and cerulean blue to make a deep lilac pink and paint the shaded areas at the sides of the face. Paint the shadows around the nose with a mix of raw sienna and cerulean blue.

5 Add raw sienna to the centre of the face, to add warmth. Use a light wash of cerulean blue to paint the hair on the right-hand side of the face and add touches of neat alizarin crimson to the temples.

"Keeping colours separate by letting them dry and layering them makes the colours brighter."

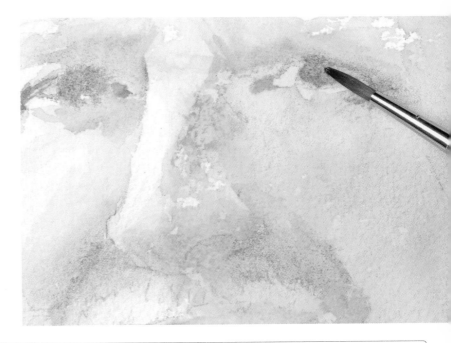

6 Paint cadmium red light around the eyes to define them. Drybrush the same colour down the nose to give it texture – the cadmium red will make the alizarin crimson look cooler. Use pure cerulean blue to paint the eyes.

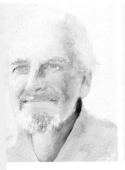
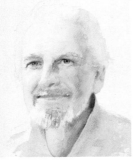
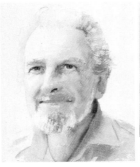

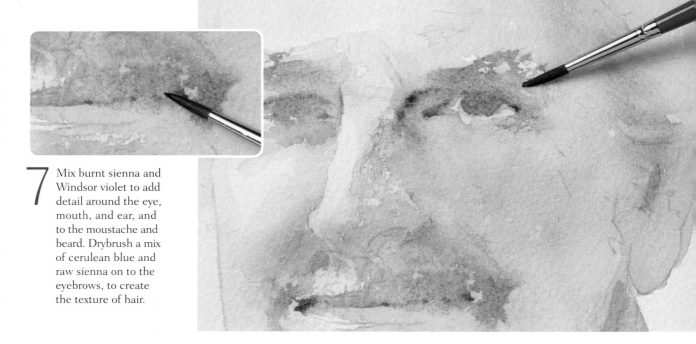

7 Mix burnt sienna and
Windsor violet to add
detail around the eye,
mouth, and ear, and
to the moustache and
beard. Drybrush a mix
of cerulean blue and
raw sienna on to the
eyebrows, to create
the texture of hair.

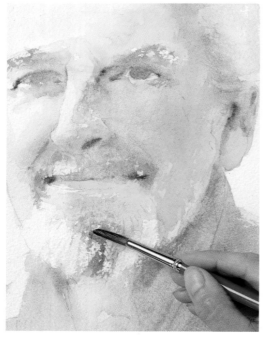

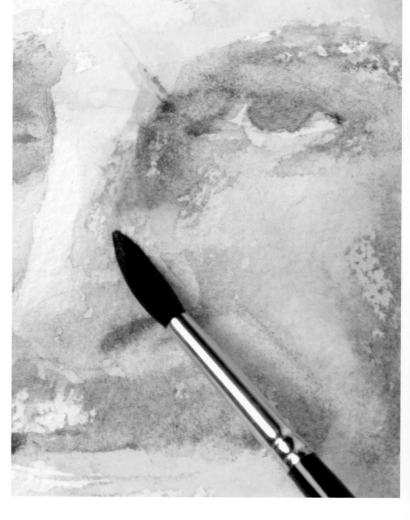

8 Mix burnt sienna and cadmium red together
to paint the side of the face. Add French
ultramarine and paint the dark areas of the
moustache and beard. Use burnt sienna and
Windsor violet for the shadow inside the shirt.

9 Model the cheeks and eye sockets with a
mix of cadmium red, alizarin crimson, and
cerulean blue. Drybrush a mix of burnt sienna
and cadmium red on to the right side of the
face to create the texture of older skin.

SKINTONES

Hold a black pencil against the picture to check that the skin tones are dark enough, as it is not always easy to judge when painting on white paper. This will help you to decide whether you need to make any of the colours stronger and darker.

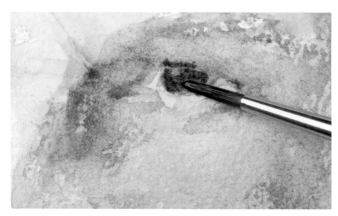

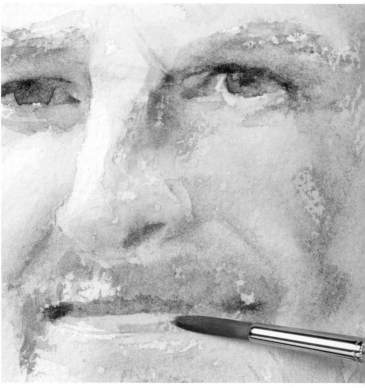

10 Mix French ultramarine with raw sienna to make green-blue, a realistic colour for blue eyes. Drop a little water on to the eyes to make them look wet. Darken the eyes with a mix of burnt sienna and Windsor violet.

11 Strengthen the colour around the eyes with a mix of cadmium red and burnt sienna, then darken the mouth with alizarin crimson. Mix French ultramarine and burnt sienna together to paint the pupils.

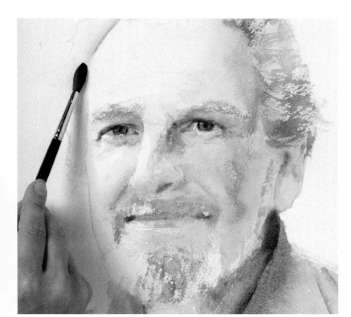

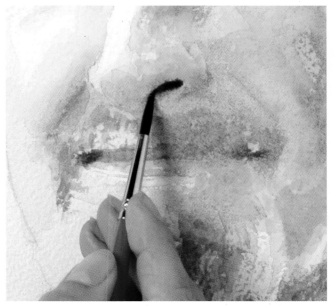

12 Darken the shirt with cerulean blue and burnt sienna. Drybrush details on to the hair with a mix of French ultramarine, burnt sienna, and cerulean blue. Add more details with alizarin crimson and Windsor violet.

13 Add cadmium red to the end of the nose. Use a mix of burnt sienna and French ultramarine for the nostril, the corners of the mouth, and inside the ear, then soften the details with a clean, wet brush.

14 Add detail to the moustache with a mix of French ultramarine and burnt sienna, drybrushing it on to add texture. Lift out a little colour on the eyes with a brush. This will create soft, shiny highlights and will make the eyes look glassy.

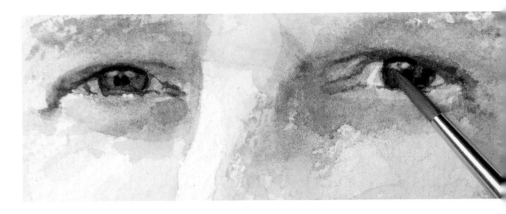

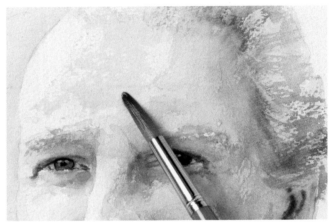

15 Paint alizarin crimson in the centre of the forehead. Drybrush a mix of cerulean blue and burnt sienna on to the hair on the right side of the face to darken it.

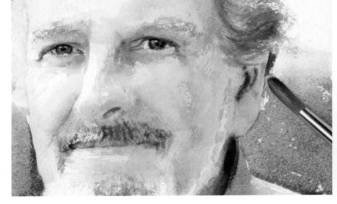

16 Paint a background wash of cerulean blue and burnt sienna, graded so it has just a touch of burnt sienna at the top. Lighten the beard by lifting out lines of colour.

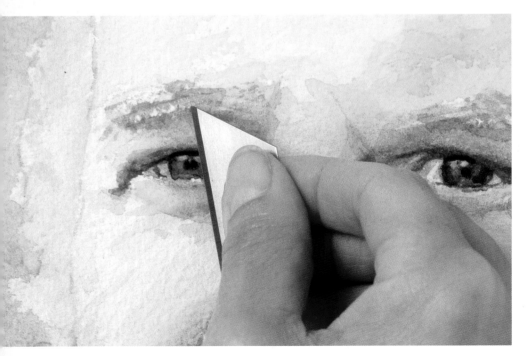

17 Use a razor blade to scratch out short, fine lines of paint on the eyebrows. This will take you right back to the paper and create a broken line, which is very good for describing hair. Do the same thing to create highlights in the hair.

Portrait ▶

The slow build-up of skin tones with layers of washes has ensured that the colours have remained fresh. Painting the large, broad shapes of the subject before adding the small details makes the features look more realistic.

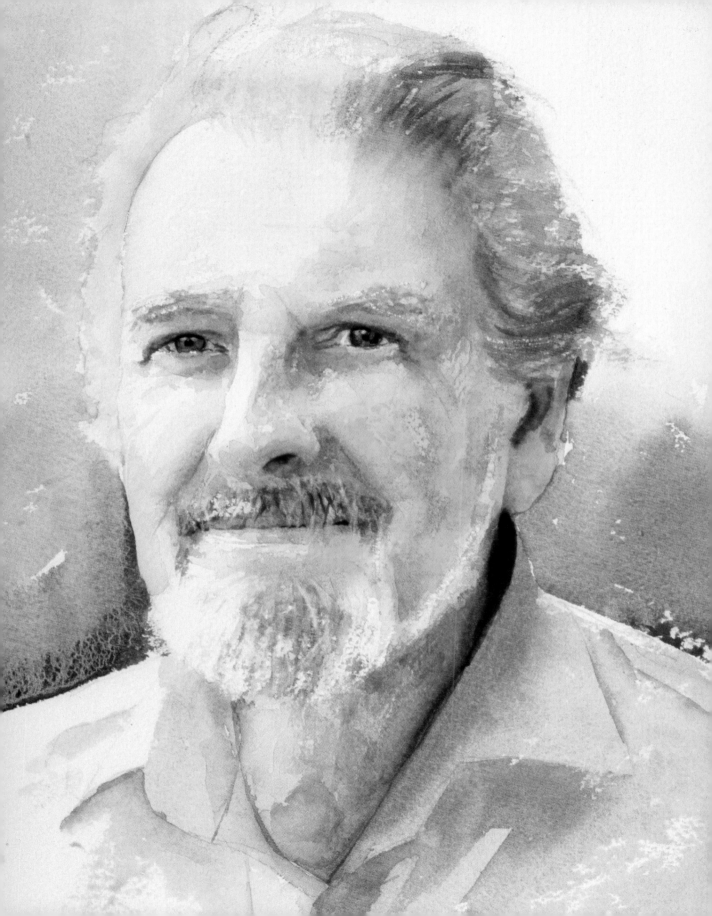

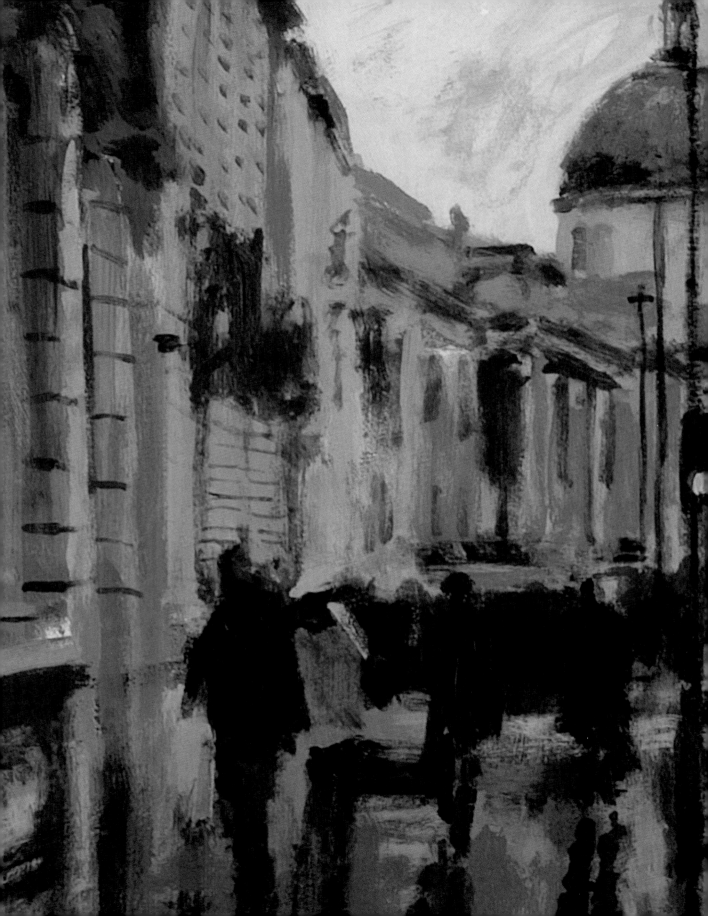

Acrylics
Workshop

Introduction to acrylics

Acrylics provide a great opportunity to create exciting pictures, for beginners and professionals alike. They offer brilliance of colour, speed and convenience of use and, above all, versatility. You can use acrylics to produce precise, detailed paintings, or adventurous, abstract pieces, and you can use them on a wide range of surfaces.

Whatever the subject or the mood you want to create in your painting, acrylics allow you to use a whole range of techniques. Because these paints are water-based, they can be used to create delicate detail or, when applied thickly, rich and dramatic textures. Diluted, acrylics can give you a perfectly smooth, flat

wash; squeezed straight from the tube, they build a luscious impasto; and mixed with the many additives available, the surface can be sculpted, roughened, textured, or glazed.

Acrylics also have the advantage of speed and ease of use: you can create pleasing pictures quickly knowing you can readily correct any mistakes. So, if part of a painting is not to your liking, you can paint it out and repaint it in minutes. If you want to balance a composition, acrylics allow you to make last-minute changes easily – so you can correct perspective, for example, or add highlights at any stage. Equally important are the practicalities of working with acrylic

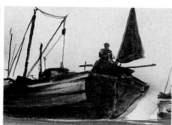

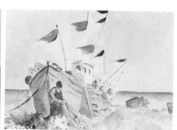

paints. They are compact and easy to store, and they are easy to carry with you if you are painting outdoors. The colours do not fade and the surface of acrylic paintings is tough, so not easily damaged. Acrylics don't have an odour, so you can paint anywhere, even in the kitchen; equipment can be cleaned with water and household soap.

This section guides the beginner through all the stages of making exciting pictures in acrylics, from buying materials to the basic techniques, with advice on how to mix colours and how to create pleasing compositions, with opportunities to practise in order to build understanding and confidence. This hands-on approach means you start painting straightaway and have the satisfaction of producing work you can really be pleased with. The following chapters introduce increasingly sophisticated ways of exploiting acrylics, with examples of how different subjects have been treated by various artists over the years. The 12 projects show you, step by step, how the techniques you have practised can be combined to construct appealing paintings. As you start to produce more and more exciting effects in acrylics, your skills will increase – as will the pleasure you obtain from exploring the huge range of opportunities provided by this versatile medium.

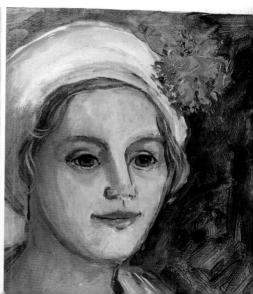

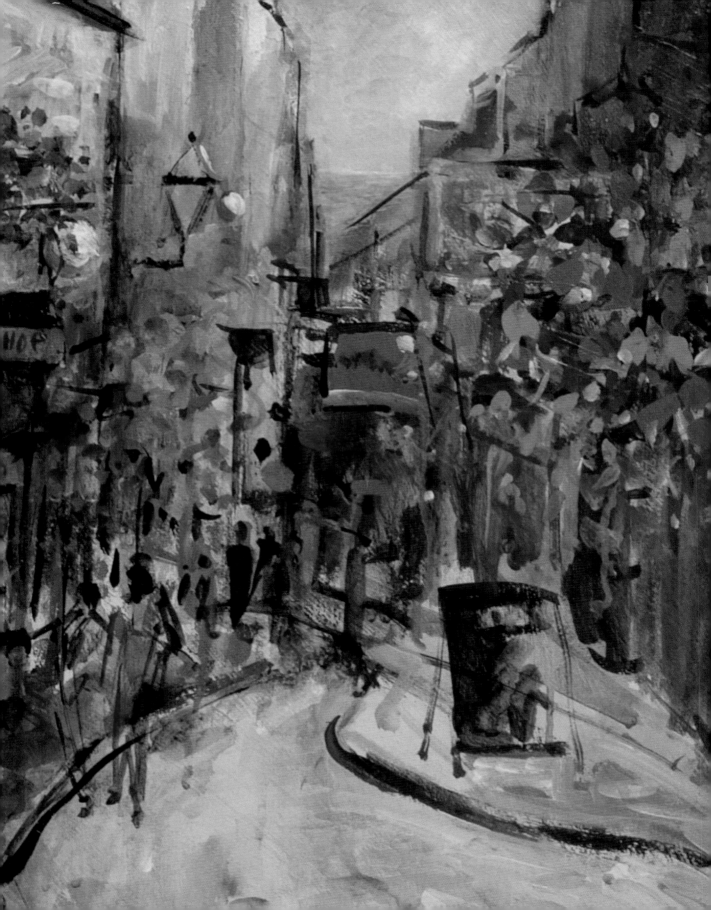

Acrylics
Materials and Techniques

Acrylic paints and other materials

There is an ever-increasing range of acrylic paints available, but there is no need to buy a lot of colours. It is a good idea to start with a limited palette and experiment to see which colours you can mix. Acrylic paints are available in tubes, tubs, and bottles. The most convenient to use are tubes. They are less bulky, the colour is always fresh and clean, and you can easily control the amount of paint you squeeze out.

RECOMMENDED COLOURS

The 12 paints below make a good basic starter palette. Using these colours, you will be able to mix limitless variations of colour. The list includes primary colours – two reds, two yellows, and three blues; one of each of the secondary colours – orange, green, and purple; together with magenta and white. You don't need a black – this can be mixed up.

 Cadmium red deep
 Cadmium red light
 Cadmium yellow deep
 Yellow light hansa
 Light blue
 Phthalo blue

 French ultramarine
 Indo orange
 Phthalo green
 Dioxazine purple
 Medium magenta
 Titanium white

TYPES OF PAINT

Tubes of paint are the most popular form of packaging. The caps are easy to take off and put back on.

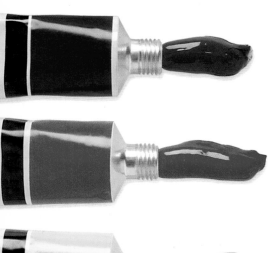

Tubs of paint may be used for large pieces of work, such as a mural painting. The paint is scooped from the tub.

Bottles of paint stand upright. The paint is squeezed out through a nozzle. Bottled paint is usually more liquid.

OTHER MATERIALS

There is no need to buy a huge number of brushes – the range below will enable you to achieve a wide variety of effects. As well as paint, paper, and brushes, your basic painting kit should include a pencil, an eraser, masking tape, kitchen towel, a paint rag (cotton towelling is best), and large jars of water for mixing paints and cleaning brushes.

BRUSHES

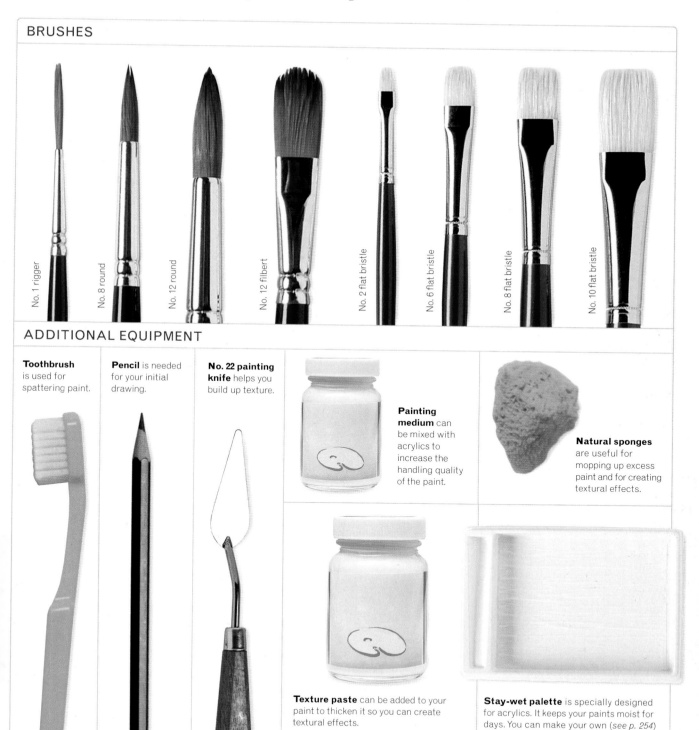

No. 1 rigger

No. 8 round

No. 12 round

No. 12 filbert

No. 2 flat bristle

No. 6 flat bristle

No. 8 flat bristle

No. 10 flat bristle

ADDITIONAL EQUIPMENT

Toothbrush is used for spattering paint.

Pencil is needed for your initial drawing.

No. 22 painting knife helps you build up texture.

Painting medium can be mixed with acrylics to increase the handling quality of the paint.

Natural sponges are useful for mopping up excess paint and for creating textural effects.

Texture paste can be added to your paint to thicken it so you can create textural effects.

Stay-wet palette is specially designed for acrylics. It keeps your paints moist for days. You can make your own (*see p. 254*) or buy one from a shop, as shown above.

Supports: the painting surface

One of the many advantages of acrylic paint is that you can use it on a wide variety of paper and other material, provided the surface is non-greasy. Supports for acrylic paint range from cartridge paper to watercolour paper, canvas board to cardboard. They all offer a different surface, which affects the way the paint is absorbed and how the painting looks – so spend some time experimenting.

TYPES OF SUPPORT

Acrylic paper is a lightweight support made for use with acrylic paint. Highly diluted acrylic is best used on watercolour paper. Other supports include cartridge paper, newspaper, cardboard, mountboard, hardboard, canvas board, and stretched canvas. If areas are left unpainted, the colour of some cardboards and mountboards can add to the painting.

Acrylic paper is available in pads of varying sizes. It has an embossed finish and textured surface similar to canvas.

Watercolour paper is ideal for acrylic painting. It comes in varying weights and surfaces, all suitable for acrylics. It is also available in tinted shades.

Cardboard is a sympathetic surface. The colour of the board can be used to contribute to a colour scheme.

Canvas can be bought already primed and stretched over a frame, in a variety of sizes and proportions. It comes in different textures.

Canvas board is a handy alternative to stretched canvas. The primed canvas is stuck to a panel, giving a firm painting surface.

PAINT ON SUPPORTS

The surface you choose to work on has a noticeable effect on the finished work. These five paintings of waterlilies were all composed in the same way, but painted on five different surfaces – and each result is markedly different.

Acrylic paint can be applied thickly on canvas.

Stretched canvas This warm surface seems to welcome the paint. The slight spring of the canvas gives vitality to the brushwork. You can use thin or thick paint.

Acrylic paper Washes slide easily across this rather slithery surface and tend to come to an abrupt end. The addition of water increases the fluidity and softens the washes.

The washes are softened with water.

Canvas board This is a hard, firm surface that invites a bold, fearless approach. The tough surface makes it possible to overpaint and make changes without anxiety.

The texture of the board is visible.

Tinted watercolour paper The warm oatmeal colour of this paper helps unify this painting. You can apply thin washes, so the paper colour shows through, or use opaque paint.

Unpainted areas give an overall colour.

Cardboard This cheap, accessible paint surface invites experimentation. It is tough and rugged, and takes heavy paint. The cardboard's strong colour modifies transparent washes.

Light, opaque colours stand out from the toned background.

Brushes and painting knives for acrylics

A wide range of brushes is available to use with acrylic paint. You can use brushes that are recommended for oil or watercolour, but use the cheaper synthetic brushes rather than the more expensive sable ones, because acrylic paint tends to be harder on brushes than other painting media. You can also mix and apply acrylic paint with a painting knife, which has a cranked handle to lift it from the painting surface.

BRUSH AND PAINTING KNIFE SHAPES

Brushes and painting knives come in different shapes and sizes. Brushes can be round, flat, filbert, or rigger, and are numbered: the larger the brush, the higher the number. Use the recommended brushes and knife (*see p.247*) to create a wide range of strokes from fine lines to broad washes, as shown below. Each brush or knife lends itself to specific effects.

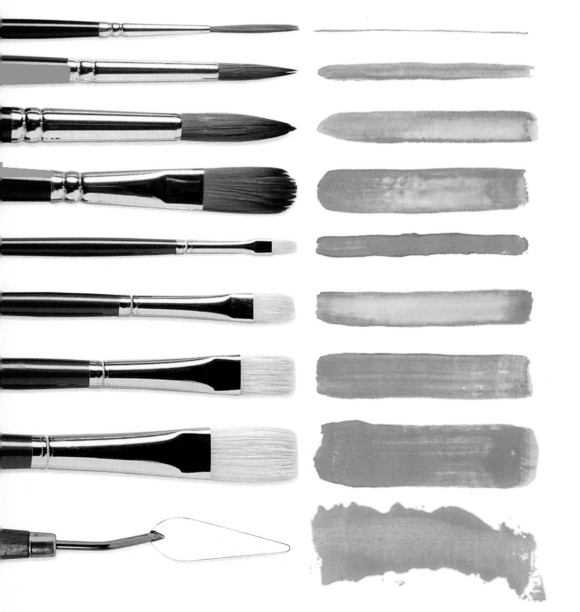

No. 1 rigger is perfect for delicate, sensitive, fine lines.

No. 8 round is a handy general brush for drawing and detail.

No. 12 round is good for larger areas that need definite contour.

No. 12 filbert is suitable for soft, rounded marks and shapes.

No. 2 flat bristle is used to make small, stabbing brushstrokes.

No. 6 flat bristle is useful for intermediate brushstrokes.

No. 8 flat bristle holds more paint and is ideal for covering larger areas.

No. 10 flat bristle is used for covering, and laying in broad areas.

No. 22 painting knife is used both for mixing and applying paint.

HOW TO HOLD A BRUSH OR PAINTING KNIFE

Acrylic brushstrokes should be fluid and spontaneous. The brush should be held lightly in the hand, with fingers and wrist in a relaxed position, allowing the brush to perform.

A variety of brushstrokes will result if you vary the angle of the brush, the pressure applied, and the speed. Never fiddle with a brushstroke once it is down on the paper or board.

To make a variety of strokes using a round brush, hold it with your hand close to the brush head, as if you are holding a pencil.

To hold a flat bristle brush, place your hand over the handle with the index finger outstretched, and support from underneath with your thumb.

To work with the painting knife you need to grip it with a closed fist, as if you were working with a trowel.

Varying strokes

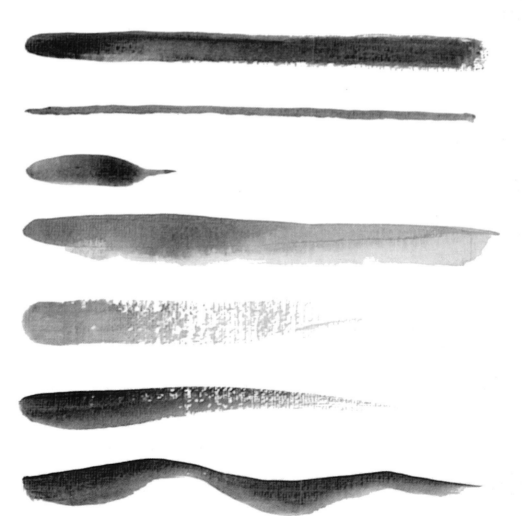

To create a smooth stroke, push the brush down evenly as you move it over the paper.

To make a long, fluid stroke, use the tip of the brush and apply even pressure.

To make a leaf-like mark, pull the brush slowly across the paper, lifting off as the leaf tapers.

To gradually lighten a brush stroke, slowly lift the brush off as you move across the paper.

To create a textured effect, use a fairly dry brush and drag it quickly across the paper.

To make a pressurized stroke, push the brush down hard and then release it quickly.

To give the impression of form, flip the brush over as it travels over the paper.

Brushstrokes

Discover the variety of effects that you can achieve by trying out, and experimenting with, your brushes; the range of marks you can make using round, flat, or rigger brushes is shown below. The more you practise, the more you will improve your brush control and your confidence. Vary the speed, pressure, and direction of the marks to create unexpected and unusual results.

BRUSH EFFECTS

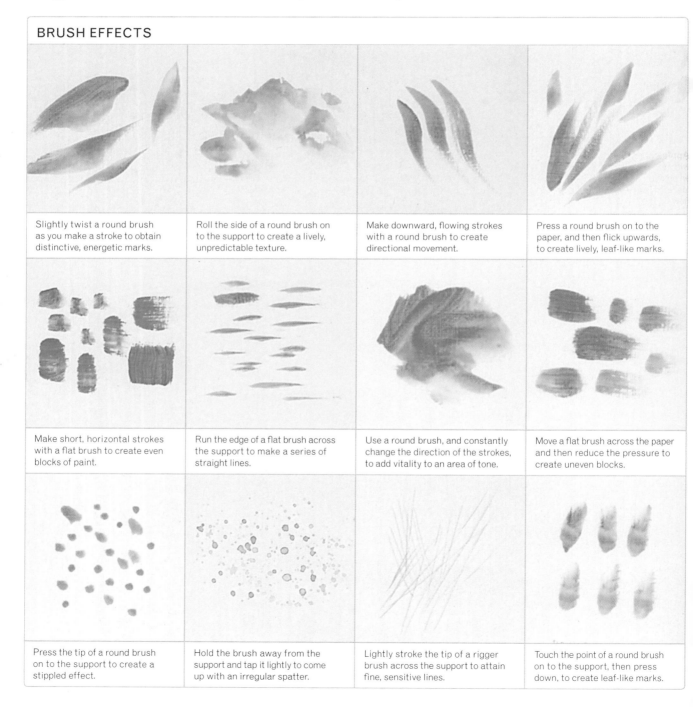

Slightly twist a round brush as you make a stroke to obtain distinctive, energetic marks.

Roll the side of a round brush on to the support to create a lively, unpredictable texture.

Make downward, flowing strokes with a round brush to create directional movement.

Press a round brush on to the paper, and then flick upwards, to create lively, leaf-like marks.

Make short, horizontal strokes with a flat brush to create even blocks of paint.

Run the edge of a flat brush across the support to make a series of straight lines.

Use a round brush, and constantly change the direction of the strokes, to add vitality to an area of tone.

Move a flat brush across the paper and then reduce the pressure to create uneven blocks.

Press the tip of a round brush on to the support to create a stippled effect.

Hold the brush away from the support and tap it lightly to come up with an irregular spatter.

Lightly stroke the tip of a rigger brush across the support to attain fine, sensitive lines.

Touch the point of a round brush on to the support, then press down, to create leaf-like marks.

APPLYING STROKES

A few uncomplicated mark-making techniques can be used to create simple images. Try out the individual marks that are painted on this page, and then put them together to make a vase, a hedgehog, and a tree.

Use a round brush to make the splodges for the hedgehog's head, body, and features, and then suggest the spines with a rigger.

Apply calligraphic strokes with a round brush to suggest an ornate vase. Hold the brush loosely so the brushstrokes flow rhythmically.

Use simple dabs of a moist sponge and the splatter from a toothbrush to give the impression of foliage. Then add the tree trunk with a rigger.

Fast-drying acrylics

Acrylic paints dry fast. This means you can rework areas of your painting almost immediately. But beware – the paints on your palette also dry out exceptionally quickly. And once dried, they are useless. So it is best to use a stay-wet palette – this has a damp layer under the mixing surface to keep the paints moist. You can buy a stay-wet palette at art shops or make one yourself.

HOW TO MAKE A STAY-WET PALETTE

It's easy to make your own stay-wet palette to the exact size you want. All you need is a shallow plastic tray, capillary matting (available from a flower shop or garden centre), baking parchment, and clingfilm. Many artists like mixing colours on the brown colour of baking parchment – but if you prefer a white surface, use greaseproof paper instead of baking parchment.

Shop bought A stay wet-palette bought from a shop usually comes with a white mixing surface.

MAKING A STAY-WET PALETTE

For the bottom layer of your stay-wet palette, cut the capillary matting to the size of your tray. Then tuck it snugly into the tray.

Pour water on to the matting and then press it down to ensure that the water is fully absorbed and evenly distributed.

When the whole of the matting darkens with the water, cover it completely with three layers of kitchen towel.

Press the layers of kitchen towel down on to the matting with your hands. Don't worry if the kitchen towel becomes wrinkled.

Cut the baking parchment to a slightly larger size, so that it covers the walls of the tray. Then press it down over the kitchen towel.

Now you can mix paints on the parchment. When you take a break, cover the palette with clingfilm so the paints don't dry out.

PAINTING OVER THE TOP OF ACRYLICS

As acrylics dry so quickly, it is easy to correct mistakes almost instantly. So that you can cover areas you want to change, make sure you add white to your mixes to obtain paint mixes that are completely opaque.

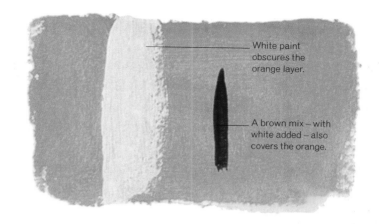

White paint obscures the orange layer.

A brown mix – with white added – also covers the orange.

Covering up Here, you can see how an orange layer of paint has been obscured with white paint and a brown opaque mix.

REWORKING A PAINTING

This still life study shows how easily you can repaint acrylics. The initial painting is on the left, and the finished reworked painting on the right. The artist simply waited a minute or two for the colours to dry and then repainted parts of the image she wanted to change.

The pale lilac has been painted over the rather unsightly pear stalk.

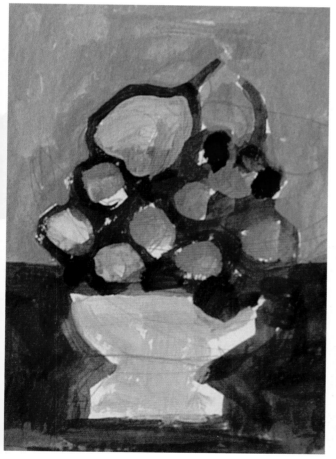

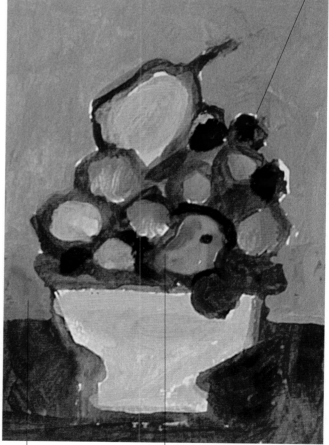

The pale lilac of the background has been extended down, over the tabletop, so that the bowl of fruit stands out more prominently.

An orange has been added on top of the green fruit to give a bright focal point.

Colour mixing with acrylics

It is important to understand how the six main colours, namely red, purple, blue, green, yellow, and orange, relate to each other. The three primary colours – red, blue, and yellow – cannot be mixed from any other colours. When two primary colours are mixed together, they produce a secondary colour: purple, green, or orange (see pp.138–145). Try mixing pairs of primary colours on scrap paper before you start.

MIXING TWO PRIMARY COLOURS

When you mix pairs of primary colours together you create various sorts of secondary colours depending on the pigments you use. For vibrant secondary colours, use pigments that are close to each other on the colour wheel. For instance, if you want a sharp, bold green, mix a greenish blue and a greenish yellow. For a subtler green, choose pigments that are farther away from each other on the colour wheel – so use a purplish blue and an orangey yellow.

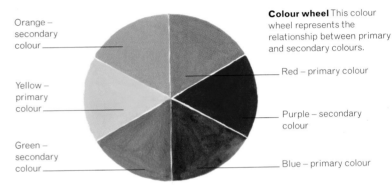

Orange – secondary colour

Yellow – primary colour

Green – secondary colour

Colour wheel This colour wheel represents the relationship between primary and secondary colours.

Red – primary colour

Purple – secondary colour

Blue – primary colour

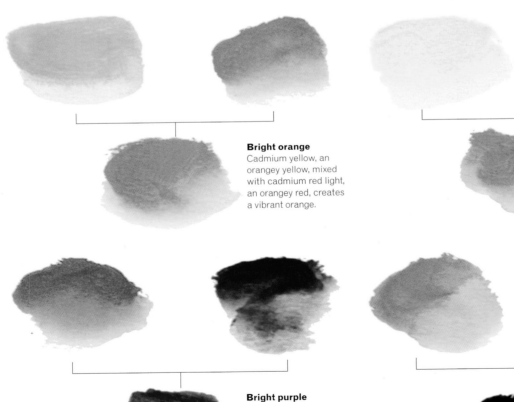

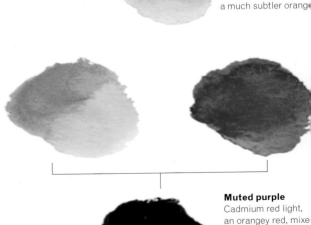

Bright orange
Cadmium yellow, an orangey yellow, mixed with cadmium red light, an orangey red, creates a vibrant orange.

Muted orange Yellow light hansa, a greenish yellow, mixed with cadmium red deep, a purplish red, produces a much subtler orange

Bright purple
Cadmium red deep, a purplish red, mixed with French ultramarine, a purplish blue, creates a vibrant purple.

Muted purple
Cadmium red light, an orangey red, mixe with phthalo blue, a greenish blue, create a much subtler purpl

METHODS OF MIXING PAINTS

If the manufactured colour is not exactly what you want, you will have to add another colour to change the hue. There are three basic ways of mixing paint. Mixing on the palette is the safety-first method: you make sure you get exactly the right colour before applying it. Mixing on the support is a quicker approach, and it encourages spontaneity. Mixing on the brush is for the adventurous. The colours don't blend evenly, so you'll get some exciting passages of paint.

HOW TO MIX ON THE PALETTE

Squeeze out blue and yellow on your palette. Use a brush to move some yellow.	Pick up some blue and stir it into the yellow. Add more blue or yellow until you get the colour you require.	Continue mixing the colours with the brush until they are completely blended.	You are now ready to apply the mix to the painting, knowing you have the exact colour you want.

HOW TO MIX ON THE SUPPORT

With your brush, apply a generous amount of yellow directly on to your support.	Load your brush with blue and apply it on to the yellow with a stroking motion.	Blend the two colours with vigorous turns of the brush. Adjust the colour by adding more yellow or blue.	The final green mix is actually on your painting, ready to be stroked into the subject matter you want.

HOW TO MIX ON THE BRUSH

With a twisting motion, roll the brush into the yellow paint without touching the blue paint.	With the brush loaded with yellow, gently roll it into the blue so you get both colours on the brush.	Apply the paint on to the support. Be prepared for some spontaneous colour effects.	The colours do not evenly mix, creating wonderful strokes that go from yellow to green to blue.

Neutrals and darks

The colour wheel consists of an array of pure, bright colours because there are never more than two primary colours mixed together. However, you also need dark, neutral colours in your painting. These can be attained by mixing two complementary colours together – the complementary of any secondary colour is the primary colour that it does not contain – or by mixing all three primary colours together.

COMPLEMENTARY COLOURS

On the colour wheel (*see p. 256*), you can see that red is opposite green, yellow is opposite purple, and blue is opposite orange. These opposites are known as complementary colours.

Placed side by side in a painting, complementary colours seem to become more vibrant and intense, but when they are mixed together they create subtle greys and browns.

Yellow and purple

The muted spine of the book is a mix of purple and yellow.

The yellow book stands out against the purple background.

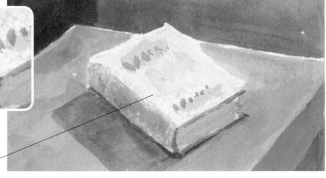

Blue and orange

The muted hull of the boat is a mix of blue and orange.

The orange sail stands out against the blue water and sky.

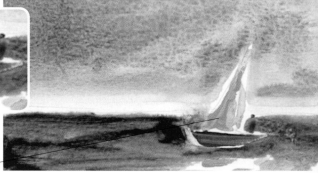

Red and green

The muted darker foliage is a mix of red and green.

The red flowers stand out against the green foliage.

DARKS WITH PRIMARY COLOURS

It is possible to buy black and brown acrylic paint, but you will get far more satisfying results by mixing all three primary colours in varying proportions. This method enables you to mix a much more lively range of blacks and browns than you could ever get in the shops.

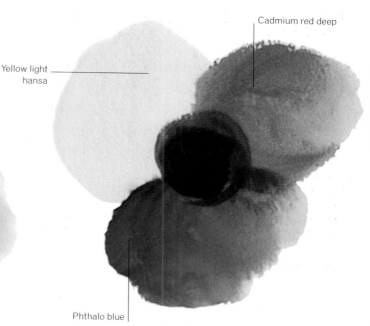

Yellow light hansa

Cadmium red deep

Phthalo blue

Transparent black Yellow light hansa and phthalo blue are transparent colours which, when mixed with the cadmium red deep, produce a transparent black.

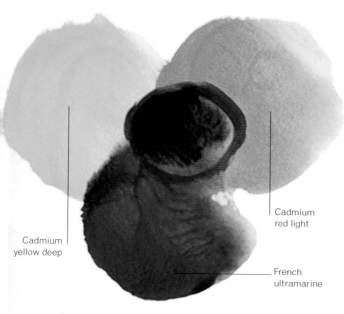

Cadmium yellow deep

Cadmium red light

French ultramarine

Warm brown The opaque quality of the cadmium yellow deep, mixed with the cadmium red light, dominates the French ultramarine to make a dark brown.

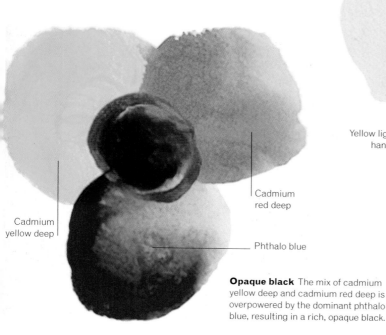

Cadmium yellow deep

Cadmium red deep

Phthalo blue

Opaque black The mix of cadmium yellow deep and cadmium red deep is overpowered by the dominant phthalo blue, resulting in a rich, opaque black.

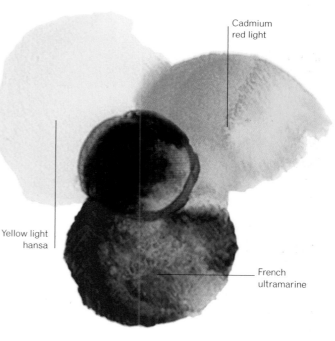

Cadmium red light

Yellow light hansa

French ultramarine

Transparent brown The combination of yellow light hansa, cadmium red light, and French ultramarine results in a warm transparent brown.

Lightening and darkening

Paint mixing is not just about getting the right colour, it's also about getting the right shade. So once you have mixed a colour, you may need to lighten or darken it. To lighten, simply add water, which increases the transparency of the paint, or add white paint, which makes the paint more opaque. To darken, mix in the complementary colour. But beware, the colour varies depending on the complementary you use. For example, phthalo blue darkens indo orange in a different way to French ultramarine.

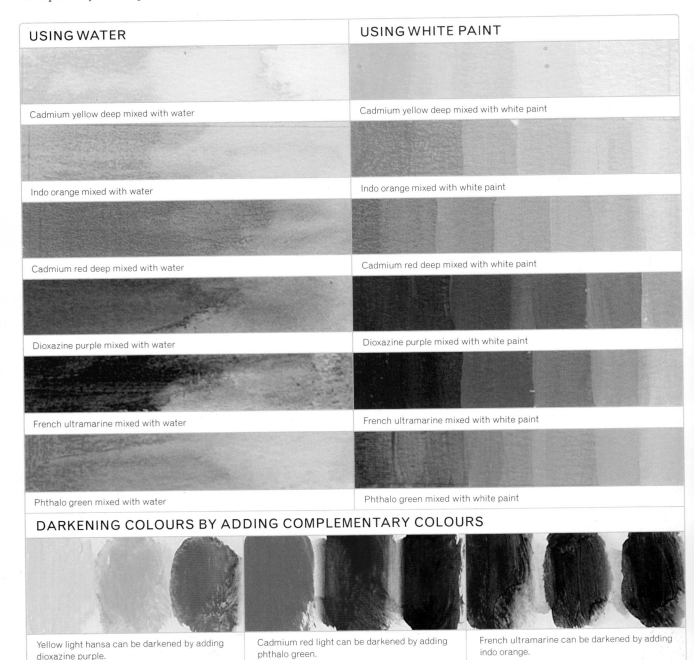

USING WATER

Cadmium yellow deep mixed with water

Indo orange mixed with water

Cadmium red deep mixed with water

Dioxazine purple mixed with water

French ultramarine mixed with water

Phthalo green mixed with water

USING WHITE PAINT

Cadmium yellow deep mixed with white paint

Indo orange mixed with white paint

Cadmium red deep mixed with white paint

Dioxazine purple mixed with white paint

French ultramarine mixed with white paint

Phthalo green mixed with white paint

DARKENING COLOURS BY ADDING COMPLEMENTARY COLOURS

Yellow light hansa can be darkened by adding dioxazine purple.

Cadmium red light can be darkened by adding phthalo green.

French ultramarine can be darkened by adding indo orange.

SKIN TONES

To render skin tones, you need lots of colour mixes in lots of shades. To paint this portrait, for instance, the mixes varied from peachy pinks, to rich dark browns, to golden oranges, to neutral greys as shown in the colour mixes on the right. To attain lighter shades, white paint was added to some of the mixes. For dark and neutral colours, complementary colours were used.

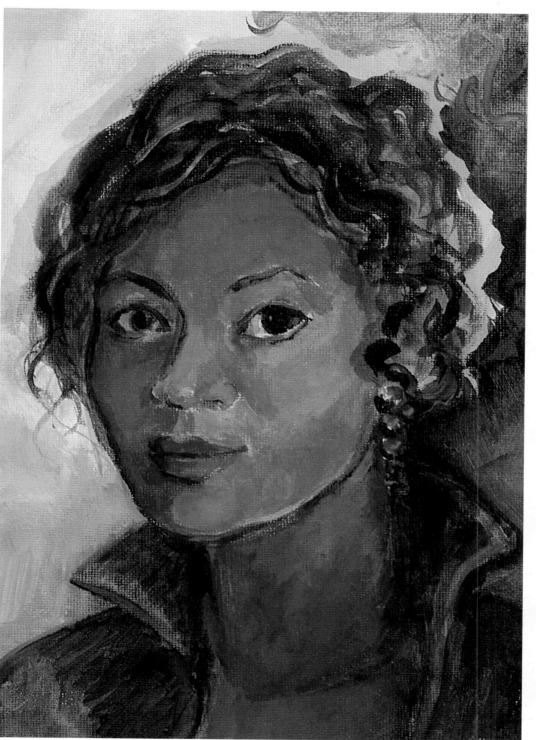

Colour mixes

Indo orange and titanium white

Indo orange, phthalo green, and titanium white

Indo orange, cadmium red deep, French ultramarine, and titanium white

Cadmium yellow deep, indo orange, French ultramarine, and titanium white

Indo orange, French ultramarine, and titanium white

Cadmium red deep, phthalo green, and titanium white

Cadmium red deep, cadmium red light, French ultramarine, and titanium white

Cadmium red deep, cadmium red light, and phthalo green

Cadmium red deep and dioxazine purple

Glazing

Glazing involves painting a transparent wash over dry paint, so the colour of the underlying layer is modified. In effect, it is another way of colour mixing, using two colours to create a third one, with the advantage of adding a magical depth and luminosity to your painting. Acrylics are perfect for glazing. They dry fast, so you can glaze areas quickly and efficiently, and you can build up as many layers of glazes as you want.

UNDERLYING LAYER

Mix French ultramarine with water and apply it to your support with a filbert brush.

Build up your wash by painting overlapping horizontal strokes.

Finish the wash and then wait a minute or two so it dries completely.

FIRST GLAZE

Clean your brush, then paint a vertical stroke of diluted yellow light hansa over the blue.

Continue building up the yellow with overlapping vertical strokes.

The blue shimmers through the yellow, creating a soft, yellowish green.

SECOND GLAZE

Clean your brush again, then paint diluted cadmium red deep over the first two washes.

Continue building up the red wash with overlapping horizontal strokes.

The red over the blue creates purple while the red over the yellowish green creates orange.

FINAL GLAZE

Clean your brush again and add diluted phthalo blue on top of the orange.

Paint a small square of phthalo blue on top of the orange.

The resulting colour is a dark, muted green, perfect for shadow areas.

BLUE ON BLUE

Paint a horizontal wash of French ultramarine, let it dry, then paint dilute phthalo blue on top.

Extend the phthalo blue wash with overlapping vertical strokes.

Together the two colours create an aquamarine, ideal, for example, for a swimming pool.

YELLOW ON BLUE

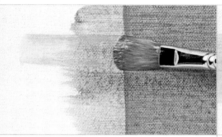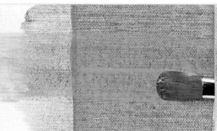

Let the phthalo blue dry, then apply dilute yellow light hansa over the two underlying layers.

Build up the yellow light hansa with overlapping horizontal strokes.

The yellow combines with the blue underlying layers to create muted yellowish greens.

USING GLAZING

Here, glazes are used to create the patterning on the goldfish. Moreover, building up dark glazed areas, using layers of indo orange and medium magenta, creates shadow tones on the fish. This helps suggest their three-dimensional forms.

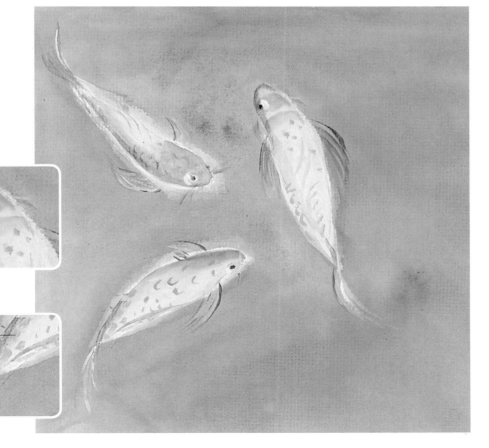

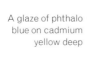

A glaze of indo orange on medium magenta

A glaze of phthalo blue on cadmium yellow deep

Creating textures

A tactile, textured surface can bring a painting alive – and it is easily achieved in acrylics. For subtle textures, use the dry brush technique, which involves applying sticky paint with a delicate touch. For bolder effects, try texture paste, which is usually applied with a painting knife. A lot of texture paste allows you to make sculptural effects. For very fine textures, thin out your paint with painting medium.

DRY BRUSH TECHNIQUE

Dry brushwork lets you attain broken, textured strokes of colour. Mix up sticky paint, with little or no water added, and then lightly brush it across your support. It is best to use a support with a prominent "tooth", such as canvas or rough watercolour paper.

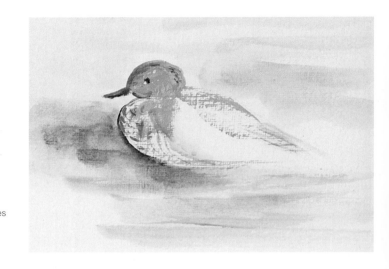

The tooth of the support shows through.

Dry, sticky paint only adheres to the raised parts of the textured support, making it perfect for feathers.

TEXTURE PASTE

For really thick, gungy textures – known as impasto – use texture paste. It can be used directly on your support or added to your paint, and is best applied with a knife. Try it with all kinds of subject matter. When textured, clouds really look three-dimensional and stand out from the sky, and buildings look great if you capture something of their actual texture in the paint.

Texture paste applied directly to the support and then painted over.

Texture paste mixed with paint first and then applied to the support.

Texture paste was added directly to the support with a knife. A blue-green wash was then added over the rock and a thin blue one over part of the foam.

THICK AND THIN

Acrylic is a versatile, tough medium. You can create wonderfully watery textures and then add thick paint on top or start with a thick, opaque layer and superimpose thin washes.

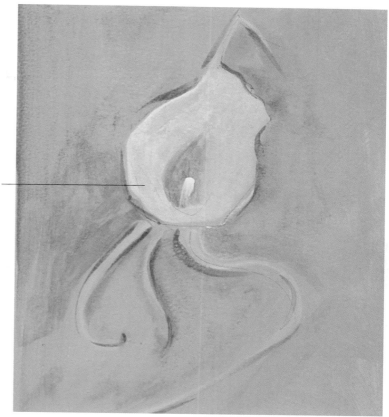

Titanium white, diluted with painting medium, is superimposed on thick paint.

Paint thinned with painting medium creates delicate washes, revealing the background colour.

Thin over thick In the painting on the right, a thick, opaque colour was painted with a mix of phthalo green and light blue. The flower was added with thin layers of semi-transparent colour.

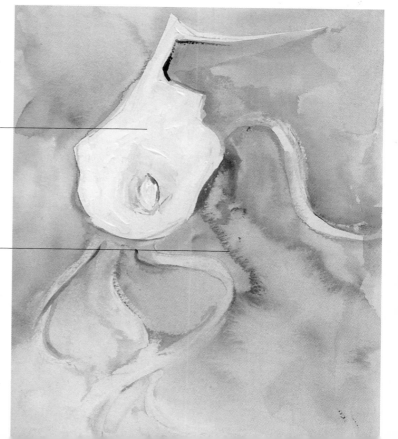

Thick dry paint allows you to create textured brushstrokes.

The flower's form is brought out with thick brushstrokes of titanium white.

The thin initial washes settle into pleasing patterns.

Thick over thin Here highly diluted washes of phthalo green and dioxazine purple were flooded on to the support. The flower was painted with thick, neat titanium white after the background washes had dried.

Composition

It is important to plan a painting before getting started. You need to frame your subject so all the component parts sit comfortably. In particular, you need to be aware of the focal points of your composition, placing them in the centre of your picture can look a little static, while placing them near the edge can look unbalanced. Instead, use the rule of thirds to put them in the most powerful positions.

VIEWFINDER

A basic viewfinder can be made easily by holding two L-shaped pieces of card to form a rectangle in front of your subject. The size and shape of the frame may be altered by moving the pieces of card in and out. The frame that you choose will help dictate the format of paper you use, as seen below.

Move the corners in or out to frame your subject

FORMAT

A vital part of composition is choosing which format – the shape of paper – to use. The three paintings below demonstrate how the format can direct attention to different areas of the painting.

The formats are portrait (vertical rectangle), landscape (horizontal rectangle), and square, but you could also try a circular, oval, or panoramic (long horizontal rectangle) format.

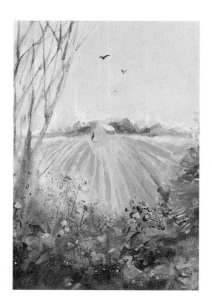

Landscape format Using a horizontal format enables more of the foreground to be included. Our eye lingers longer on the flowers and foliage before moving into the field.

Portrait format The vertical format emphasizes the vertical lines of the ploughed field. So the eye quickly jumps beyond the foreground and into the field.

Square format Here, the eye is attracted to the distant house and solitary figure because they are almost encircled by the trees, bushes, and undergrowth.

USING THE RULE OF THIRDS

When planning your composition, try using the rule of thirds. Use a pencil to divide your support into thirds, both vertically and horizontally, to make a nine-box grid. Then put the important elements of your composition, such as interesting detail or areas of colour contrast, on the four points where the lines intersect. Eventually you won't need a pencil; you will have an instinctive feel for these points of emphasis.

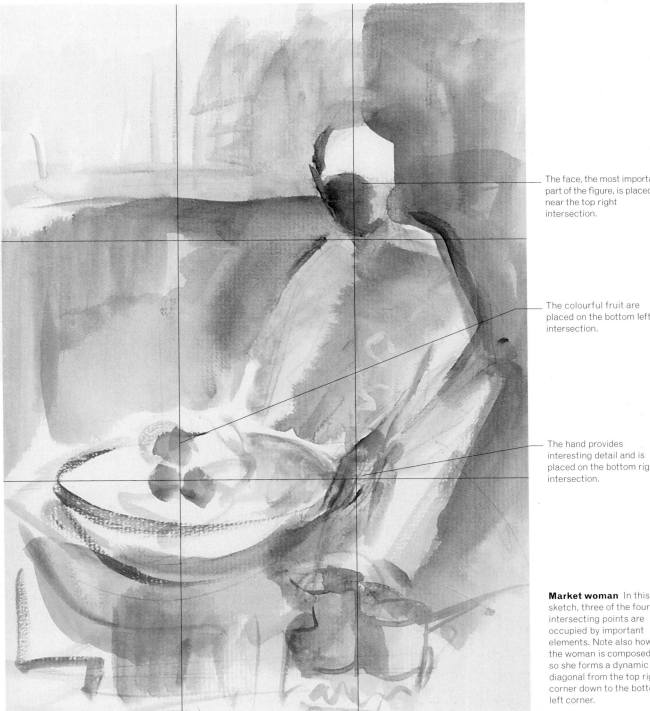

The face, the most important part of the figure, is placed near the top right intersection.

The colourful fruit are placed on the bottom left intersection.

The hand provides interesting detail and is placed on the bottom right intersection.

Market woman In this sketch, three of the four intersecting points are occupied by important elements. Note also how the woman is composed so she forms a dynamic diagonal from the top right corner down to the bottom left corner.

Sketching

Your sketchbook should be your constant companion. Think of it as a visual diary and a place to try out new techniques and new subject matter. No matter where you are, try to record scenes that give you a buzz. Often, you'll only have the chance to jot down a few lines, a simple reminder of a time and a place. If you aren't pressed for time, though, sit down and embark upon a more detailed study. Also sketch straight on to your support in pencil, so you have a guide when beginning your painting.

SKETCHES AND SKETCHBOOKS

Sketchbooks come in all shapes and sizes. Choose one that is small enough to carry around easily, with a sturdy cover to survive the wear and tear of travelling. If you intend to apply washes of colour, make sure it has leaves of thick watercolour paper, not flimsy cartridge paper.

Project sketch

A preliminary sketch for a painting need not be too detailed; an outline drawing is usually enough.

This preliminary sketch for the Boat on the beach project (*see pp.110–115*) was drawn directly on to the support before painting began.

Field sketch

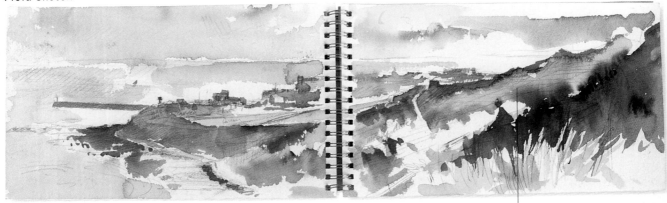

You can paint over the spine of your sketchbook to attain a dramatic panoramic format, ideal for coastal landscapes.

Colour washes were added quickly, creating a wonderfully lively sketch.

USING SKETCHES

Sketches provide great reference material for paintings. And they have one big advantage over photographs: they force you to start making decisions about your final image. Which elements of the composition are you going to include? Which will you leave out? What colours will you emphasize? Photographs tell all, sketches force you to be selective.

Pencil sketch

Think about the format of the composition when completing a sketch. This format is almost square and it keeps the eye within the bay.

Colour sketch

If you have time, add washes of paint to your sketch. They don't have to look finished, they are simply colour "notes" you can refer to later.

Final painting

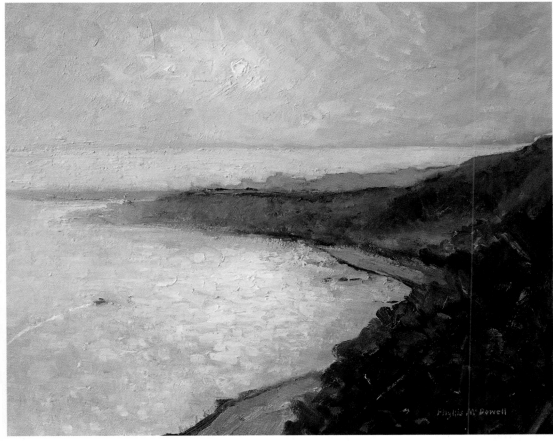

The foreground shadow tones are built up in blues, greens, and purples.

In the final painting, the artist included more sky to entice the eye to wander out to the horizon. Don't feel tied down to your sketches; they are a jumping-off point, not the finished work.

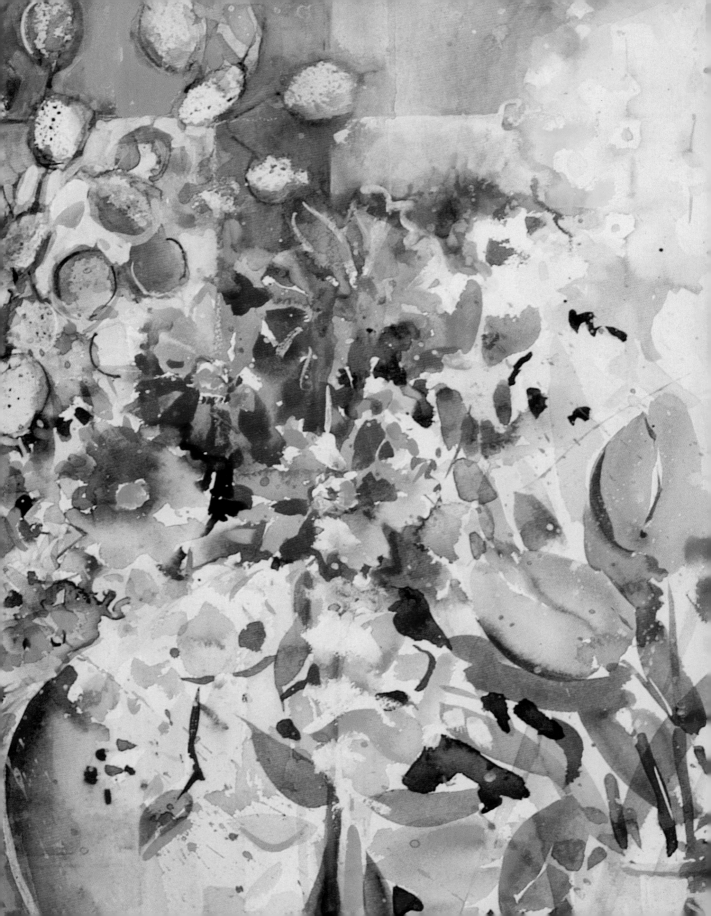

Colour with
Acrylics

Phyllis McDowell

"Colours have a powerful
effect on mood: use them
to stimulate or soothe."

Choosing colour

Colour is a means of expression for the painter, and has a direct effect on emotions. In selecting a colour scheme for your painting, you can choose whether to stimulate or to soothe. It is important to select colours and set the mood before you start to paint.

Limiting your palette will ensure a harmonious result, whereas trying to copy every colour that you see before you is likely to result in discord. In fact a painting can be worked successfully using just one pair of complementary colours.

COMPLEMENTARY COLOURS

Once colours are applied to the painting, they react with each other and change according to where they are placed. Trying to incorporate too many colours into one work results in chaos. It is best to be selective and choose one pair of complementary opposites – blue and orange, red and green, or yellow and purple. Placed side by side, the colours will enhance each other. Mixing the two in varying proportions ensures an endless range of subtle and muted colours.

Blue and orange

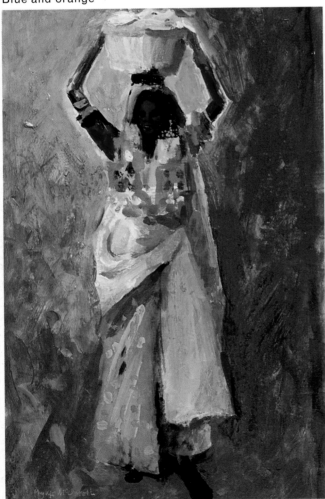

The vibrant blue background contrasts wonderfully with the complementary orange of the water carrier's sari.

Yellow and purple

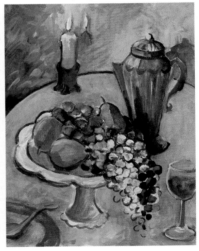

Yellow is a reflective colour and creates areas of brightness in this painting, which uses only one pair of complementary colours to produce a striking still life.

Red and green

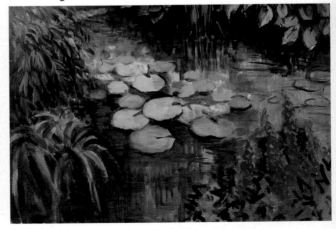

Red spikes of flowers in the foreground of this painting enhance the complementary greens of the lily pads.

ANALOGOUS COLOURS

Colours that lie close together on the colour wheel (see p.256) are called analogous; they slide gently, almost imperceptibly around a small section of the colour wheel, and are naturally harmonious. The colours yellow, orange, and red are examples of analogous colours. Even though these are stimulating in their own right, a touch of a pure blue-green placed on top of the glowing warmth will add an extra "zing". Cool green, blue, and blue-violet are other examples of analogous colours that create a feeling of peace and tranquillity.

Yellows and reds These colours tend to blend together visually when used next to each other and create a harmonious effect that is, at the same time, warm and dominant.

Blues and greens These analogous colours form the basis of the painting below. Darker strokes are achieved by adding a thick impasto on top of a thin layer of paint.

Harmonious hues A limited palette of blues and greens creates a tranquil evening light. The figure dressed in blue harmonizes with the surrounding analogous colours and adds to the gentle mood of the painting.

A touch of a warmer colour on the fence brings out the coolness of the other colours.

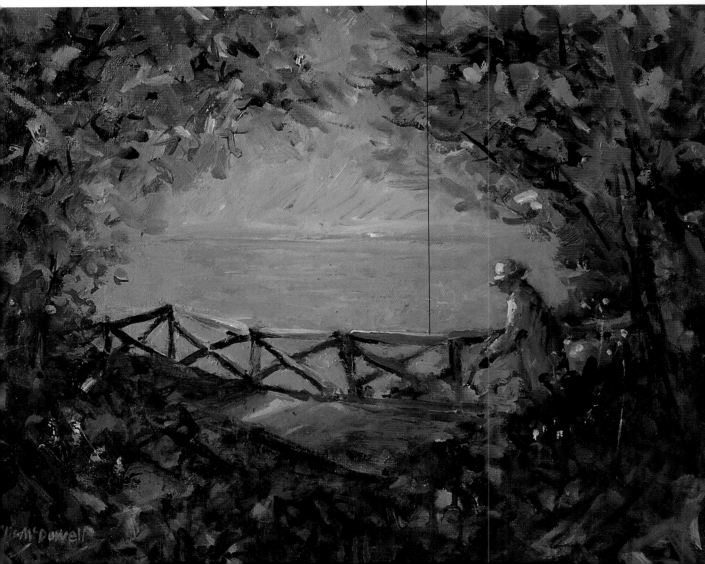

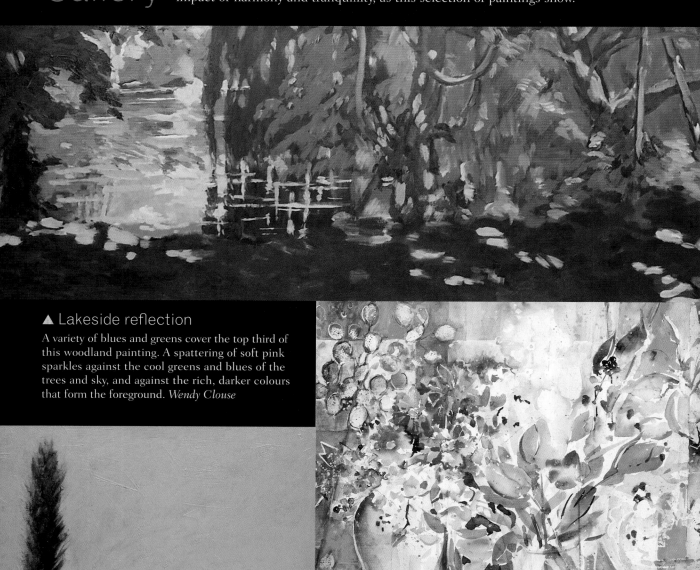

impact or harmony and tranquillity, as this selection of paintings show.

▲ Lakeside reflection

A variety of blues and greens cover the top third of this woodland painting. A spattering of soft pink sparkles against the cool greens and blues of the trees and sky, and against the rich, darker colours that form the foreground. *Wendy Clouse*

◄ Golden valley

Vibrant colours are used for dramatic effect in this uncluttered painting of a rural landscape. The warm, golden orange used for the fields in the foreground is intensified by the complementary violet shadow, which is cast diagonally across it. *Paul Powis*

▲ Honesty and tulips

The interplay of primary and secondary colours gives this painting vitality. Complementary red and green seem to vibrate, while the combination of violet and yellow, and blue and orange, produce a subtle foil for the strong primary colours. *Phyllis McDowell*

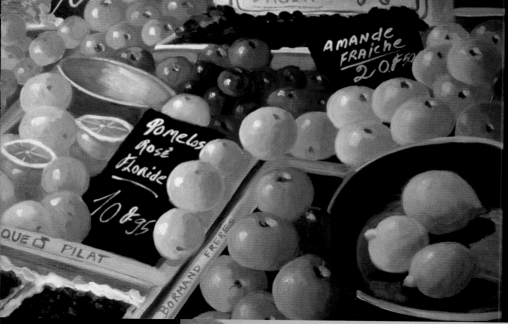

◀ Pomelos II

This arrangement of fruit displayed on a French market stall shows colour at its most lucious. The soft green of the apples in the foreground enhances the warmth of the oranges, reds, and yellows that make up the rest of the composition. *Dory Coffee*

Lac St Croix ▶

The intense ultramarine blue band of colour representing water is a restful foil for the orange rooftops, which stand out strongly against the blue backdrop. The same colours are used for the hills in the background but reduced in intensity to create the effect of distance. *Clive Metcalfe*

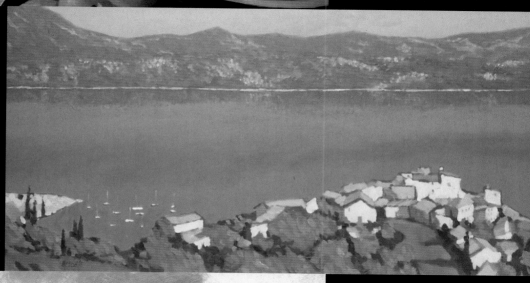

◀ Kingsdown II

An analogous colour scheme has been selected for this painting. The blues and greens, which lie close to each other on the colour wheel, create a cool mood, which is given greater intensity by the strategic placement of warm yellows. *Clive Metcalfe*

25 Flowers in a vase

In this painting the colour and vitality of flowers, rather than their botanical accuracy, is captured with a variety of brushstrokes. These brushstrokes are made with both a light and a heavy touch. Areas of bright orange and red are offset by the use of cool blues within the floral arrangement, and this complementary colour scheme is echoed in the watery background colours. The contrasting geometric form of the vase is suggested with graded colour. Glazes are used to add more depth to the flowers and to suggest shadows on the tabletop.

EQUIPMENT

- Watercolour paper – cold-pressed
- Brushes: No. 6 and No. 8 flat bristle, No. 8 and No.12 round, No. 1 rigger
- 2B Pencil
- Painting medium
- Indo orange, cadmium yellow deep, cadmium red deep, titanium white, light blue, phthalo blue, medium magenta

TECHNIQUES

- Glazing
- Spattering

SKETCH THE COMPOSITION

The pencil marks will not be seen in the finished painting.

Lightly sketch the outlines of your composition to position the vase and the shape of the flowers. There is no need to draw each individual flower in great detail at this stage.

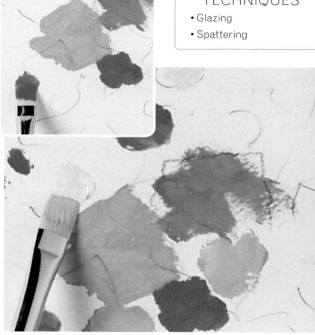

1 Paint the first flower with indo orange and painting medium and the next with cadmium yellow deep and painting medium, using the No. 6 flat bristle brush. Mix indo orange and cadmium red deep for smaller flowers, then add increasing amounts of titanium white for further flowers.

BUILDING THE IMAGE

 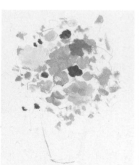 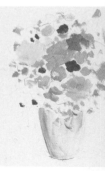

2 Mix titanium white with light blue to paint large flowers using the No. 8 flat bristle brush. Add phthalo blue to the mix to scumble smaller areas. Mix a violety pink mix from medium magenta and titanium white and use for small flowers, and for the centre of the front blue flower.

GLAZING

When glazing, make sure your water does not contain any white paint, to ensure the glaze is transparent.

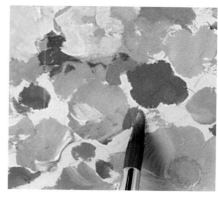

3 Glaze the vase with a mix of phthalo blue and painting medium. Wet the paper on the left side next to the flowers using a clean brush. Paint wet-in-wet with light blue – to give a soft edge to the colour.

4 Paint wet-in-wet next to the vase with light blue. Continue to paint the background with colours drawn from those in the bouquet. Use the violety pink mix and then a mix of magenta and indo orange wet-in-wet.

5 Mix phthalo blue and light blue and use to fill gaps in the bouquet and suggest leaves and stems with the No. 12 round brush. Paint the centre of the orange flower with light blue and the No. 8 round brush.

6 Add some form to the flowers by glazing over parts of them with a mix of light blue and titanium white with added painting medium. Use this mix too around the edge of some flowers to define them.

7 Use a grey mixed from the complementary colours – phthalo blue and indo orange – at the bottom of the vase. Add painting medium to the mix to paint the dappled shadow on the table.

8 Add dots with the mix of phthalo blue and light blue. Add stems using the grey mix and the No. 1 rigger brush. Outline areas of white with this mix to create small flowers. Add more fine stems using the light blue mix.

9 Paint the dark centre of the bright orange flower with phthalo blue. Counterbalance this centre by adding a few dark areas lower down in the bouquet with phthalo blue. Spatter phthalo blue with the No. 8 round brush.

Flowers in a vase ▶

This flower painting has an effervescent, joyful quality because it is executed quickly and spontaneously. Leaving some of the paper untouched allows the white paper to sparkle, in contrast with the bright colours.

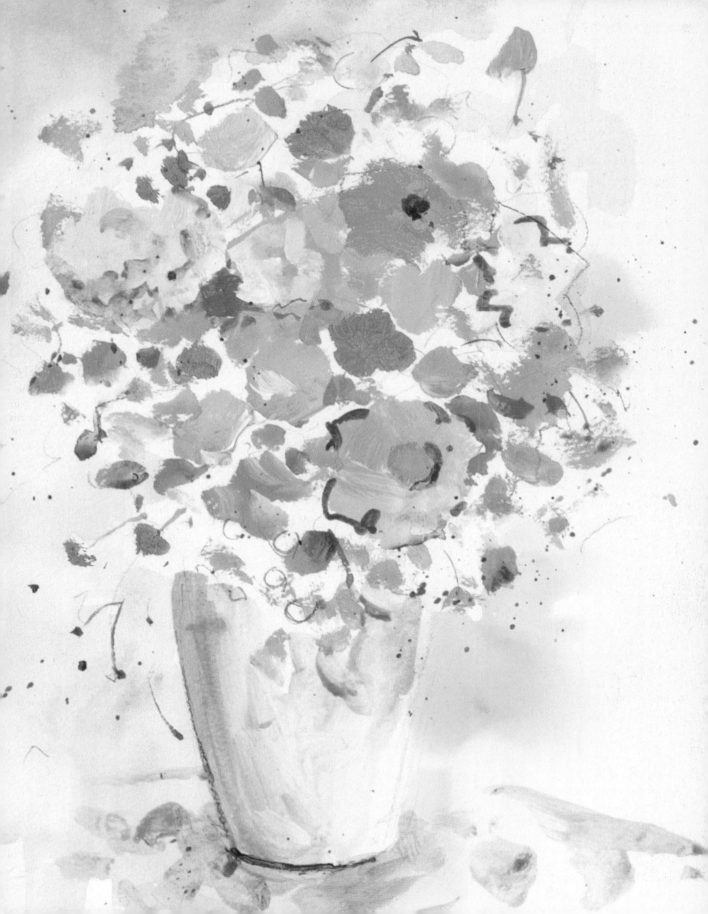

26 Rocky seascape

In this painting of sea and rocks, a range of analogous colours is used to create a harmonious, tranquil impression. Lightening the ultramarine blue used for the sky as it reaches the horizon, conveys a feeling of distance. Painting medium is blended with the blues and greens to create an underpainting for the sea. Once this underpainting is dry, the same cool colours and painting medium are applied as glazes to give an impression of the sea's watery depths. The dash of orange-red, depicting the flag on the boat, sings out and adds intensity to the analogous colour scheme.

EQUIPMENT
- Watercolour paper – cold-pressed
- Brushes: No. 8 and No. 12 round, No. 1 rigger
- 2B pencil
- Painting medium
- French ultramarine, phthalo green, light blue, titanium white, cadmium red light, phthalo blue, yellow light hansa, indo orange

TECHNIQUES
- Wet-in-wet
- Glazing

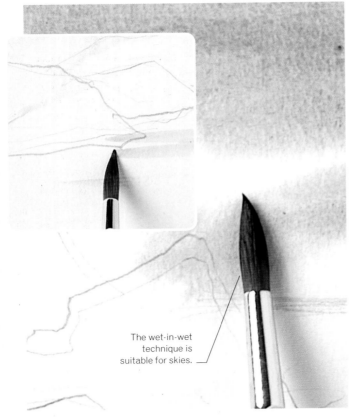

The wet-in-wet technique is suitable for skies.

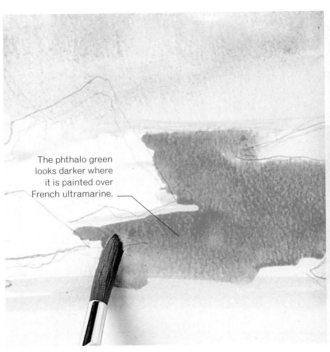

The phthalo green looks darker where it is painted over French ultramarine.

1 Sketch out your composition with a 2B pencil. Wet the sky with the clean, wet No. 12 round brush and paint, wet-in-wet, a wash of French ultramarine. Flick horizontal lines of French ultramarine over the dry paper of the sea.

2 Paint the sea with phthalo green using the No. 12 round brush. Mix the phthalo green with more water and paint the lower part of the sea so that the colour is gradually graded from top to bottom.

BUILDING THE IMAGE

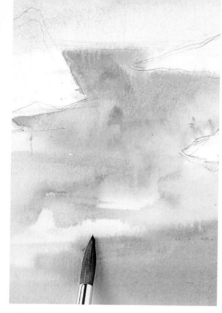

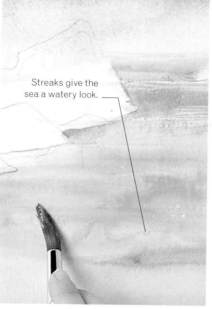

Streaks give the
sea a watery look.

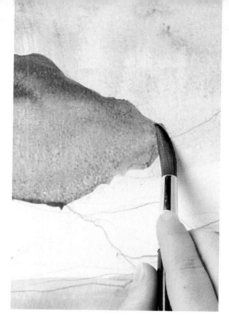

3 Paint streaks of phthalo green at the
bottom of the painting. Mix light blue
and titanium white for higher streaks over
the sea. Add a line of titanium white
at the horizon so it appears to recede.

4 Mix painting medium with phthalo
green and titanium white and glaze
this over the sea. Use less titanium
white in the mix as you reach the
bottom of the painting for a richer glaze.

5 Paint the distant hills with a mix of
French ultramarine, cadmium red
light, light blue, and titanium white.
Add a little phthalo green to paint the
hills on the left, which are nearer.

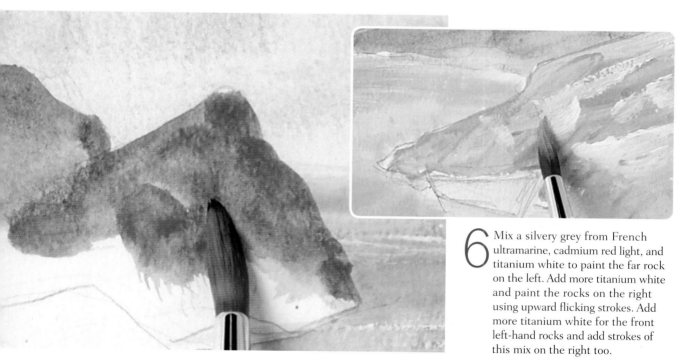

6 Mix a silvery grey from French
ultramarine, cadmium red light, and
titanium white to paint the far rock
on the left. Add more titanium white
and paint the rocks on the right
using upward flicking strokes. Add
more titanium white for the front
left-hand rocks and add strokes of
this mix on the right too.

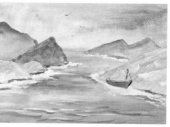

7 Paint a dark line of phthalo green at the base of the rocks. Paint thick dabs of titanium white for the breaking waves at their base. Darken the front left rock slightly with the silvery grey mix with added titanium white. Use the No. 1 rigger and titanium white to add more foam and highlights.

8 Paint the boat rim with phthalo blue and yellow light hansa. Paint the side with French ultramarine, adding titanium white for the lower part. Use French ultramarine and cadmium red light for the shadow on the far side of the boat and the mast.

9 Add some phthalo blue under the waves to define them. Glaze the sea with a mix of phthalo green and painting medium to add depth. Add a glaze of French ultramarine and painting medium at the bottom of the painting.

"Layering adds to the impression of depth."

10 Add more French ultramarine to the right sky. Mix phthalo green, cadmium red light, and French ultramarine and, using the No. 8 round brush, paint three seagulls of varying size in the sky; the smaller seagulls appear to be farther away. Paint above these marks with titanium white.

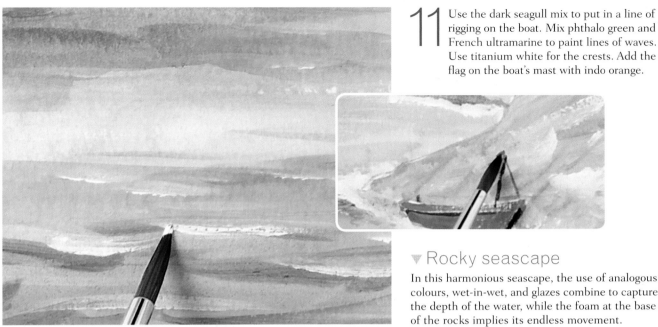

11 Use the dark seagull mix to put in a line of rigging on the boat. Mix phthalo green and French ultramarine to paint lines of waves. Use titanium white for the crests. Add the flag on the boat's mast with indo orange.

▼ Rocky seascape

In this harmonious seascape, the use of analogous colours, wet-in-wet, and glazes combine to capture the depth of the water, while the foam at the base of the rocks implies its endless movement.

27 Garden arch

A garden of flowers is a visual delight that may be easier to paint if a man-made structure is incorporated into the composition. In this painting, the archway and rustic wall provide the framework for this balmy, tranquil scene. Analogous and complementary colours are used to depict the flowers that run riot against the passive, neutral-coloured wall. The colours used in the background are lighter and less distinct, giving an impression of space. Sponging is used to good advantage for areas of foliage, while painting wet-in-wet creates a soft, muted feel.

EQUIPMENT

- Textured mountboard
- Brushes: No. 8 and No. 12 round, No. 2 and No. 10 flat bristle, No.1 rigger
- 2B pencil or charcoal stick
- Sponge
- Painting medium
- Yellow light hansa, titanium white, dioxazine purple, phthalo green, light blue, cadmium red light, phthalo blue, cadmium yellow deep, indo orange, cadmium red deep, medium magenta, French ultramarine

TECHNIQUES

- Sponging
- Wet-in-wet

ANALOGOUS COLOURS

Analogous colours are naturally harmonious and can help to establish the mood of a painting. Here, warm yellows, oranges, and reds have been chosen to enhance the sparkle of the flowers.

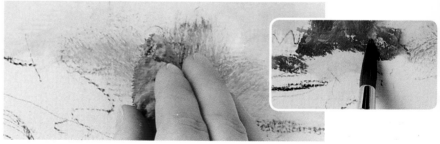

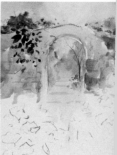

1 Sketch your composition with pencil or a charcoal stick. Paint the sky with a mix of yellow light hansa and titanium white, using the No. 12 round brush. Add dioxazine purple to the mix and blend into the sky.

2 Mix phthalo green, dioxazine purple, and a touch of titanium white to suggest the foliage behind the wall using the No. 12 round brush. Use a sponge to dab and smudge on the same mix of phthalo green, dioxazine purple, and titanium white.

BUILDING THE IMAGE

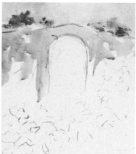
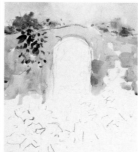
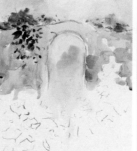

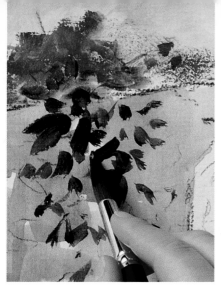
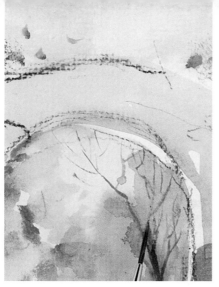

3 Paint the wall with a wash of light blue, dioxazine purple, and a little cadmium red light. Add phthalo green to the mix for foliage on the wall. Paint the dark leaves with a mix of phthalo green and phthalo blue. Add yellow light hansa for lighter ones.

4 Paint the arch with yellow light hansa and dioxazine purple. Add foliage, wet-in-wet, with phthalo green and a phthalo green and dioxazine purple mix, and let this dry. Use the No. 1 rigger and the foliage mix with added light blue for the tree.

5 Paint the wall's shadow and stones with dioxazine purple and phthalo green. Add flowers with a cadmium yellow deep and titanium white mix, indo orange, a cadmium yellow deep and indo orange mix, cadmium red light, and cadmium red deep.

6 Paint the foreground with cadmium yellow deep. Add further colour with a mix of light blue and titanium white. Paint thicker dabs of cadmium yellow deep and titanium white for flowers in the middle ground.

7 Use the No. 12 round brush to suggest flowers on the right with watery medium magenta. Mix phthalo green and light blue to suggest foliage. Mix medium magenta with titanium white to add dabs of opaque colour for a sense of dimension.

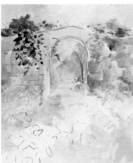
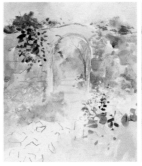
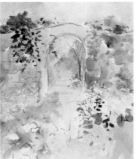
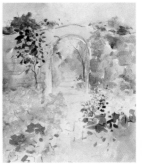

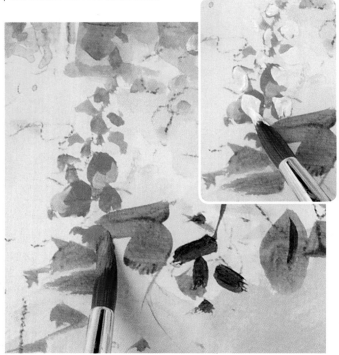

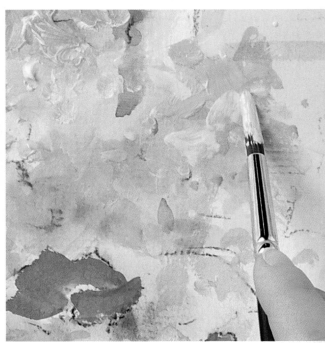

8 Paint leaves with a watery mix of phthalo green and yellow light hansa. Add cadmium red light to this mix for leaves on the right. Use French ultramarine and titanium white for flowers, add dots of titanium white, and let dry. Finish with dots of French ultramarine mixed with painting medium.

9 Wet the foreground on the left and paint flowers and leaves wet-in-wet with phthalo blue and phthalo green. Add more flowers with medium magenta, and a titanium white and light blue mix. Move to the right to paint flowers with cadmium red deep and cadmium red light.

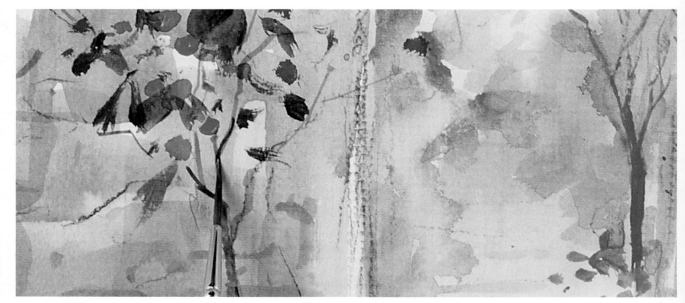

10 Suggest leaves and stems with phthalo green and light blue using the No. 1 rigger. Add cadmium red deep for detail lower down the wall. Put shadow behind the left-hand yellow flowers with dioxazine purple and phthalo green. Soften the edge of the yellow flowers on the left with a mix of light blue and titanium white. Add watery phthalo green over the top of the yellow flowers on the right.

Garden arch ▶

This painting of vibrant summer flowers, basking against a neutral wall under a golden sky, is organized to lead the eye through the archway, and into an area where the imagination can come into play.

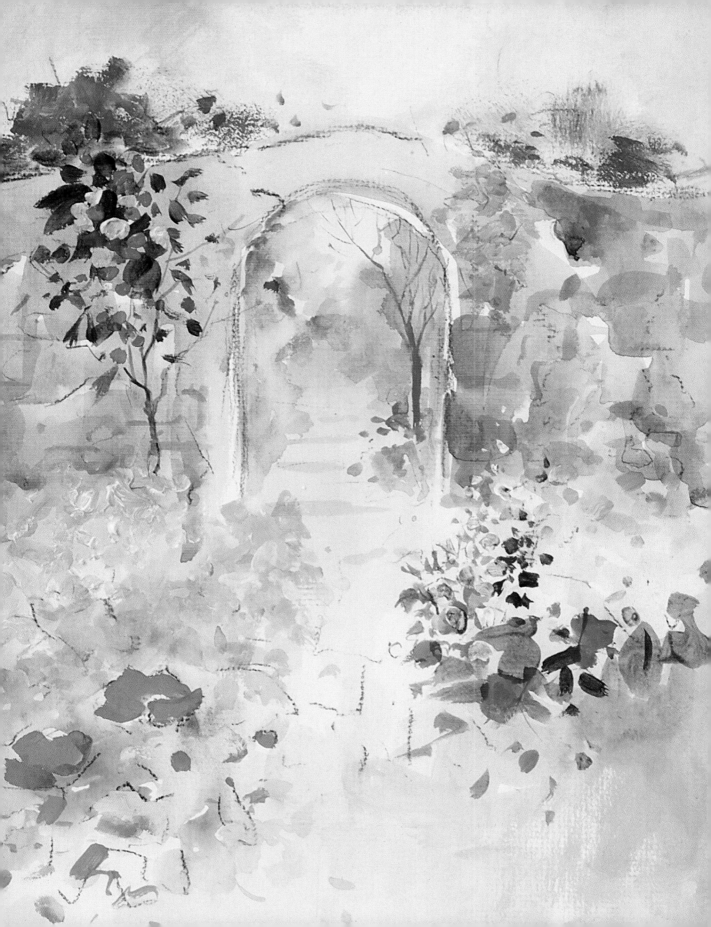

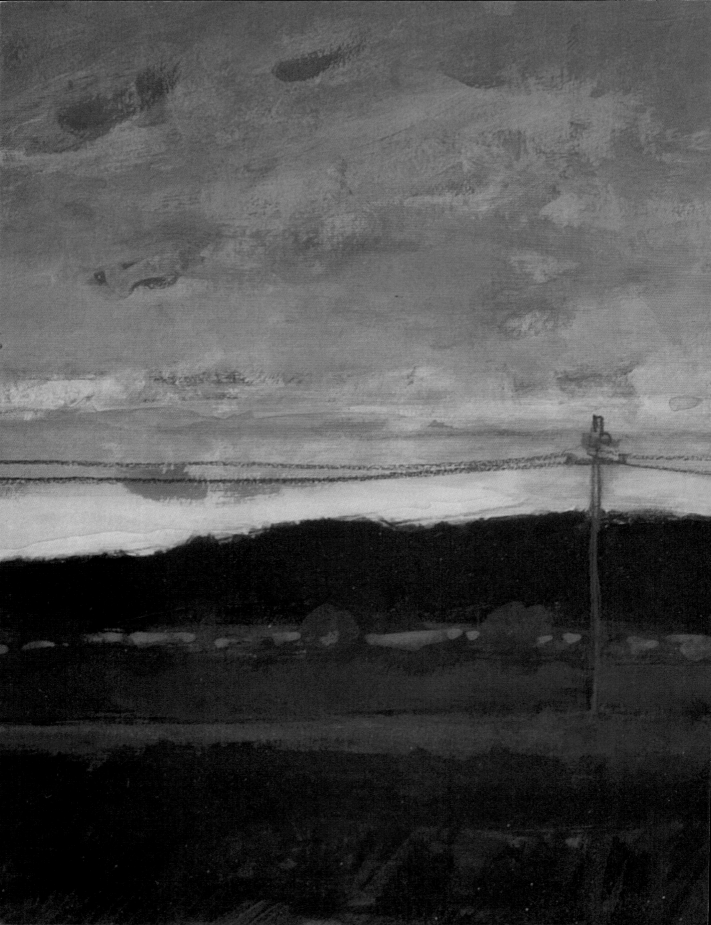

Light with Acrylics

"Plan your lighting:
use it to give shape,
colour, and form."

Working with light

The way you use light will have a major impact on your painting. The direction of light – whether the source is from behind, in front of, or from the side of the subject – alters the appearance of colours, detail, and texture. Lighting can also influence mood. Light is easier to control if it is artificial – from a lamp or candle, for example. Natural light is constantly changing, in both its quality and direction. So, if you are using natural light, try to work within a time limit to minimize the effects of changing light conditions.

DIRECTIONAL LIGHT

The appearance of a subject changes completely when lit from different directions, whether under natural or artificial light. Back lighting creates dramatic, clearly defined shapes, and eliminates most surface detail. When lit from the front the image becomes clear and bright: colour, decorative patterns, and texture are fully revealed. Side lighting exposes the three-dimensional aspect of a subject. Although colour, pattern, and texture can be seen, they don't dominate. Instead, the interplay of light and dark is the most important aspect of the painting.

Back lighting

Back lighting highlights the silhouette of the vase and the vertically cast shadow.

Front lighting

Front lighting reveals the decoration and shape of the vase.

Side lighting

Side lighting shows the three-dimensional form of the vase.

ARTIFICIAL LIGHTING

When painting indoors, you can control the lighting on the subject by setting up an artificial light. An adjustable desk lamp allows you to choose the direction you want the light to come from. Changing the position of the lamp will completely change the appearance of the subject, for example casting a shadow or highlighting different areas.

Still life lit from above In this set-up, the light from the adjustable lamp is directed on to the flowers, highlighting their riotous colour. The side of the bottle receives diffuse light. Areas that are not getting direct light are plunged into shadow.

LIGHT IN NATURE

The sun changes a landscape from the time it rises until the time it sets. Evening light is very different to the light of the morning and alters the whole emphasis, pattern, and composition of a painting. Patterns of light and dark, colour, and the relationships between colours, change throughout a day, as well as from from day to day and season to season. Be conscious of light when looking at a landscape and use your observations to help capture nature's magical moments.

Early morning light creates soft, muted colours.

Detail on the tree trunk is only just visible.

Trees at dawn The early morning light shows the soft, natural colour of the tree trunks and the earth. The texture of the surfaces is just visible. As the sun rises, the colours will intensify and more detail will be revealed as the front lighting gradually becomes brighter.

Evening light creates a luminous gold colour in the sky.

Back lighting makes the detail on the tree trunks disappear, and the shapes become silhouetted against the sky.

Trees at dusk The sun is setting behind the trees, leaving the sky a luminous gold colour. The back lighting throws the trees and foreground into cool violet-green silhouettes, eliminating the natural colour of foliage and trunks. The intricate tracery of the fine branches and twigs is clearly defined against the pale sky.

Gallery

The direction of light, from the front, back, or side of the subject, is all-important to the drama and pattern of a painting.

Blue wall and red door ▶

The strong front lighting in this composition picks out every detail of the door, windows, and curtain. The pattern of the paving stones is clearly defined, as is the texture on the walls. The lighting gives a theatrical impression. *Nick Harris*

▼ Bluebells and yellow flowers

Direct, front lighting illuminates the natural colour of the flowers and leaves. The patterning on the vase and background add to the riot of colour. Impasto paint makes the colour more forceful. *Sophia Elliot*

▲ On the road to Chestertown

Side lighting dramatically picks out the hard edges of the main forms in this painting – the dog and the man's legs – and creates distinct patterns of medium and dark tones. The contour of the dog's ears is seen clearly against the flat blue sky. *Marjorie Weiss*

◀ **Hats**

The still life arrangement of hats in a millinery store is lit by artificial light, which focuses on the colour and texture of the fabrics. The weave of the straw hat can be picked out and contrasted with the shiny red ribbon that decorates it. *Rosemary Hopper*

▼ **Winchelsea sunset**

The back lighting created by the setting sun gives a dramatic appeal to this painting. The near distance is silhouetted using mixes of rich, dark colour. The pinkish orange strip of sky on the horizon glows between strips of cool blues. *Christopher Bone*

28 Pears on a windowsill

Back-lighting creates silhouettes, as in this dramatic hard-edge painting of three pears sitting provocatively on a windowsill, set against a sky of blended blues and violet. The fruit is drawn precisely, and the stems are used as a device to direct the eye across the composition. The positioning of the pears, and the spaces in between, are important for balance in the painting. The light on a narrow sliver of the windowsill creates a contrast with the rich black of the pears and lower windowsill, which is achieved by glazing with layers of luminous, transparent dark colours.

EQUIPMENT
- Canvas board
- Brushes: No. 8 and No. 12 round, No. 12 filbert, No. 2 flat bristle, No. 1 rigger
- Masking tape, painting medium, stick of chalk
- Phthalo blue, medium magenta, titanium white, light blue, cadmium yellow deep, cadmium red deep, phthalo green, yellow light hansa

TECHNIQUES
- Blending
- Hard edge
- Mixing blacks

1 Cover the window frame with masking tape. Paint the sky with a mix of phthalo blue, medium magenta, and titanium white. Add more titanium white and overlap with strokes of this mix. Continue down the painting with overlapping strokes using a mix of light blue and increasing amounts of titanium white.

2 Add cadmium yellow deep to the mix to make a light green and paint this below the blue, blending for a gradual change between the colours. Blend below the green with added titanium white. Add medium magenta to make a warm grey for the bottom of the sky.

BUILDING THE IMAGE

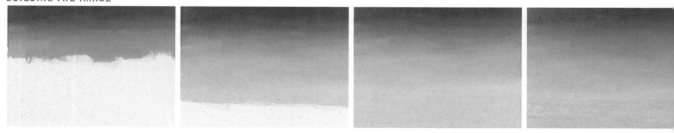

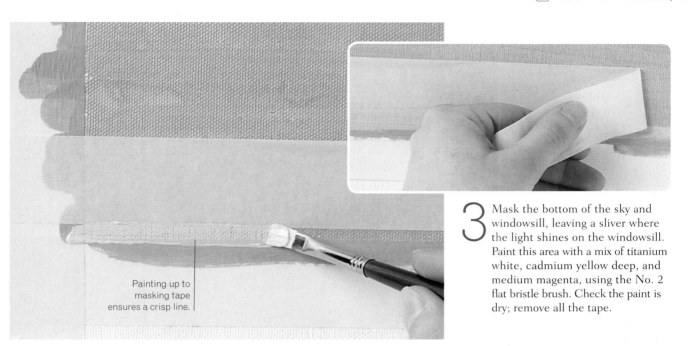

Painting up to
masking tape
ensures a crisp line.

3 Mask the bottom of the sky and
windowsill, leaving a sliver where
the light shines on the windowsill.
Paint this area with a mix of titanium
white, cadmium yellow deep, and
medium magenta, using the No. 2
flat bristle brush. Check the paint is
dry; remove all the tape.

4 Cover the pink stripe with tape. Glaze
cadmium red deep and painting
medium over the exposed windowsill.
Layer glazes of phthalo blue and
painting medium and then phthalo
green and painting medium over the
top. Let dry before removing the tape.

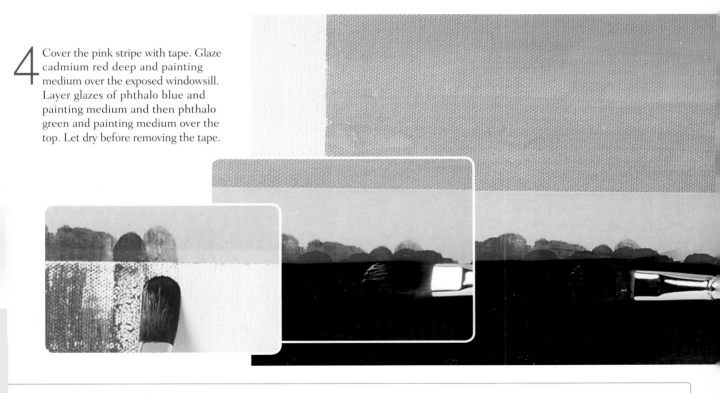

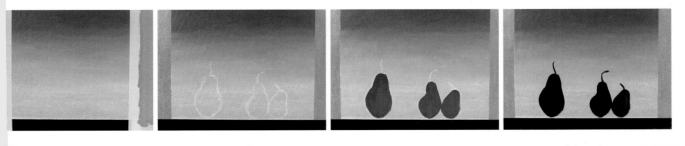

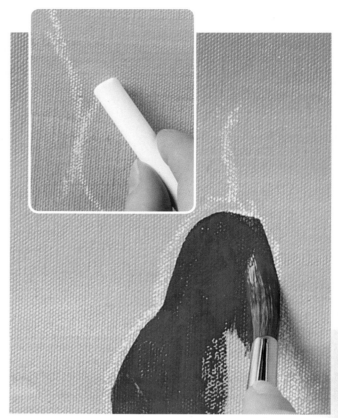

6 Draw in the outline of the three pears using a stick of chalk. Paint the pears with cadmium red deep using the No. 12 round brush. Bring the colour over the windowsill so the pears appear to be sitting on it. Load the brush with paint in order to paint the pears in as few strokes as possible.

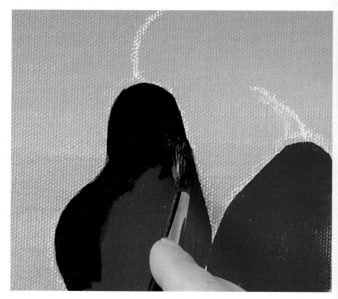

5 Put masking tape along the edges of the window frame. Paint the window frame medium magenta with the No. 12 filbert brush. Mix yellow light hansa with painting medium and glaze this mix over the medium magenta.

7 Mix phthalo green and painting medium and glaze over each of the pears. Switch to the No. 8 round brush to paint the edges of the pears with this glaze. Paint just below each pear with the green mix for the reflected colour on the windowsill.

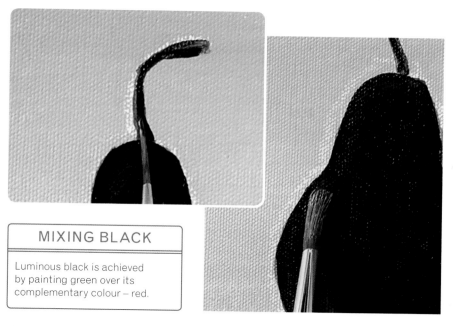

8 Mix cadmium red deep and phthalo green and paint the stalks of the pears using the No. 1 rigger. Glaze a mix of phthalo green and yellow light hansa for subtle highlights on the pears, using the No. 8 round brush. Remove the chalk with a clean, damp brush.

MIXING BLACK

Luminous black is achieved by painting green over its complementary colour – red.

▼ Pears on a windowsill

The well-planned use of masking tape has helped to create the contrast between hard edges and soft blending, which in combination with the contrast of dark and light, makes this a striking painting.

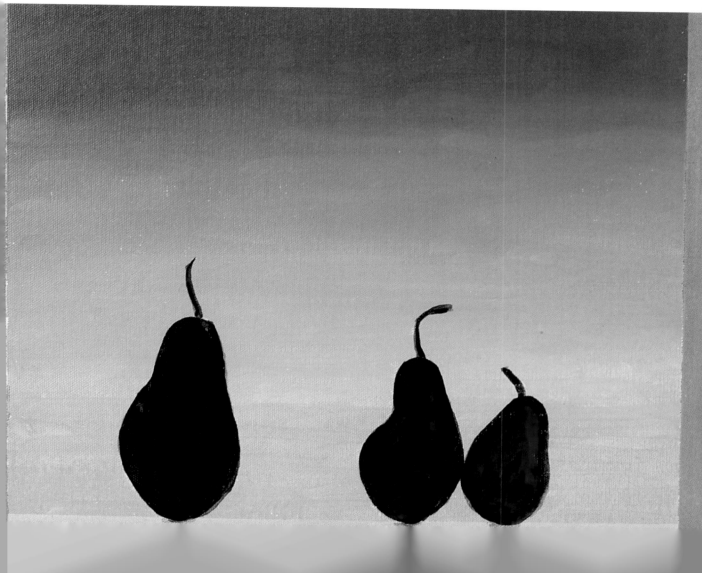

29 Cat among flowers

This cat with its inscrutable expression, sitting sedately among flowers, is painted on brown throwaway cardboard – one of many different unconventional art surfaces to experiment with. In this painting, there is no obvious shadow because the light is coming from the front. The cat is illuminated, showing details of eyes, nose, mouth, and whiskers, which are drawn in graphically. Dry brushwork and scumbling convey the texture of the cat's fur. Areas of the cardboard are left unpainted, and the addition of spontaneous drawing lines gives the painting movement and life.

EQUIPMENT
- Cardboard
- Brushes: No. 6 and No. 10 flat bristle, No. 8 and No. 12 round, No. 1 rigger
- Painting medium
- Cadmium red light, light blue, phthalo blue, cadmium red deep, medium magenta, titanium white, French ultramarine, phthalo green, cadmium yellow deep

TECHNIQUES
- Drybrush
- Using a rigger
- Scumbling

1 Sketch your composition with white chalk and charcoal. Paint the cat with the No. 10 flat bristle brush and a light grey mix of cadmium red light and light blue. Scrub on the paint to lay down the major areas of colour.

2 Mix phthalo blue, cadmium red light, and cadmium red deep for a darker grey, and paint the outline of the cat using the No. 8 round brush. Add more cadmium red deep to the mix to drybrush a suggestion of markings on the cat's fur.

BUILDING THE IMAGE

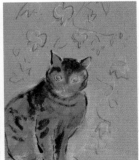
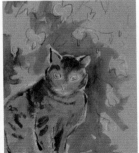
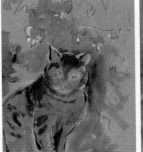
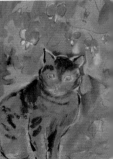

3 Use a watery mix of phthalo blue and cadmium red light for part of the background. Paint flowers with medium magenta; while wet add titanium white for a paler pink. Mix medium magenta and titanium white for smaller flowers. Add cadmium red light to this for variety.

4 Paint the sky with a mix of phthalo blue, cadmium red light, and titanium white using the No.10 flat bristle brush. Add French ultramarine and a little titanium white for variety. Continue to add more of both of these mixes to brighten areas of the sky.

5 Paint the leaves with phthalo green. Modify the green by adding cadmium red light and phthalo green to paint parts of the leaves. For further variety add cadmium yellow deep and add titanium white to this for areas of reflected light.

6 Mix French ultramarine and titanium white to paint the background and define the leaf shapes. Outline flowers and leaves with phthalo blue, cadmium red light, and cadmium red deep. Leave spaces in the outlines to suggest movement.

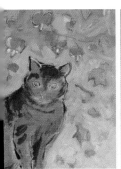
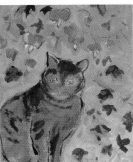
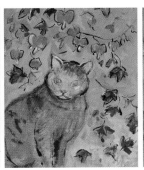
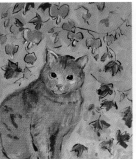
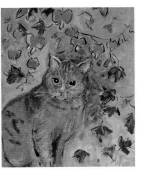

7 Add lines of titanium white to the leaves using the No. 1 rigger. Add a touch of medium magenta to the titanium white for more lines.

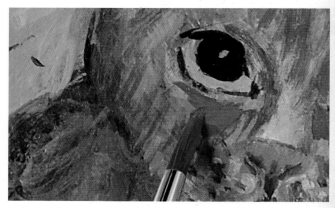

8 Mix titanium white and painting medium to glaze the cat's head and scumble over its body. Add warmth to the head with glazes of medium magenta and light blue, and cadmium red light and cadmium yellow deep. Paint the cat's nose with medium magenta and titanium white.

9 Mix cadmium yellow deep, phthalo green, and titanium white to paint the cat's irises. Paint its pupils with a mix of phthalo blue and cadmium red light and outline its eyes with this mix using the No. 1 rigger.

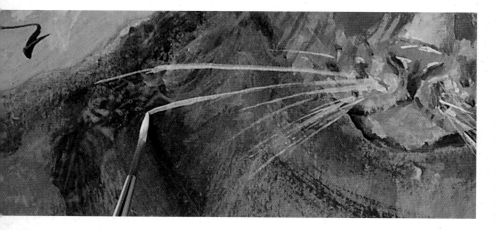

10 Warm the head with medium magenta, cadmium red light, and titanium white using the No. 12 round brush. Paint a glaze of phthalo blue and a little cadmium red light to darken the background.

11 Paint each whisker with one fast stroke using the No. 1 rigger and titanium white. Mix French ultramarine with a little titanium white to paint parts of the sky.

Cat among flowers ▶

The simple blue sky background, the areas of unpainted cardboard, and the rough, dry brushstrokes of the cat's fur, contrast with the cat's whiskers and the lively brushwork of the flowers and leaves, which have been painted with the rigger brush.

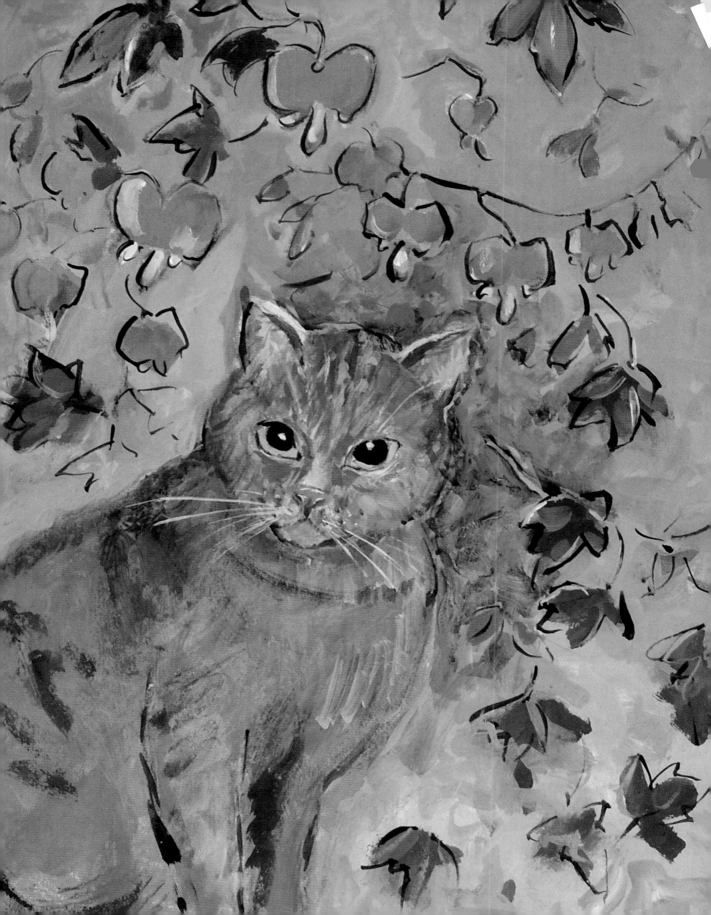

30 Sunlit interior

In this painting of an interior, the main light source, coming from the window, illuminates the transparent glass objects on the windowsill, throws the opaque ornaments in the room into silhouette, and floods light on to the polished tabletop. By applying thick layers of paint, a technique known as impasto, the brushstrokes stand up in relief. Acrylic paint dries fast, so here glazes are painted on top of the impasto almost immediately. Painting thick with texture paste, before applying glazes, effectively creates the gilding on the mirror and the handles on the cabinet.

EQUIPMENT
- Canvas board
- Brushes: No. 8 and No. 12 round, No. 2 and No. 8 flat bristle, No. 1 rigger
- Texture paste, painting medium
- Indo orange, phthalo blue, titanium white, French ultramarine, cadmium yellow deep, cadmium red light, cadmium red deep, medium magenta, yellow light hansa

TECHNIQUES
- Shadow colours
- Glazing

The No. 2 flat bristle brush gives definition.

1 Use indo orange, phthalo blue, titanium white, and texture paste to make a grey mix. Paint the wall, around the mirror, with this thick mix, using the No. 8 flat bristle brush. Add more titanium white to the mix to paint the wall on the far left of the painting.

2 Add more indo orange to the grey mix for the top of the cabinet, and more phthalo blue and titanium white for its front. Outline the cabinet drawers with a mix of phthalo blue and indo orange and fill in the rest of the cabinet with mixes of indo orange, phthalo blue, and titanium white.

BUILDING THE IMAGE

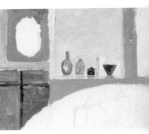

3 Paint the wall in shadow under the window and to its right with the grey mix with added titanium white. Mix French ultramarine and titanium white to paint the sky, using the No. 12 round brush. Blend a mix of indo orange and titanium white into the blue for lightness.

"The source of light dictates the feel and mood of a painting."

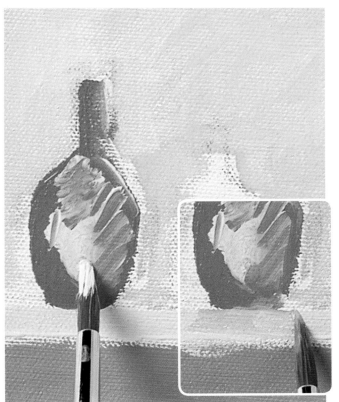

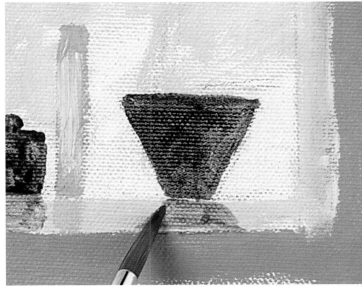

4 Paint the window frame titanium white with a little cadmium yellow deep. Paint the left bottle cadmium red light, and the light shining through titanium white. Mix these two bottle colours to paint its reflection. Paint the second bottle and its reflection with French ultramarine and painting medium.

5 Paint the third bottle phthalo blue and cadmium red light, add painting medium for its reflection. Paint the fourth cadmium yellow deep, and use titanium white for the light shining through. Paint the fifth bottle phthalo blue and cadmium red light; add painting medium for its shadow.

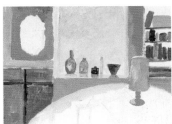
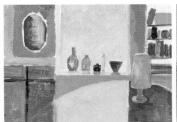
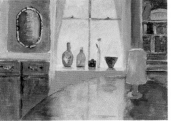

6 Paint the top left book cadmium red deep, the box cadmium red deep and titanium white, and the shelves with grey mix. Suggest books with stripes of cadmium yellow deep, French ultramarine, phthalo blue with titanium white, and cadmium red deep mixed with French ultramarine.

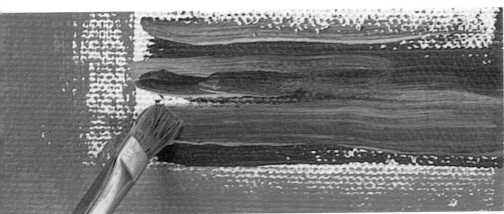

7 Paint the first file with phthalo blue and titanium white, the second with cadmium yellow deep, and a mix of these for the other three files. Paint magazines on the bottom shelf with a green mix of phthalo blue and cadmium yellow deep, and with cadmium red light.

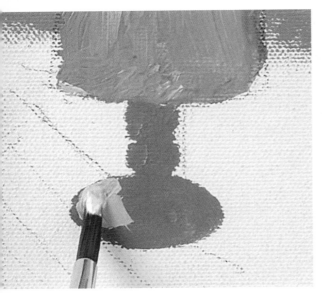

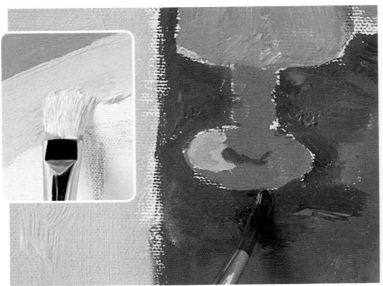

8 Mix medium magenta and texture paste for the lampshade. Add titanium white where it catches the light. Mix phthalo blue and medium magenta for the stand; add its reflection with titanium white.

9 Paint the reflection on the table with a mix of medium magenta, cadmium yellow deep, and titanium white. Paint the rest of the table with cadmium red deep, phthalo blue, medium magenta, cadmium yellow deep, and titanium white.

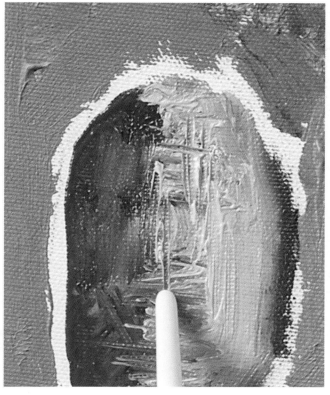

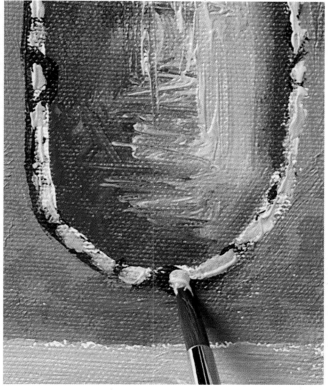

10 Paint the dark reflections in the mirror with a mix of phthalo blue and painting medium and add titanium white for the light reflections. Add cadmium red deep to both mixes for variety. Use a brush handle to scratch out some of the paint to suggest reflections.

11 Paint the shadow on the wall using a mix of phthalo blue and cadmium red light. Mix phthalo blue and cadmium red deep to suggest shadows on the frame. Paint the gold frame with cadmium yellow deep, yellow light hansa, and texture paste, using the No. 8 round brush.

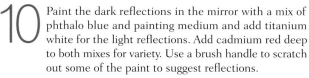

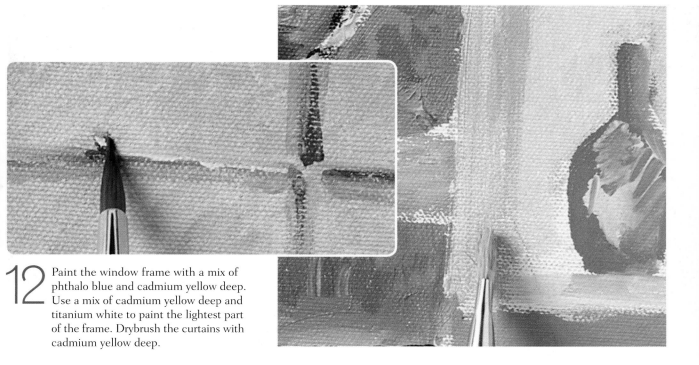

12 Paint the window frame with a mix of phthalo blue and cadmium yellow deep. Use a mix of cadmium yellow deep and titanium white to paint the lightest part of the frame. Drybrush the curtains with cadmium yellow deep.

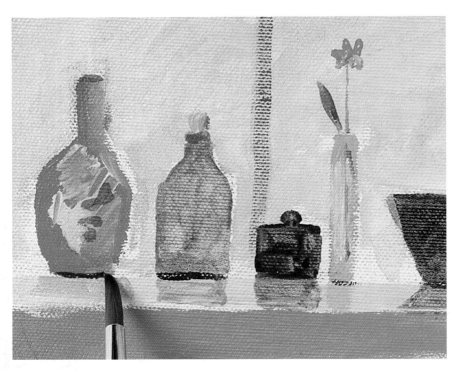

13 Mix phthalo blue and yellow light hansa for the flower's stem. Paint the petals with indo orange. Use phthalo blue and cadmium red light to paint a dark line at the base of each of the bottles. Add touches of the green mix to the red bottle and add the top to the blue bottle with a mix of indo orange and cadmium yellow deep.

14 Use phthalo blue, cadmium red light, and painting medium for the back of the bookcase. Add lettering to the books with complementary colours – indo orange, the green mix, and medium magenta. Paint the vertical edge with French ultramarine and titanium white.

15 Glaze the shadow behind the curtain with phthalo blue, cadmium red deep, and painting medium. Glaze the table with yellow light hansa and painting medium. Glaze phthalo blue, cadmium red deep, and painting medium for the shadows on the table.

16 Paint the cabinet's handles with phthalo blue, a touch of indo orange, and texture paste. Add brightness to them with a mix of cadmium yellow deep, yellow light hansa, and texture paste. Glaze the cabinet and shadows on the left of the table with cadmium red deep and painting medium. Blend in the glaze for a subtle transition between dark and light.

▼ Sunlit interior

The drama that light can give to a painting is shown here as sunlight floods through the window, illuminating the central third of the composition in contrast with the darker areas to the left and right. Layers of glazes effectively create the polished surface of the table and the colourful shadows and areas of reflected light.

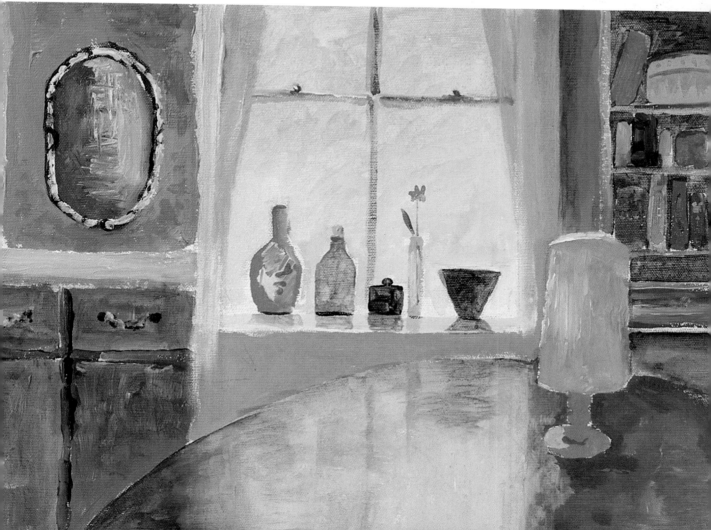

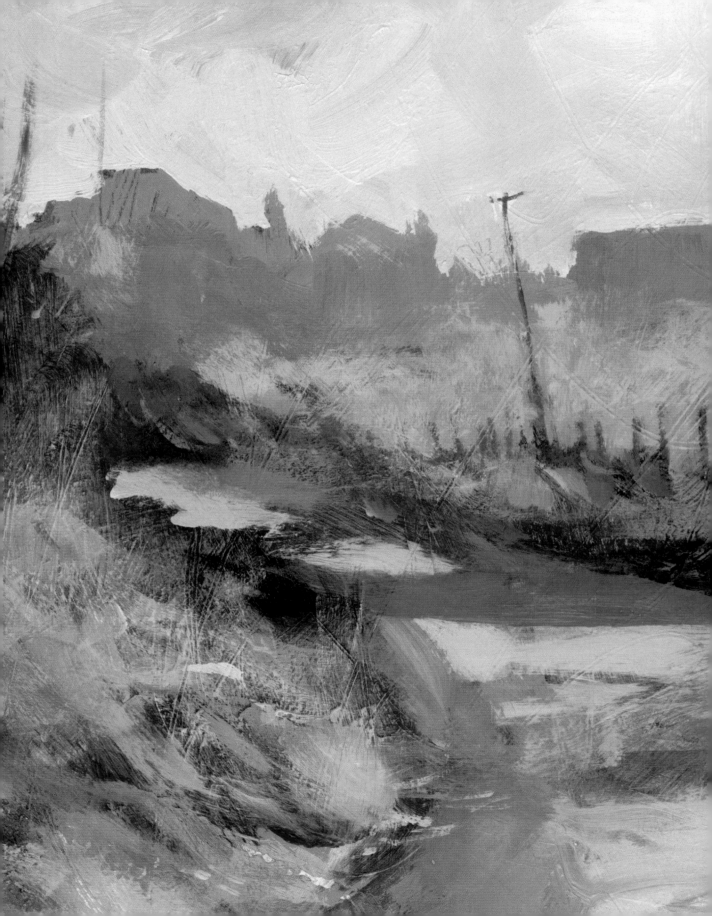

Depth with Acrylics

"Use warmer colours and larger shapes at the front to create depth."

Creating depth

Giving the impression of depth in your painting is a way of inviting the viewer into the picture. There are three ways of creating depth: colour, scale, and linear perspective. Strong, warm colours such as red and orange make a subject come to the front whereas cool, pale colours such as blue appear to recede. An object that is in the foreground will also appear much larger than a similar sized object in the distance. Knowledge of the rules of perspective will also help you create a sense of depth in your paintings.

WARM AND COOL COLOURS

Colour can be used to create a sense of depth in your painting. The red, green, and blue bands of colour here illustrate colour recession. Warm colours, like red and orange, are dominant and appear to come forward. Blue appears to recede, so it is used to give the impression of distance. Green, neither truly warm nor cool, slots in behind the red and in front of the blue.

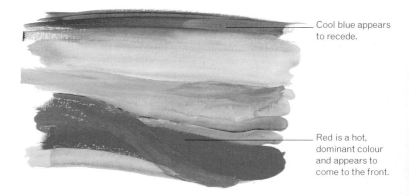

Cool blue appears to recede.

Red is a hot, dominant colour and appears to come to the front.

COLOUR PERSPECTIVE

The colours of objects appear to change depending on their distance from you. This is because atmospheric conditions affect how we see colour. Colours close to you appear strong and warm. Distant colours look less bright, less defined, and take on a cooler bluish hue. You can use this knowledge of colour perspective to create depth in your paintings.

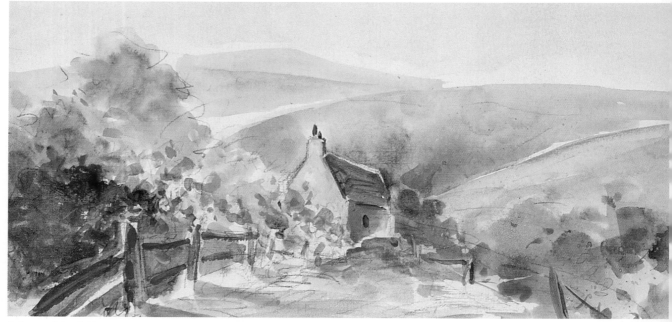

Colour and depth The use of warm and cool colours in this rural scene creates an impression of depth. The fence and foliage are painted in warm colours, which come forward and establish the near distance. Faraway hills appear to be soft blue and violet-grey in colour.

SCALE AND LINEAR PERSPECTIVE

A sense of depth can be achieved by using scale and linear perspective. Objects get smaller as they recede into the distance – this is scale. In a sketch of a row of houses, for example, those in the foreground will be larger than those farther away. The rules of perspective are also helpful in creating depth in your painting. Lines that are parallel in reality appear to converge and meet on the horizon. This convergence occurs at the vanishing point, which can be seen clearly here in the composition of the street scene.

Preliminary sketch

Rooftops slope downwards into the distance.

The lines of the street converge at the vanishing point.

Finished painting

Strong, warm colours and large scale bring the side of this building to the foreground.

The buildings appear to converge as they recede into the distance. Cool colours add to the sense of depth.

Scale and linear perspective Parallel lines appear to converge in this painting, and the buildings on the street appear to get smaller as they recede. The flower baskets, people, and shop signs become smaller and less distinct as they go deeper into the painting.

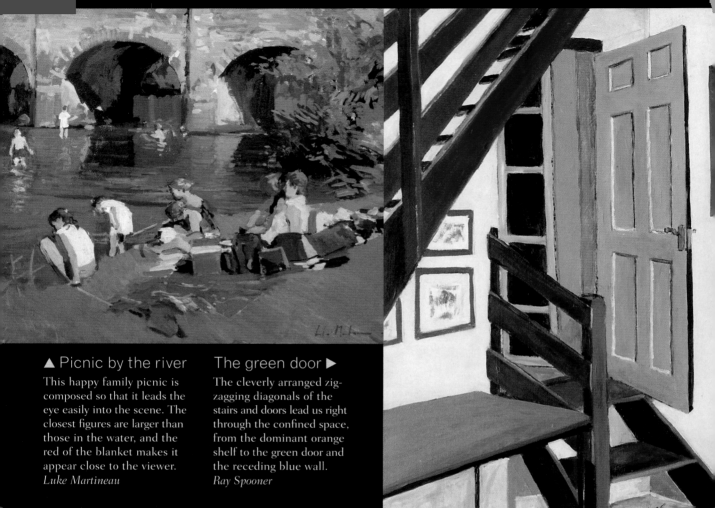

▲ Picnic by the river

This happy family picnic is composed so that it leads the eye easily into the scene. The closest figures are larger than those in the water, and the red of the blanket makes it appear close to the viewer.
Luke Martineau

The green door ▶

The cleverly arranged zig-zagging diagonals of the stairs and doors lead us right through the confined space, from the dominant orange shelf to the green door and the receding blue wall.
Ray Spooner

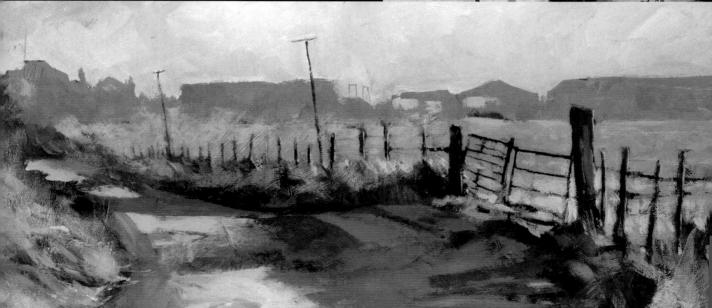

◄ Fishermen in Port Isaac

The foreground rocks are bolder, stronger, and larger than the more distant rocks. The sandy ground becomes more subdued as it gets farther away. Distance makes the houses on the hill appear blue. *Wendy Clouse*

▼ Towards the National Gallery from the Haymarket

One-point perspective is used to give the impression of depth in this busy street scene. The kerbstones in the foreground are given more emphasis than the distant kerbstones, and buildings seem to get smaller and closer together as they recede. *Nick Hebditch*

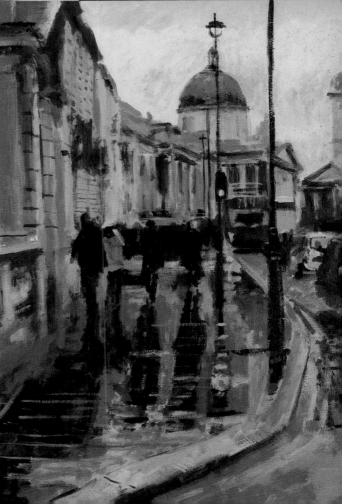

▲ Flower market, Provence

The flowers and their containers appear to get smaller as they curve into the distance. The display in the foreground is stronger, larger, and more defined. The near shadow covers more area and is richer in colour than the distant shadow. *Clive Metcalfe*

◄ Ancient highway

Linear perspective has been used in this rural scene to give an impression of depth. The road narrows as it disappears into the distance. The fence, gate, and telegraph poles are larger and a stronger colour in the foreground. The colour of the distant buildings is reduced to soft blue-grey. *Clive Metcalfe*

31 Canal at sunset

Painting an atmospheric, glowing sunset is not as difficult as it might appear.
To create the mood in this painting, the whole of the paper is first underpainted
with warm yellows. A soft orange, graded glaze over the top third creates a feeling
of recession in the sky. Bold overlapping horizontal strokes of warm analogous
colour merge yellow into pink and red at the bottom of the painting. Dry brushwork
and gentle sponging establish the distant trees and their reflections, while darker
colours, and scratched in detail, bring the foreground into focus.

EQUIPMENT
- Acrylic paper
- Brushes: No. 10 flat bristle, No. 8 and No. 12 round, No. 1 rigger brush
- Sponge, rag, toothbrush
- Painting knives: No. 20
- Painting medium
- Cadmium yellow deep, titanium white, medium magenta, light blue, phthalo green, cadmium red light, phthalo blue, yellow light hansa, cadmium red deep

TECHNIQUES
- Reflections
- Scratching
- Dry brushwork

The warm background establishes the painting's atmosphere.

Simple dry brushstrokes suggest distant trees.

1 Scrub on a mix of cadmium yellow deep and titanium white with the No. 10 flat bristle brush. Add more titanium white, then gradually add more yellow to return to the original strength at the bottom of the painting.

2 Paint over the yellow sky, with a purple mix of medium magenta and light blue. Soften the purple with a rag. Mix light blue, medium magenta, and cadmium yellow deep and work over the water at the bottom, right to left.

3 Mix phthalo green and cadmium red light to drybrush the trees on the right. Drybrush the distant trees on the right and left with a mix of medium magenta and phthalo green. Use the first green mix for the darks on the left.

BUILDING THE IMAGE

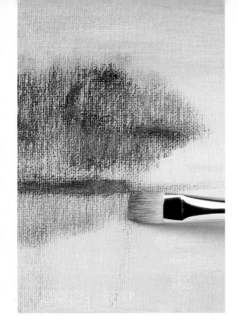

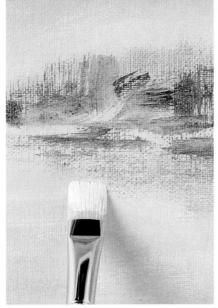

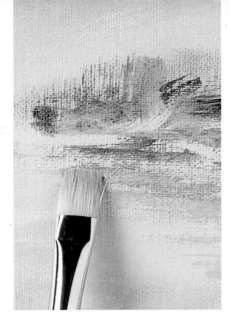

4 Mix medium magenta and light blue for the far trees. Paint the reflections of the trees with a mix of phthalo blue and medium magenta. Build up the reflections with phthalo green and cadmium red light.

5 Gently stroke the reflections with vertical strokes of titanium white to suggest the water surface. Paint cadmium yellow deep with unblended brushstrokes over the front water, so that the area appears to come forward.

6 Scumble the water surface with a mix of medium magenta, light blue, and titanium white to create the shimmer on the water on the right. Mix phthalo green and yellow light hansa to put in more reflection.

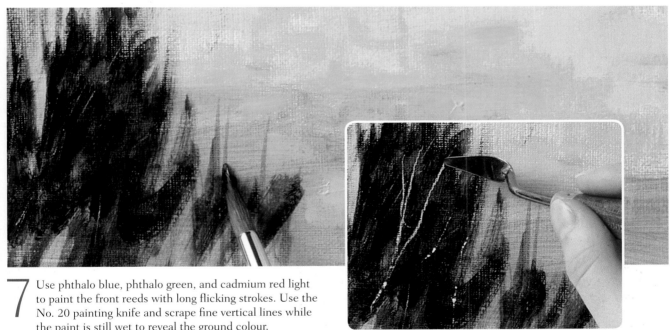

7 Use phthalo blue, phthalo green, and cadmium red light to paint the front reeds with long flicking strokes. Use the No. 20 painting knife and scrape fine vertical lines while the paint is still wet to reveal the ground colour.

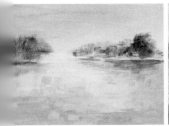

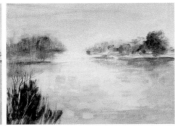

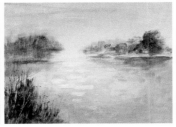

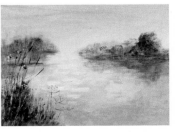

8 Use the No. 1 rigger brush to paint finer reeds and cow parsley with the green mix from step 7. Use a mix of titanium white and medium magenta for further fine lines.

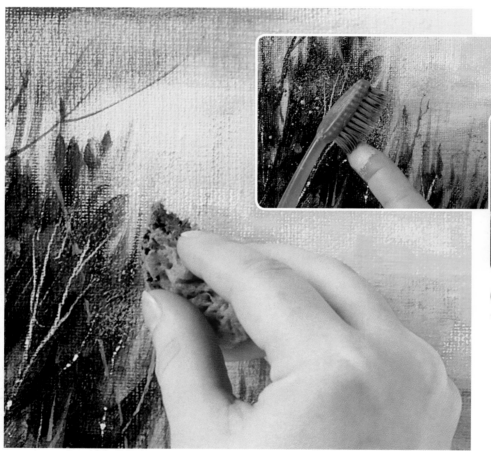

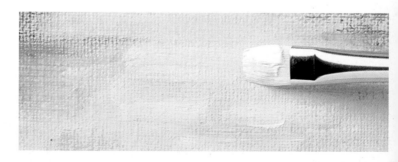

9 Dip a sponge in water and then pick up a mix of light blue and phthalo blue to gently dab among the reeds to suggest flowers and seed cases. Flick a mix of medium magenta and titanium white over the reeds with a toothbrush. Spatter a mix of phthalo blue and cadmium red light by firmly tapping the No. 8 round brush.

10 Refine the water at the front with overlapping brushstrokes of a medium magenta and titanium white mix, letting the individual strokes show. Paint the mid water with a mix of cadmium yellow deep and yellow light hansa, and towards the horizon a mix of titanium white and light blue for recession.

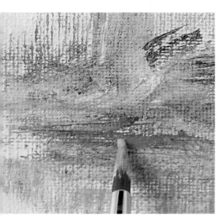

12 Paint some tall bulrushes using the No. 1 rigger brush and a mix of phthalo blue and yellow light hansa. Paint the flowers with a mix of medium magenta and titanium white using the tip of the No. 8 round brush.

11 Build up the horizon foliage and the reflections with phthalo green and painting medium. Mix cadmium red light and a little phthalo blue for the riverbank. Reduce the green on the right with phthalo green and cadmium red deep.

▼ Canal at sunset

A sense of space and recession has been created by lightening the colour towards the horizon. The varied greens of the foliage have the effect of intensifying the warm orange colours.

32 Steam train

This painting of a steam engine rushing towards the viewer dramatically illustrates perspective. A sense of depth is achieved through the apparent convergence of the parallel lines of the railway track, and the train getting smaller as it disappears under the bridge. Speed and movement are realized through the use of dry brushwork, and by the swirling shape of the steam. The red of the buffer is the most dominant colour, so is placed carefully in the composition using the rule of thirds. The shape of the bridge is a useful device to bring the viewer's eye back into the picture.

EQUIPMENT
- Watercolour paper – cold-pressed
- Brushes: No. 8 and No. 12 round, No. 2 flat bristle, No. 1 rigger
- Painting knives: No. 22 and No. 20
- Painting medium, texture paste
- Dioxazine purple, phthalo green, yellow light hansa, French ultramarine, titanium white, indo orange, phthalo blue, cadmium red deep, cadmium red light, cadmium yellow deep

TECHNIQUES
- Painting knife
- Creating texture
- Scratching

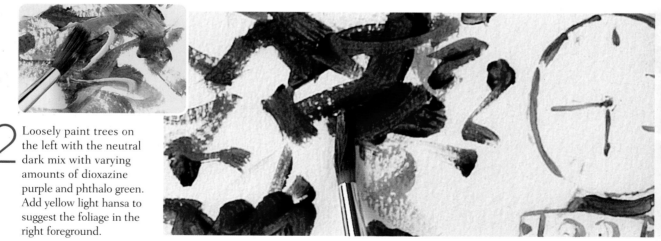

1 Draw in the train, track, bank, and bridge with a neutral dark mix of dioxazine purple and phthalo green, with varying quantities of each colour.

2 Loosely paint trees on the left with the neutral dark mix with varying amounts of dioxazine purple and phthalo green. Add yellow light hansa to suggest the foliage in the right foreground.

BUILDING THE IMAGE

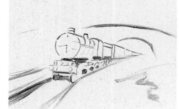
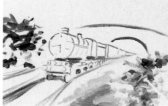
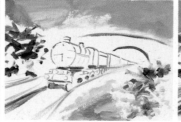
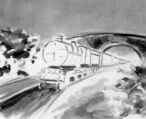

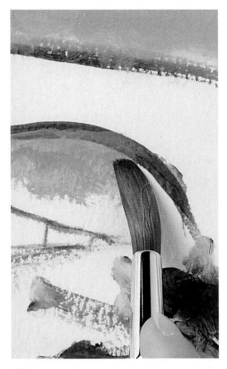

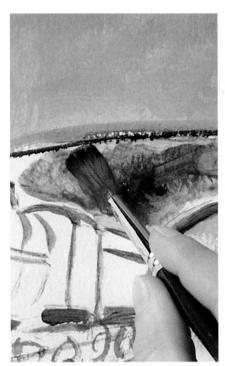

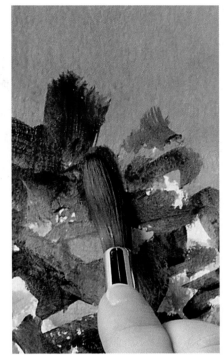

3 Scrub some of the foliage mix in the ground at the front. Create a sky mix using French ultramarine and titanium white and paint the sky with rapid, vigorous strokes using the No. 12 round brush.

4 Mix French ultramarine and indo orange for an underpainting of the track. Add titanium white to paint the left track. Paint the bridge with the neutral dark mix with added painting medium.

5 Add yellow light hansa and phthalo blue to the left foliage. Mix dioxazine purple, phthalo green, titanium white, and painting medium for the foliage shadow. Add tree height with phthalo green and dioxazine purple.

6 Paint the right bank with a sandy mix of indo orange, yellow light hansa, dioxazine purple, and titanium white. Add the sky mix for the bank that is farther away. Lighten the front with a touch of titanium white. Mix dioxazine purple, phthalo green, and painting medium for underneath foliage on the right.

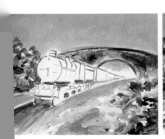
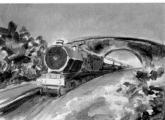
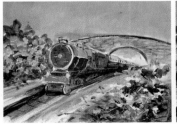
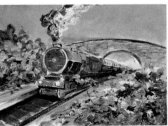

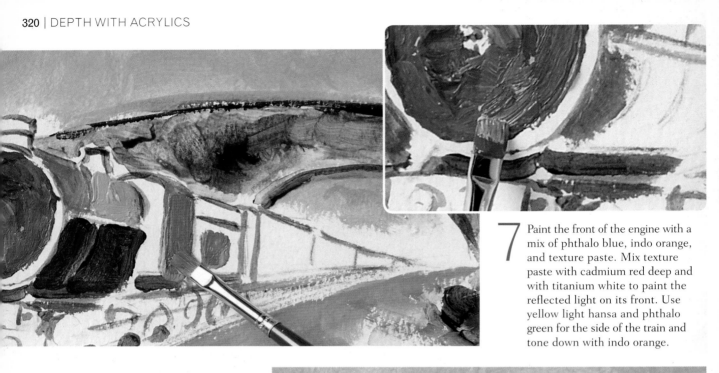

7 Paint the front of the engine with a mix of phthalo blue, indo orange, and texture paste. Mix texture paste with cadmium red deep and with titanium white to paint the reflected light on its front. Use yellow light hansa and phthalo green for the side of the train and tone down with indo orange.

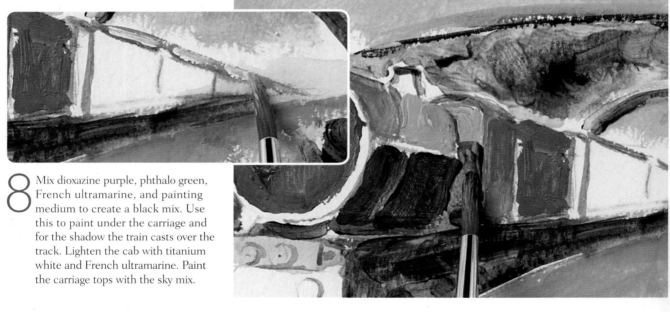

8 Mix dioxazine purple, phthalo green, French ultramarine, and painting medium to create a black mix. Use this to paint under the carriage and for the shadow the train casts over the track. Lighten the cab with titanium white and French ultramarine. Paint the carriage tops with the sky mix.

9 Paint between the carriages, define them, and add wheels and windows with phthalo blue. Mix cadmium red deep and phthalo blue for the distant carriages. Add highlights of cadmium red deep with texture paste and paint their tops with indo orange, yellow light hansa, and titanium white.

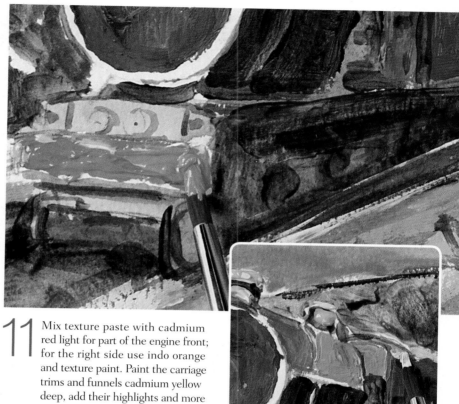

10 Use the black mix for the funnel and to redefine the track. Repaint the bank with the sandy mix. Drag titanium white over the track to refine it. Add titanium white to the black mix to paint the windows.

11 Mix texture paste with cadmium red light for part of the engine front; for the right side use indo orange and texture paint. Paint the carriage trims and funnels cadmium yellow deep, add their highlights and more trims with yellow light hansa.

12 Add lamps and the front wheels' highlights with titanium white and suggest movement with flicked strokes over the wheels. Use French ultramarine and titanium white for trims and the warm black mix for buffers and sleepers.

13 Mix texture paste with indo orange and phthalo blue and use the No. 2 flat bristle brush to paint this on the bridge to create its texture. Scratch in with the point of the No. 20 painting knife to suggest the stonework.

14 Mix phthalo green, yellow light hansa, and cadmium red light with texture paste for left foliage. Paint right foliage with phthalo green and painting medium. Apply indo orange, phthalo green, and texture paste with the No. 22 painting knife. Use the point of the knife to scratch in branches and stems.

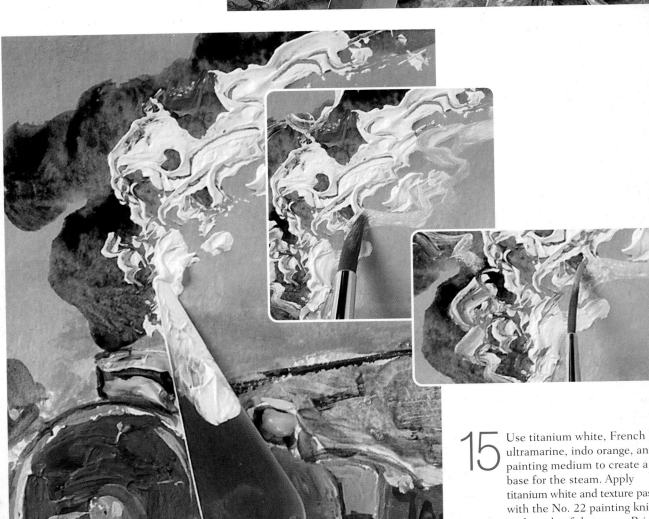

15 Use titanium white, French ultramarine, indo orange, and painting medium to create a base for the steam. Apply titanium white and texture paste with the No. 22 painting knife to the right of the steam. Paint titanium white mixed with painting medium to add to the steam's 3D effect. Add flecks to the smoke with indo orange.

16 Paint under the red of the engine, and define the track, with the black mix. Paint the sleepers indo orange and phthalo blue, and their shadow with phthalo blue and painting medium. Paint the buffers with titanium white and texture paste, and their shadow with the black mix. Flick indo orange on the foreground foliage.

▼ Steam train

Perspective is carefully created in this painting, but the precise mechanical details of the steam engine and wheels are omitted, to help underline the impression of depth, speed, and power.

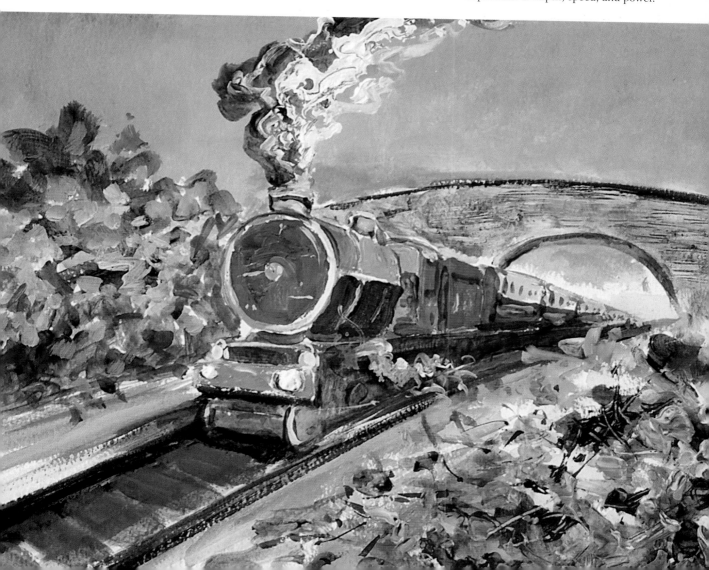

33 Teatime still life

The high viewpoint of this painting enables the viewer to look down on the tabletop and see clearly the goodies on offer. Lighting the scene from the side emphasizes the volume of the forms. The ellipses of the plates, jug, cup, and saucer, are wide open, creating bold shapes which are an important part of the composition. The angles of the serviette and the knife lead dramatically into the painting. The warm shadows link one object to another, and the green decorations on the cup cakes provide contrasting pointers, or highlights.

EQUIPMENT
- Stretched canvas
- Brushes: No. 8 and No. 12 round, No. 1 rigger
- 2B pencil
- Light blue, French ultramarine, titanium white, indo orange, phthalo blue, cadmium yellow deep, phthalo green, medium magenta, cadmium red deep, cadmium red light, yellow light hansa

TECHNIQUES
- Painting metal
- Highlights

CREATING A COMPOSITION

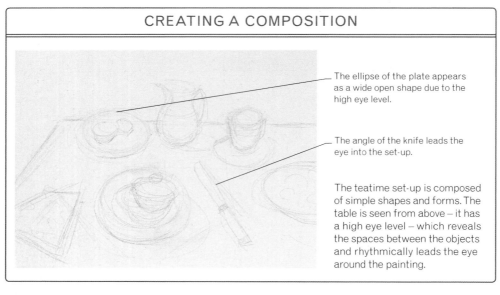

The ellipse of the plate appears as a wide open shape due to the high eye level.

The angle of the knife leads the eye into the set-up.

The teatime set-up is composed of simple shapes and forms. The table is seen from above – it has a high eye level – which reveals the spaces between the objects and rhythmically leads the eye around the painting.

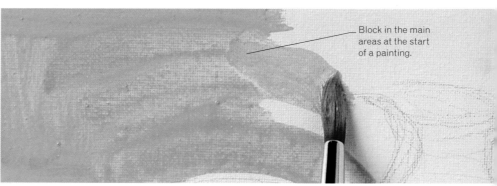

Block in the main areas at the start of a painting.

1 Sketch out the scene with the 2B pencil. Block in the background with light blue, using the No. 8 round brush to carefully paint around the plate, cup, and milk jug that stand above the height of the table.

BUILDING THE IMAGE

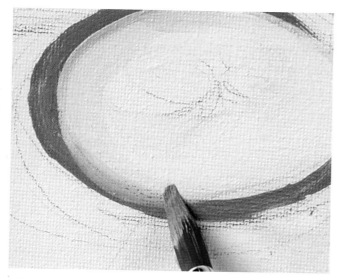

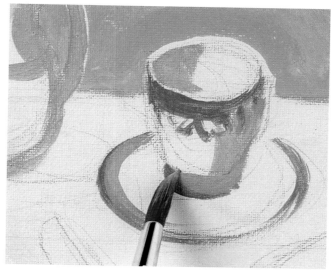

2 Use French ultramarine and titanium white for the rims and pattern of the plates and cup. Paint inside the top left plate with titanium white. Mix a cool grey from French ultramarine, indo orange, and titanium white for shadows on the plates.

3 Use the cool grey mix to paint the shadow on the right-hand side of the jug to give it form. Use the same cool grey mix to paint the shadow inside and outside the tea cup and on the side of each of the cup cakes.

4 Paint the remaining plates and the jug with titanium white. Add indo orange and phthalo blue to the cool grey mix to paint the cup cakes' foil cases. Add more titanium white to this mix to paint the lighter foil on the left of each case.

5 Add the pattern of the cup cake foil with fine lines of titanium white. Mix phthalo blue and titanium white to paint the shadows cast by the cup cakes and tea cup.

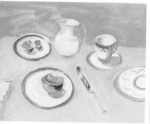

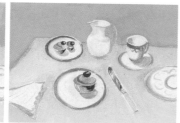

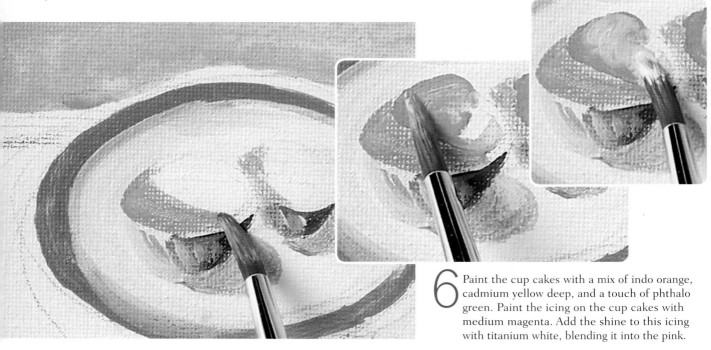

6 Paint the cup cakes with a mix of indo orange, cadmium yellow deep, and a touch of phthalo green. Paint the icing on the cup cakes with medium magenta. Add the shine to this icing with titanium white, blending it into the pink.

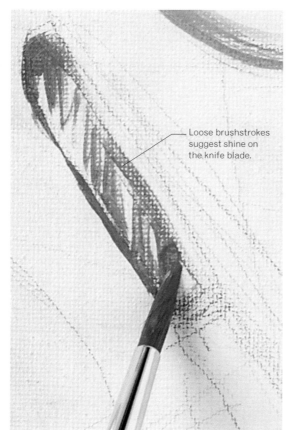

Loose brushstrokes suggest shine on the knife blade.

7 Paint the plate and suggest the napkin with a mix of French ultramarine and titanium white. Add phthalo green and paint the knife blade, leaving areas of white where the light is reflected.

8 Paint the handle of the knife with a mix of indo orange, cadmium yellow deep, and phthalo blue. Paint titanium white down the side of the knife and at the end of the handle where it meets the blade.

9 Paint the tablecloth with a mix of cadmium yellow deep and titanium white using the No. 12 round brush. Define the edges of the plate with this mix. The yellow of the tablecloth will draw out the violet tones in the blue.

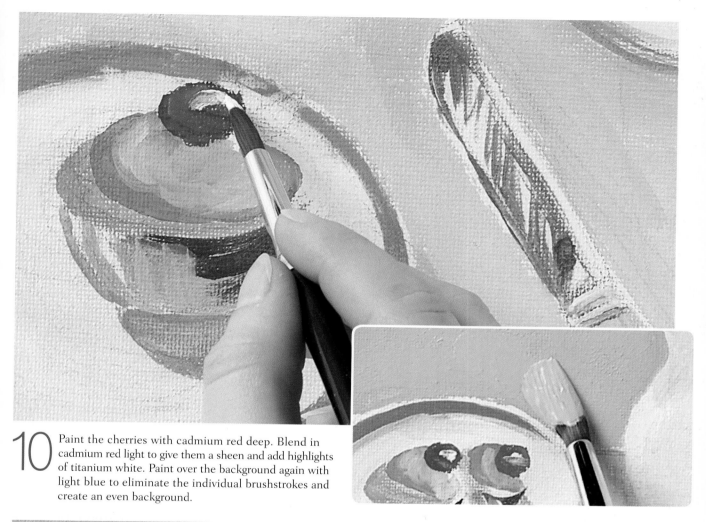

10 Paint the cherries with cadmium red deep. Blend in cadmium red light to give them a sheen and add highlights of titanium white. Paint over the background again with light blue to eliminate the individual brushstrokes and create an even background.

USING PATTERNS

Patterns can be used as compositional devices to create links between objects. Patterns such as checks or stripes appear to converge as they move away from the foreground, giving an impression of depth.

11 Add the check pattern on the tablecloth with titanium white, and paint folds on it with cadmium yellow deep. Mix medium magenta and cadmium yellow deep for lines of overlapping tablecloth and blend these with cadmium yellow deep.

12 Mix medium magenta, titanium white, and cadmium yellow deep to paint the napkin and the shadow on the tablecloth in the top right-hand corner. Mix medium magenta and cadmium yellow deep to paint the shadows of the objects on the tablecloth.

"Colourful shadows add shape and rhythm to a painting."

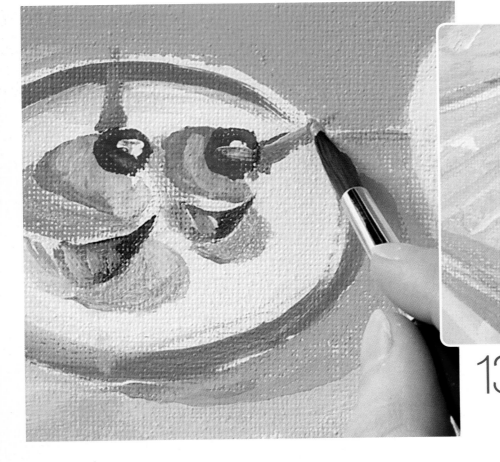

13 Paint the glacé leaves on the cakes with a mix of phthalo green and yellow light hansa using the No. 8 round brush. Add pattern to the napkin with light blue and medium magenta.

14 Paint over the blade with light blue and titanium white to soften the reflections. Strengthen the pattern of the cup cake foil cases with thin stripes of titanium white using the No.8 round brush.

▼ Teatime still life

The clear, singing colours of this painting are luscious and mouth-watering, and a pleasure to look at. The high viewpoint and the pattern on the tablecloth add to the feeling of depth.

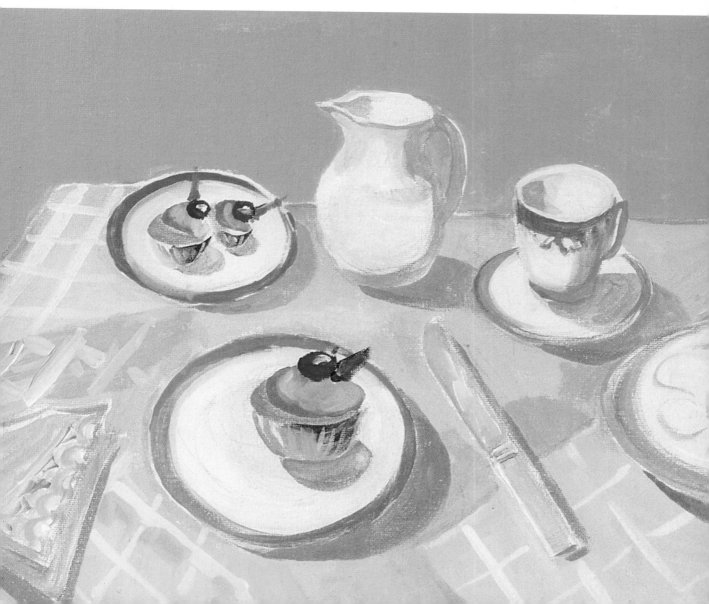

Achieving Impact with Acrylics

"Contrasts of colour, pattern, and light and dark, create impact."

Creating impact

For a painting to be considered successful, it must have impact and leave an impression on the viewer. Impact can be achieved in a number of ways. The introduction of strong diagonals into a painting will create impact through direct movement. Impact also occurs when the darkest areas of a painting are placed next to the lightest areas. An overall, rhythmic impact can be gained by painting light against dark, and dark against light, in sequence across the painting – a technique called counterchange.

USING DIAGONALS

Diagonal shapes that cut across a painting are dramatic and create dynamic movement, giving a painting impetus. Diagonals play a strong part in creating impact in the painting on the right, which shows an elderly woman walking home after a day in the fields. The tree trunk and branches form strong diagonal lines, which, along with the upward brushstrokes used to make the leaves, convey vigour and intensity. The leaning figure of the woman gives an impression of movement, emphasized by the diagonal slant to the stick in her hand.

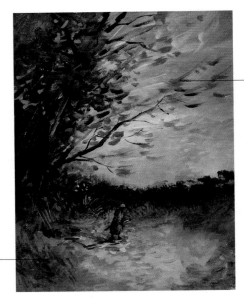

Swift, upward brushstrokes capture the movement in the leaves.

A variety of diagonal strokes are used to depict the grasses and thicket.

Breezy evening This painting uses diagonals and strong colours to capture the power of nature.

DARK AND LIGHT

Extreme contrasts of dark and light in a painting are visually exciting and stimulating. These areas of contrast have an edge that creates immediate impact and naturally provide a focus for a painting. Creating such an area in your painting will help draw the viewer in. Underplaying the rest of the painting by limiting the range of darks and lights around the focal point means that these areas will not compete for attention and lessen the dramatic impact.

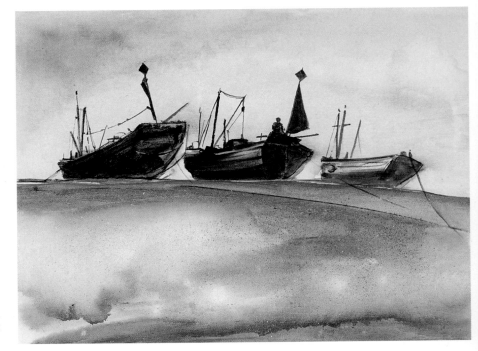

Extreme contrasts Impact is achieved through the dramatic placing of the silhouetted shapes of the fishing boats against a light sky. The undefined foreground does not intrude on the main focus of the painting.

COUNTERCHANGE

Creating adjacent areas of light and dark shapes across a painting provides impact through what is called counterchange. This technique adds impact by producing strong areas of contrast, and it helps draw the eyes across a painting from areas of light to dark and back to light again. Actual colour becomes less important than the play of light and dark. Counterchange is often used in portraits, where side lighting creates alternating highlights and shadows across the face and background, so providing extra impact.

Contrast This series of contrasting shapes shows how the positioning of very pale and dark areas next to each other creates impact.

Applying counterchange In this simple painting, the eye is drawn across from the pale blue background on the left, to areas of dark, light, and back to dark.

Flower painting The white of the petals is played off against the dark spaces in-between, a use of counterchange to produce impact in this otherwise very subtle painting of flowers.

allery

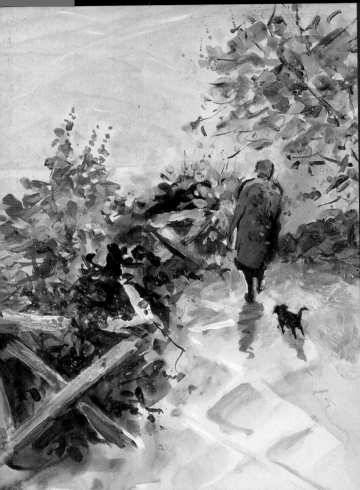

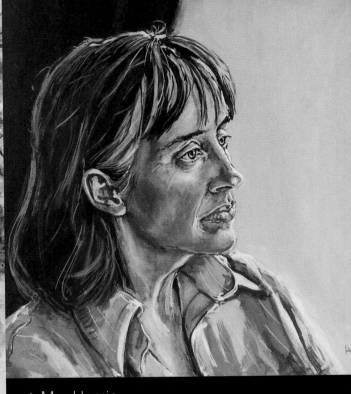

▲ Mrs Harris

The impact of this portrait is created by the dynamic contrast of dark and light in the background. The diagonal lines that run along the blouse and neck lead the viewer's eye into the painting. *Ken Fisher*

▲ Walking the dog

The diagonals of the fence lead the eye into the scene. Counterchange is used for the patterning of the paving, and the red hat against the blue-green of the foliage adds impact. *Phyllis McDowell*

Shoal ▶

This painting shows the dynamic use of diagonals. The fish swimming in from the top left are in opposition to the main shoal of fish swimming in from the top right. Colour contrast adds sparkle and impact. *Lindel Williams*

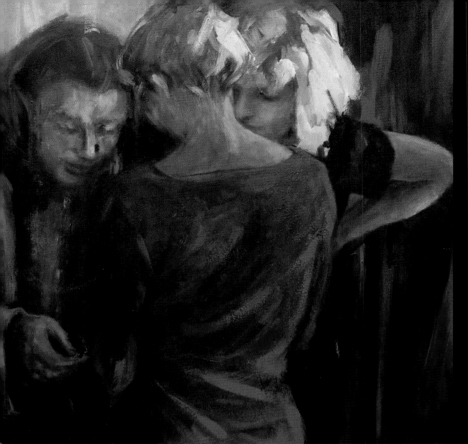

◄ Feeling the fabric

A limited palette has been selected for this intimate painting of a cluster of girls. The way in which the lights and darks have been distributed over the paint surface gives visual impact. This is an example of counterchange.
Vikky Furse

▼ Spindrift

The strong diagonal and interesting patterning of the breakwaters leads the eye into the painting. The sea in the foreground forms an opposing diagonal driving force to the composition.
Ken Fisher

34 Cherry tree in blossom

Dynamic, vigorous brushstrokes, depicting the branches of a tree, flow in from the left in this vibrant painting of cherry blossom, thrown forward into relief by the bright blue sky behind. Dark leaf shapes are applied to give depth, and a variety of green marks are added to suggest foliage flickering in the light. Scrumptious dollops of pink, violet, and white are mixed with texture paste and applied, almost at random, with the painting knife to create the blossoms and buds. To add sparkle and give breathing space, flecks of the white ground are left untouched.

EQUIPMENT

- Stretched canvas
- Brushes: No. 2, No. 6, and No. 8 flat bristle, No. 12 round, No. 1 rigger
- Painting knives: No. 22
- Texture paste
- Phthalo blue, cadmium red light, titanium white, phthalo green, cadmium red deep, cadmium yellow deep, yellow light hansa, dioxazine purple, medium magenta, indo orange, light blue

TECHNIQUES

- Painting knife
- Texture paste
- Layering

SKETCHING WITH PAINT

When starting a painting you can draw directly on to the canvas or paper with brush and paint. This fluid approach, which eliminates mapping out the composition in pencil or charcoal, gives the painting immediate impact, vitality, and movement.

1 Sketch out the position of the branches using the No. 2 flat bristle brush and phthalo blue. Mix a dark from cadmium red light with the phthalo blue to add variety to the colour of the branches. Use this mix too to suggest where the leaves are.

BUILDING THE IMAGE

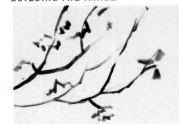
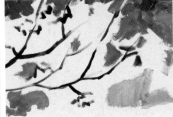
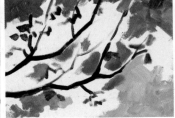
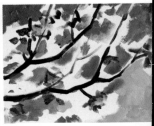

2 Paint the sky with a mix of phthalo blue and titanium white, using the No. 8 flat bristle brush and vigorous, multi-directional strokes. Add more titanium white to paint the lower part of the sky, creating a gradient from dark to light, which increases the feeling of space.

3 Thicken the lines of the branches that are closest to the tree with the first dark mix. Taper them off at the ends. Paint some leaves with phthalo green using the No. 6 flat bristle brush. Add more leaves using a mix of phthalo green and cadmium red deep.

4 Paint cadmium red deep over the white canvas where the cherry blossom is using the No. 12 round brush and calligraphic strokes. Use cadmium red deep and phthalo green for the background leaves, with no light shining on them, using the No. 6 flat bristle brush.

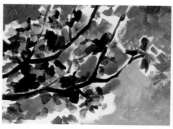
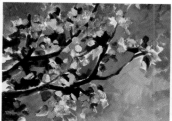
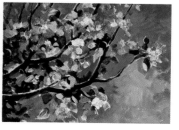

5 Add some cadmium red light and increasing amounts of cadmium yellow deep to the background leaf mix. Use these mixes over both the dark greens and the white canvas to create further variety.

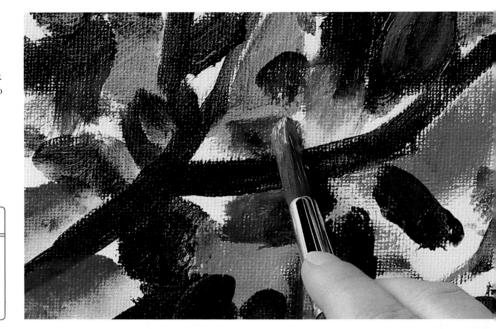

IMPASTO

Impasto is a method of applying paint to give a rich quality to the paint surface. Colour is put on thickly and directly using a flat bristle brush or a painting knife.

6 Continue building up the leaves. Mix phthalo green and yellow light hansa to paint the leaves that are catching the light. Mix yellow light hansa with a hint of phthalo green to paint the lightest leaves in the sunlight.

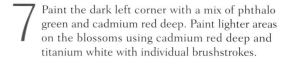

7 Paint the dark left corner with a mix of phthalo green and cadmium red deep. Paint lighter areas on the blossoms using cadmium red deep and titanium white with individual brushstrokes.

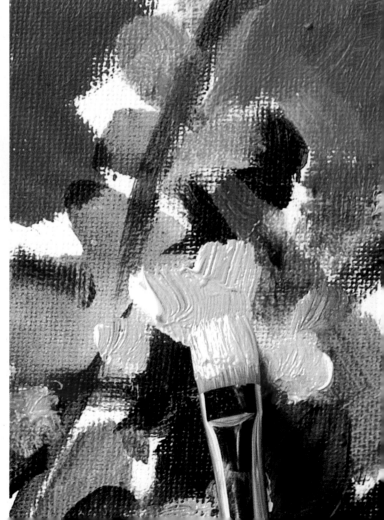

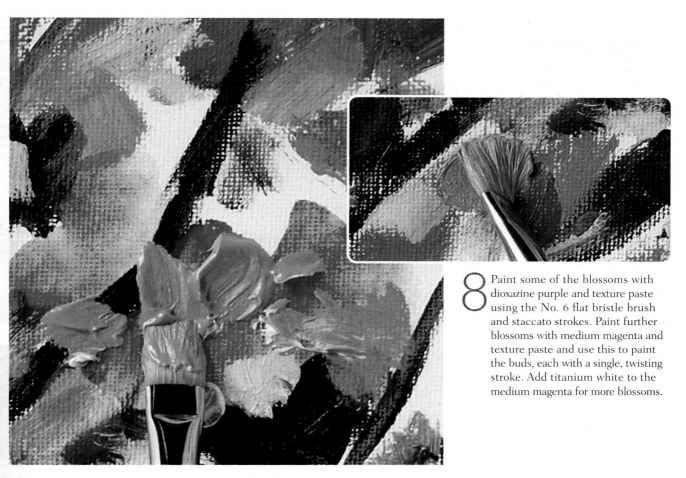

8 Paint some of the blossoms with dioxazine purple and texture paste using the No. 6 flat bristle brush and staccato strokes. Paint further blossoms with medium magenta and texture paste and use this to paint the buds, each with a single, twisting stroke. Add titanium white to the medium magenta for more blossoms.

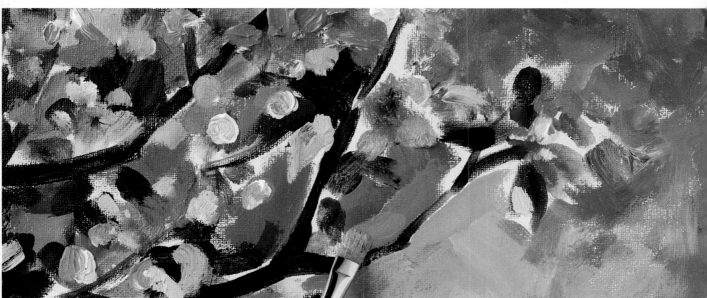

9 Knock back the white around the blossoms with a mix of phthalo blue and titanium white to help create a rich background. Fill in the far left branches with phthalo green and cadmium red deep and add a few more at the top left.

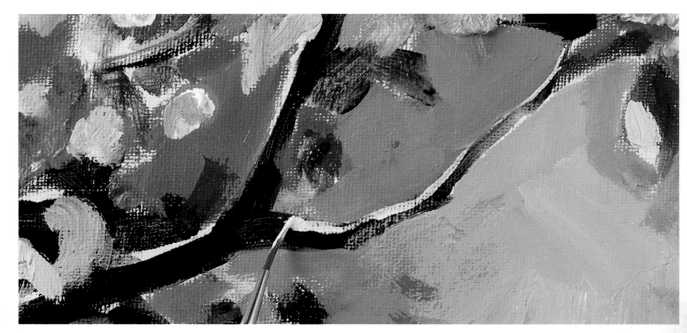

10 Add some more leaves over the new branches with a mix of phthalo green and cadmium yellow deep and use this mix elsewhere to add richness to the foliage. Paint the tops of the branches that are in the light with titanium white using the No. 1 rigger brush.

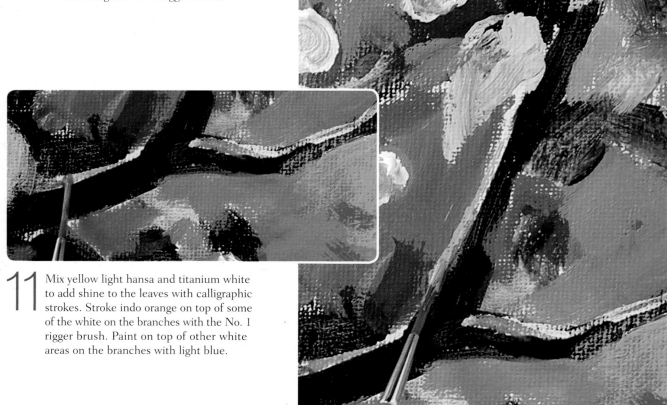

11 Mix yellow light hansa and titanium white to add shine to the leaves with calligraphic strokes. Stroke indo orange on top of some of the white on the branches with the No. 1 rigger brush. Paint on top of other white areas on the branches with light blue.

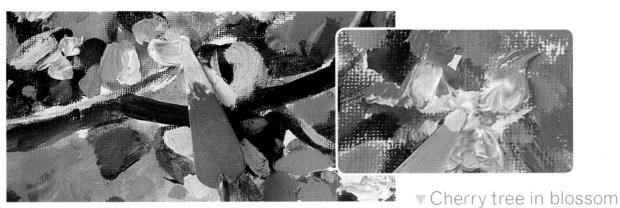

12 Apply dioxazine purple and texture paste to the blossoms and buds using the point of the No. 22 painting knife. Repeat with medium magenta and texture paste. Use yellow light hansa and texture paste and the point of the painting knife to add small dots that suggest stamens.

▼ Cherry tree in blossom

These branches, laden with cherry blossom, express the vitality of nature. Setting the riot of blossom colour, and varying shades of green foliage, against a bright blue sky throws them forward and gives the painting impact.

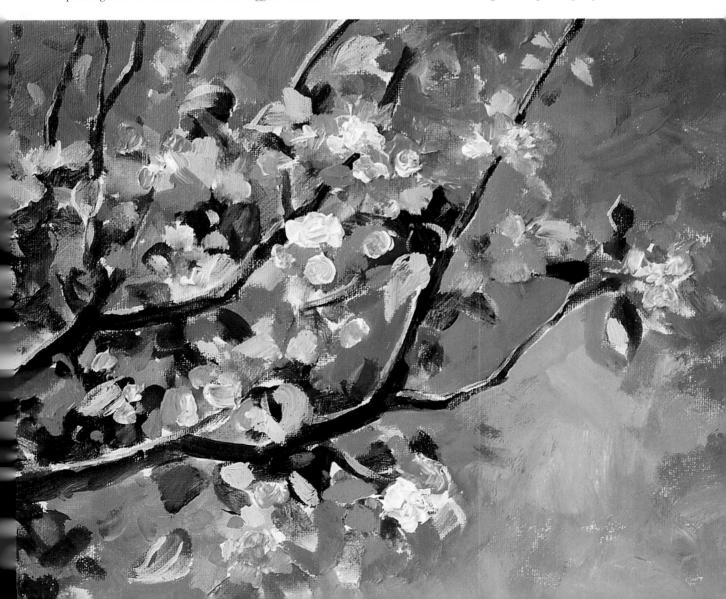

35 Boat on the beach

This painting re-creates the lively environment of a working beach, with the fisherman standing by his boat working at his net, surrounded by the tools of his trade. The spontaneous feel is partly achieved by leaving areas of watercolour paper uncovered, and the sky is merely hinted at. The paraphernalia on the beach is suggested, rather than defined, through the use of sponging, spattering, scratching, and wax resist. The jaunty angles of the flagpoles, ladder, and rope provide impact, and the flags painted with one brushstroke convey movement.

EQUIPMENT
- Watercolour paper – cold-pressed
- Brushes: No. 8 and No. 12 round, No. 1 rigger
- Wax candle, cardboard, toothbrush, kitchen paper
- Phthalo blue, cadmium red light, cadmium red deep, cadmium yellow deep, medium magenta, light blue, French ultramarine, titanium white, phthalo green, indo orange

TECHNIQUES
- Resist
- Painting with stiff card
- Putting in a figure

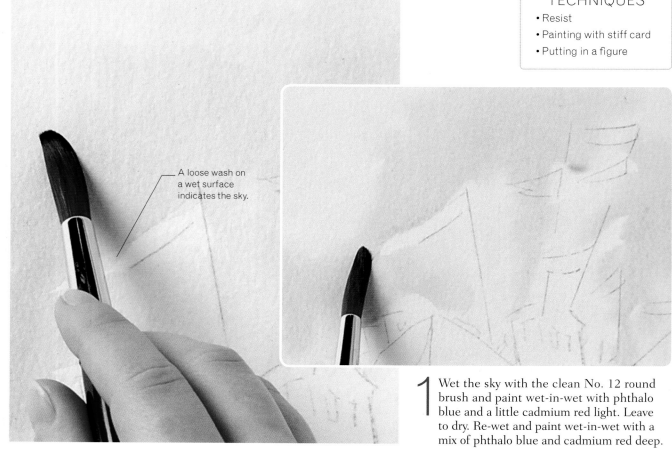

A loose wash on a wet surface indicates the sky.

1 Wet the sky with the clean No. 12 round brush and paint wet-in-wet with phthalo blue and a little cadmium red light. Leave to dry. Re-wet and paint wet-in-wet with a mix of phthalo blue and cadmium red deep.

BUILDING THE IMAGE

The application of candle creates a textured effect.

2 Draw into the foreground with the wax candle where there is netting and pebbles to create a resist, which will retain the white of the paper. Press firmly when using the candle.

3 Wet areas of the beach with a clean brush, then paint with cadmium red light, cadmium yellow deep, and a mix of these two. Paint the boat and fisherman with a mix of cadmium yellow deep and medium magenta.

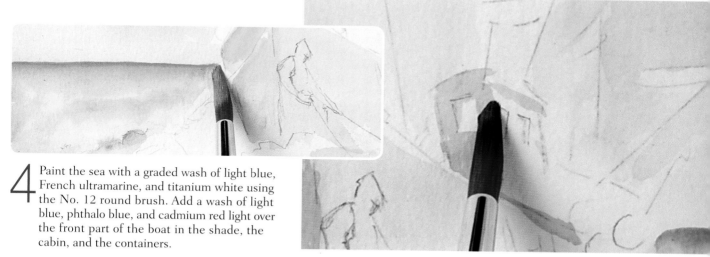

4 Paint the sea with a graded wash of light blue, French ultramarine, and titanium white using the No. 12 round brush. Add a wash of light blue, phthalo blue, and cadmium red light over the front part of the boat in the shade, the cabin, and the containers.

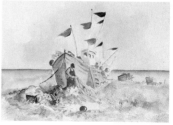

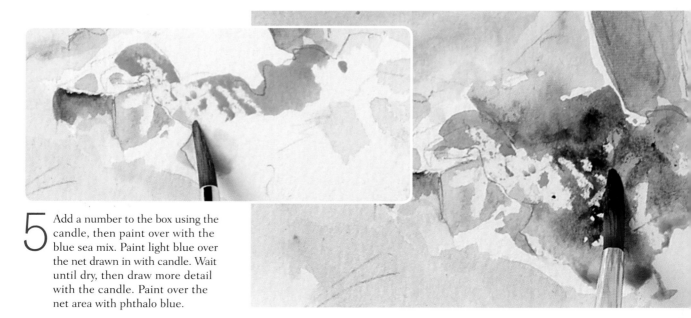

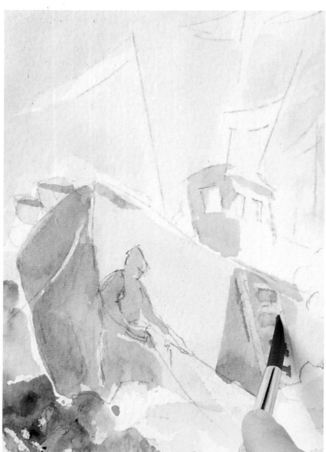

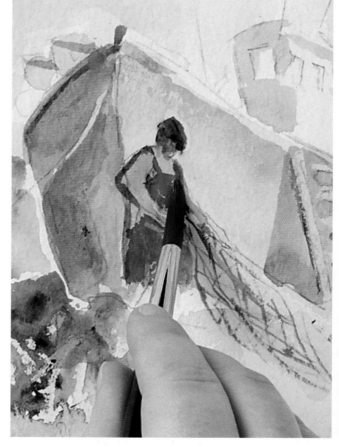

5 Add a number to the box using the candle, then paint over with the blue sea mix. Paint light blue over the net drawn in with candle. Wait until dry, then draw more detail with the candle. Paint over the net area with phthalo blue.

6 Paint a grey wash of phthalo blue and cadmium red light over the figure. Draw in the ladder with the candle, then paint the grey wash over this area to create the shadow cast by the ladder on the boat.

7 Paint the net with phthalo green and light blue. Add texture to the boat by drawing on with the candle then painting over with phthalo blue. Paint the fisherman's cap and arm with the grey mix and his overalls indo orange.

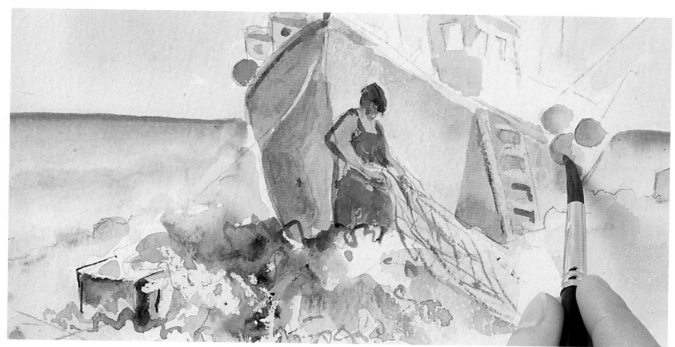

8 Paint the shadow under the net, and the boxes and debris on the beach, with the grey mix. Paint medium magenta at the base of the boxes and use it to put in the detail of the buoys. Add detail to the back of the boat with light blue.

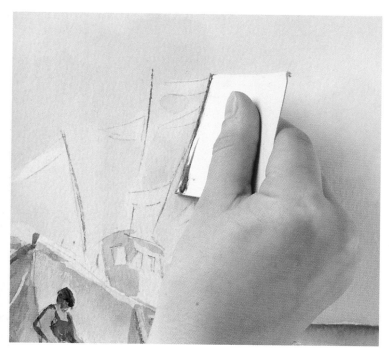

9 Cut a piece of cardboard the length of one of the boat's flagpoles. Paint the edge of this cardboard with the grey mix. Press the painted edge on to the painting to create the straight lines of the boat's flagpoles, giving each of them a crisp printed line.

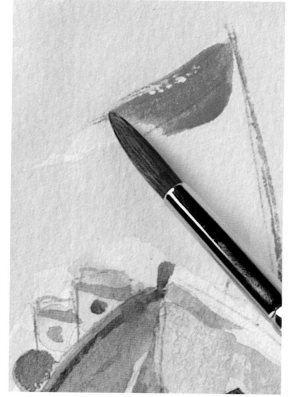

10 Paint two flags black with a mix of phthalo green, phthalo blue, cadmium red deep, and cadmium red light using the No. 8 round brush and one pressurized stroke. Paint other flags indo orange and cadmium red deep.

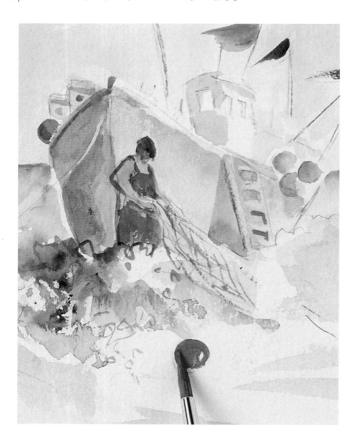

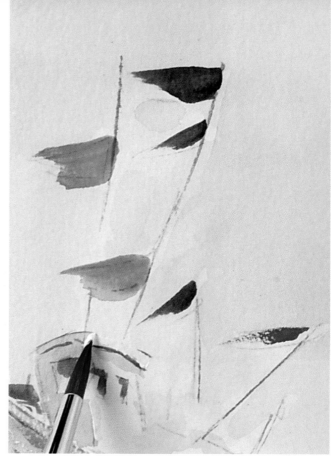

11 Paint cadmium red deep over the front buoy on the boat and add a buoy to the beach with a pink mix of cadmium red deep and medium magenta. Paint the edges of the boat and buoys with the grey mix.

12 Paint the prow indo orange and add touches of titanium white to the cabin. Draw the candle on the box to the right of the boat and paint over with the grey mix. Add more buoys next to this box with the pink mix.

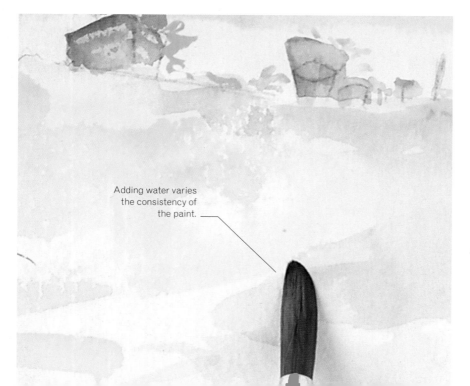

Adding water varies the consistency of the paint.

"The movement in the flags gives the impression of a breezy day."

13 Mix watery light blue for the foreground and right of the beach. Add diluted titanium white to the fisherman's hat and use titanium white to paint his sleeves and add highlights on the buoys. Add detail to the beach with light blue.

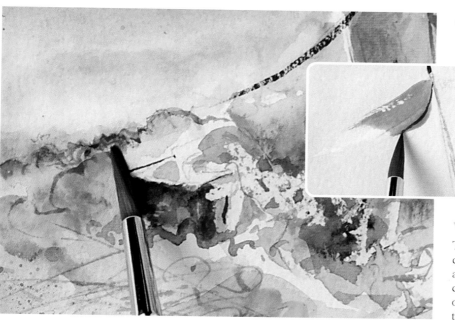

14 Wet areas of beach, then paint wet-in-wet with phthalo green. Add lines of grey mix to the flags. Cover the painting with kitchen towel, leaving part of the beach exposed, and flick over indo orange with a toothbrush and with the No. 8 round brush. Define the edge of the beach with indo orange and paint the rope with the grey mix.

▼ Boat on the beach

The light coming from the right creates counterchange patterns on the boat, and this, along with the use of diagonals, creates impact. The dynamic triangle of the red buoys is designed to move the eye around this beach scene.

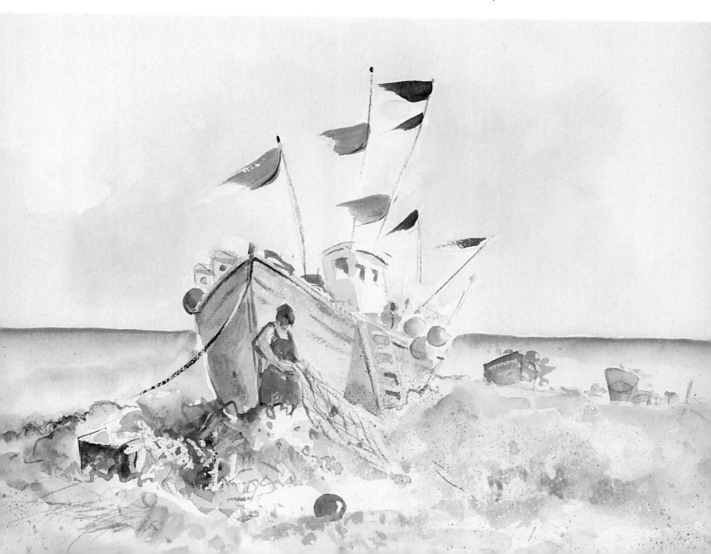

36 Portrait of a young woman

A portrait painting can be one of the most challenging subjects for an artist to undertake, but the beauty of using acrylics is that it is simple to adjust areas that you are not happy with. The main aim in this portrait is to illustrate form in a simple way. The head is seen as a cube and the neck as a cylinder. In this instance, the head is turned slightly to one side so that both the front and the side planes can be seen. The front of the face and neck, and the top plane of the nose, are illuminated, whereas the side planes of each are in shadow.

EQUIPMENT
- Stretched canvas
- Brushes: No. 8 round, No. 10 flat bristle, No. 1 rigger
- Charcoal stick, kitchen towel, painting medium
- Titanium white, cadmium yellow deep, indo orange, phthalo blue, cadmium red deep, phthalo green, French ultramarine, light blue, cadmium red light, medium magenta

TECHNIQUES
- Proportion
- Creating form

PROPORTIONS

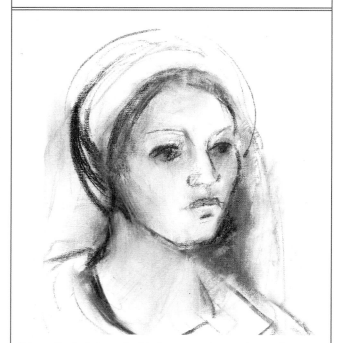

It is particularly important to be aware of proportions when working on a portrait. The measurements of the forehead, nose, mouth, and chin have to be correct in relationship to each other in order to create a convincing likeness.

1 Draw the face with a charcoal stick, putting in the main shadows which show the direction of the light. Establish the tonal range with the charcoal, removing it in places with kitchen towel to create highlights and soft mid tones.

BUILDING THE IMAGE

 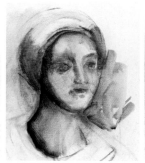 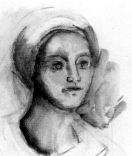 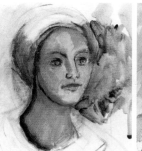 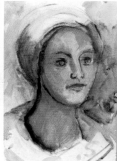

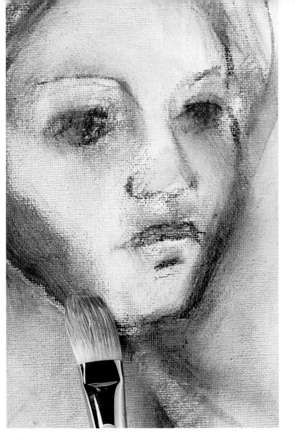

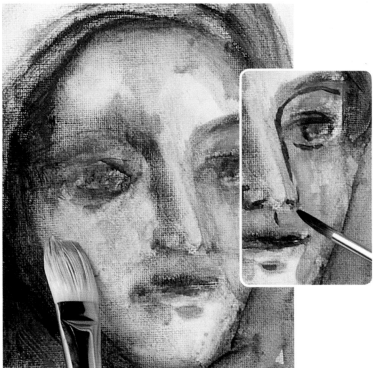

2 Indicate some background on the left, with a mix of titanium white, cadmium yellow deep, indo orange, and phthalo blue, using the No. 10 flat bristle brush. Add more phthalo blue to indicate the darker areas of the face and headscarf.

3 Blend the dark areas with a clean, wet brush. Draw in the features with phthalo blue. Put a watery mix of phthalo blue on the right and soften all areas of the face with a pink mix of indo orange, titanium white, and cadmium red deep.

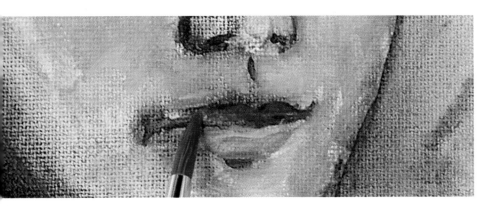

4 Add more cadmium red deep to the pink mix for the lips; and phthalo green for the shadow area. Add indo orange and titanium white to the mix to paint the mid tones. Add more cadmium red deep to the mix to define the lips.

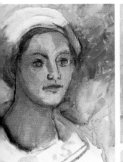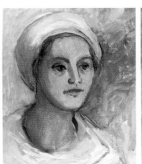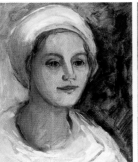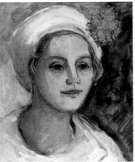

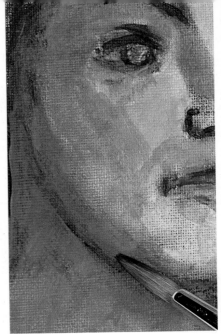

5 Paint the right background with phthalo blue and, while wet, add French ultramarine. Add titanium white for the left background. Sketch in the shoulder with French ultramarine. Add right shadow with a phthalo blue and indo orange mix.

6 Build up the thickness of the paint in the background with a layer of phthalo blue and French ultramarine. Add titanium white, then paint the left background. Mix indo orange and cadmium red deep to put in wisps of hair around the face.

7 Mix indo orange, cadmium red deep, and titanium white for the face in shade. Soften the edge of the face with phthalo green and titanium white. Paint titanium white and phthalo blue to the left of the head and on the headscarf in shade.

8 Paint the neck and nose shadows with phthalo green, cadmium red deep, and titanium white. Add titanium white and cadmium red deep to the headscarf in the light. Paint its shaded side with a mix of titanium white and light blue, and add mixes of titanium white with phthalo blue and phthalo green.

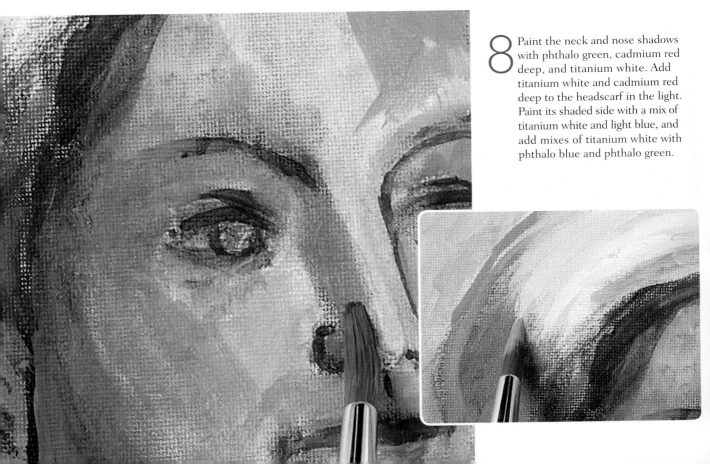

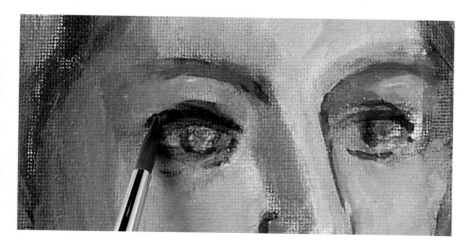

9 Paint parts of the face that are in the light with a mix of indo orange, cadmium red deep, titanium white, and phthalo blue. Define the eyes with a warm dark mix of phthalo blue, phthalo green, and cadmium red deep. Add titanium white to put the shadow under the eye.

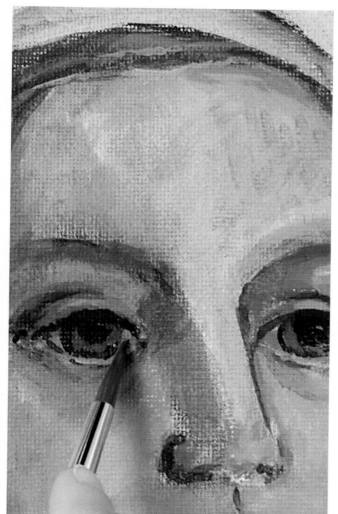

"Knowledge of perspective is helpful in painting convincing portraits."

10 Put titanium white and a touch of cadmium red deep on the lower eyelid. Paint the irises with phthalo blue, phthalo green, a little cadmium red deep, and titanium white. Use the warm dark mix to paint the pupils and titanium white and phthalo blue for the whites.

11 Paint the dress with a mix of phthalo green, cadmium red deep, and titanium white. Define the edge of the neckline with a mix of phthalo green and cadmium red deep. Paint other areas of the dress with titanium white with a touch of phthalo green.

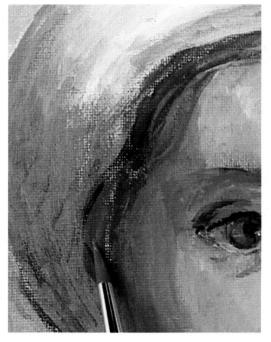

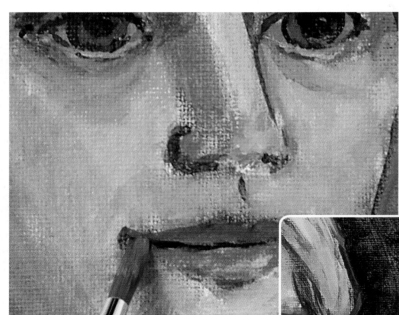

12 Paint highlights on the hair with a mix of cadmium yellow deep, cadmium red light, and titanium white, using the point of the No. 8 round brush. Strengthen the shadow hair colour with cadmium red deep and phthalo blue.

13 Raise the corner of the lips using the warm dark mix. Paint the background with cadmium red light, French ultramarine, and painting medium. Add fine lines of hair with a mix of cadmium yellow deep, indo orange, and phthalo blue.

14 Paint the flower with thick dabs of medium magenta, indo orange, cadmium red light, and cadmium red deep. Ground the flower with French ultramarine where it meets the headscarf. Add streaks of a mix of medium magenta and titanium white and of light blue to liven up the headscarf.

Portrait of a young woman ▶

The use of counterchange, light against dark and dark against light, adds impact to this portrait. The warmth of the flesh tones and the rich, decorative flower appear vibrant against the areas of blue.

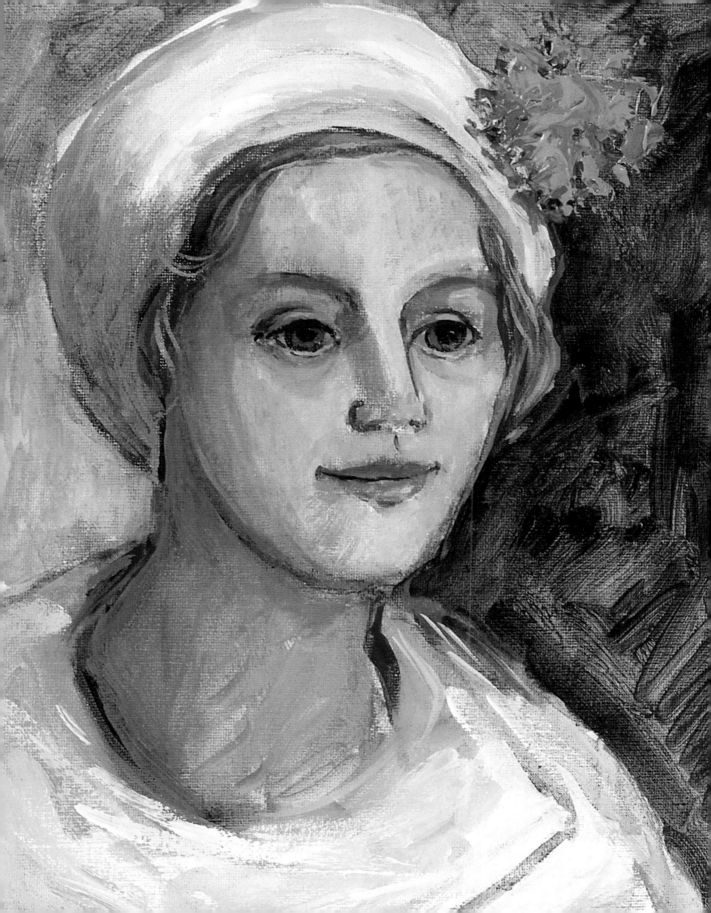

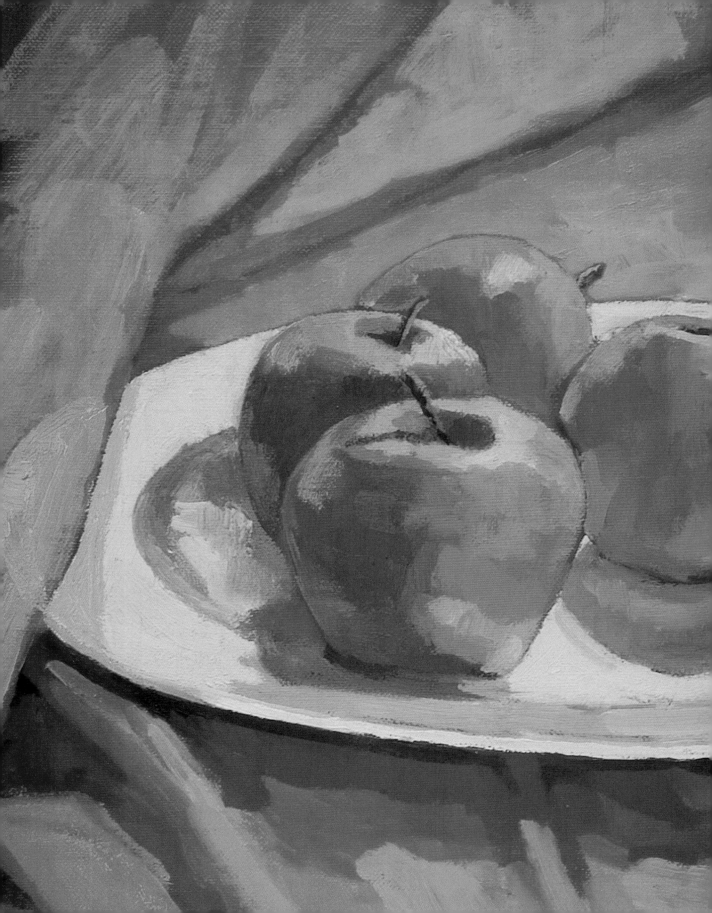

Oil-painting
Workshop

Introduction to oil-painting

Oil paint is a very expressive medium to use, with sensuous, tactile textures and glowing colours. However, perhaps because of its association with the Old Masters and other towering figures in the world of art, it is often regarded as having a certain mystique that puts it beyond the successful reach of the novice. In fact, it is a forgiving medium that is easy to work with, for you can simply clean or scrape off anything that you are not pleased with and start again.

By the 16th century oil paint had become the favourite medium of artists all over Europe. The paint could be thinned with turpentine and oil to give it great translucency, while at the same time achieving the deep, rich colours that both pleased wealthy patrons wanting to be portrayed in all their rich finery, and imbued religious and secular subjects with depth and sensuousness.

Oil paint is also delicious for the artist to handle. It has great plasticity, which means it can be moulded into many different textures, and even when it is applied thinly it possesses a pleasing body and malleability. This is because of the oil with which the pigments are premixed in the tubes, as well as the oil in the painting medium with which the paints are mixed on the palette before the brush is put to canvas. It allows patient, subtle work with a fine

brush or, depending on the artist's temperament and intentions, vigorous applications with a knife to plaster it thickly on the support. Of all media, it allows for the greatest versatility of technique, but is also capable of throwing up chance effects, which add to the magic of using it and encourage the development of the artist.

This section is a hands-on approach to painting in oils and will set the budding artist on the path to using this most satisfying medium with enthusiasm and confidence. It begins by detailing the pigments, brushes, and other equipment you will need, including new products that take away some of the perceived problems for amateur artists using oils in the home, such as odour and slow-drying paints. You will discover the techniques of applying paint, from translucent glazes to thick impasto, and learn about colour mixing, both in practical terms and in the use of contrasting and harmonizing colours to bring vibrancy and balance to your paintings. Each chapter takes you a step further to a concise understanding of what oil painting is about, and galleries of paintings by various artists illustrate the points made in the text. The 12 projects help you to realize that you are able to create finished paintings on a wide range of subjects.

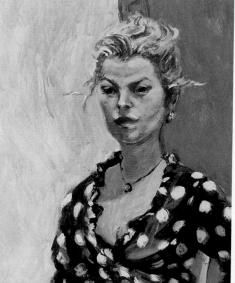
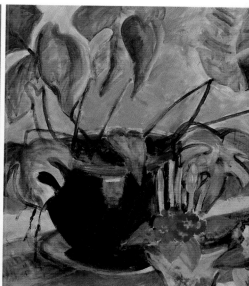

Oil-painting
Materials and Techniques

Oil paints and other materials

There is a wide choice of oil paints available in tubes or pots, varying in strength of pigment and quality. The best quality paints are professional or "Artists' colours". These contain stronger pigments than "Students' colours", so they have more brilliance, more covering power, and are less likely to change with time. Limit the number of colours you purchase in favour of buying Artists' paints.

RECOMMENDED COLOURS

The 15 colours below make up a useful standard palette. With this number of colours you will have a good ready choice when painting, because with these you will be able to make virtually any colour by mixing two or more together. You may want to add a few more colours that you particularly like. It is often economical to buy the colours that you use most, such as titanium white, in a larger tube.

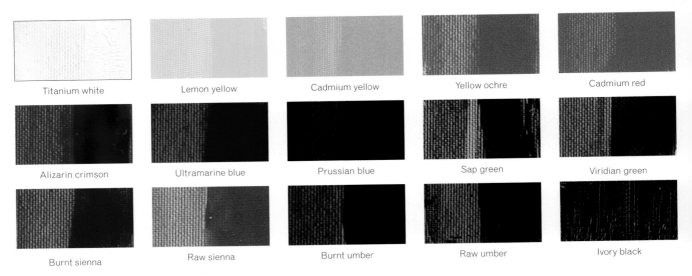

Titanium white Lemon yellow Cadmium yellow Yellow ochre Cadmium red

Alizarin crimson Ultramarine blue Prussian blue Sap green Viridian green

Burnt sienna Raw sienna Burnt umber Raw umber Ivory black

OIL PAINT VARIATIONS

The drying time of Artists' oil colours can vary from a few days to a few weeks, depending on how thick the paint is applied. Alkyd paints are faster drying oil paints, and their drying time is a fraction of that of traditional oil paints, so they are handy for painting outdoors. Water-mixable oil colours contain an oil binder that has been modified to mix with water, so these paints take even less time to dry.

OTHER MATERIALS

You need about six brushes to start with, and two or three painting knives, a fan brush for blending, and a 25mm (1in) brush for priming and varnishing (not shown). A palette is indispensable, on to which can be clipped a dipper for painting mediums. You also need a rag to wipe off paint, a jar of white spirit to clean hands and brushes, and protective clothing.

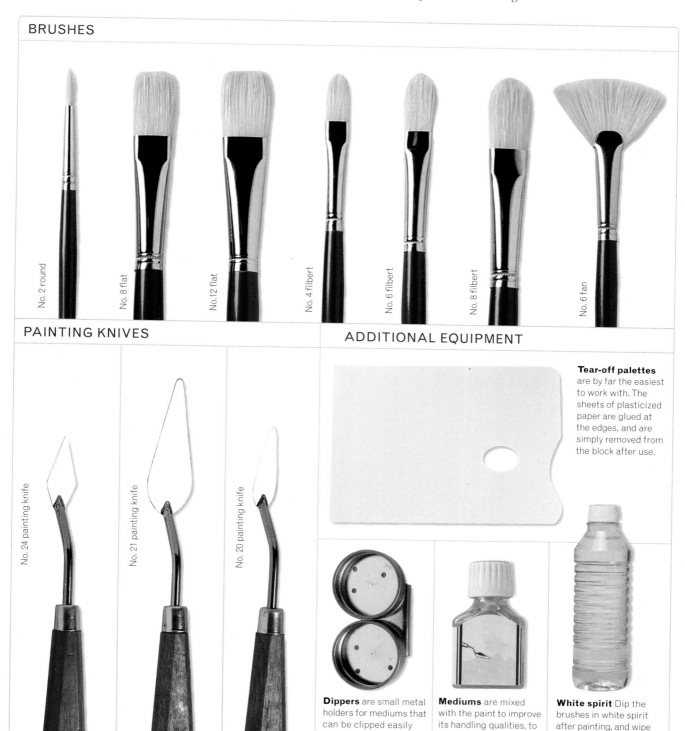

BRUSHES

No. 2 round

No. 8 flat

No.12 flat

No. 4 filbert

No. 6 filbert

No. 8 filbert

No. 6 fan

PAINTING KNIVES

No. 24 painting knife

No. 21 painting knife

No. 20 painting knife

ADDITIONAL EQUIPMENT

Tear-off palettes are by far the easiest to work with. The sheets of plasticized paper are glued at the edges, and are simply removed from the block after use.

Dippers are small metal holders for mediums that can be clipped easily to the palette.

Mediums are mixed with the paint to improve its handling qualities, to thin it, or to thicken it.

White spirit Dip the brushes in white spirit after painting, and wipe them on a rag.

Supports: the painting surface

A support is the surface you paint on. All supports need to be primed before use, so that the surface is sealed and the support does not absorb the paint. Paper blocks of oil painting paper, and some canvas boards and canvases, are sold ready primed. Primed supports are white. Canvas is the classic oil painting support and is available in cotton or linen, but many artists prefer to paint on board.

TYPES OF SUPPORT

Oil painting paper, canvas, canvas board, MDF board, and hardboard are all suitable supports for oil painting. Their surface textures vary from fine, through medium, to rough. Experiment with supports to see which surface suits you best. Do not buy your support too small; a size of about 40 x 50cm (15 x 20in) will allow you space to work.

Oil painting paper is available in specially prepared blocks. Primed heavyweight watercolour paper is also suitable for oil painting.

Canvas may be cotton or linen. Cotton canvas is less expensive than linen, but linen canvas keeps its tautness better.

Canvas board is available ready primed in different sizes in art shops. It is board with a linen texture paper glued on it.

Multi Density Fibre (MDF) board comes in different thicknesses and has to be cut to size.

Hardboard provides both a smooth and a rough, textured side and, like MDF, is reasonably priced.

DIFFERENT SURFACES

The traditional support for oil painting is canvas, which lasts for centuries. Canvas has a stretch to it that responds to the pressure of the brush. Good quality boards primed with acrylic gesso are less expensive and may last as long. The paintings here show the results obtained on different supports.

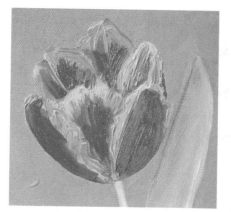

Canvas The paint is applied thickly on this medium texture cotton canvas. Canvas is available in many different textures from fine to rough.

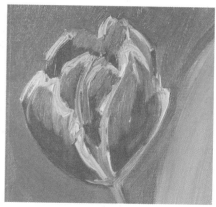

Canvas board The paint is applied medium thick on this medium grain canvas board. This leaves the possibility of adding finer detail.

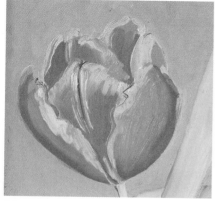

Oil painting paper This is a medium fine paper with the paint used medium to thick. The paper can be glued to a board or canvas later.

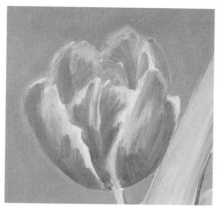

MDF board The surface is smooth and without grain. The paint is worked medium thick and shows the individual hairlines of the brush.

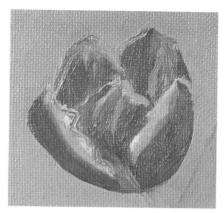

Hardboard Both sides are suitable for impasto. Here the paint is applied medium thick on the rough side. The smooth side is like MDF.

PRIMING THE SUPPORT

Apply the acrylic gesso primer with a large primer brush or a large household brush, moving the brush with bold strokes.

Paint from left to right, and up and down, to seal the support properly, and to give a good key to the surface so that the paint will adhere.

Allow the gesso to dry before starting the painting. Drying will only take 30 minutes to an hour, unless the primer is applied with thick texture.

Oil paint brushes and painting knives

Brushes come in different qualities and price ranges, but hog bristle brushes are generally recommended for oil painting. Hog brushes with a natural spring are likely to last longer. Sable or nylon brushes can be used for glazes and fine work. Sable brushes are expensive; nylon brushes are more reasonably priced. You can also paint with a painting knife. The handle of a painting knife is cranked to lift it from the paint surface.

BRUSH SHAPES

There are four shapes of brushes: round, flat, filbert, and fan. Brushes are numbered from 1 to 24, and the lower the number the smaller the brush. For a starter set include a No. 2 round, a No. 8 and No. 12 flat, a No. 4, No. 6, and No. 8 filbert, and a No. 6 fan brush. Choose a round brush that comes to a good point. It is useful to have more brushes in the middle sizes.

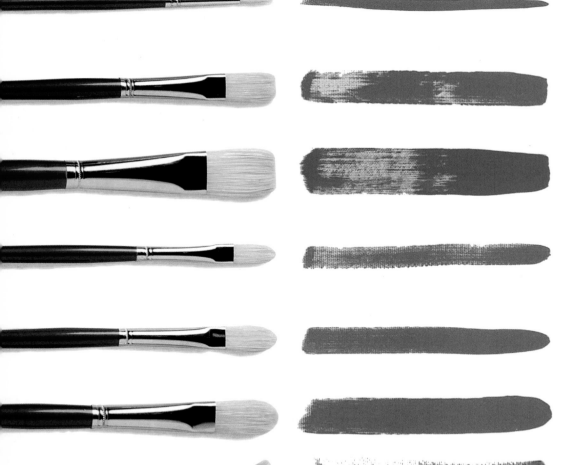

No. 2 round is perfect used pointed for lines and details, and is also used on its side.

No. 8 flat is used flat for a broad stroke, or on its side for a thinner line.

No. 12 flat gives a broader stroke, and the top can be used to make straight edges.

No. 4 filbert is a versatile brush, used flat as here, on its side, or on its point.

No. 6 filbert holds more paint. The rounded point is good for blending.

No. 8 filbert gives a broader stroke, but can still create a fine line used on its side.

No. 6 fan is used lightly to skim the surface, and softly blend and feather.

PAINTING KNIVES AND THEIR MARKS

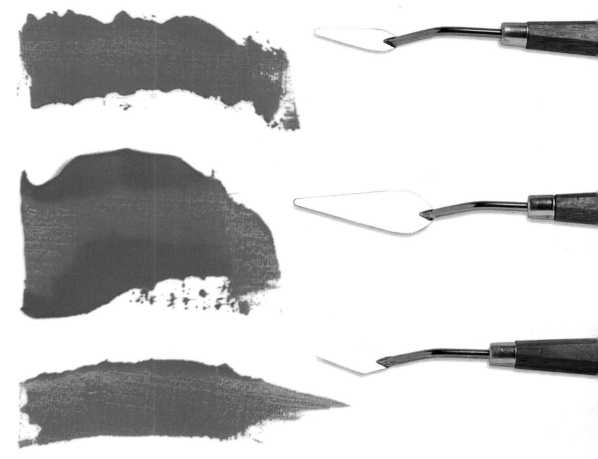

No. 20 painting knife is useful for applying little flecks of paint, and small impasto work.

No. 21 painting knife is suitable to paint sharp edges, petal shapes, and impasto.

No. 24 painting knife is good for smaller work, sharp edges, and impasto work.

HOW TO HOLD A BRUSH AND PAINTING KNIFE

Hold the brush about halfway along the handle for most of your painting. Paint with a stretched arm, and move your arm around freely over the painting and outside it. For finer detail and smaller shapes move your hand closer to the brush, but hold it lightly. Always use the largest brush for the space. Hold the painting knife like a knife. You can push paint onto the support with the painting knife both sideways, as shown in the marks above, and lengthways.

For flowing brushmarks hold the brush like you would hold a knife. Move the wrist and arm around to make free and easy brushstrokes.

For finer detail hold the brush like you would hold a pen. Make short or dabbing movements to deposit the paint for detail.

Keep your thumb on or to the side of the handle of the knife. Move towards the hand or roll the wrist inwards for a sideways dab.

Brushstrokes

Practise holding the brush at different angles, from upright to flat, and almost parallel to the paint surface. Vary the pressure and move the brush in different directions turning your wrist. Try out a line, a colour field, and dabbing. Experiment with the various types of brushes and painting knives to make abstract marks. Break up a line or colour field with varied brushstrokes for a playful effect.

VISUAL EFFECTS

Use the tip of a round brush to create short lines with quick short brushstrokes.

Apply the side of a round brush up and down in quick diagonal strokes to make a colour field.

Twist the point of a round brush, moving it from left to right for irregular rounded marks.

Press the side of a round brush onto the canvas and lift up again for definite little dabs.

Press down the side of a filbert brush in a crisscross pattern for an irregular colour field.

Use the tip of a filbert brush and move it up diagonally and to the right in short strokes.

Press down the broad side of a filbert brush and lift up for a layered colour field.

Apply a filbert brush up and down in quick diagonal strokes for an irregular colour field.

Pull down the broad side of a flat brush in short movements for a layered effect.

Use the top of a flat brush and pull sideways and up to make diagonal, partly overlapping hatchings.

Use the side of a flat brush for zigzag movements sideways to fill a colour field more playfully.

Use the top of a flat brush upright and pull sideways, turning in a fan movement, for light filling in.

Press the blade of a painting knife down and lift up. Load with paint for each dab.

Vary the flat side and sharp edge of a painting knife for irregular crisp mark making.

Move the flat side of a painting knife down and to the left in short dabs to break up the surface of a colour.

Use a painting knife sideways up and down with a turning wrist to make a colour field.

APPLYING STROKES

Just a few abstract strokes and dashes can create simple sketches. Practise images like sheep in a field, a palm tree, and a pot of geraniums.

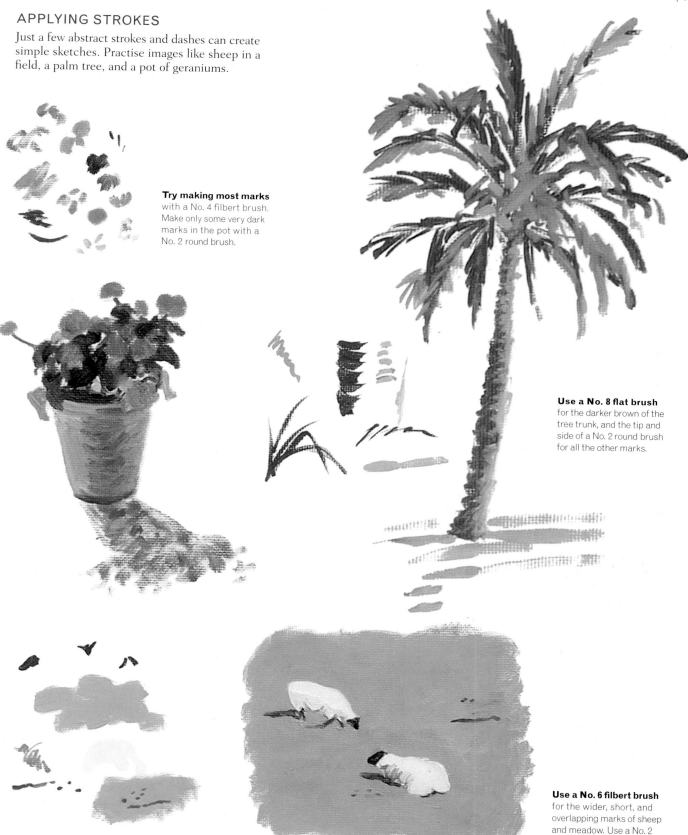

Try making most marks with a No. 4 filbert brush. Make only some very dark marks in the pot with a No. 2 round brush.

Use a No. 8 flat brush for the darker brown of the tree trunk, and the tip and side of a No. 2 round brush for all the other marks.

Use a No. 6 filbert brush for the wider, short, and overlapping marks of sheep and meadow. Use a No. 2 round brush for details.

Colour mixing with oils

Colours are mixed to create new colours by stirring them around with each other and blending them on the palette. Squeeze out the 15 colours of the recommended colour palette on the edge of the palette first. You can also mix colours directly on the support when the paint is mixed wet-in-wet with the lower paint layer. This usually results in the colours partly blending with each other.

MIXING ON A PALETTE

Normally the paint is mixed on the palette. Here more yellow than red is picked up on the same brush for a light orange.

With the first mixing stroke on the palette you see the different strands of red and yellow drawn by the hairs of the brush.

By circling the brush a few times on the palette with the two paints, they are blended thoroughly and create orange, a new colour.

MIXING WITH A BRUSH

Pick up some yellow paint with the brush from a blob of yellow on the palette. With the same brush pick up some red as well.

Mix the colours on the support in one stroke and blend them slightly. Both red and yellow still show as separate colours.

Moving the brush with red and yellow round in circles blends the two colours, first partially, and then thoroughly, into orange.

MIXING ON CANVAS

Apply a red colour field with one brush. Then apply yellow paint on top with another brush. The colours blend when mixed on the canvas.

Apply the yellow paint wet-in-wet. The colours remain separate, but at the edge between red and yellow they blend into orange.

Moving the brush first deposits more defined yellow. When you keep stirring the brush the yellow and red will blend.

MIXING WITH A PAINTING KNIFE

Use a painting knife to pick up yellow and blue from the palette to mix into a green. Keep the blobs as clean as you can.

With one movement of the painting knife both blue and yellow, and the newly mixed colour, green, are visible.

Moving the palette knife back and forth mixes the paints thoroughly, although variations in the paint may still be detected.

MIXING WITH TWO COLOURS

With the recommended standard palette of 15 colours you can make almost any colour you wish. The colour wheel shows how two primary colours can be mixed to form the secondary colours. Here different oranges and violets are made by mixing the various yellows, reds, and blues on the palette. The two resulting violets are then mixed with white to show that they are different violets.

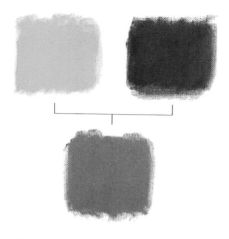

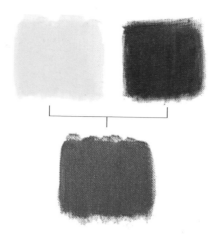

Cadmium yellow and alizarin crimson make a mid orange because their hues are equally strong.

Lemon yellow and alizarin crimson make a darker orange because alizarin crimson is a more dominant colour than lemon yellow.

Alizarin crimson and ultramarine blue make a mid violet because alizarin crimson and ultramarine blue are equally strong colours.

Alizarin crimson and Prussian blue make a darker, and bluer, violet because Prussian blue is the stronger of the two.

Mixing the first violet, made from alizarin crimson and ultramarine blue, with white gives a good strong lilac.

Mixing the second violet, made from alizarin crimson and Prussian blue, with white makes a rather cool grey blue.

SEPARATE BRUSHES

It is good practice to keep some brushes with important colours going, during painting, so that you can come back to them. This saves effort and paint. It speeds up your painting when you can use the same brushes quickly to pick up some more of the various paint mixes on the palette.

Hold brushes with important colours in your non painting hand.

You can also keep saved brushes upright in a pot for used brushes.

Mixing darks and lights

It comes as a surprise that whereas mixes of two colours give clear new colours, when three colours are mixed together the results are neutral colours. Depending on the colours mixed, ranges of neutrals with subtle differences can be created, from dark to light. Two or more different pigments can also tone down colour. Neutral colours are important foils for bright colours and can make them sing.

MIXING NEUTRALS FROM PRIMARY COLOURS

When all three primary colours are mixed together in equal amounts they make a dark or neutral colour. You can create an infinite variety of colourful darks by varying the proportions of each primary colour.

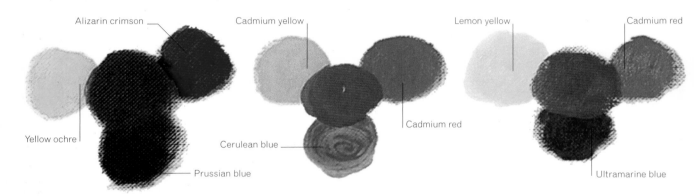

Alizarin crimson

Cadmium yellow

Lemon yellow

Cadmium red

Yellow ochre

Cerulean blue

Prussian blue

Cadmium red

Ultramarine blue

Dark brown Prussian blue is the stronger colour and dominates both alizarin crimson and yellow ochre.

Light brown Cerulean blue, which is a lighter, weaker blue, mixes with cadmium yellow and cadmium red to create a lighter brown.

Reddish brown The combination of cadmium red and ultramarine blue dominates the weaker lemon yellow to form a reddish brown.

MIXING NEUTRALS FROM COMPLEMENTARY COLOURS

You can also mix two complementary colours together to make a colourful neutral. Yellow mixed with violet, red mixed with green, or blue mixed with orange, make neutral colours that set off strong colours well. Adding just a little of the complementary colour can tone down or modify the brightness of a colour.

Blue and orange are mixed to a greenish mid brown. The outcome will be darker when a stronger blue is used.

Red and green are mixed to a reddish mid brown. The outcome will be cooler when using a stronger green.

Yellow and violet are mixed to a yellowish mid brown. The outcome will be darker when using yellow ochre.

MIXING WITH BLACK AND WHITE

Colours can be lightened or darkened by mixing them with other colours. They can also be lightened or darkened by mixing them with black and white. In the chart below the first horizontal row shows five variations of grey between white and black. The other rows show variations of some of the colours recommended for the standard palette when white and black are added.

+ white ———————— Colour from the tube ———————— + black

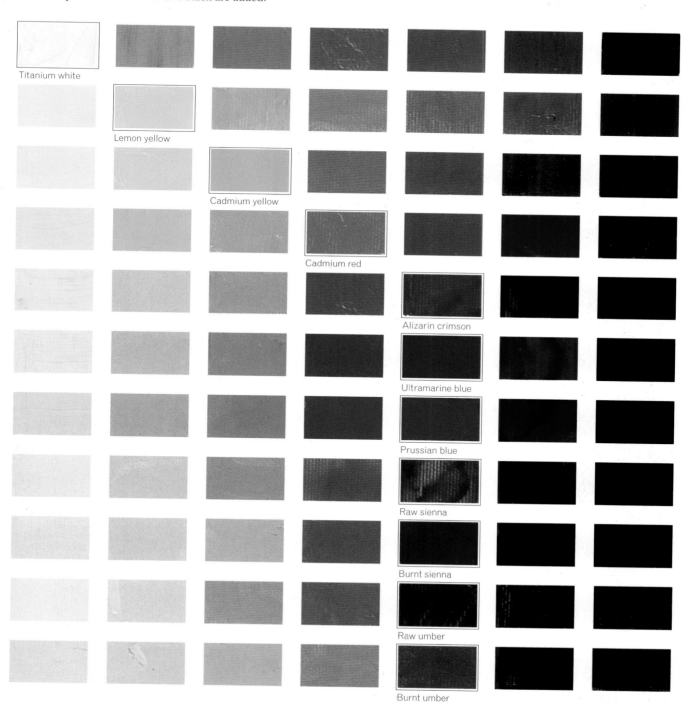

Titanium white

Lemon yellow

Cadmium yellow

Cadmium red

Alizarin crimson

Ultramarine blue

Prussian blue

Raw sienna

Burnt sienna

Raw umber

Burnt umber

Glazes

A glaze is a larger area of diluted and transparent paint used on its own or laid over other glazes. The paint is made thin and translucent by adding turpentine or odourless thinner to the paint or a thin mixture of turpentine and oil, using two parts turpentine to one part oil. You can also add an alkyd-based glazing medium to the paint to make a glaze. A scumble glaze lets the undercolour show more unevenly.

LAYING GLAZES

A painting is usually built up of several layers of paint. Try laying a single glaze and then practise painting a second glaze over the top using a different colour. A useful way of toning down a colour is to apply a second glaze in its complementary colour over it.

SINGLE GLAZE

Use a flat brush. Dilute cadmium red with turpentine or a glazing medium and start to paint a colour field with broad overlapping strokes.

Draw the brush in parallel movements until you have a block of colour. The white undercoat shimmers or shines through.

Check the consistency of the colour and lift some paint off by squeezing your brush dry and painting over the colour field again.

OVERGLAZE (YELLOW OVER RED)

When the paint is still wet start applying an equally thin and transparent layer of yellow. Here the yellow is used somewhat too dry.

Dip the paint in the medium and slowly drag the yellow over the red in fluid movements. A shimmering orange results.

The two wet layers mix slightly, but you can still distinguish the two separate colours. Check and refine the second glaze.

OVERGLAZE (RED OVER YELLOW)

Lay a yellow underglaze with a thin mixture of oil and turpentine. The white of the support shines through in places.

Now draw a clean brush with an equally thinned red over the yellow glaze in fluid movements to create a red veil over the yellow.

The two colours mix slightly on the support, but can still be distinguished. A vivid orange is the result, showing some variations.

OVERGLAZE WITH COMPLEMENTARY COLOUR

Paint a thin glaze of viridian green first. With a clean brush, draw a glaze of cadmium red over the green in slow movements.

Apply the red glaze in overlapping strokes. The two complementary colours form a mid reddish brown, with the green showing through in places.

Check the consistency of the top glaze by going over the area again and softening the overlaps of paint, but do not overwork the new colour.

SCUMBLE GLAZE

At the top, apply a green glaze over a yellow underglaze. Towards the bottom the brush is used in a horizontal scumbling movement.

Add a quick vertical scumble glaze over the horizontal scumble for a more irregular effect, still letting more of the yellow underglaze show.

A few thicker touches are scumbled to the right. The yellow glaze shows through the green scumble glaze irregularly.

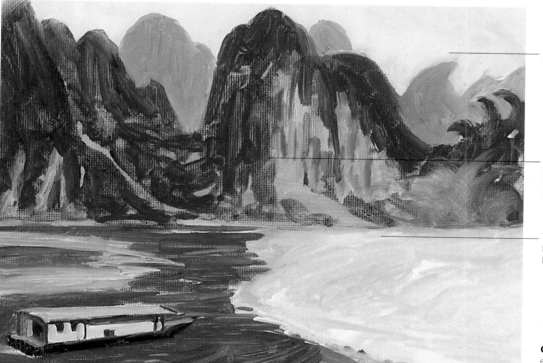

The sky is a single glaze of light blue.

Several glazes partially overlapping each other form the mountains and the water.

The yellow glaze of the beach is scumbled over by a lighter yellow glaze.

Guilin, China This scene is entirely painted in glazes. In some places a single glaze is applied, while in other areas, such as the river, multiple glazes are overlaid.

Mixing oil with mediums

Apart from thinning the paint with turpentine or odourless thinner, a mix of two parts turpentine and one part oil, or a glazing medium, to make glazes, you can add different mediums to make the paint thicker.

This is done by adding thicker mixes of two parts oil and one part turpentine, or by using an alkyd-based painting or impasto medium. An important rule of oil painting is to paint "thick over thin".

USING MEDIUMS

A glazing medium can be used for glazing and blending. Its addition can increase the gloss effect of the paint and help the paint to dry more quickly. For medium thickness painting when you want more expressive brushstrokes a painting medium can be added. An impasto medium can be added to the paint when you require much thicker paint for textural effects.

Glazing medium will thin the paint and create transparency.

Painting medium will thicken the paint for expressive brushstrokes.

Impasto medium will bulk out the paint considerably and add texture.

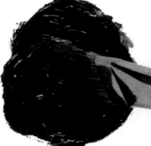

Violet mixed with impasto medium on the palette becomes viscous and can be applied by brush or painting knife.

PAINT MIXED WITH MEDIUMS

The paint samples below show how paint is altered when mixed with different mediums. The second row of samples have sand added to the mediums for texture.

Paint from the tube usually does not spread easily, and it can adhere unevenly to the surface.

Turpentine makes a thin and transparent colour, but can also result in a rather dull quality.

Impasto medium gives the paint the consistency of egg yolk, making it rich and easy to use.

Turpentine and linseed oil make a glossy medium thickness paint that is easy to work with.

THICK OVER THIN

Remember always to paint "thick over thin". If you do the reverse and apply thin paint over thick paint the thin top layer dries quicker over the slower drying underlayer. When this underlayer dries in its turn it contracts, and causes the hardened top layer to crack and form tiny uneven ridges. You can prevent this by first painting in thin paint and glazes before adding thicker layers of paint. These may be mixed with a painting medium or with mixtures of turpentine and linseed oil. Finally, thick or impasto layers may be added to the painting.

USING THICK PAINT (IMPASTO)

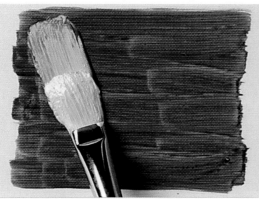

Paint a thin green glaze. Overlay this with a thick yellow paint bulked out with impasto medium.

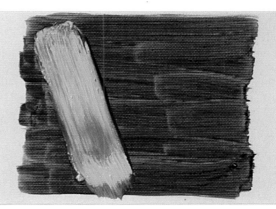

Apply the yellow paint thickly and with a bold stroke. The paint is sticky and runs out quickly showing the undercolour.

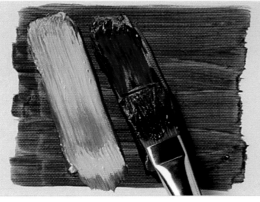

Next paint an impasto violet alongside the yellow. The thick violet paint is viscous and slightly pushes the green aside.

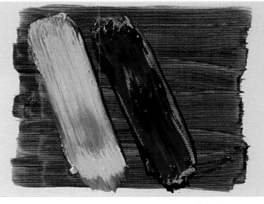

Both colours stand up in ridges and show a variety of thicknesses within the brushstrokes.

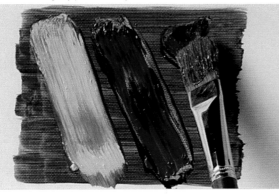

Make a dot of violet next to the two stripes of colour. Push the brush down on to the green and turn it.

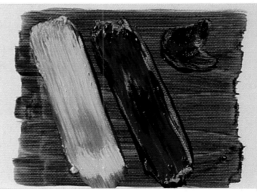

The resulting surface of the dot sticks up as an irregular contrast to the thin green underpaint.

Composition

Composition is the art of arranging the colours and shapes in a painting to convey what excites the painter about a subject. It is about analysing the subject so that each part of the painting is right in itself, in relation to the other elements of the painting, and in relation to the work as a whole. Plan active and complicated areas, but balance these with open and simpler areas to give the eye a rest.

VIEWFINDER

Working with a viewfinder makes it easy to establish a good composition. Cut two L-shaped pieces of card and hold them to make a rectangle that is roughly to the proportions of the support. Look through it at your subject to plan the composition of your painting. Pull the viewfinder closer to your eye and you will see more of the scene before you. Move it to the left and right, or up and down, to vary the scene.

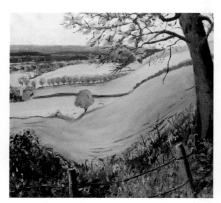

Frame and crop the picture by sliding the corners of the viewfinder.

FORMAT

The composition of your painting also relates to the format or shape of the support. A landscape or horizontal format is suited to views of the countryside or sea, while a portrait or vertical format is suited to the shape of the head and shoulders. A square format allows a flexible composition, which you might prefer for interesting still life arrangements.

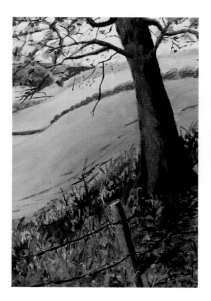

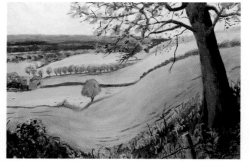

Landscape format The tree leads the eye from the shade into the sunny landscape, across the fields with the single small tree, to the farm buildings on the left.

Portrait format The focal points here are the tree and the fence post, which contrast with the tiny shapes of bluebells at the edge of the woodland.

Square format The accent here is on the large tree, and the small tree and diagonal lines in the middle distance.

USING THE RULE OF THIRDS

Decide on the main focus of interest in the painting, and plan another one or two significant points in the scene to lead the eye on a journey through the picture. An easy way of placing the focal points is by using the rule of thirds. Divide a painting equally into three both horizontally and vertically, and place the focal points where the dividing lines cross. This rule of thirds is a help in composing the painting from the outset.

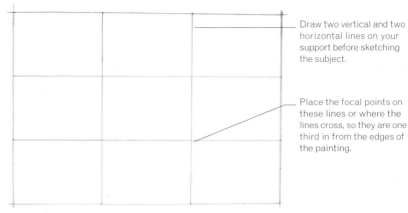

Draw two vertical and two horizontal lines on your support before sketching the subject.

Place the focal points on these lines or where the lines cross, so they are one third in from the edges of the painting.

The man is the largest subject and the darkest tone in the picture plane. He is placed along a vertical line.

A. Boshoff.

Beach at Great Brak In this painting the eye travels from the jumping smaller child to the father and his watching daughter in the water. The major figures are positioned according to the rule of thirds, making a balanced composition.

The pigtail of the girl and her plastic armbands give just enough detail to attract the eye.

Sketching

Drawing and sketching is an important preparation to painting. Learning to draw is an exciting journey of discovery, and drawing will sharpen your observational skills. In a working drawing you can plan the position of focal points, the proportions, and relationships in the painting, and the perspective if you use one. It may also show the colour key and tonal values of the scene. A sketch may show the development of the thought process of the painter in the planning of the work.

KEEPING A SKETCHBOOK

Most painters keep a sketchbook in which they jot down whatever strikes them in quick sketches. Others make more elaborate studies of what they see, but often you need just a pencil, a scrap of paper, and five minutes to make some marks. Making sketches can be like keeping a visual diary, and the main interests of the artist will show in the sketchbook.

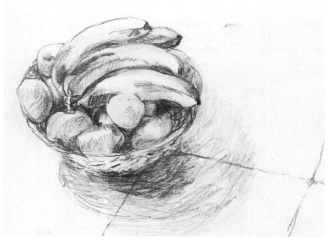

Planning a composition A carefully executed drawing in pencil has included the lines of the tiles on the table top as a compositional device. The drawing would lack something without these carefully drawn lines.

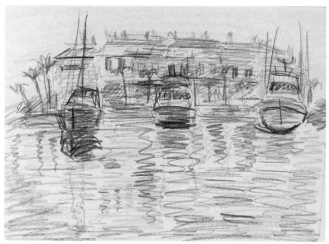

Quick colour sketch The speed of execution of this quick sketch shows an energy and vibrancy, with simple lines, which may not be so easy to achieve in a more elaborately worked painting.

DRAWING IN PENCIL

Pencil is a versatile tool. Artists use softer and blacker B pencils, varying from 2B, the hardest, to 6B, the softest and blackest. Use the point of a pencil to draw fine and precise strokes, or the side of the graphite point for shading and wider marks. Held lightly it creates greyer marks; pressed down firmly blacker marks result. While a pencil drawing can be a valuable work of art in its own right, pencil can also be used for preparatory sketches. Sketching the main outlines of the composition on your support before you begin painting makes the final work that much more assured.

A sketch for the Café scene project (*see pp. 438–443*) was drawn directly on to the support before painting began.

PLANNING A PAINTING

Plan a painting with one or two preparatory sketches in pencil, crayon, or paint. The sketch can be done on paper as a guideline for the final work, or it can be done on the support itself, to be painted over later. In the sketch you can freely establish the perspective, and the relationships and relative sizes of subjects, without fear of getting it wrong.

Pencil sketch The overall relationships in this interior are worked out in a line drawing. The scene is drawn with great attention to detail, and the entire picture plane is filled. Use an eraser to improve precision.

Oil sketch The scene is repeated in a quick oil sketch, just using primary colours, and black and white, to work out the different tones. The cushions are worked up in this stage, an idea abandoned in the final work.

The lights on either side of the sofa give off a soft light on the walls, lampbases, and sofa.

The flowers, vase, ashtray, and sculpture of Zeus holding a candle are focal points.

The glass table and the pattern in the rug are treated simply.

Final painting After the two preparatory sketches the scene can be put down with confidence. The colours and tones are simplified. The cushions and the shapes in the rug form a harmonious rhythm.

Preparation and finishing touches

Prepare yourself thoroughly for a painting session so that you are not held up once you start painting. The act of getting ready also helps to put you in the right mood for painting. You need a table that is large enough to hold your palette, paints, brushes, painting knives, mediums, and other painting equipment. Place your support on an easel if possible, and avoid placing the subject in direct sunlight as the light may change considerably before you can finish your painting.

Light Make sure that natural light hits the surface of the support. Do not work in your own shadow.

Subject Have an unobstructed view of your subject so you do not have to move to see it. Paint it against the light rather than in direct sunlight.

Palette Have all your colours ready squeezed from the tubes on to the edge of the palette.

Easel Use an easel to hold the support up vertically. Position it so that you can step back while painting to get an overview.

Brushes Place brushes upright in pots while painting. Use one for clean brushes and the other for used brushes with colours you want to come back to.

Turpentine and linseed oil Keep them near at hand to use pure or in mixtures from thin to thick.

Painting table Keep your painting table below your hand so you can reach the palette without moving.

Dipper Keep the dipper clipped on to the palette or close to it, and fill the holders with the mediums you need.

VARNISHING

Leave the painting where it can dry undisturbed. It can take a day to a few weeks for the painting to become hand dry, and up to three to six months to harden off completely. When the painting is thoroughly dry you can varnish it to protect it against dust and to enrich the paint surface. Varnish is available in matt or gloss finishes. Use a primer and varnishing brush, and cover the whole surface of the painting, working from left to right and from top to bottom.

This part of the painting is unvarnished. The lean underlayer looks more matt than the fat impasto layer on top of it.

After varnishing, this part of the painting has a consistent gloss sheen. The varnish covers ridges and crevices alike, and protects against the ravages of time.

Varnish is transparent and provides a removable film of protection to the painting surface. The right half of this work is varnished with gloss varnish. The left half is as yet unvarnished.

FRAMING

A well-chosen frame greatly enhances a painting. For small oil paintings choose a frame with a width of about 2.5cm (1in). Larger paintings need a frame that is at least 5 or 7.5cm (2 or 3in) wide. A slimmer frame may look insubstantial. Choose a frame by holding a sample corner frame on every corner of the painting to see the result. The colour of the frame should match some colour in the painting, or relate harmoniously to the work.

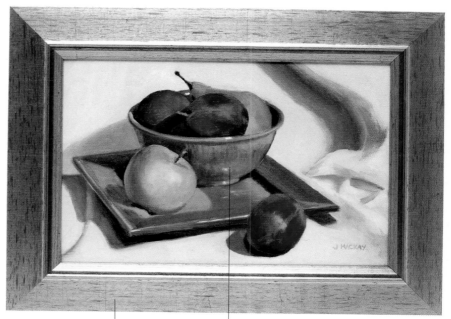

The wood frame relates well to the natural subject of this still life picture, and enhances the colours in the painting.

The colour of the light wood harmonizes with the golden fruits.

The blue ceramic bowl and dish are emphasized by the contrasting frame.

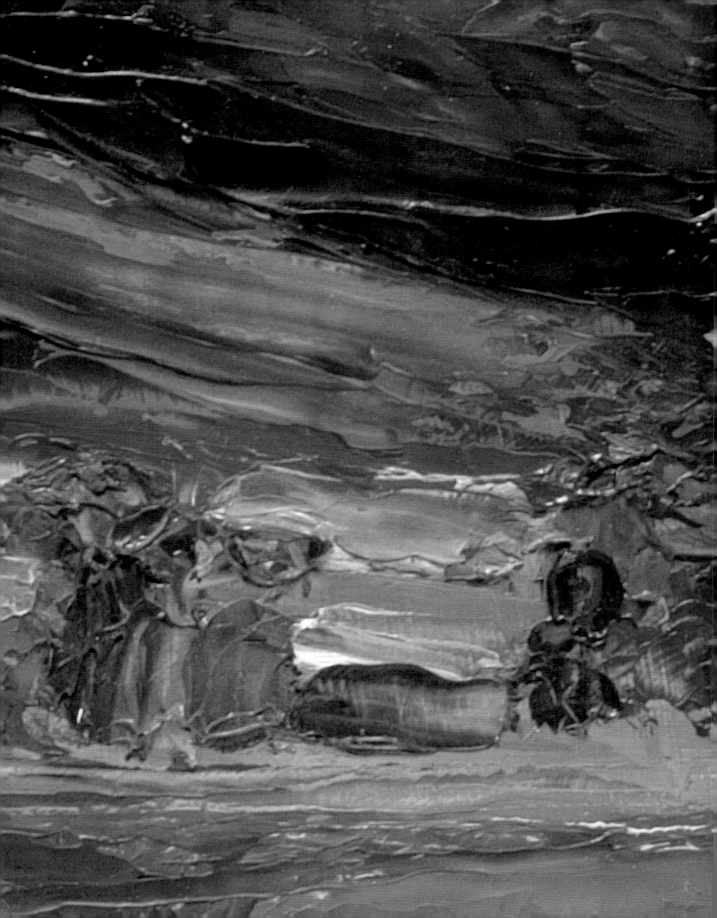

Textures in Oil

"Express yourself with texture: juxtapose translucent glazes with thick, tactile paint."

Textural effects

One of the most exciting aspects of painting in oils is the wide range of textures that you can create. You may choose to express your feelings about your subject by slowly building up thin glazes, so that you achieve a smooth, subtle finish from the cumulative effect of layers of paint; at the other end of the scale, you may wish to make urgent, spontaneous marks with thickly laid paint to create a tactile, heavily textured surface. The approach you use will influence the viewer's response as much as the subject itself.

FROM GLAZES TO IMPASTO

Laying a series of transparent glazes that allow underlying colours to glow through each successive application creates a translucent and refined work. Impasto painting, where the pigment is applied thickly to the surface, has a very different, sculptural result. This may be done alla prima (meaning in one go), with thick paint throughout, or begun with medium-thick paint and finished with a thick and varied layer of marks made by a brush, painting knife, fork, or comb. Directional marks will draw the viewer's attention across the canvas, helping to guide the eye to your point of focus. Adding sand, sawdust, marble dust, or plaster to the paint gives extra texture.

The white of the support shines through the thin glaze, giving it translucency.

The raised edges of the strokes of thick-textured impasto paint are clearly visible.

DIFFERENT EFFECTS

The three illustrations below show how the same scene can take on a different emphasis, depending upon the technique you use to apply the paint to the surface.

Laying thin glazes

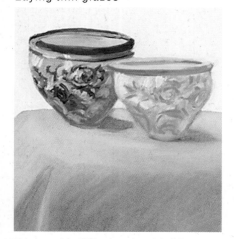

Using a series of thin glazes to paint all the objects gives a smooth surface.

Combining thick and thin

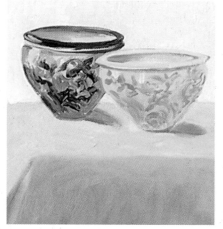

The light table top, pots, and background consist of thicker paint, giving a variation of texture.

Painting impasto

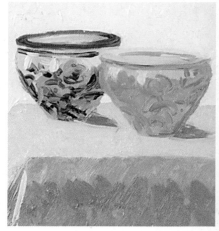

All the elements are painted impasto, the texture showing the malleability of the pigment.

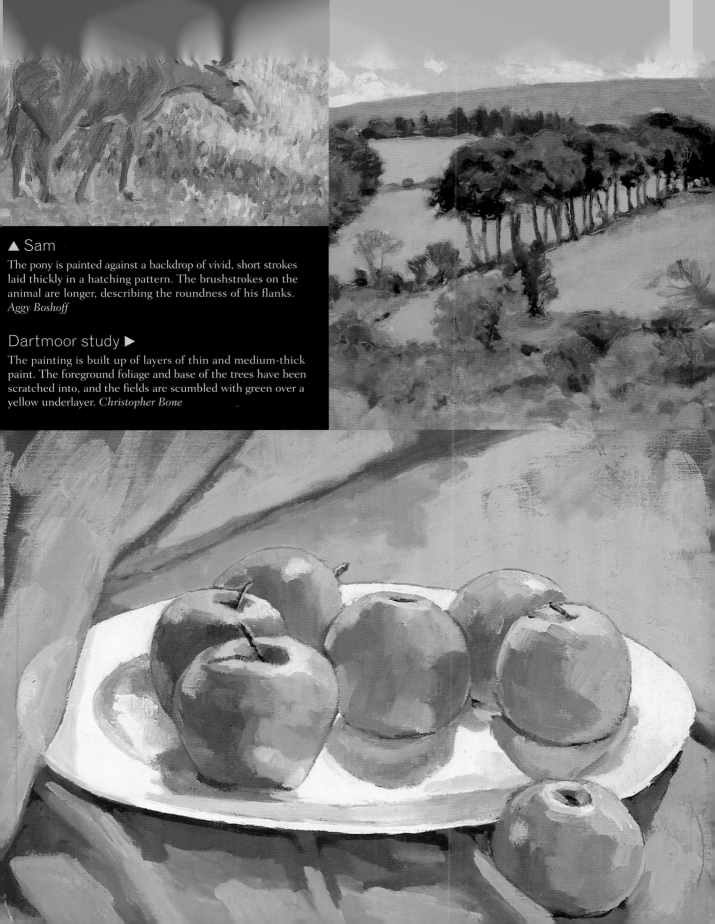

▲ Sam

The pony is painted against a backdrop of vivid, short strokes laid thickly in a hatching pattern. The brushstrokes on the animal are longer, describing the roundness of his flanks. *Aggy Boshoff*

Dartmoor study ▶

The painting is built up of layers of thin and medium-thick paint. The foreground foliage and base of the trees have been scratched into, and the fields are scumbled with green over a yellow underlayer. *Christopher Bone*

[37] Beach with parasols

In this tropical beach scene the three main areas of the sky, sea, and beach are each worked up with several layers of colour. Overlaying glazes are used to establish an intensity of colour and produce a shimmering quality that characterises bright sunlight. The paint is applied thinly, but the brushstrokes are expressive. Subtle scumbling is used to suggest the texture of the sandy beach, while the expanses of sea and sky are created by softly blending layers of paint wet-in-wet. Only the later additions to the clouds are painted more thickly to give volume.

EQUIPMENT
- Oil painting paper
- Brushes: No. 2 round, No. 8 and No. 10 flat, No. 4 and No. 6 filbert
- Cotton rag
- Turpentine or odourless thinner, glazing medium, painting medium
- Prussian blue, titanium white, cerulean blue, cobalt turquoise, yellow ochre, cadmium yellow, alizarin crimson, cadmium red, ultramarine blue, lemon yellow, burnt sienna, cobalt blue

TECHNIQUES
- Glazing
- Wet-in-wet

Drawing the composition lightly gives guidelines for painting.

Using the paint wet-in-wet makes it easier to blend.

1 Mix Prussian blue and titanium white with turpentine. Paint the sky with broad strokes using the No. 10 flat brush, leaving the white clouds. Glaze the mix over the lightest part of the sea. Add more titanium white to the mix for the cloud bases.

2 Mix cerulean blue, cobalt turquoise, titanium white, and turpentine. Glaze the mid sea area using the No. 8 flat brush. Work this turquoise mix wet-in-wet into the edges of the lighter areas of the sea, and into the clouds.

BUILDING THE IMAGE

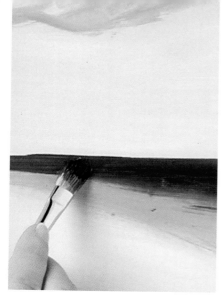

3 Mix Prussian blue and glazing medium. Glaze the darkest areas of the sea towards the horizon with the No. 4 filbert brush. Use light horizontal strokes, mixing with the mid colour of the sea.

4 Mix Prussian blue and the turquoise mix with glazing medium to blend the mid and dark colours. Add titanium white to scumble into the clouds. Mix Prussian blue, titanium white, and glazing medium for the mid area.

5 Scumble in the clouds with the mid sea glazing mix. Mix titanium white, glazing medium, and turpentine to scumble the lightest area of the sea, and paint the tops of the clouds with the No. 6 filbert brush.

6 Use the turquoise mix with glazing medium rather than turpentine to paint the top of the sky and to define the tops of the clouds. Increase the amount of cobalt turquoise in the mix as you progress further down towards the horizon.

7 Add some turpentine to the turquoise mix to thin it. Paint the shadow sides of the parasols with the No. 2 round brush. Rub off some of this paint with a clean rag. Use the paint on the rag to add other shadows behind the loungers.

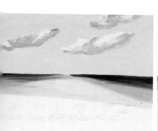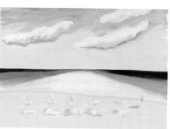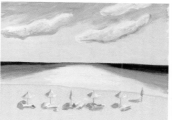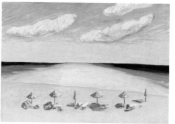

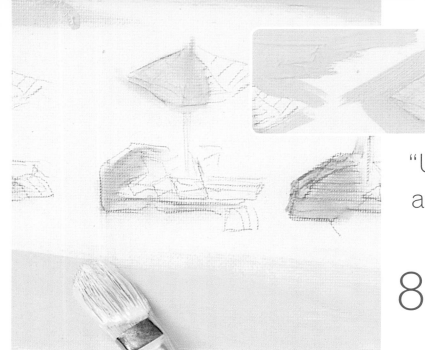

"Use a large brush for
as long as possible in
your painting."

8 Mix yellow ochre, titanium white, and cadmium
yellow with turpentine. Paint the beach with the
No. 8 flat brush with long light strokes. Work
around the parasols and loungers using the No. 2
round brush. Lightly touch the sea with this mix,
and the parasol sides in the sun.

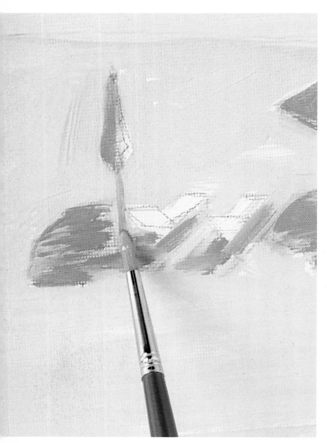

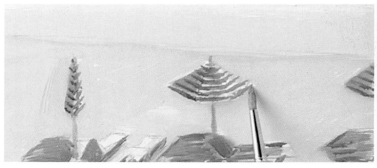

10 Paint the bags and towels with a thin mix of cadmium red and
turpentine. Mix ultramarine blue with turpentine to make some
of the shadows cooler. Use this mix for the shaded stripes of the
parasols, adding cobalt turquoise for the mid blue stripes. Paint
the stripes in the sunshine with cobalt turquoise and turpentine.
Use titanium white and turpentine for the white stripes.

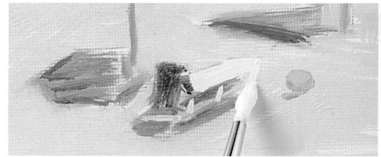

9 Mix cerulean blue, alizarin crimson, titanium
white, and yellow ochre with painting medium.
Add to the shadows on and under the parasols,
and under the loungers. Add parasol stands.
Lightly add some of the shadow mix to the clouds.

11 Add lemon yellow to the white stripe mix to paint the loungers.
Mix cadmium red and cadmium yellow to enliven the shadows and
paint the beach ball. Add more cadmium red for shadow on the
ball. Paint the parasol stands in the sunlight with burnt sienna and
turpentine, and add some of this colour to the shadows.

12 Mix cadmium yellow, turpentine, and painting medium. Scumble this mix over the beach with the No. 6 filbert brush. Add this colour to items on the beach, and dash lines into the sea.

13 Add cobalt blue to the turquoise mix with glazing medium. Paint the top of the sky and add to the clouds. Scumble titanium white with glazing medium over the sea and add patches to the clouds.

▼ Beach with parasols

Varied yellows and blues unify the different elements. Working on parasols and loungers as a group prevents too much detail, but soft shadows and colour accents add life.

38 Forest stream

The forest setting for this painting is a tangle of leaves and branches, cut through by a stream that runs along its floor. The scene is unified by starting the painting with two very thin glazes of colour. Thicker paint applied on top of the glazing in small strokes or dabs gives texture to the foliage of trees and undergrowth. By keeping the larger shapes of the bushes and trees in mind while painting, the distraction of precise detail is avoided. The repetition of the branches curving over the stream creates a subtle rhythm.

"Apply an underglaze for instant colour in a painting."

EQUIPMENT

- Canvas
- Brushes: No. 2 round, No. 4 filbert and No. 8 filbert
- Cotton rag
- Turpentine or odourless thinner, glazing medium, impasto medium
- Burnt sienna, Prussian blue, cobalt turquoise, raw sienna, ultramarine blue, cadmium red, yellow ochre, alizarin crimson, raw umber, titanium white, sap green, viridian green, cadmium yellow, ivory black, lemon yellow, cobalt blue

TECHNIQUES

- Glazing
- Drybrush

Applying the glaze with a cloth is a useful first layer.

1 Mix burnt sienna and turpentine, and apply this glaze to the areas of woodland, using a cloth and sweeping movements. Mix Prussian blue and cobalt turquoise to create a background glaze for the sky and water.

2 Mix raw sienna, ultramarine blue, cadmium red, and yellow ochre. Lightly paint the main trunks and branches using the No. 4 filbert brush. Add more ultramarine blue to the mix for definition.

BUILDING THE IMAGE

 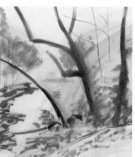 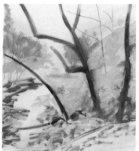 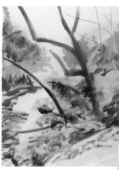

3 Add alizarin crimson and raw umber to the bluer tree mix. Use the No. 8 filbert brush to roughly sketch in more branches and the riverbank. Add some titanium white to paint in variations on the forest floor and local colour among the trees. Drybrush with rough brushstrokes.

4 Mix sap green, viridian green, titanium white, some of the sky mix, and turpentine. Paint the foliage with short horizontal and diagonal strokes using the width of the No. 8 filbert brush. Add more sap green, viridian green, and cadmium red to the mix, and drybrush the shaded areas.

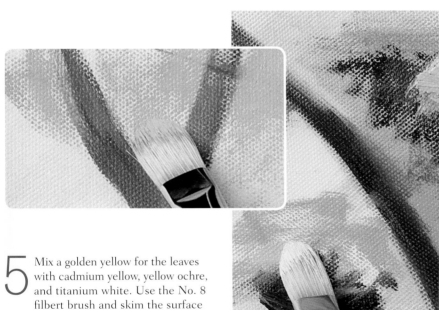

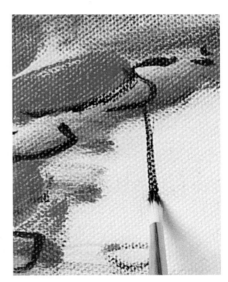

5 Mix a golden yellow for the leaves with cadmium yellow, yellow ochre, and titanium white. Use the No. 8 filbert brush and skim the surface with dry brushstrokes. Add more titanium white for sunlit leaves, painting them with horizontal dabs.

6 Accentuate the lines of the trees and the undersides of the rocks with an ivory black, lemon yellow, and raw umber mix. Use the No. 2 round brush lightly to do this.

7 Add more titanium white and cobalt turquoise to the sky mix, with less turpentine so it is thicker. Dab over the sky and among the leaves. Add titanium white to paint in sunlight.

8 Mix ivory black, viridian green, and raw umber to define the branches. Add lemon yellow for a mid green and dab in crescent moon shapes among the main foliage.

9 Mix cadmium yellow and cadmium red, and scumble the foreground. Add alizarin crimson to the sky mix for lilac pebbles. Add painting medium to this lilac mix to tone down areas.

FOLIAGE

Do not worry about painting the precise details in a mass of foliage. Textured dabs of colour can suggest the moving shapes of falling leaves.

10 Mix lemon yellow and titanium white with plenty of glazing medium. Use the No. 2 round brush to dab patches of light into the darker areas. Mix impasto medium with cadmium yellow to paint thicker dabs of colour.

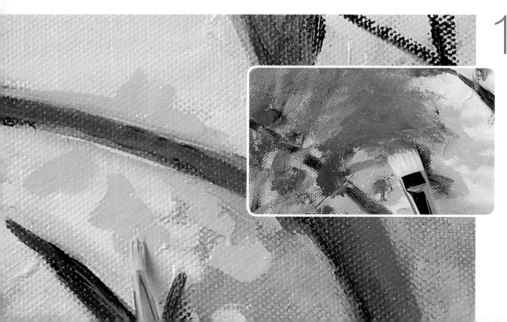

11 Mix cobalt blue and alizarin crimson with glazing medium. Use this mix to paint some shadow areas. Paint darker foliage with a mix of sap green, viridian green, and cobalt blue. Use the thick yellow mix from step 10 to add more highlights.

Forest stream ▶

This painting is underpinned by glazes that hold the larger masses of foliage together. Varied brushstrokes using drybrush, and dabs of thick and thin paint, worked over the whole scene, add interest to the surface.

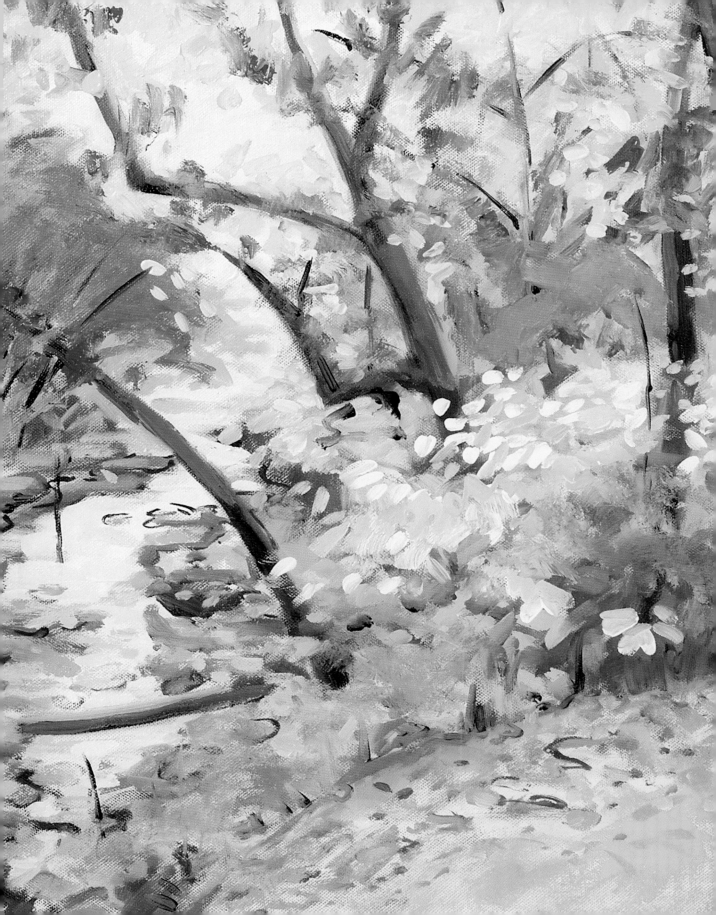

39 Red pears

This painting of luscious pears shows how the addition of an impasto medium can be used to thicken oil paint and increase its textural possibilities. Layer upon layer of paint is used to create the pears, using a brush or a painting knife so that the paint stands up in thick ridges. Sometimes the underlying colour gets dragged into the top paint, but this simply adds to the expressiveness of the brushstrokes. A final overpainting of the fruit with glazing medium added to the paint makes the red of the pears look even stronger.

EQUIPMENT

- Primed hardboard
- Brushes: No. 2 round, No. 8 and No. 12 flat, No. 8 filbert, No. 6 fan
- Painting knives: No. 21 and No. 24
- Glazing medium, linseed oil, impasto medium
- Brilliant pink, rose madder, alizarin crimson, viridian green, sap green, ultramarine blue, titanium white, lemon yellow, cadmium yellow, transparent yellow, Prussian blue, cerulean blue, yellow ochre, burnt sienna, cadmium red, magenta

TECHNIQUES

- Impasto
- Painting knife

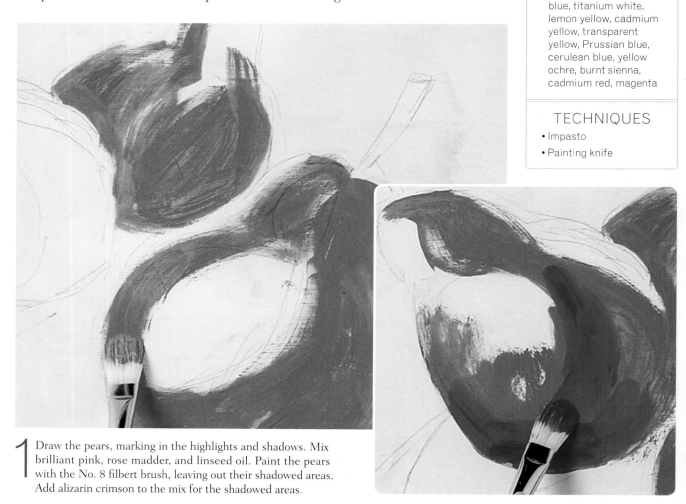

1 Draw the pears, marking in the highlights and shadows. Mix brilliant pink, rose madder, and linseed oil. Paint the pears with the No. 8 filbert brush, leaving out their shadowed areas. Add alizarin crimson to the mix for the shadowed areas.

BUILDING THE IMAGE

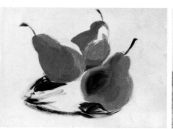
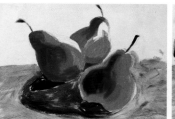
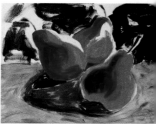

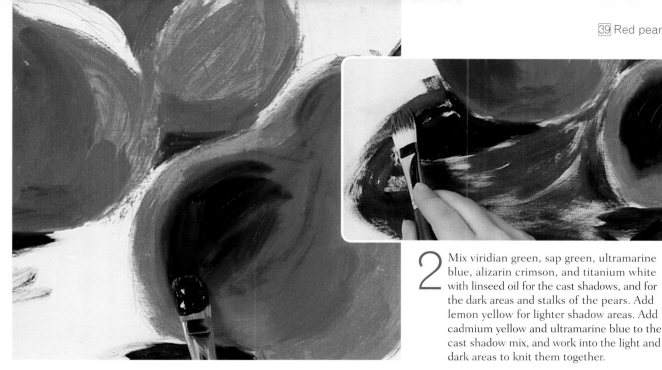

2 Mix viridian green, sap green, ultramarine blue, alizarin crimson, and titanium white with linseed oil for the cast shadows, and for the dark areas and stalks of the pears. Add lemon yellow for lighter shadow areas. Add cadmium yellow and ultramarine blue to the cast shadow mix, and work into the light and dark areas to knit them together.

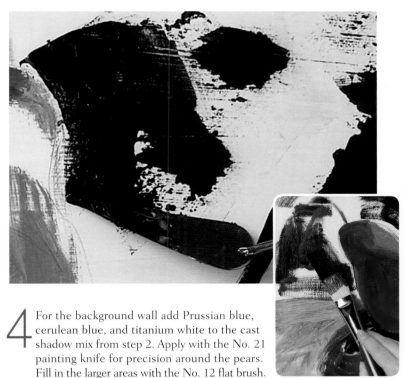

3 Use the No. 12 flat brush and combine transparent yellow and viridian green with impasto medium to paint in the rest of the foreground. Use bold horizontal and diagonal brushstrokes for variety and texture.

4 For the background wall add Prussian blue, cerulean blue, and titanium white to the cast shadow mix from step 2. Apply with the No. 21 painting knife for precision around the pears. Fill in the larger areas with the No. 12 flat brush.

 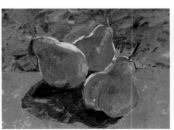 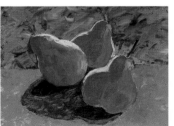

5 Mix yellow ochre with burnt sienna and paint the light side of the stalks with the No. 2 round brush. Repaint the darker shadows on, and cast by, the pears with cadmium red and yellow ochre, toned down with some of the background mix from step 4.

6 Mix cadmium yellow and viridian green, and work into the background. Mix cadmium yellow, cadmium red, and magenta for the pears' mid tones. Use cadmium yellow, cadmium red, and lemon yellow for the lighter areas.

7 Use the No. 21 painting knife to apply lemon yellow highlights on the other pears. Mix brilliant pink, titanium white, and cadmium yellow. Apply to the lightest parts of the pears, using the No. 24 painting knife, for highlights on the edges.

8 Add titanium white to the green foreground mix and apply with the No. 21 painting knife all over the background wall to lighten. The background now appears to be subtly lighter than the pears.

9 Use some glazing medium mixed with cadmium red to make a thin glaze. Add this over the existing colour of the pears, gently dragging the colour over the top of the thicker paint with the No. 6 fan brush.

Colour in Oil

"Plan your palette to create a vibrant and harmonious painting ."

Choosing your palette

To create a really vibrant painting you need to plan your colours carefully. You may decide upon a highly coloured approach, or a painting in which brighter colours are set off by more neutral ones. You must also consider the relative lightness and darkness of your colours, so that if you were to photocopy your painting in black and white you would still see a pleasing balance in the composition. Look, too, for complementary colours that you can juxtapose to emphasize their brilliance and harmony.

COMPLEMENTARY COLOURS

Decide upon the colour palette you want to use before you start to paint, to make sure you have an overall unity in your work. Colour contrasts make each colour look brighter and the painting will become immediately more appealing to the eye; a red, for instance, will look a more brilliant red because you have made its shadow greener. The colour contrasts of the three sets of complementary colours – yellow-violet, red-green, and blue-orange – in particular have this effect because these colour combinations appeal most to our innate sense of harmony.

Blue-orange

The pool's turquoise colour really sings out because of its juxtaposition with the orange terrace.

Red-green

If you hold one hand over the green of the lime you will see that the painting really loses interest and vibrancy without it.

Yellow-violet

The shadows are painted more blue and violet than they were in real life to form a foil for the yellow of the flowers.

TONE

Tonal balance is as important as colour balance, so you need to analyse the tonal values of your colours. "Tone" refers to the relative lightness or darkness of a colour, which can be altered by mixing it with another colour or with black or white. You can judge tonal values more easily by half-closing your eyes, which effectively banishes colour in favour of tone. You will soon see if your composition is tonally unbalanced, for example with a preponderance of dark tone in just one area.

This red and green are too close in tonal value to enliven each other.

Here there is an extreme contrast of tone.

This trio of colours forms a single block of similar tone.

In this colour chart, some adjacent colours raise each other's intensity. Others are so close in tone they appear dull and flat.

COLOUR MIXING

The paintings shown below demonstrate two different ways of varying the tone of colours. In the left-hand painting, the colours have been mixed with black or white. In the right-hand picture, the colours have been modified by mixing them with darker and lighter colours. Note how a dark tone appears even darker when placed next to a light tone.

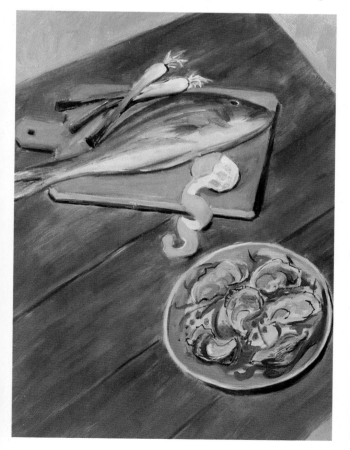

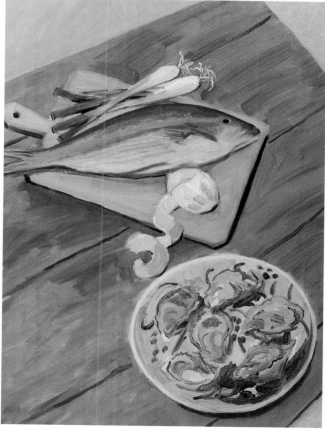

Cockerel and chicken ▶

The greens of the grass and foliage throw the brilliant oranges and reds of the chickens into sharp relief. Touches of violet in the background foliage complement the yellow of the daffodils. *Julie Meyer*

▼ Girl in wood

The scene consists of a variety of greens, which are balanced by the red of the dress and the many touches of red throughout the scene. The colour of the path also has reddish-pink in it. *Aggy Boshoff*

P.Gauguin 88

▲ Les dindons

While the palette in this painting is more subdued, it too is based on the harmony of red and green. Pink is used extensively in the buildings, and there are touches of orange in the foreground and middle distance. *Paul Gauguin*

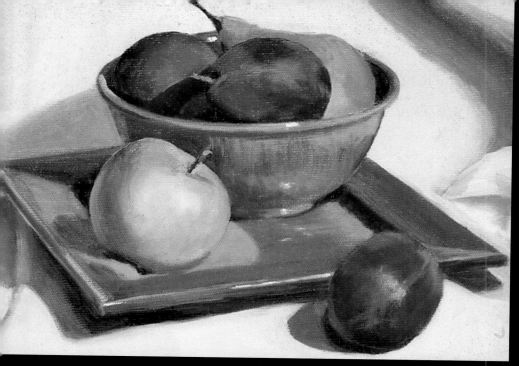

◄ Still life with blue pottery

Two pairs of complementary colours are used here to great effect. The yellow apple acts as a foil for the purplish plums, while the pear has an orange hue to balance the blues. *Jennifer Windle*

▼ Magenta tulips

The strong magenta of the tulips is a cool red with a hint of blue in it. The acid green of the background and the bluish -green of the leaves together counterbalance this colour effectively. *Aggy Boshoff*

▼ Flowers

Here the orange of the fruit is intensified by its proximity to blue, its complementary colour. The use of a second set of complementary colours, red and green, adds to the overall harmony of the work. *Samuel John Peploe*

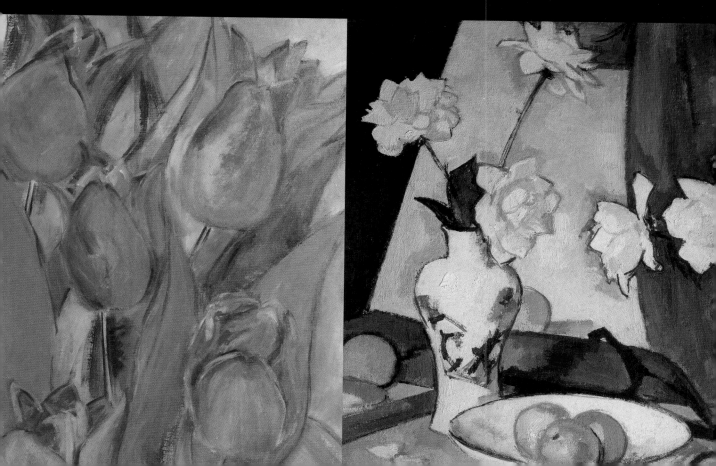

40 City river

Four different tones of blue are used in this calm painting of an urban river and its many bridges. The sky, the water, and the different hills are all painted with Prussian blue with either black or white added to create the various tones. This tonal colour mixing produces a range of colours so that contrasts through the painting can be established. The sky and water are the lightest tones after the light buildings, and contrast with the repeated shapes of the darker bridges. The paint surface is built up gradually so that the tonal relationships can be easily adjusted.

EQUIPMENT
- Oil painting paper
- Brushes: No. 2 round, No. 8 flat
- Painting medium, impasto medium
- Prussian blue, titanium white, ivory black, lemon yellow, cadmium red, cadmium yellow, yellow ochre, lemon yellow, viridian green, alizarin crimson, cobalt turquoise, burnt sienna, ultramarine blue, raw sienna

TECHNIQUES
- Blending
- Scumbling

"A limited palette can look colourful too."

The light blue mix establishes the lightest tones in the picture.

1 Paint the sky with a light blue mix of Prussian blue and titanium white with impasto medium. Use the No. 8 flat brush, making broad strokes. Paint the light areas of water in the same mix, and the side of the building that is the same tone.

2 Add ivory black to the sky mix to darken it. Paint the distant hills, blending them softly into the sky. Use this colour for shadows under the bridge, blending them into the water, and scumble the darker areas of the bridge.

BUILDING THE IMAGE

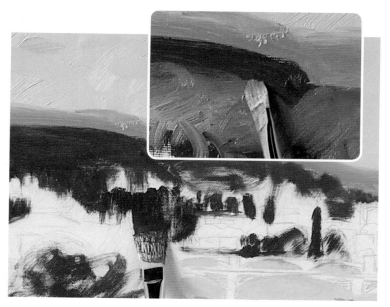

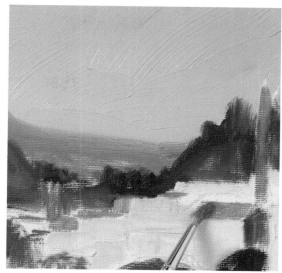

3 Add more ivory black and Prussian blue to the mix. Paint the closest hills and suggest the trees with vertical strokes. Bring the colour down by the buildings and paint the darkest water reflections. Use the step 2 mix to lighten some of the hills and trees.

4 Mix lemon yellow, titanium white, and painting medium for the distant buildings. Mix a soft red from cadmium red, cadmium yellow, yellow ochre, and painting medium to paint the roofs and chimneys using the No. 2 round brush.

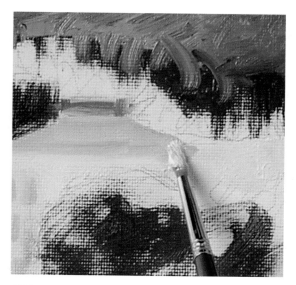

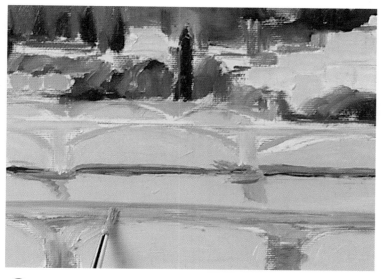

5 Mix lemon yellow and titanium white to paint some buildings on the left. Add a little Prussian blue to the mix for other buildings. Add viridian green to this mix for roofs and the church spire.

6 Paint the shadow side of some buildings with a soft lilac mix of titanium white, alizarin crimson, and Prussian blue. Use this lilac mix in places on the bridges – which look lighter the further away they are.

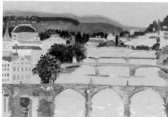

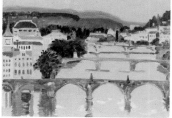

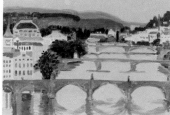

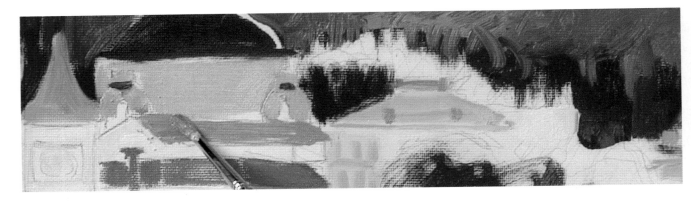

7 Mix alizarin crimson, Prussian blue, and ivory black for the domed roof on the left. Lighten this mix with titanium white for the roof in front of it. Paint the roof of the front building and detail on the spire with cobalt turquoise. Blend a mix of titanium white and Prussian blue to vary other buildings.

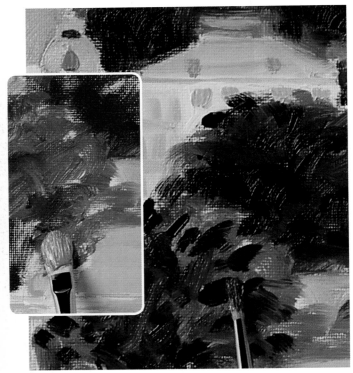

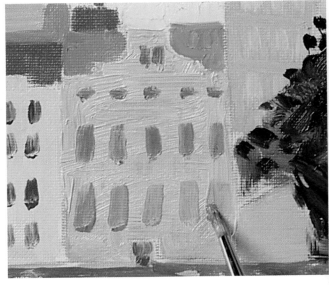

8 Mix viridian green, lemon yellow, and titanium white to soften the trees. Add their reflections in the water with horizontal strokes. Make a mid green by adding burnt sienna, then add ultramarine blue for the darkest areas of the trees, keeping the trees on the right lighter.

9 Mix cadmium yellow, titanium white, and painting medium for the edges of the domed roof. Paint windows on the front buildings with the light blue from step 2 mixed with painting medium, and a mauve mix of alizarin crimson, Prussian blue, titanium white, and painting medium.

10 Scumble the mauve mix over the first bridge and put in the statues on the bridge. Scumble a darker mix of Prussian blue and ivory black over the bridge and paint the shadows of the arches.

11 Mix raw sienna and burnt sienna to paint detail on the other bridges, and windows on the domed building. Add more burnt sienna to the mix and paint some stone detail on the front bridge.

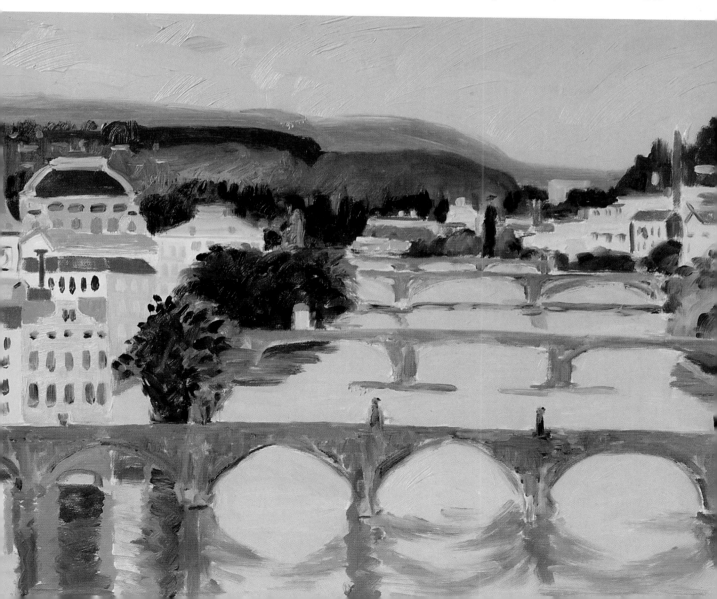

12 Mix cadmium red, yellow ochre, titanium white, and painting medium. Paint the clock hands, and scumble the mix over the bridge. Paint a mix of Prussian blue, ivory black, and titanium white with a touch of viridian green under the first bridge to emphasize its reflections.

▼ City river

The cool variations of blue have been counterbalanced by the red of the roofs and chimneys, the warm yellow of the buildings, and the stone colours of the bridges. Effective use of tone creates areas of light and dark, and subtle contrasts.

[41] Farmyard goats

This country scene of two goats in a farmyard is based on the simple colour contrast of blue and orange – complementary colours. The shapes of the cool blue shadows cast by the background walls and the goats counterbalance and emphasize the orange hair of the goats brightened in the sunlight. The goats are highlighted with a pinkish white that is also used on the cobblestones in the foreground. To balance the blues and greys even more, a warm red is used in the dark background on the vague shape of the pig and in the depths of the pen.

EQUIPMENT

- Canvas
- Brushes: No. 2 round, No. 12 flat, No. 6 filbert, No. 6 fan
- Painting knives: No. 24
- Turpentine or odourless thinner, impasto medium
- Cobalt blue, titanium white, yellow ochre, ivory black, alizarin crimson, burnt sienna, cadmium red, viridian green

TECHNIQUES

- Scumbling
- Painting knife

Shadow under the goats links to the colour used for the wall shadow.

1 Paint the wall with a bluish mix of cobalt blue, titanium white, yellow ochre, and turpentine using the No. 12 flat brush. Add ivory black to the mix to paint the shadows on and under the wall. Add a bit more cobalt blue to the mix for shadows under the goats and some cobblestone detail.

2 Mix a bluish black, using a lot of ivory black with a little cobalt blue, and use the No. 6 filbert brush to paint the dark shadows behind the goats and the gaps between the cobblestones. With the same black mix paint the post and the door of the pen in the background.

BUILDING THE IMAGE

3 Paint the mid tone areas of the goats with a mix of yellow ochre and titanium white, using the No. 6 filbert brush. Add some of this colour to the wall on the left and to the cobblestones. Darken the walls behind the goats with the bluish mix from Step 1 with added ivory black.

4 Mix a warm dark brown from alizarin crimson, burnt sienna, and ivory black to add warmth to the background and to the wall on the right side, which is in the shade. Use this mix to roughly paint the darkest areas of the goats using the No. 6 filbert brush.

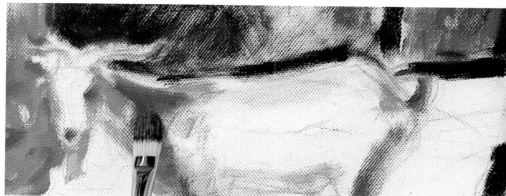

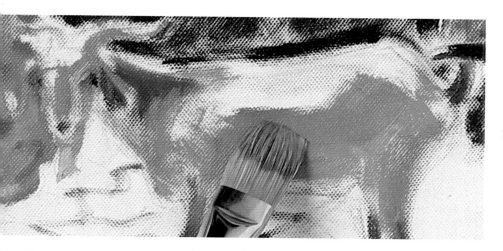

5 Add cobalt blue and a little titanium white to the brown mix from step 4 to add variety to the dark areas of the goats. Paint the shadows on the sides of the goats with the bluish mix from step 1 mixed with some ivory black, and put a stroke along the middle of the face of the rear goat.

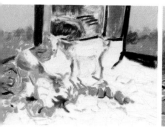
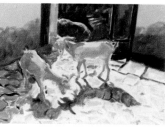
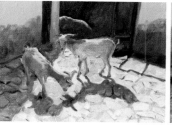
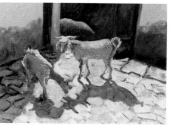

6 Mix impasto medium, titanium white, and a little yellow ochre for the goats. Scumble this yellow mix over the stones too. Add burnt sienna to the mix to darken areas of the goats' hair with the No. 6 filbert brush.

7 Mix titanium white with a tiny amount of cadmium red and use this light pink mix to create highlights on the cobblestones next to the goats, and to add some warmth to the foreground. Apply the colour with the No. 24 painting knife, which helps to create the angular shape of the individual cobblestones.

"Keep working around the painting, modifying colours and shapes again and again."

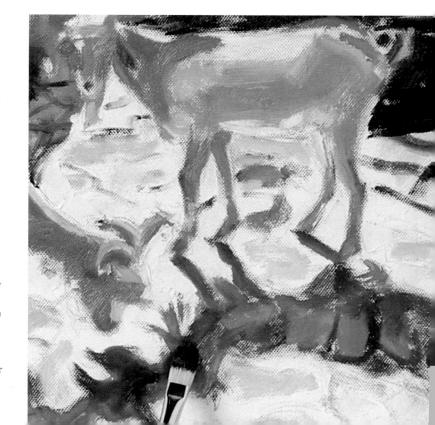

8 Mix viridian green, alizarin crimson, and ivory black and use this to increase the contrast of the shadows on the wall. Use this mix in the background, and shape the pig using the No. 6 filbert brush. Mix ivory black and alizarin crimson to refine the shape of the goats. Scumble this mix in the shadows under the goats.

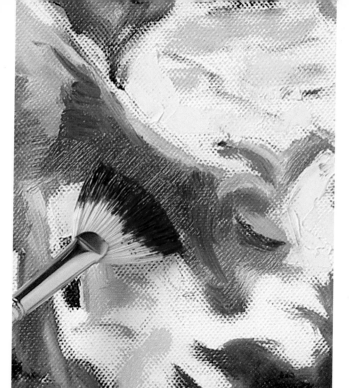

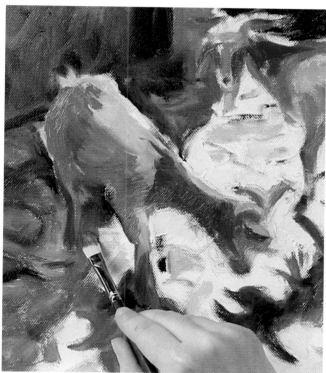

9 Mix a dark reddish brown from alizarin crimson, ivory black, and viridian green. Use this mix and the No. 6 fan brush to paint the darkest shadows on the goats, and the lighter areas of the pig. Scumble this mix over the background too.

10 Mix cobalt blue with alizarin crimson and titanium white, and use this to add variety to the mid tones on the goats and the blue shadow areas. Scumble the mix on the cobblestones, and use it to outline the shadows.

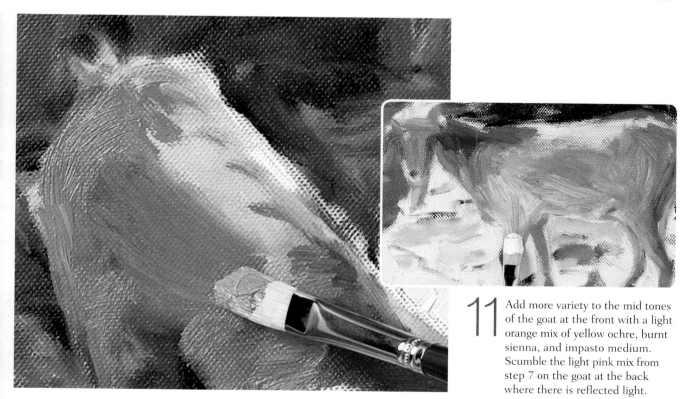

11 Add more variety to the mid tones of the goat at the front with a light orange mix of yellow ochre, burnt sienna, and impasto medium. Scumble the light pink mix from step 7 on the goat at the back where there is reflected light.

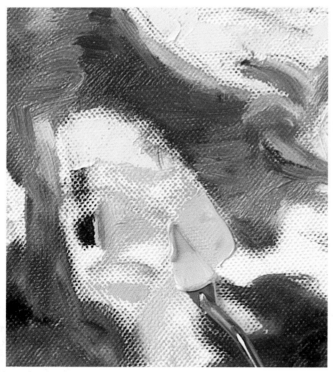

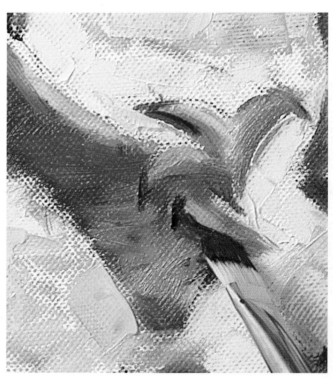

12 Mix titanium white with a little more cadmium red than used in Step 7, and paint the cobblestones with the No. 24 painting knife. Vary the cobblestones with a mix of yellow ochre, the mix from Step 10, and titanium white.

13 Use the dark reddish brown mix from Step 9 to add detail to the goats' heads and in the cobblestones. Strengthen the light cobblestones by using the painting knife to scrape out some light pink and yellow mixes.

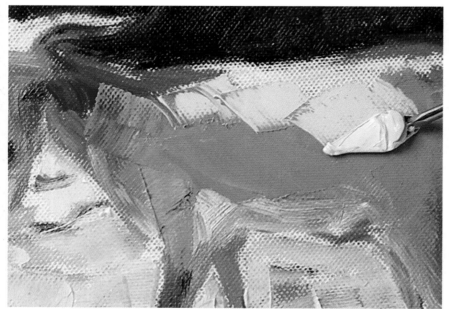

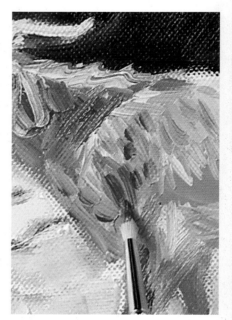

14 Mix a greyish blue from cobalt blue, ivory black, and titanium white, and reinforce the darkest part of the goat at the back. Mix white, a little cadmium red, and yellow ochre, and add the lighter area at the top of the goat's back, the top of its head, and the top of the pig.

15 Use mixes of burnt sienna, alizarin crimson, ivory black, and titanium white for mid tones on the goat at the back. Place highlights with titanium white.

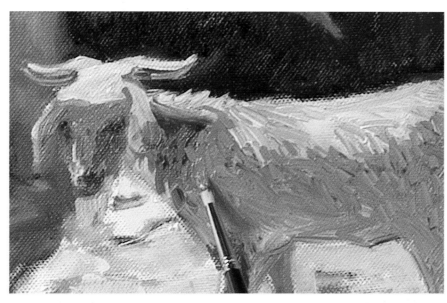

16 Mix alizarin crimson and titanium white for reflected colour on the goats' horns. Add the orange mix from Step 11 to the goats, and to the pig. Use burnt sienna, and yellow ochre for more colour on both goats.

▼ Farmyard goats

The use of a simple colour palette, based on the complementary colours of blue and orange, has created a harmonious final picture. Using the same colour mixes on the goats, the farmyard, and the shadows gives the painting unity.

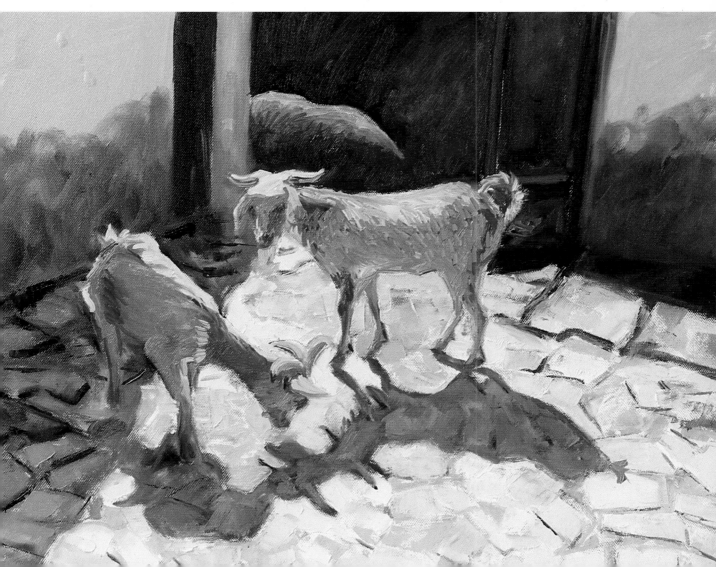

42 Anemones in a vase

This painting of a vase of flowers features a range of bright colours against a simple background. Its composition is unusual because the flowers are placed right at the top. While the round vase in the centre catches the eye first, the contrast of strong pink and blue flowers with the cool green background draws the eye up. The petals are simple blocks of colour rendered with a painting knife, with further colour overlaid by brush. Stippling in the centres and stamens creates the characteristics of anemone flowers.

EQUIPMENT

- Canvas
- Brushes: No. 2 round, No. 12 flat, No. 4, No. 6, and No. 8 filbert
- Painting knives: No. 21 and No. 24
- Turpentine or odourless thinner, impasto medium
- Lemon yellow, viridian green, ultramarine blue, cerulean blue, titanium white, magenta, permanent rose, violet, cobalt turquoise, ivory black, sap green, cadmium yellow, Prussian blue

TECHNIQUES

- Stippling
- Broken colour

Using the painting knife spreads the paint evenly.

1 Sketch the outlines, focusing on the largest shapes. Mix lemon yellow, viridian green, and some impasto medium. Spread the paint with the No. 21 painting knife. Work from the edge, and drag the knife across the canvas.

2 Use the No. 24 painting knife to carefully paint in all the spaces between the flowers and inside the handle of the jug. Change to the No. 12 flat brush to paint in the larger areas at the sides of the picture.

BUILDING THE IMAGE

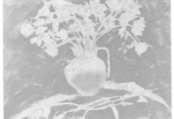

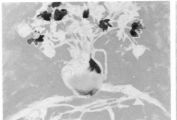

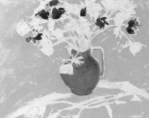

3 Paint some of the background mix on to the body of the vase where it reflects the green colour of the tabletop. Rub the paint in circular motions with a rag until it becomes translucent and the white of the canvas shines through.

4 Mix ultramarine blue and cerulean blue with a little titanium white and scumble on to the vase with a painting knife. Add titanium white and turpentine to the mix and paint the vase with the No. 8 filbert brush. Leave white canvas for overhanging flowers.

5 Mix magenta with titanium white to create a base colour for the pink flowers. Apply the paint to the flowers with the No. 24 painting knife. Add permanent rose to the mix and a little violet for variation. Leave some petals white for later colour.

6 Add more violet to the mix for a deeper purple shade. Apply this to create the base of the blue flowers and to the creases between the petals. Use the No. 24 painting knife to create areas of colour for petals rather than precise detail.

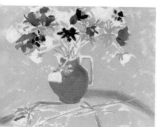
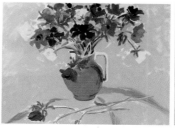
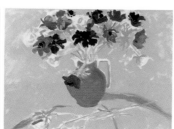
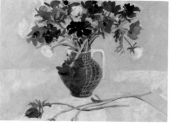

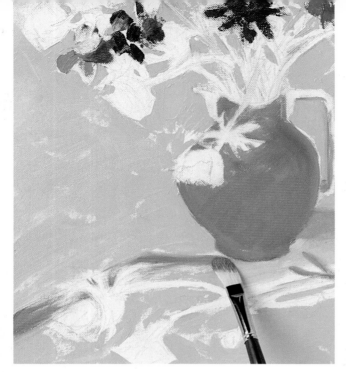

7 Mix some of the vase colour with the background mix and use this to paint in the folds of the cloth. Use the No. 6 filbert brush to do this. Paint some of the flower stems that are lying on the table with this mix too.

8 Mix lemon yellow, viridian green, cobalt turquoise, and titanium white. Using the No. 2 round brush, paint this soft green mix on the leafy fronds around the blooms and on some of the flower stems.

9 Add some titanium white to the pinker flower mix from step 5 and use the No. 4 filbert brush to paint in the pink flowers. Add more titanium white to the mix for variation where the light shines through the petals. Stipple ivory black stamens into the centres of the flowers.

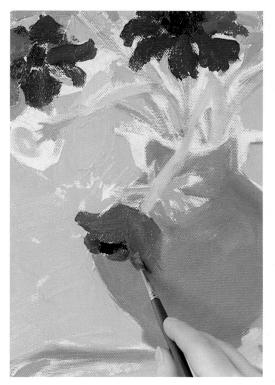

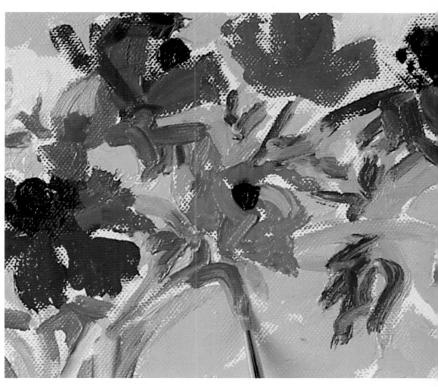

10 Mix violet and cerulean blue to make a purple, and paint individual flower petals. Paint over some petals using the pink, violet, and blue mixes.

11 Mix viridian green, sap green, and some titanium white, and draw the paint up the stems of the flowers. Use the No. 2 round brush to paint in the shadowed stems and fronds with a mix of cadmium yellow, viridian green, and cobalt turquoise.

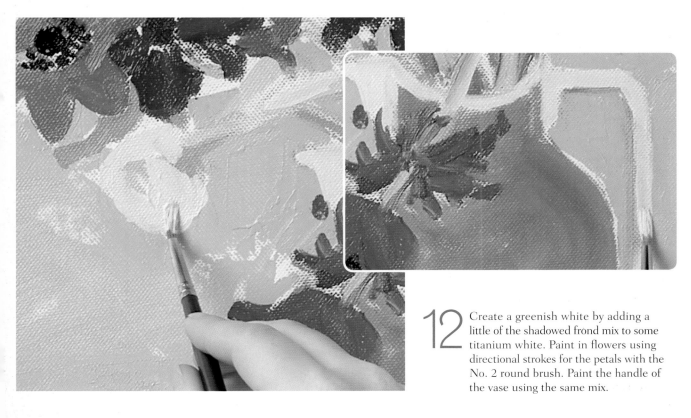

12 Create a greenish white by adding a little of the shadowed frond mix to some titanium white. Paint in flowers using directional strokes for the petals with the No. 2 round brush. Paint the handle of the vase using the same mix.

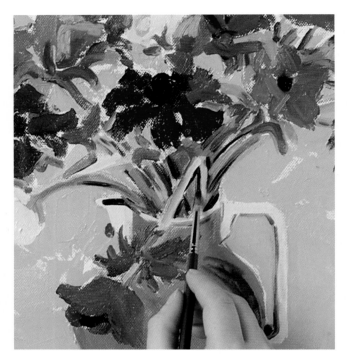

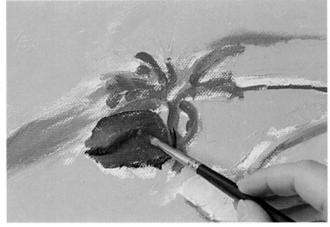

14 Define the petal edges of the closed flowers on the table with a mix of cerulean blue, titanium white, and magenta. Go back over all the flowers with the No. 2 round brush refining the shapes, and varying the mark making.

"Use broken colour to add vibrancy to the paint surface."

13 Return to the shadowed frond mix and add some ivory black. Use this to mark in more shadows between the stems of the flowers. Paint shadow under the handle of the vase and at the base of the vase with this mix too.

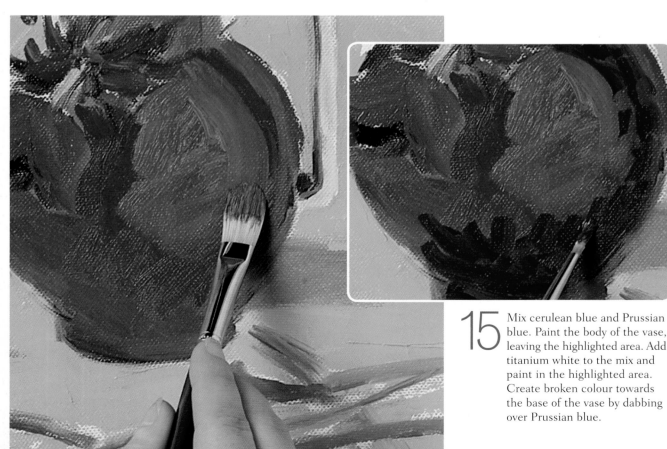

15 Mix cerulean blue and Prussian blue. Paint the body of the vase, leaving the highlighted area. Add titanium white to the mix and paint in the highlighted area. Create broken colour towards the base of the vase by dabbing over Prussian blue.

16 Dab more colour over the background with the mix from step 1. Add titanium white to the mix and apply it to the tabletop with the No. 21 painting knife. Partly paint in the pattern of lines on the vase.

▼ Anemones in a vase

Painting the anemone petals as simple shapes has enhanced the effect of vibrant colour against the cool green background and table. The strong blue of the vase intensifies the blue, magenta, and violet of the flowers.

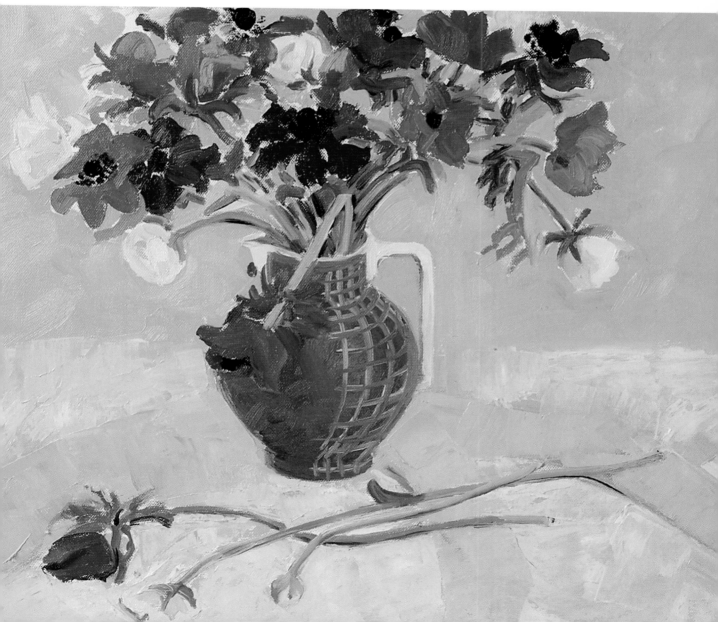

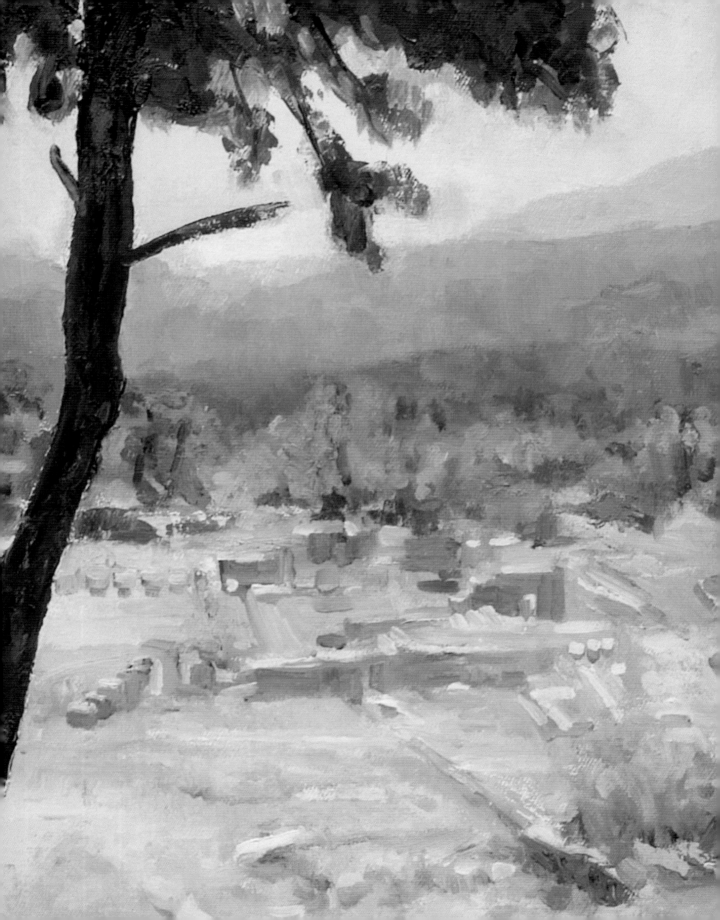

"Use colour and line to
create a sense of depth
in your paintings."

Understanding perspective

Perspective is a means of making a two-dimensional surface appear three-dimensional, distinguishing foreground objects from those in the distance and thus creating depth. It also establishes the relative position and size of figures and objects in the painting. The application of the rules of perspective is not necessarily a very complicated matter – making the perspective believable will suffice. Two ways to give the illusion of depth in a painting are linear perspective and atmospheric perspective.

ATMOSPHERIC OR COLOUR PERSPECTIVE

Because of atmospheric haze, a distant landscape appears progressively bluer and paler to us than the foreground. As colours appear warm or cool, and advance or recede respectively, you can use them to reflect this atmospheric phenomenon in your painting. The line through the colour wheel shown here divides the warm colours veering to red from the cool colours, which tend towards blue. Redder colours advance, while bluer ones recede.

Colour wheel

Warm colours

Cool colours

The warmth or coolness of an individual colour depends upon the amount of blue or red in it. While red is intrinsically a warm colour, for example, there are warm reds and cool reds.

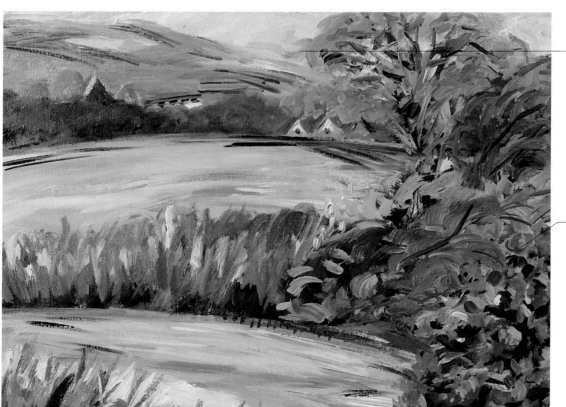

The hills are blue and lack detail, giving the impression of great distance.

The warm red of the flowering bush draws it closer to the eye.

This landscape shows how warm colours advance to the foreground while cool ones recede. The size of the buildings places them in the middle distance.

LINEAR PERSPECTIVE

All parallel lines in a scene converge to a point known as the vanishing point, which may be inside or outside the picture plane. Lines from subjects placed higher than the eyeline descend to the vanishing point, while those lower ascend.

Parallel lines running in a different direction have a different vanishing point. Figures and objects become smaller the further back they are in the picture plane, because they are also governed by the rules of perspective.

One-point perspective

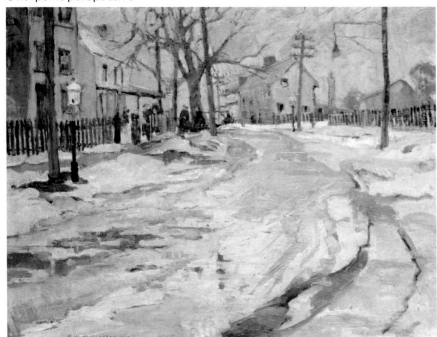

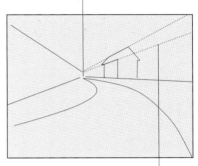

In this painting, looking straight down the street, the parallel lines of the roofs, railings, and road converge to a single vanishing point.

Because the roof line is higher than the artist's eye level, it descends to meet the road, which rises towards it.

Two-point perspective

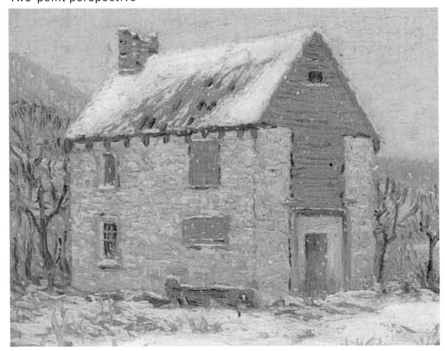

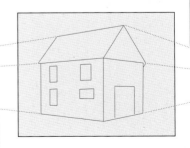

Here the building stands at an angle, with two sides visible. The parallel lines of each side converge outside the picture frame.

Taken to their conclusion, the lines from the front and side of the building would meet at two different vanishing points.

Gallery

Atmospheric and linear perspective can be used either singly or together to bring a persuasively three-dimensional quality to a work.

▲ Mont Sainte-Victoire

The perspective of this mountain scene is established by making the reds and greens more vibrant in the foreground and middle ground, with cool blues fading into the distance. *Paul Cézanne*

▲ Primulas

Even this close-up of objects on a table top obeys the rules of linear perspective. The parallel sides of the books and the wooden box will meet somewhere above the painting's edge. *Aggy Boshoff*

Labranda, Turkey ▶

The strong tonal contrast of dark tree trunks against a light background emphasizes the depth in this painting. Warm colours and defined shapes make the foreground advance, while the background is an indistinct haze of cool blues. *Brian Hanson*

◀ Le Pont de Trinquetaille

The fan-shaped parallel lines of the foreground steps give an exaggerated perspective to make this bridge, which was modern for its time, seem more impressive. *Vincent van Gogh*

▼ Evening stroll on Brighton promenade

The one-point perspective and the diminishing height of the figures silhouetted against the sun give a strongly three-dimensional effect, reinforced by the paler colours of the background. *Mark Topham*

43 Boats in the harbour

A sense of depth is created in this sunny harbour scene as the size of the boats and the paving slabs in the foreground are painted larger than the background buildings. The lines of the boats and pavement lead the eye into a jumble of warm colours and shapes, which you soon recognize to be buildings and their reflections. Painting the reflections slightly darker helps to differentiate them from the buildings, which are in full sunlight. To create their watery quality, the reflections are painted thick with added impasto medium, then dragged through with a comb.

EQUIPMENT
- Canvas
- Brushes: No. 2 round, No. 8 and No. 12 flat, No. 4 and No. 6 filbert, No. 6 fan
- Painting knives: No. 24
- Turpentine or odourless thinner, linseed oil, impasto medium
- Lemon yellow, cobalt turquoise, cerulean blue, yellow ochre, titanium white, cadmium red, burnt sienna, ultramarine blue, ivory black, raw sienna, Prussian blue, cadmium yellow, alizarin crimson, viridian green

TECHNIQUES
- Drybrush
- Combing

Using the edge of the brush helps define the roofs of the houses.

The quay reflects the warm colour of the houses.

1 Dip the No. 12 flat brush in turpentine before using it to mix up a glaze of lemon yellow for the lightest areas of the houses and the river. Paint the sky, boats, and pavement with a mix of cobalt turquoise, cerulean blue, and turpentine.

2 Mix yellow ochre and titanium white with some turpentine. Use the No. 8 flat brush to paint in the sunlit areas of the houses and quay. Add some cadmium red and lemon yellow to the mix for the warmest areas of the houses and reflections.

BUILDING THE IMAGE

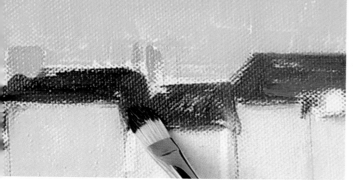
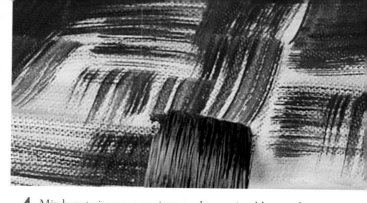

3 Mix burnt sienna, ultramarine blue, and a touch of titanium white. Use the No. 4 filbert brush to paint in the roofs of the houses, knitting them together rather than drawing them individually, and to sketch in foreground detail. Add a little ivory black to the mix for the boat shapes and shadows.

4 Mix burnt sienna, raw sienna, ultramarine blue, and titanium white. Paint the darker reflections with the No. 6 filbert brush, using dry brushwork in some areas. Mix Prussian blue with the sky mix. Darken the pavement with light strokes using the No. 8 flat brush.

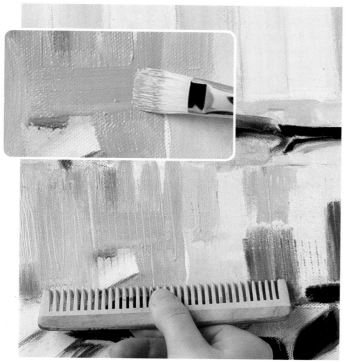

5 Mix cadmium yellow and cadmium red, and thicken with some impasto medium. Use the No. 8 flat brush to work this orange mix into the houses and the reflections. Comb through the paint to make vertical scratches.

6 Lighten the pavement mix with titanium white, cobalt turquoise, and cadmium yellow. Mix in some turpentine and linseed oil, and use the No. 12 flat brush to drag the colour down into the sky. Add more titanium white to the mix for details on the boats and the paving stones.

7 Mix ivory black and ultramarine blue. Use the No. 2 round brush to paint in the darkest details of the gaps in the paving stones and the boat edges. Mix cobalt turquoise and titanium white for further detail on the boats and masts.

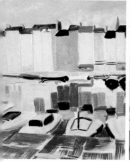
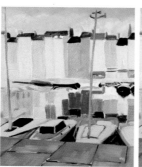
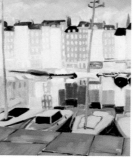
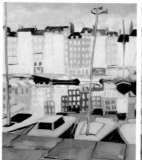
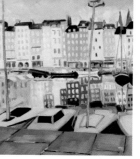

8 Mix titanium white with a little lemon yellow and use the No. 6 fan brush to drag some highlights over the fronts of the houses.

9 Mix pure titanium white with some turpentine and linseed oil. Paint in the windows and white boats using the mix thickly on your brush.

10 Mix cadmium red and a touch of cadmium yellow with turpentine. Add detail to the far boats and masts. Paint the mast reflections.

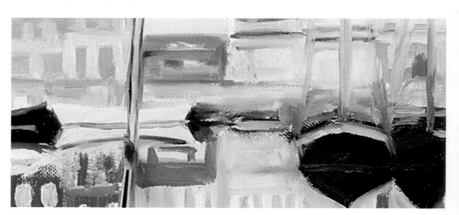

11 Mix alizarin crimson and ultramarine blue for parts of the water and the dark windows. Mix lemon yellow, viridian green, and turpentine to paint the doorways and some shop fronts. Outline the foreground masts with a mix of burnt sienna and ivory black.

12 Use pure ivory black on the edge of a painting knife to scratch in some darker details at the street level and to dot in the windows of the boat. Use the painting knife to make distinct marks.

Boats in the harbour ▶

The foreground area of this painting has been kept simple with relatively little detail. This emphasizes the confusion of warm, detailed buildings and reflections across the water, which creates the impression of a busy harbour.

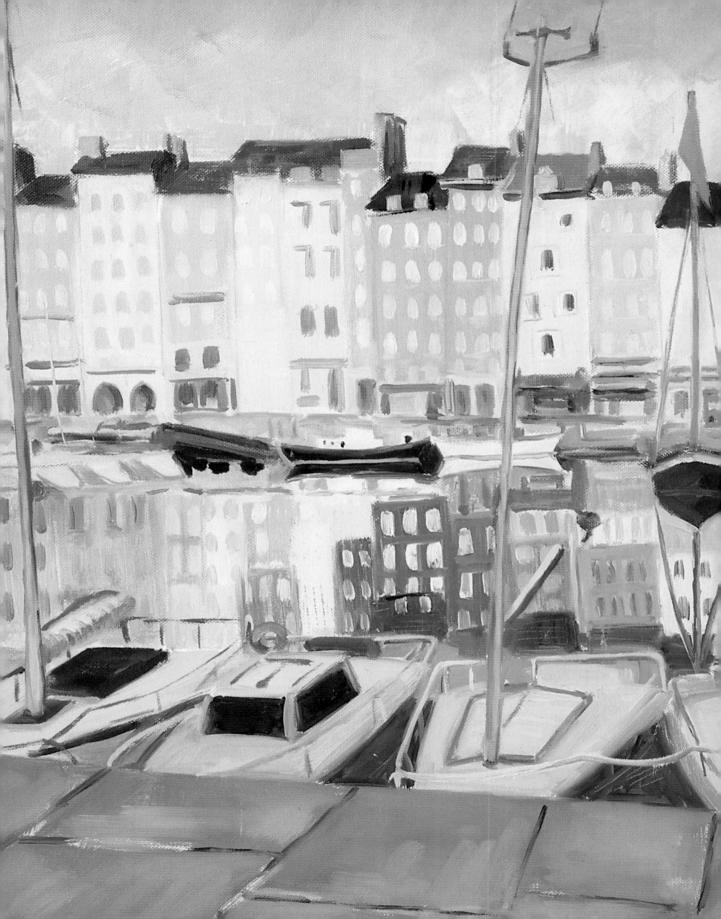

44 Spanish landscape

In this painting of a sun-drenched landscape, perspective has been captured through careful use of colour and detail. The foreground is painted with the brightest colours to bring the area forward, the middle distance is painted with lighter colours, and the mountains are painted with cool blues as they recede into the distance. Shapes in the middle distance are smaller and more sketchy than those in the foreground, while the mountains show no details at all. Hatching and dabbing are used to add interest to the fields and detail to the olive groves.

EQUIPMENT

- Canvas
- Brushes: No. 2 round, No. 12 flat, No. 8 filbert
- Turpentine or odourless thinner, linseed oil
- Cobalt turquoise, titanium white, cadmium yellow, cadmium red, viridian green, sap green, ultramarine blue, cerulean blue, alizarin crimson, burnt sienna, ivory black, lemon yellow, Prussian blue

TECHNIQUES

- Hatching
- Dabbing

The cool blue in the mountains helps them to recede into the distance.

Trees and foliage are quickly created with a dryish brush.

1 Mix cobalt turquoise and titanium white with turpentine and linseed oil. Paint the sky, and parts of the mountains, and scumble the mix over cooler field areas. Mix cadmium yellow and titanium white with turpentine and linseed oil to establish field colours.

2 Add cadmium red to the field colour for the olive groves, and more for the areas of exposed earth. Add viridian green, sap green, cadmium yellow, titanium white, and turpentine to the sky mix for the base of the mountains. Add more cadmium yellow for the foreground fields and greenery.

BUILDING THE IMAGE

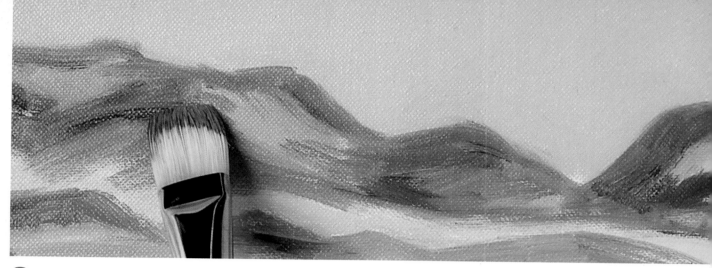

3 Mix ultramarine blue, cerulean blue, alizarin crimson, and burnt sienna, with turpentine and linseed oil. Use the No. 12 flat brush to paint the mountains. Accentuate the darker areas by adding more ultramarine blue to the mix. Add titanium white for nearer areas.

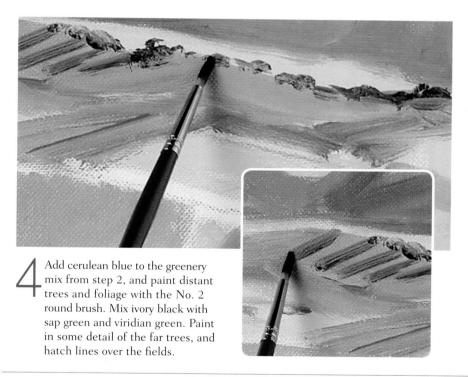

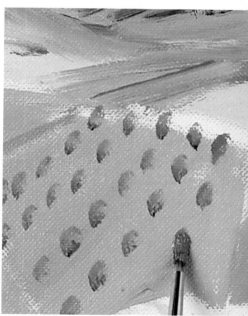

4 Add cerulean blue to the greenery mix from step 2, and paint distant trees and foliage with the No. 2 round brush. Mix ivory black with sap green and viridian green. Paint in some detail of the far trees, and hatch lines over the fields.

5 Dab in the olive trees with a mix of titanium white, sap green, viridian green, and cerulean blue. Add lemon yellow to the greenery mix to paint the remaining fields towards the right foreground and to add undulations to the darker fields.

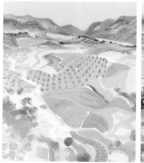

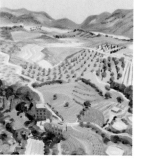

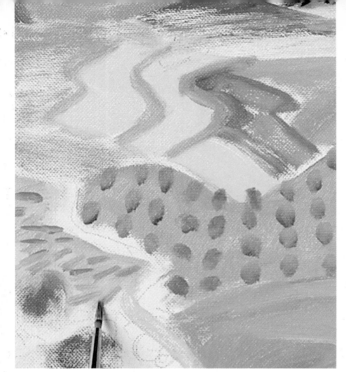

6 Mix sap green and cadmium yellow with turpentine. Hatch the field on the far left with irregular lines. Vary the hatching in colour and shape for fields further in the background and to the right to give different effects.

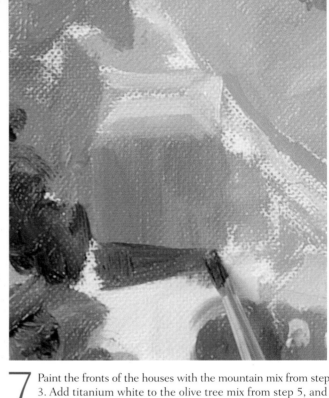

7 Paint the fronts of the houses with the mountain mix from step 3. Add titanium white to the olive tree mix from step 5, and paint in the roofs of the houses. Add alizarin crimson, cerulean blue, and more turpentine for the shadows of the houses.

8 Add a little more ivory black to the greenery mix to mark in the shadowed areas underneath the olive trees. Paint with the side of the brush, working in a diagonal direction. Use the direction of your shadows to indicate the contours of the land.

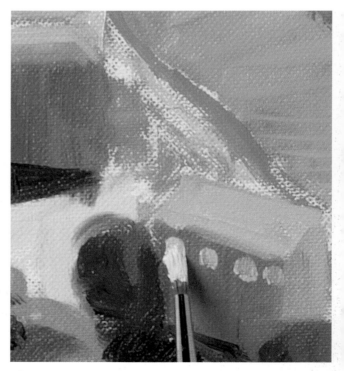

9 Mix titanium white with a little cerulean blue to highlight the roofs of the houses and to paint the lighter windows. Mix ivory black, viridian green, and alizarin crimson to paint the darker windows, the rooflines and other details on the houses.

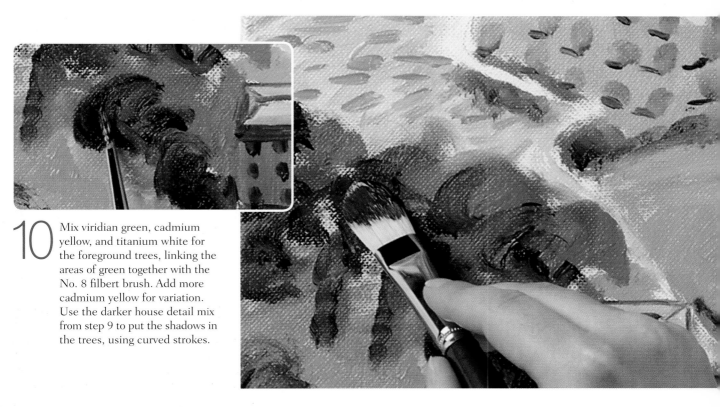

10 Mix viridian green, cadmium yellow, and titanium white for the foreground trees, linking the areas of green together with the No. 8 filbert brush. Add more cadmium yellow for variation. Use the darker house detail mix from step 9 to put the shadows in the trees, using curved strokes.

"Keep details sketchy so they blend in with the whole landscape."

11 Change to the No. 2 round brush to fill in some of the green borders around the fields, and the remaining white areas towards the front of the painting, with the yellower green mix from step 10. Paint stronger greens in the foreground using the shadow mix from step 7 with a little viridian green.

12 Mix ivory black, cerulean blue, cadmium yellow, and turpentine to make an olive green. Paint in the olive trees on the right side of the painting with the No. 2 round brush, creating variation in size and shape.

13 Mix Prussian blue, titanium white, and alizarin crimson, and paint contrasting hatches on the yellow fields. Use the mountain mix from step 3 to accentuate the shadows under the houses and dab under the trees on the left.

14 Mix alizarin crimson, cadmium red, and titanium white to make a cool pink colour. Paint the roads with smooth strokes, varying the pressure.

LIGHT AND SHADE

Sunlight lightens the colour of objects but creates strong shadows. The resulting large tonal range can add interest to a landscape.

Spanish landscape ▶

This landscape is a patchwork of harmonious colours that get smaller and less detailed towards the distance. A variety of abstract marks keeps the eye engaged on its journey through the landscape.

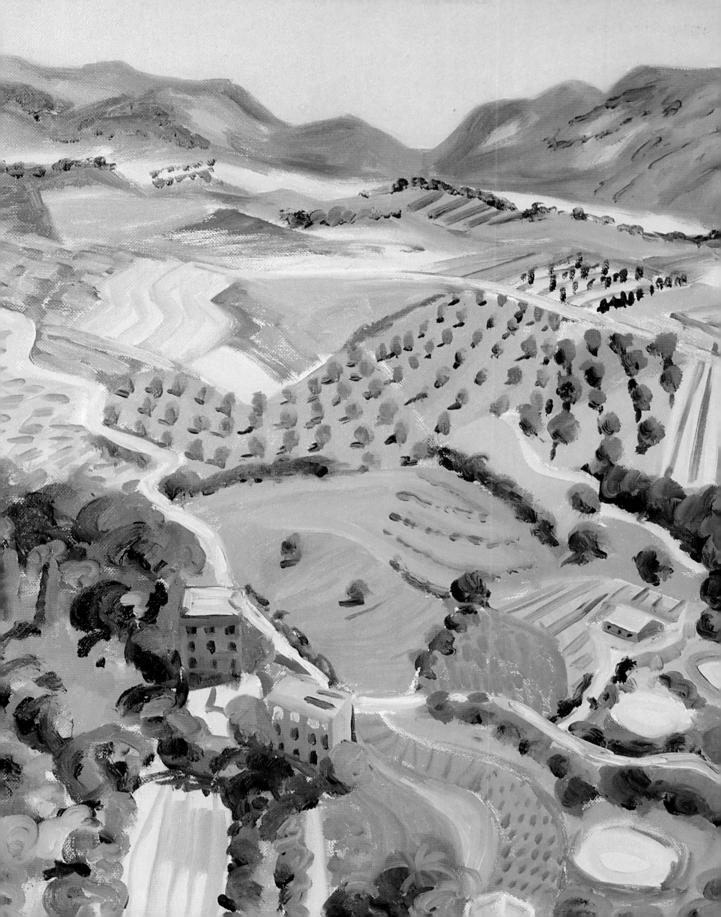

45 Café scene

The essential element for this scene of an outdoor café in a city square is the use of one-point perspective. The painting is given dynamism by lines that radiate from a vanishing point that is positioned in the top left of the picture. A second vanishing point, created by the parallel lines of the square and the buildings' façades, is set far outside the frame to the right. The use of masking tape helps to establish these points before the painting begins. Adding a variety of figures brings life and scale to an otherwise empty scene.

EQUIPMENT
• Oil painting paper
• Brushes: No. 2 round, No. 8 flat, No. 4 filbert, No. 6 fan
• Painting knives: No. 20
• Turpentine or odourless thinner, painting medium, masking tape
• Alizarin crimson, cadmium red, Prussian blue, titanium white, cobalt turquoise, burnt umber, ivory black, cadmium yellow, lemon yellow, ultramarine blue, cerulean blue

TECHNIQUES
• Masking tape
• Adding figures

THE VANISHING POINT

Lines higher than eye level go down to the vanishing point.

Lines lower than eye level rise up to the vanishing point.

To draw the linear perspective in a scene, first establish the vanishing point. This is the point where two parallel lines meet and cross on the horizon, which is at your eye level. You may find it helpful to use a ruler when drawing the perspective in your pre-painting sketch.

"A painting can have several vanishing points."

The masking tape line along the kerb leads to the vanishing point.

1 Use masking tape as a guide for the perspective on the road next to the kerb. Paint the square and part of the road with a mix of alizarin crimson, cadmium red, Prussian blue, a lot of titanium white, and turpentine. Use the No. 6 fan brush and horizontal strokes, painting over the top edge of the tape in places.

BUILDING THE IMAGE

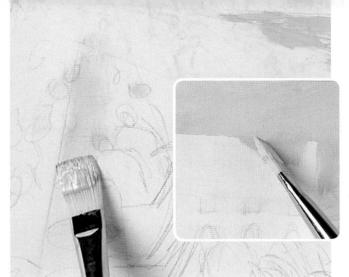

2 Mix a sky blue from Prussian blue, cobalt turquoise, titanium white, and turpentine. Paint the sky with the No. 8 flat brush, leaving areas white for clouds. Make the roofline more precise as you paint the sky. Use this mix in places in the café area.

3 Remove the masking tape. Paint the rest of the road, which was covered with masking tape, with the lilac mix from step 1, leaving the kerb. Paint over areas of the road with the sky mix from step 2 to differentiate it from the paved square and to add texture.

4 Mix a warm black from burnt umber, cadmium red, ivory black, and turpentine to paint the café in the shadow and its awning. Dab in the heads of people with this mix using the No. 4 filbert brush. Scumble in the lampposts and the shadows among the tables and chairs.

5 Mix cadmium red, cadmium yellow, and turpentine. Use this orange mix to add colour in the café, and to paint the chair backs. Mix cadmium yellow, lemon yellow, titanium white, and turpentine for sunlight on the terrace. Paint the buildings with this mix too, leaving the windows white.

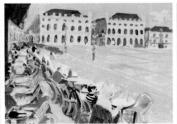
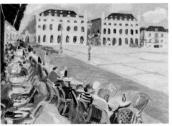

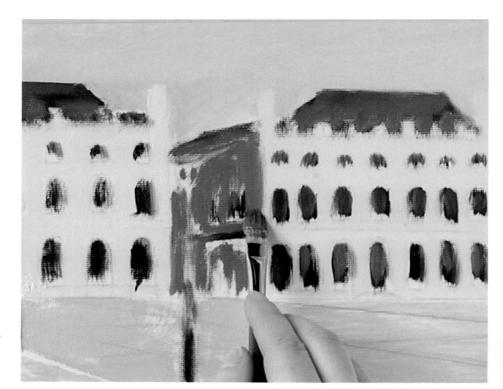

6 Add ultramarine blue to the warm black mix from step 4 to make a darker blue for the windows and rooftops. Add some of the sky mix from step 2 to lighten and vary the roofs and windows, and for the shaded sides of the buildings.

7 Use the orange mix from step 5 to paint the rattan chairs in the foreground, using the No. 2 round brush. Use the mix for accent colour, for the shirt, and beer in the glass, elsewhere in the foreground, and for detail on the lampposts.

8 Use cadmium red on some figures sitting at the café tables, and on items on the tables. Mix a light yellow from titanium white, lemon yellow, and turpentine, to paint the tabletops, to enliven the façades of the buildings, and to render the lighter decoration on the lampposts.

9 Mix lemon yellow, cadmium yellow, titanium white, and turpentine. Use this mix for detail on the gates and on some figures at the front of the café. Mix ultramarine blue, alizarin crimson, and turpentine for one of the figure's shirts.

FIGURES

Figures in a painting must also be in perspective. Remember, the heads of people in the distance should be painted relatively smaller than those of people in the foreground.

10 Mix ultramarine blue, cerulean blue, and turpentine for shadows under chairs. Use the orange mix from step 5 to dot in ovals for receding faces. Add titanium white to the mix for faces in the foreground. Mix a very light pink of titanium white and a little cadmium red for skin in sunlight.

11 Mix titanium white with turpentine and painting medium to paint the clouds. Mix in cobalt turquoise, and paint the sky and tabletops. Use the No. 20 painting knife to scratch in titanium white highlights to the area in front of the café to make the distant people look less distinct.

12 Lighten the awning and add the metal struts by drawing in lines of cadmium yellow mixed with painting medium. Mix titanium white with a little Prussian blue and painting medium and apply to the clouds with a painting knife to tone them down.

13 Lighten the square with a mix of titanium white and a little cerulean blue. Mix alizarin crimson, Prussian blue, titanium white, and painting medium, to darken the road, varying the colour as you paint. Use this mix to redefine the lines in the square.

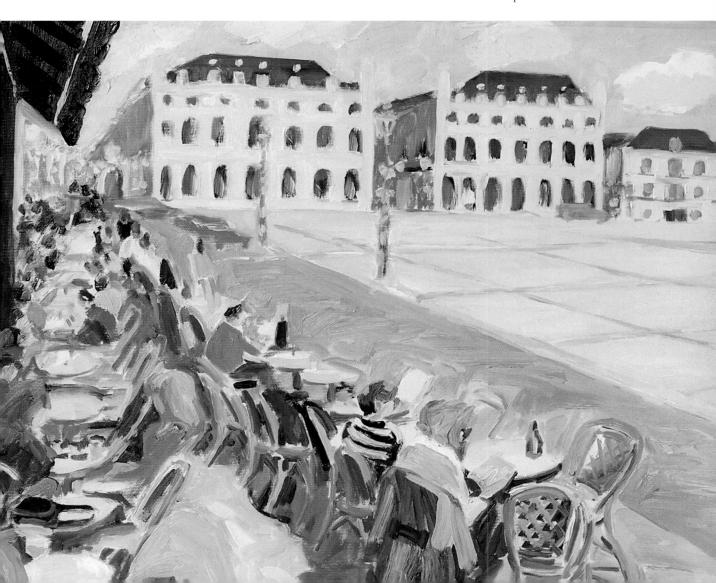

14 Mix a dark green from ivory black and cadmium yellow to paint the bottle, details on the chairs, and areas of shadow among the figures. Paint the hair on the heads of some of the figures with the orange mix from step 5 and ivory black.

▼ Café scene

In this painting a real sense of depth has been created by its consistent use of perspective. The road, buildings, and café all converge at one vanishing point and the people at the café who are further away are depicted with smaller dabs of colour.

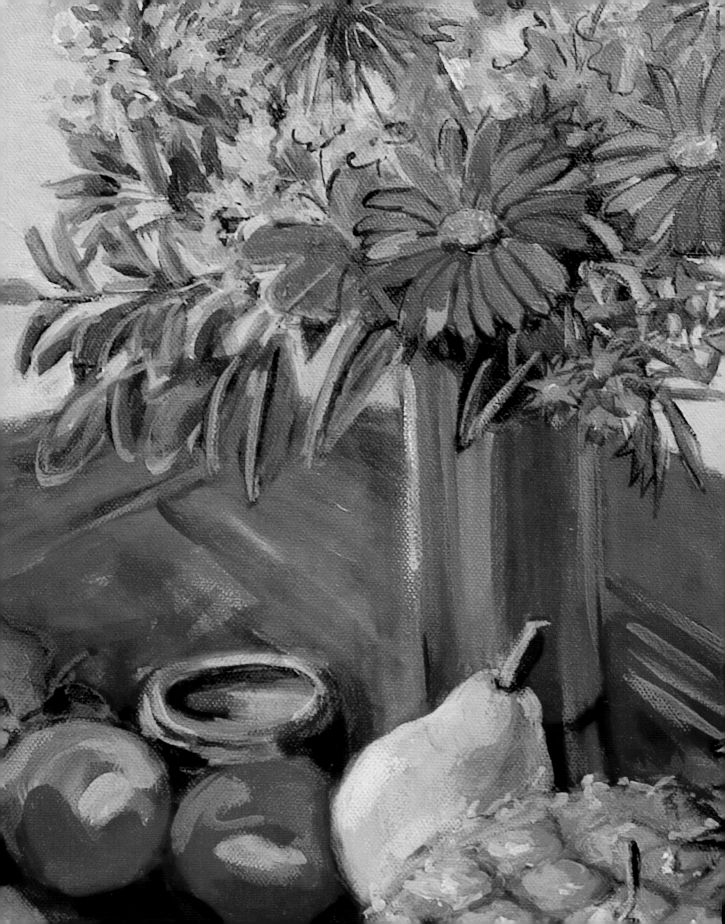

Contrast
in Oil

"Contrasts of colour,
shape, line, and tone create
interest and excitement."

Creating contrast

Just as a piece of music benefits from contrasting sounds, so a painting is made exciting by visual contrasts. The most important of these is in the use of colours, with bright ones set against muted, warm ones contrasted with cool. Remember also to look for contrast in large and small shapes, lines that are short or long, thick or thin, edges that are soft or hard, and textures that are smooth or rough. Set verticals against horizontals, light tones against dark, and lines against colour fields.

COLOUR

Colour contrasts can be used to good effect in your paintings. As well as the vibrant and harmonious contrast of complementary colours (*see. p.402*) try contrasting bright and muted, and cool and warm colours. Place a little bright colour between more saturated or muted colours, which reflect less light, for a strong statement. Create a balancing contrast with warm and cool colours: too many cool colours can make your painting feel unpleasantly cold in atmosphere, so add contrasting warmer colours.

The pinks and yellows of the rocky hillside create a warm contrast.

The water and foreground rocks are glazed with cool blues.

EDGE

Vary the edges between two colours to create both hard- and soft-edged shapes. The resulting contrasts of definition will add interest to your painting. Do not be afraid to leave some areas of your painting less explicit – there is no need to spell out everything all of the time. The eye is sophisticated and corrects and concludes for itself.

As the main focus of the painting, the hedge, urn, and plant have been given hard edges.

The stone surface in the lower half of the painting consists entirely of soft edges.

LINE

Pay as much attention to the lines in your painting as you do to the colour fields. Emphasizing the outlines of certain objects will make them stand out as important elements of the design. Consider the direction of the lines you use to improve the dynamic of your painting. Verticals and horizontals are elements of balance, whereas diagonals are unbalancing and surprising.

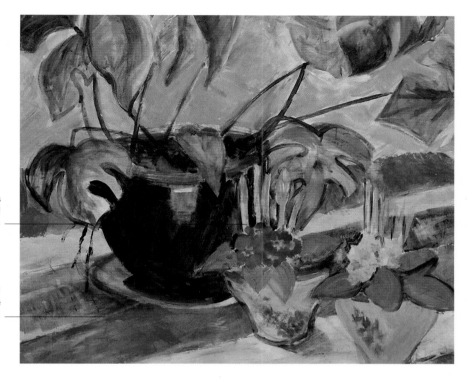

The vertical stems of the plants contrast with the diagonals and provide a natural balance.

The strong, repeated, diagonal lines of the tablecloth give the painting impact.

TONE

Use the contrast of light and dark tones to give focus to your painting. The darker tones immediately lead the eye to the lighter areas in your work. Placing your lightest mark next to your darkest establishes the focal point of your painting. However, while the extreme contrast of light and dark tones is very useful to employ, make sure that you work up the mid tones too, so that your painting does not seem harsh and unresolved.

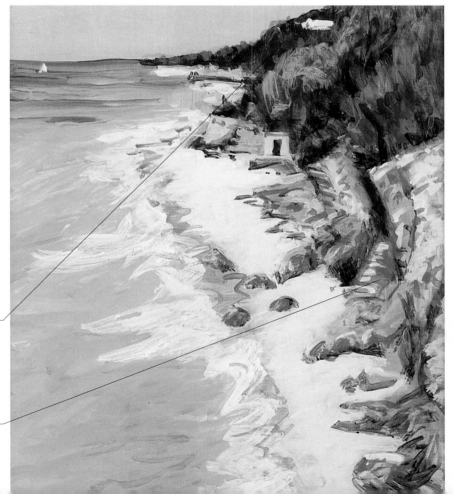

The darker tones of the greenery throw the emphasis onto the delicious turquoise wedge of sea.

The mid tones have been developed to add to this tranquil scene.

Gallery

Contrasts in a painting hold the viewer's interest. Look for ways of employing them in tone, colour, shape, edge, and line.

Flowers and fruit ▶

Harmonious contrast is found here in the complementary colours of red against green and yellow against violet. The tonal contrasts of the mid colours in the vase and fruit unify the painting. *Aggy Boshoff*

▼ Winter fishing boats, Folkestone harbour

The pink and brown tones of the jetty and pier are a warm contrast to the cool light blue colours of the harbour, sea, and sky. *Christopher Bone*

◀ Cypress Point

There are strong tonal contrasts here between the white waves and pale sand and the dark tones of shadowed foliage and rocks. The defined brushwork of the foreground grass stands out against the soft shadow area behind it. *Aggy Boshoff*

▼ Portrait of a girl in Spanish dress

The black and white of the dress are a bold tonal contrast against the light skin and blond hair of the model. Her face is in shadow where it is set against the paler area of background. *Aggy Boshoff*

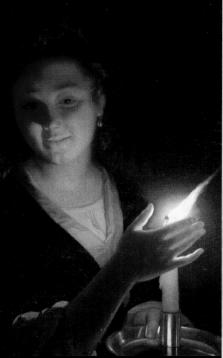

▲ Woman with a candle

The bold contrast between light and dark known as *chiaroscuro* is the most notable feature here, but there is also harmonious contrast of green and red. *Godfried Schalken*

◀ California sunset

Dark trees stand out strongly against the light sky. The foreground trees have hard edges, and the distant forest is a soft-edged blur. Violet and yellow are juxtaposed in the sky to add colour contrast. *Albert Bierstadt*

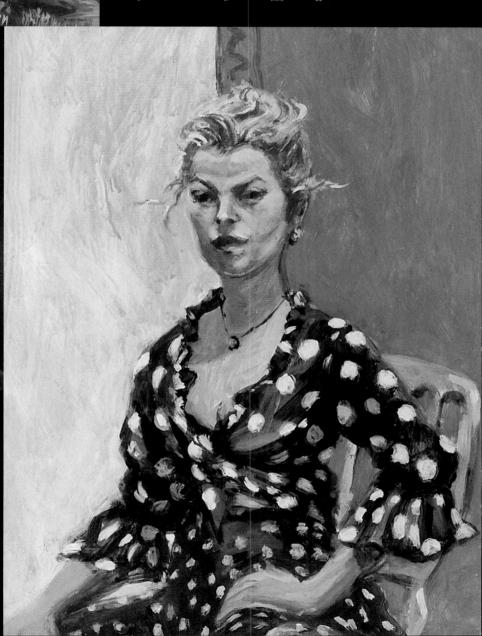

46 Still life

The objects in a still life picture are carefully selected and arranged. For this painting the lemon and bottle have been moved back and forth to harmonize best with the plate, and the crab, and prawns. The shapes of the lemon, spots on the cloth, and the bottom of the bottle mimic those of the plate, crab, and prawns, and contrast with the diagonal lines on the cloth and the verticals of the bottle. These shapes, and the tones, are set with thin blue before strong colours, such as cadmium scarlet, and thicker paint are used. Final refinements to colour and texture are scratched in.

EQUIPMENT
- Canvas
- Brushes: No. 2 round, No. 8 flat, No. 4 and No. 6 filbert
- Painting knives: No. 21 and No. 24
- Turpentine or odourless thinner, impasto medium
- Cobalt blue, cerulean blue, titanium white, cobalt turquoise, lemon yellow, cadmium yellow, alizarin crimson, burnt sienna, yellow ochre, cadmium red, ivory black, ultramarine blue, Prussian blue, raw sienna, viridian green

TECHNIQUES
- Painting knife
- Scratching

SETTING UP A STILL LIFE

The bottle of wine is cut off at the picture's edge.

The eye travels around the composition to the focal point of the crab and prawns.

The diagonal lines of the cloth lead the eye out, then back into the picture.

The oval shape of the plate is repeated by the lemon and spots of the cloth.

Take time to set up a still life. Think of the objects in terms of simple shapes such as circles, rectangles, and triangles. This will make it clear how they relate in space to each other. A good still life consists of strong shapes.

Paint with turpentine establishes all the basic shapes.

1 Sketch the composition in pencil. Paint the tablecloth with cobalt blue. Mix cerulean blue, titanium white, and cobalt turquoise, and paint the area behind the table, the shape of the bottle, and the shadows on the lemon, under the plate, and under the crab.

BUILDING THE IMAGE

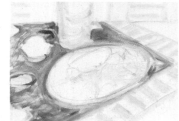
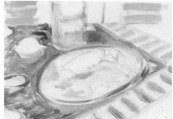
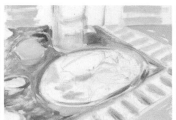
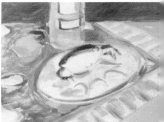

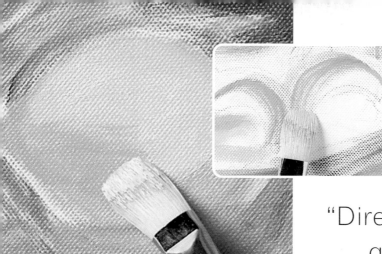

2 Mix lemon yellow, titanium white, and turpentine to paint the lemon. Use thin cadmium yellow with a No. 4 filbert brush to paint the lightest areas of the prawns and the white areas of the plate's shadow. Paint the tabletop cadmium yellow, using the No. 8 flat brush. Add cadmium yellow into the darkest areas of the lemon.

"Directional strokes can help give an object shape."

3 Add shape to the bottle with light strokes using the first lemon mix from step 2. Outline the labels on the bottle with a mix of cobalt blue and alizarin crimson. Add ultramarine blue to this mix to add colour to the background. Mix cobalt blue with a little titanium white to strengthen the cloth.

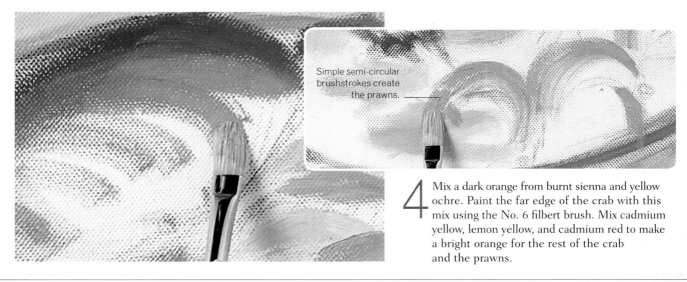

Simple semi-circular brushstrokes create the prawns.

4 Mix a dark orange from burnt sienna and yellow ochre. Paint the far edge of the crab with this mix using the No. 6 filbert brush. Mix cadmium yellow, lemon yellow, and cadmium red to make a bright orange for the rest of the crab and the prawns.

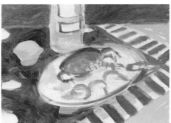
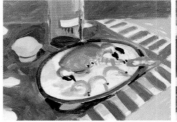
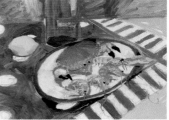

5 Strengthen the stripes on the tablecloth with cobalt blue. Add more detail to the crab and prawns with the bright orange mix, then paint some parts with strong, pure cadmium red.

6 Mix ivory black and ultramarine blue for the crab's claws. Mix lemon yellow, cadmium yellow, titanium white, and cobalt blue for the bottle. Add Prussian blue and cadmium yellow to paint the bottle's base.

7 Paint the rim of the plate with a mix of cobalt blue and titanium white. Paint the eyes of the crab and the prawns with ivory black. Add shadows to the bottle and the edge of the plate with ivory black, painting wet-in-wet.

BRUSHSTROKES

For expressive, and determined, detailed brushstrokes, load the brush with paint and push it down firmly so that a decisive dab of paint is placed.

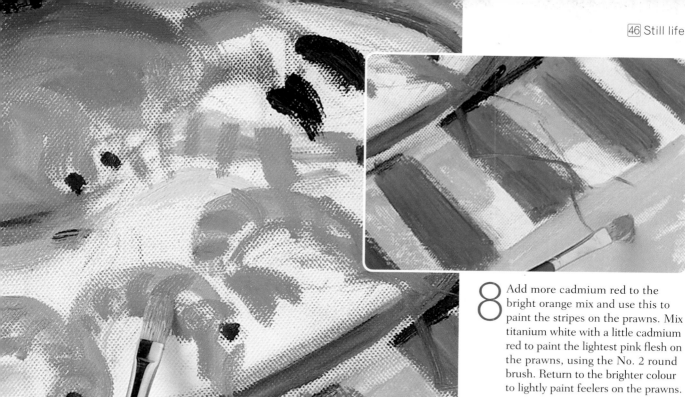

8 Add more cadmium red to the bright orange mix and use this to paint the stripes on the prawns. Mix titanium white with a little cadmium red to paint the lightest pink flesh on the prawns, using the No. 2 round brush. Return to the brighter colour to lightly paint feelers on the prawns.

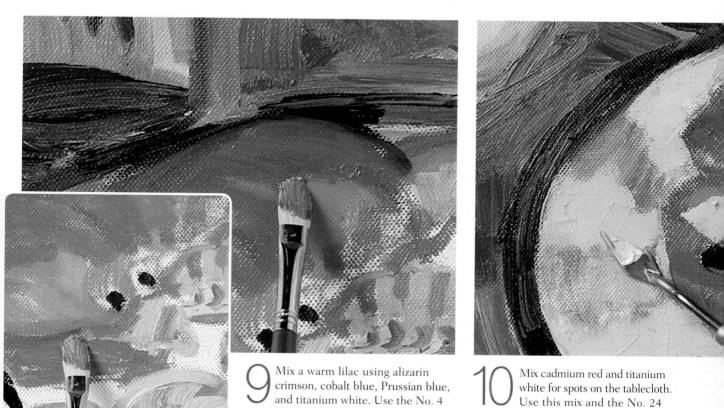

9 Mix a warm lilac using alizarin crimson, cobalt blue, Prussian blue, and titanium white. Use the No. 4 filbert brush to paint shadows under the crab and prawns, on the top of the crab, and in the bottle.

10 Mix cadmium red and titanium white for spots on the tablecloth. Use this mix and the No. 24 painting knife to paint the white of the plate, varying with a little lemon yellow and titanium white.

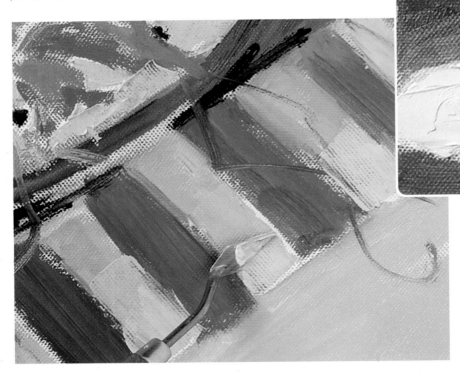

11 Paint the stripes on the tablecloth with a mix of titanium white and cobalt blue. Lighten them by overpainting with a titanium white and lemon yellow mix. Use this mix on the spots on the tablecloth too. Add more white to the mix to paint the plate. Keep the paint clean by wiping off any colour that is lifted from the painting.

12 Add mixes of cobalt turquoise or Prussian blue, and titanium white, to the background. Mix raw sienna and viridian green with impasto medium, and paint the bottle with vertical strokes using a No. 21 painting knife.

13 Paint the rim of the plate with pure cadmium yellow in areas where the light hits the gilding. Use a mix of Prussian blue and titanium white to liven up the edge of the plate. Add cadmium red to the bright orange mix. Use this mix to refine the prawns' feelers, and to strengthen the colour and shape of the crab.

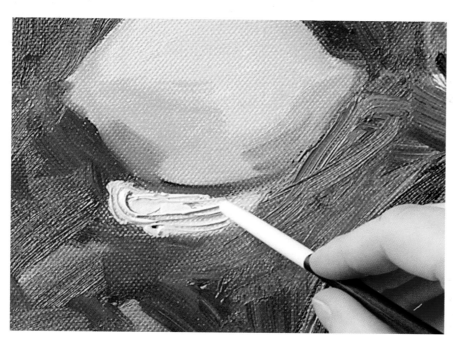

14 Use the wrong end of the brush to scratch into the paint to modify the white spots and lines of the tablecloth, so that some of the underlying blue and yellow shows through. Add further refinements to the crabs and prawns with the orange, red, and light pink mixes.

▼ Still life

The treatment of the background and shapes surrounding the plate of crustaceans has been kept as simple as possible. This allows attention to be focussed on the intricate shapes of the crab and prawns.

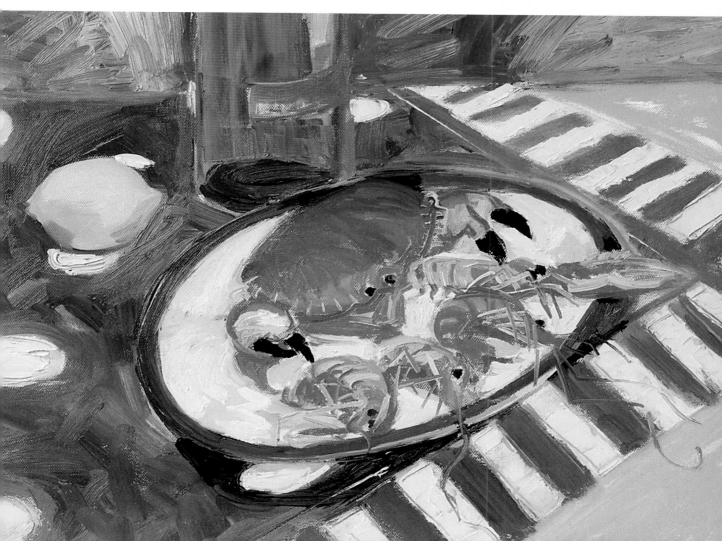

47 Bicycle in the sunlight

This painting of a bicycle leaning against a wall contains two colour contrasts. Yellow and lilac contrast in the colours of the wall and its shadows, and a more subtle contrast of red and green can be seen in the frame of the bicycle. The shadows of the bicycle are also tinged with greens to make the red of the bicycle appear more vibrant. The wall is painted first, as seen through the bicycle frame, and the bicycle then emerges. The front wheel is larger than the rear wheel, because it is closer to the eye. The shapes of both wheels contrast with the strong verticals in the painting.

EQUIPMENT
- Canvas
- Brushes: No. 2 round, No. 8 flat, No. 6 and No. 8 filbert
- Painting knives: No. 24
- Cotton rag
- Turpentine or odourless thinner, painting medium
- Cadmium yellow, cadmium red, titanium white, viridian green, ultramarine blue, alizarin crimson, cerulean blue, lemon yellow, raw sienna, rose madder, cobalt blue, Prussian blue, ivory black, burnt sienna, cobalt turquoise

TECHNIQUES
- Scumbling
- Adding highlights

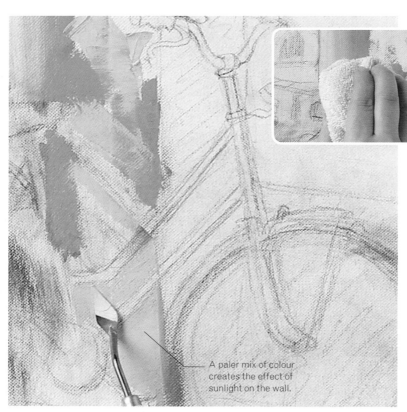

A paler mix of colour creates the effect of sunlight on the wall.

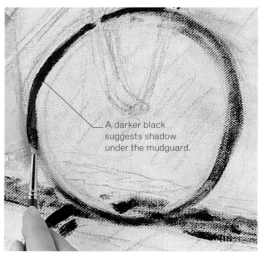

A darker black suggests shadow under the mudguard.

1 Mix cadmium yellow and cadmium red with painting medium to paint the shadows on the yellow wall, including the area seen through the wheel. Add titanium white to the mix to paint the areas of the wall in sunlight, using the No. 24 painting knife. Dip a cloth in turpentine and rub it vertically over the paint for a straight line.

2 Mix cadmium red, viridian green, ultramarine blue, and turpentine to make a thin black mix. Paint the wheels with this mix using the No. 2 round brush. Anchor the tyres on the ground by painting their shadows.

BUILDING THE IMAGE

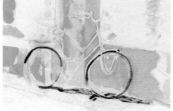
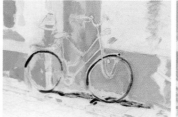
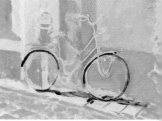

3 Paint the shadows on the whitewash wall with a lilac mix made from alizarin crimson, cerulean blue, and titanium white, using the No. 8 filbert brush. Painting the spaces inside the frame throws the bicycle into relief.

4 Mix cadmium red and cadmium yellow for the areas in sunlight to the side and for the basket. Mix cerulean blue and titanium white with the lilac mix for lighter areas of the white wall, adding lemon yellow in places.

"White is 95 per cent not white – it reflects the colours around it."

5 Add alizarin crimson and raw sienna to the lilac mix to make a warmer colour for the shadow areas on the road and the kerb. Paint with directional strokes using the No. 8 filbert brush. Add more raw sienna to the mix and scumble this colour over the road and on the wall on the far right and far left.

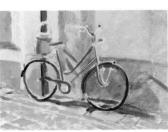

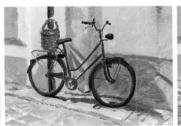

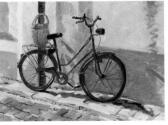

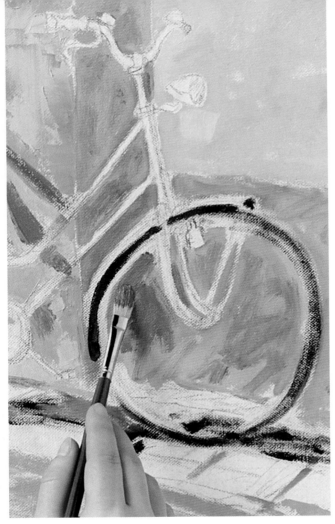

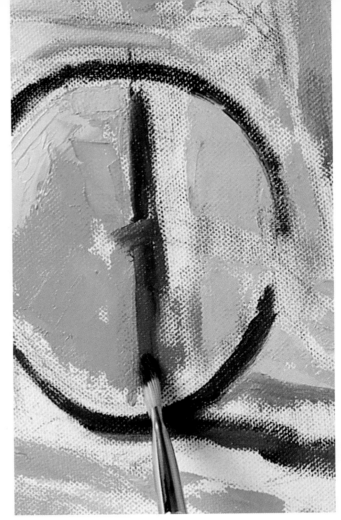

6 Mix rose madder and cobalt blue. Using the No. 8 filbert brush on its side, scumble the colour over the shadow areas on the wall. Use the thin black mix and the No. 6 filbert brush to add further precision to the wheels and to paint the shadow of the wall on the ground.

7 Mix a brownish green from cadmium red, cadmium yellow, Prussian blue, and ultramarine blue. Use this mix to paint the drainpipe. Add the same colour to the shadows on the wheels and further develop the shadows of the bicycle and drainpipe on the ground, emphasizing and softening the shadow area.

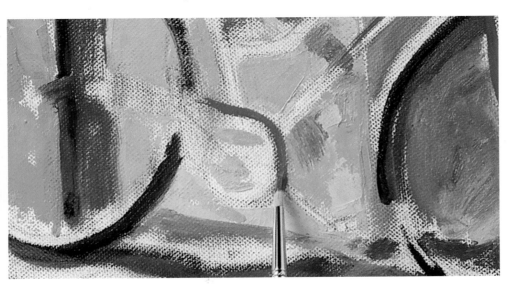

8 Paint the bicycle with a thin mix of pure cadmium red and turpentine, using the No. 2 round brush. Where the paint touches the black mix the red will become a darker shade, which can be left or overpainted with more cadmium red. Add ivory black to the drainpipe.

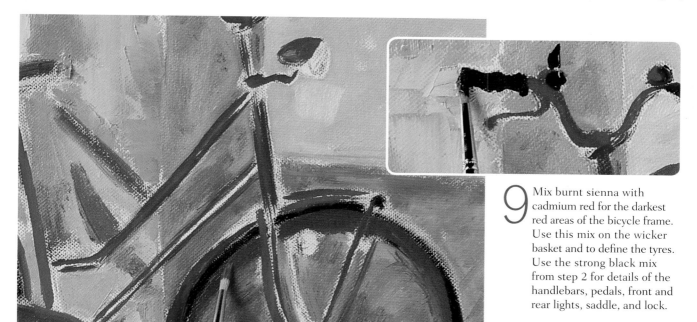

9 Mix burnt sienna with cadmium red for the darkest red areas of the bicycle frame. Use this mix on the wicker basket and to define the tyres. Use the strong black mix from step 2 for details of the handlebars, pedals, front and rear lights, saddle, and lock.

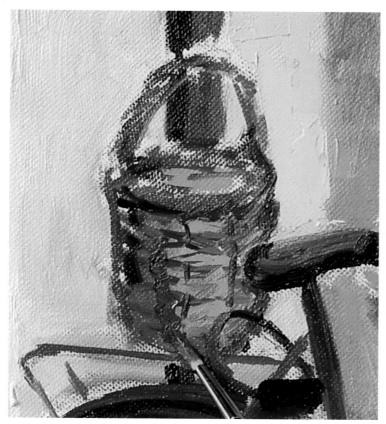

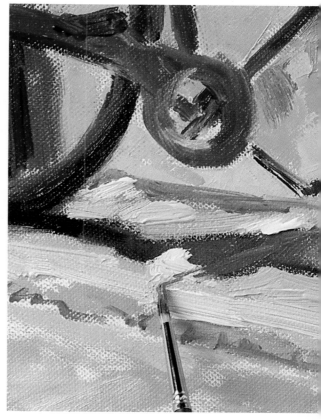

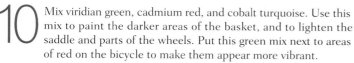

10 Mix viridian green, cadmium red, and cobalt turquoise. Use this mix to paint the darker areas of the basket, and to lighten the saddle and parts of the wheels. Put this green mix next to areas of red on the bicycle to make them appear more vibrant.

11 Make a different green mix from cadmium yellow, titanium white, and cerulean blue to add the divisions of the pavement and kerb. Put touches in the shadow of the bicycle.

12 Mix a soft green from lemon yellow, cadmium yellow, and cobalt blue for shadows on the bicycle. Add cobalt blue and alizarin crimson to the mix to paint the shadows cast by the bicycle on the wall. Warm the shadows with a mix of cadmium yellow and cadmium red.

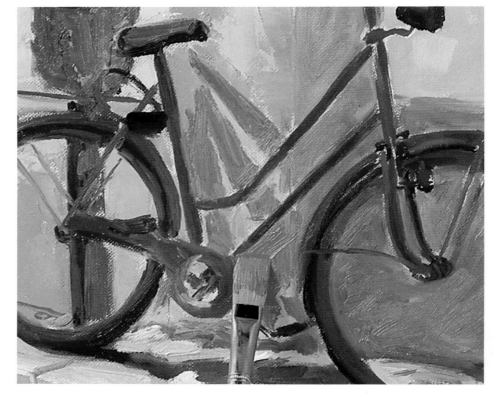

TRUST YOUR EYES

In general, paint what you can see or count. Don't paint details you know an object has if you can't actually see them.

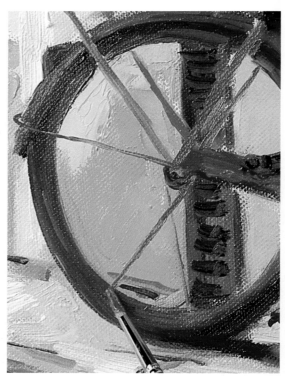

13 Add titanium white to the soft green mix and paint this lightly in the foreground. Add ivory black to the mix and draw in irregular lines to indicate the kerbstones and cobblestones.

14 Suggest some spokes with the dark red bicycle mix, varying the colour as you go. Paint details on the bicycle with ultramarine blue and define the saddle with this mix.

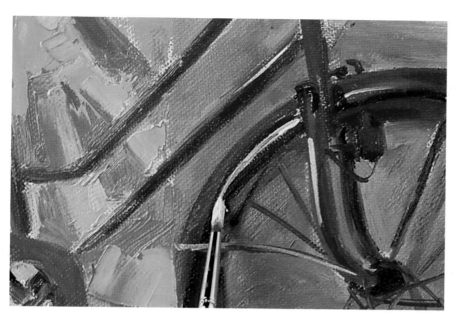

15 Add some of the black mix to the shadow by the front wheel to redefine it. Make a fairly liquid mix of titanium white with turpentine. Use this to add highlights to the metal of the bicycle frame and wheels.

▼ Bicycle in the sunlight

All the horizontal lines in the painting have been placed on the diagonal, making the picture more dynamic. The angled shadows of the bicycle cast on the wall and the pavement reinforce the effect.

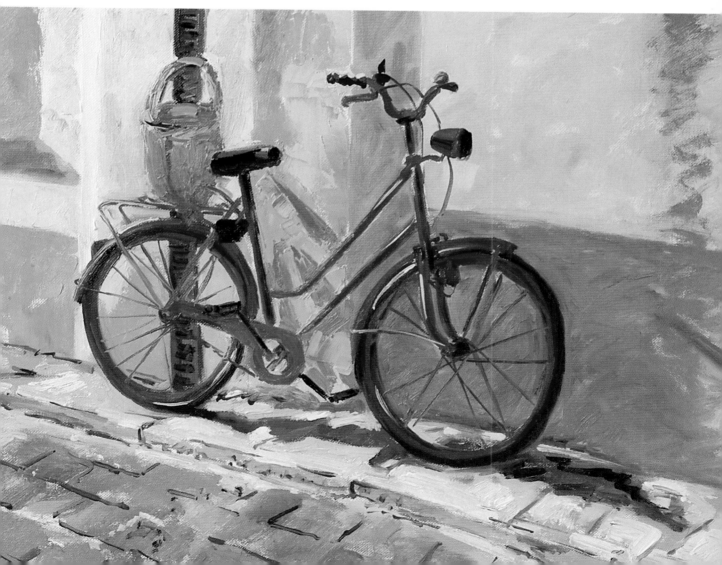

48 Portrait of a girl

This portrait is started with a thin glaze. The features are found by lifting out some of the glaze with a cloth. Capture areas of light on the face rather than focusing on the details, seeing lights and darks as abstract shapes. Gradually soften the abstract shapes as you work to emphasize the structure of the face. The final shape of the straight neckline, the cheekbone, and the pigtail are established by working up to them from the background, using a painting knife flat. In line with the bold shapes, a scrunching technique is used to create texture in the cardigan.

EQUIPMENT

- Canvas
- Brushes: No. 2 round, No. 8 and No. 12 flat, No. 4, No. 6, and No. 8 filbert
- Painting knives: No. 21
- Cotton rag, aluminium foil
- White spirit, turpentine or odourless thinner, impasto medium
- Cadmium red, cadmium yellow, burnt sienna, viridian green, sap green, titanium white, cerulean blue, Prussian blue, ivory black, yellow ochre, transparent yellow, ultramarine blue, brilliant pink, cobalt blue, cobalt turquoise, lemon yellow, permanent rose

TECHNIQUES

- Lifting out
- Scrunching
- Softening

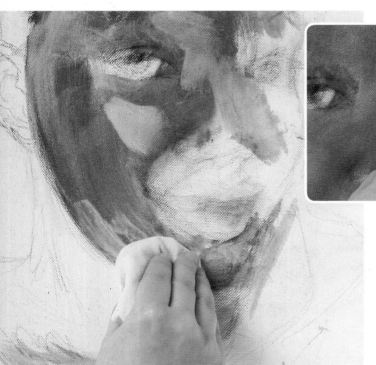

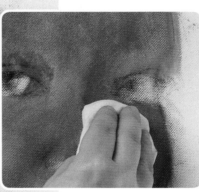

1 Draw the face, checking the proportions carefully. Mix cadmium red, cadmium yellow, and burnt sienna for a base skin colour. Apply with light brushstrokes, and use a rag to blend and lift out.

2 Create a dark base colour for the hair by mixing viridian green, sap green, and titanium white. Use the No. 4 filbert brush to paint this mix in the darkest areas of the hair, around the cheeks, and on the eyes.

BUILDING THE IMAGE

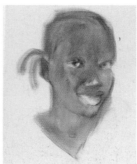
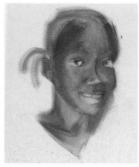
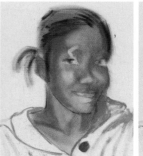
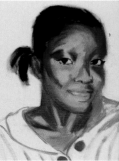

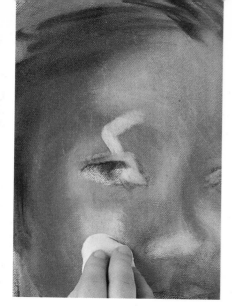

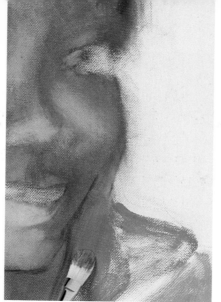

3 Dampen the cloth with some white spirit and use it to lift out some of the paint in those areas where the skin reflects the light.

4 Paint in the outline and colour of the cardigan with a mix of cerulean blue and titanium white, using the No. 6 filbert brush.

5 Mix Prussian blue and ivory black, and block in the hair with the No. 12 flat brush. Switch to the No. 2 round brush to define the eye lines.

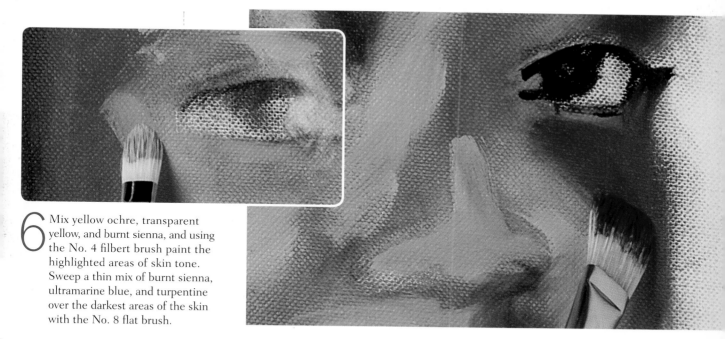

6 Mix yellow ochre, transparent yellow, and burnt sienna, and using the No. 4 filbert brush paint the highlighted areas of skin tone. Sweep a thin mix of burnt sienna, ultramarine blue, and turpentine over the darkest areas of the skin with the No. 8 flat brush.

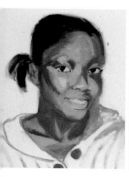
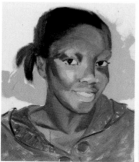
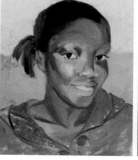
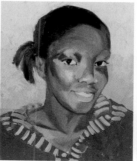
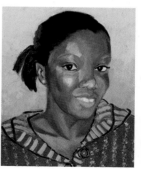

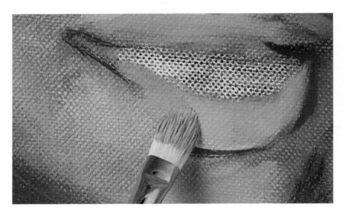

7 Define the mouth with the darker skin mix using the corner of the No. 8 flat brush. Mix brilliant pink with some titanium white to create a pale pink. Paint in the pink tones of the lips, nose, and cheeks using the No. 4 filbert brush.

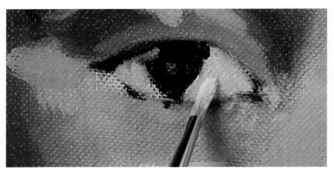

8 Return to the yellow highlight skin tone mix and add some titanium white. Paint in the delicate detail of the whites of the eyes, and add the base colour for the teeth, using the No. 2 round brush. Mix cobalt blue and cerulean blue, and scumble in the base colour of the cardigan.

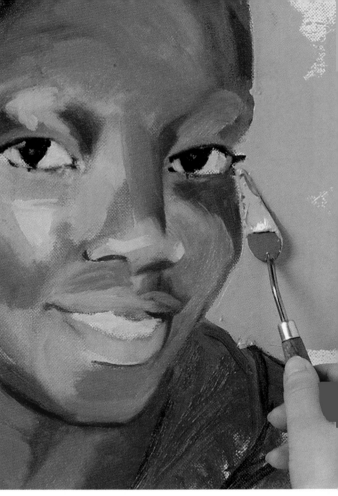

9 Use the dark skin mix from step 6 to define the jawline. Mix cerulean blue, ultramarine blue, cobalt turquoise, and titanium white with some impasto medium. Apply to the background with the No. 21 painting knife, using the edge of the knife to create a definite line around the head.

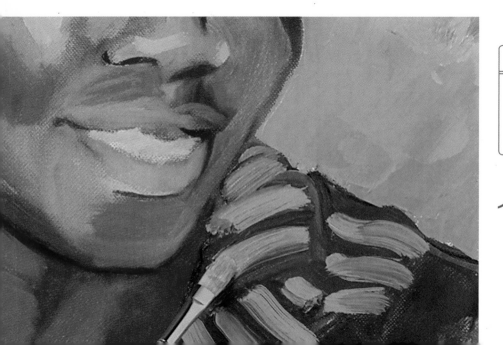

SKIN MID TONES

Spend time getting the mid tones in the skin right, as well as the highlights and shadows. The mid tones play an important role as they soften the face and pull the portrait together.

10 Spread a mix of Prussian blue, ultramarine blue, and titanium white on the cardigan with the No. 21 painting knife. Add titanium white and a little cobalt turquoise to the mix for the light blue stripes and paint them with the No. 8 flat brush.

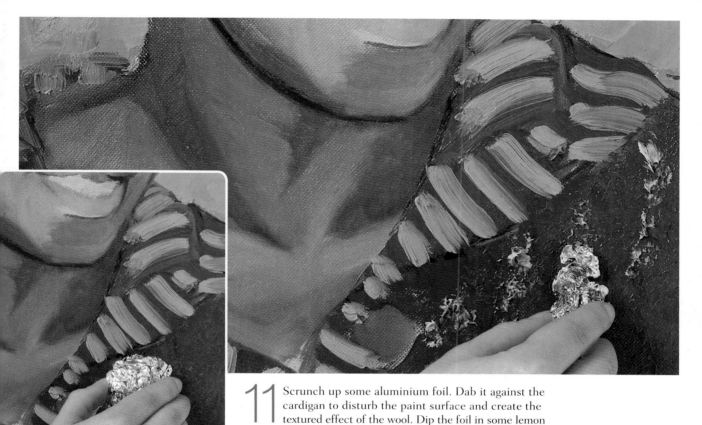

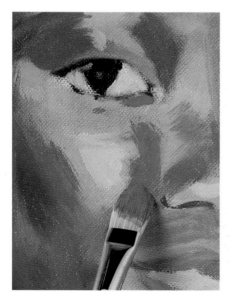

11 Scrunch up some aluminium foil. Dab it against the cardigan to disturb the paint surface and create the textured effect of the wool. Dip the foil in some lemon yellow and then dab it along the cardigan in vertical lines to create the yellow pattern.

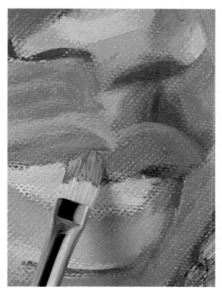

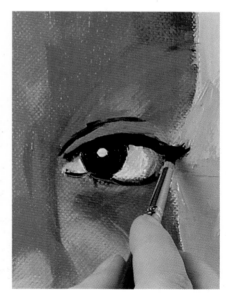

12 Return to the darker skin mix to reinforce the shadows on the neck and lower part of the face with the No. 8 filbert brush. Add some cadmium red to the mix to reinforce the mid tones.

13 Paint the upper lip a darker tone than the bottom lip, which catches the light. Mix permanent rose and brilliant pink, and apply this carefully using the No. 4 filbert brush.

14 Mix a little cadmium yellow into titanium white and turpentine to dot into the eyes. Add titanium white to the background mix for the eyelids. Define the eye line and eyelid crease with ivory black.

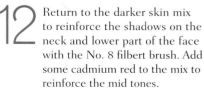

15 Mix brilliant pink, titanium white, and lemon yellow, and use this to highlight the cheek and brow with the No. 2 round brush. Cheek the mid tones of the skin and lighten in places with a mix of burnt sienna and titanium white using the No. 8 filbert brush.

16 Finish the picture by softening the hairline, lifting and merging some of the colour with your fingers. Give some character to the front teeth by adding a little pure titanium white. Do not delineate every tooth; just give an impression of the overall shape.

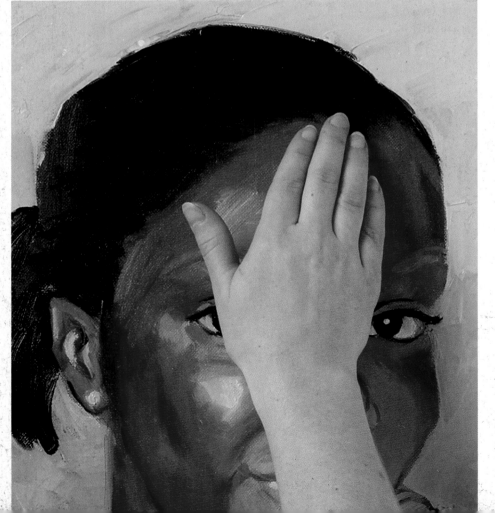

"Paint lights and shadows as distinct shapes."

Portrait of a girl ▶

In this portrait, the skin tones used have been carefully placed and not overworked, capturing the face's form. Blending the skin colour of the forehead into the hairline softens the overall effect.

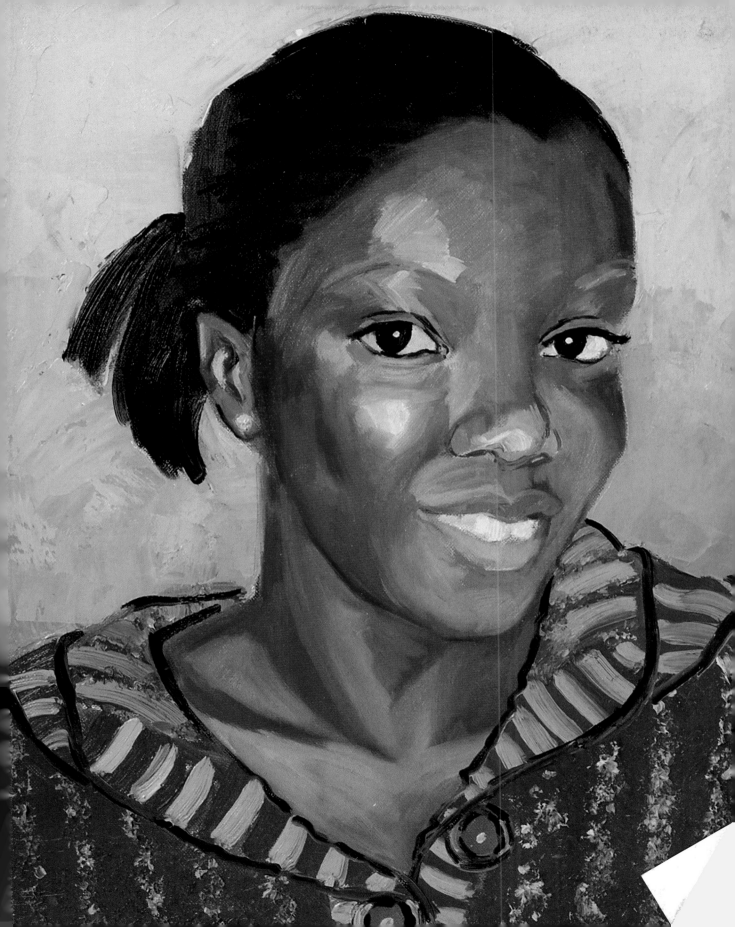

Glossary

*Terms explained in more detail under their own glossary entry are given in **bold** type.*

Acrylic gesso
A white acrylic undercoat used to prevent oil paints sinking into the **support**.

Aerial perspective
Where objects in the foreground appear warmer, darker, more detailed, and more focused than those in the background. In colour, objects become bluer as well as hazier as they recede. Also called atmospheric perspective, and a technique much used in landscape pictures.

Alkyd paint and medium
Paints and mediums containing an oil-modified resin, which helps speed up the drying time.

Analogous colours
Colours that are closely related and next to each other on the **colour wheel** – such as yellow and orange. Such colours mix together visually to give an overall impression of either warmth or coolness.

Artists' colours
The highest quality oil and watercolour paints, these contain more pigment than **students' colours**, and so produce the most permanent results. Another benefit is that they can be stronger in opacity or more translucent than students' colours.

Back lighting
Lighting created when the light source is behind the subject. Back lighting creates a silhouette and eliminates most surface detail.

Backruns
Irregular shapes, sometimes called blooms, caused when watercolour paint in one colour flows into a different one that hasn't fully dried. The marks produced have dark outer edges.

Binder
The wax in coloured pencils, gum in soft pastels, and oil in oil pastels, that sticks the particles of pigment together.

Blending
A way of letting two colours merge gradually with each other on the picture plane. With oil paint or acrylics the blending is done with a painting knife or by brushing or **feathering** lightly with a brush. With drawing, the blending tool can be your finger, a shaper, paper stump (tortillon), cotton bud, cotton wool, tissue, rag, or an eraser. Charcoal and pastel are good media for blending.

Brilliance
How bright or dull a colour is.

Broken colour
A method of giving colour to an object with little touches of various, partially overlapping, colours from a small colour range, to give more interest.

The colours are not blended together but left broken, only appearing to merge when viewed from a distance.

Broken wash
A watercolour wash produced by letting a loaded brush glance over the top of the paper as it is drawn across it, so that areas of white paper show through.

Calligraphic strokes
Rhythmic, fluid strokes and expressive lines that are drawn with a brush.

Charcoal
Charred twigs or sticks, such as willow, used as a drawing medium. Good for free sketching rather than detail.

Cold-pressed paper
Paper with a slightly textured surface that has been pressed by cold rollers rather than hot ones during its manufacture. It is also sometimes called NOT paper.

Colour field
Any area of colour that does not constitute a line.

Colour mix
Watercolour paint that has completely dissolved in water to make a pool of colour.

Colour wheel
A visual device for showing the relationship between **primary**, **secondary**, **intermediate**, and **complementary** colours.

Coloured pencil
Wax-based crayons in pencil form. Available in a wide range of colours and good for coloured linear drawing.

Combing
A technique by which a pattern of fine parallel lines of raised and indented paint is drawn into thick paint with a comb.

Complementary colours
Colours that are located directly opposite each other on the **colour wheel**: yellow and purple, red and green, blue and orange. The complementary of any **secondary colour** is the **primary colours** – red, blue, or yellow – that it does not contain. Green, for example, is mixed from blue and yellow, so its complementary is red. Complementary colours used next to each other in a work create contrast and appear to make each other look brighter.

Composition
The arrangement of various components, including the main areas of focus and balance of interest, to create a harmonious whole.

Conté crayon
Midway between hard and soft pastels and based on chalk. Available in square sticks and pencil format.

Contour line drawing
Outline drawing without the use of tone.

Cool colours
Colours with a bluish tone. Cool colours appear to recede in a picture, so can be used to help create **perspective**.

Counterchange
Repeated pattern of light and dark shades that are placed next to each other to create interesting contrasts that help give impact to a picture.

Crosshatching
Criss-crossing parallel lines to create tone. The closer the lines, the denser the tone. A good technique to use in linear media such as pencil and pen. In coloured pencil, crosshatching two colours can create an optical blend.

Dabbing
A way of applying paint in touches without stroking the **support** with the brush.

Depth
The illusion of space and distance, which is achieved through colour relationships, **perspective**, and scale.

Dipper
A set of two small round metal containers for painting media that can be clipped onto the palette.

Dry brushwork
Virtually dry paint dragged across the paper or canvas to produce textured marks, either directly onto an unpainted surface or on top of an existing paint layer.

Ellipse
The oval formed by a circle flattened in **perspective**.

Eye level
The imaginary line running horizontally across the picture roughly at the height of your eye. In **perspective**, horizontal lines above it appear to slope down, while horizontal lines below it appear to slope up, converging at eye level.

Feathering
In watercolour, painting lines with water then adding strokes of colour over the top at an angle. The strokes of colour are softened as the paint bleeds along the water lines. In oil painting, a method of working one colour very lightly over another with a large or fan-shaped brush. The result is a soft shimmering colour made up of the two colours combined.

Fixative
Liquid resin spray or atomizer commonly used in drawing. It glues easily smudged media such as charcoal and pastel to the paper. Fixative should be applied outdoors, or at least in a well-ventilated room, in a light, continuous motion from top to bottom of a drawing held vertically, at a distance of about 30cm (12in). Too much fixative deadens a drawing. Hairspray is an alternative.

Flat wash
A wash produced in watercolour by painting overlapping bands of the same colour so that a smooth layer of uniform colour is produced for, e.g., a sky.

Focal points
Points of interest which the eye is drawn to immediately, whether because of the **perspective**, the colour, or an intricate shape. A composition should have one or more focal points. Multiple focal points will lead the eye around the **picture plane**.

Foreshortening
The effect of **perspective** that makes forms appear to get smaller with distance, particularly noticeable in figure drawing, when it distorts the proportions of the body. Applying foreshortening is a technique that helps make objects look three dimensional on the flat surface.

Form
The solid shape of an object as seen from all possible angles and viewpoints.

Format
The size and shape of the drawing surface, usually rectangular or square. A tall, vertical rectangle is known as **portrait** format; a wide, horizontal rectangle is known as **landscape** format.

Front lighting
Light that shines directly on the front of the subject to reveal its true colour, detail, and texture.

Glazing
The application of a transparent layer of paint over a layer of paint that has been allowed to dry completely. The colours of the first layer show through the second layer of paint and create a new, shimmering colour.

Graded wash
A wash which is laid down in bands that are progressively diluted or strengthened so that the wash is graded smoothly from dark to light or from light to dark.

Granulation
The separation of watercolour paints when they are mixed together in a palette or on paper, which occurs if the pigments they contain are of different weights. The resulting granulated mix is speckled and pitted.

Graphite
The carbon-clay mix used in pencils. Graphite sticks are pure graphite without the wooden casing.

Hake brush
A flat brush with goats' hair bristles used in watercolour painting. Hake brushes are good for painting washes and for covering large areas of paper quickly.

Hard edge
A style of painting that produces clearly defined forms and clean contours. The colour is kept flat.

Hatching

In painting, a technique of applying paint in short parallel strokes over another paint layer to create a new colour, which is not blended on the canvas but is created by the colours appearing to merge when seen from a distance. In **crosshatching**, a second layer of parallel strokes is applied in a slightly different direction. In drawing, hatching refers to parallel lines for shading. If the hatching curves, following the form of the object, it is called bracelet shading.

Highlight

The lightest tone in a composition, occurring on the most brightly lit part or parts of a subject.

Horizon line

In linear **perspective** the imaginary line at **eye level** where horizontal lines meet at the vanishing point. The true horizon line, where the land meets the sky, may be higher or lower than your eye level.

Hot-pressed paper

Paper with a very smooth surface that has been pressed between hot rollers.

Hue

Another word for colour, generally used to mean the strength or lightness of a particular colour.

Impasto

A technique where paint is applied thickly with the brush or painting knife to create a textured surface. The paint is applied with short dabs or with a definite stroke, so that it does not blend with paint that has been applied earlier. The marks of the brush or knife are evident and these add interest to the composition. The term is also used for the results of this technique.

Intermediate colours

The colours between the **primary** and **secondary** colours on a **colour wheel**, which are created by mixing a greater proportion of the primary colour into the secondary colour.

Landscape format

Paint **support** – such as canvas, paper, or board – that is rectangular in shape and is wider than it is high. This format was traditionally used for creating large-scale landscape paintings.

Layering

Painting one colour over another that has been allowed to dry. Unlike **glazing**, the colours used can be dark and opaque, so that the first layer of paint does not show through the layer of paint that covers it.

Leading line

A line that entices the viewer's gaze into the picture. It may be a path, a road, or something less tangible, such as a shadow, a reflection, or a pencil stroke.

Lifting out

Removing paint from the surface of the paper after it has dried, often to create soft highlights. With watercolours, this is usually done with a stiff, wet brush; with oils a dryish brush or a cloth is used. With drawing, it refers to using an eraser to draw highlights out of dark tone in charcoal or pencil on white paper. Here, the technique uses the eraser as a positive drawing tool rather than just something that rubs out mistakes.

Linear perspective

A method of portraying three dimensions on a flat surface by showing how parallel lines – for example of a road or railway track – appear to converge in the distance. This point of convergence is called the vanishing point.

Luminosity

A transparent colour has luminosity when it appears to have an inner light, caused by the white of the undercoat or support, or other colours applied previously, showing through the top colour.

Masking fluid

A latex fluid that is painted on to paper and resists any watercolour paint put over it. Once the paint is dry, the masking fluid can be rubbed away to reveal the paper or layer of paint it covered.

Medium

A substance that is used to modify the fluidity or thickness of oil or acrylic paints. The paint is mixed with the medium on the palette until it has the desired quality and is then applied to the **support**. Thinning, glazing, thickening, and impasto media are available. The word medium is also used in general to distinguish between the drawing or painting materials used such as oil, acrylic, watercolour, pen, pencil, etc.

Mid tones

Mid tones are all the variations of tone between the darkest and the lightest tone in a composition.

Modelling

Using light and dark tone to give a three-dimensional impression. Also refers to a person posing for a portrait or figure study.

Monochrome

Working in black and white and shades of grey, for instance, in charcoal or pencil drawings, or working in any single colour in any of the other media.

Negative space

The gaps between objects. Negative space is as important as positive form in creating a satisfying composition. Drawing the boundaries of negative space is often more successful than drawing named objects, as it encourages close observation.

Neutral colours
In oil painting, neutral colours are mixtures of three colours, or colours toned down with black. They do not reflect as much light as bright colours, and make them look brighter when placed beside them. In watercolour, neutral colours are produced by mixing two **complementary** colours. By varying the proportions of the complementary colours, a range of semi-neutral greys and browns – more luminous than ready-made greys and browns – can be created.

Oil
A medium added to oil paint, usually consisting of linseed oil, which thickens it and makes it easier to apply to the surface. Oil paint is mixed with **turpentine** in order to produce thinner mixtures.

One-point perspective
The simplest kind of linear perspective, in which parallel lines, such as those formed by a road or path, are at right angles to a picture plane and meet at a single vanishing point on the horizon.

Opaque colour
Colour that is impervious to light and which obscures anything underneath; the opposite of transparent. When opaque paints are mixed together, the results are often dull.

Palette
Any suitable mixing surface for paint. Watercolour palettes usually have segmented wells to keep different colours separate. The word is also used to describe colours used by a particular painter or on a particular occasion.

Pan
A small block of solid, semi-moist watercolour paint, which comes in a plastic box that can be slotted into a paint box. Paints are also available in half-pans, so a wider selection of colours can be fitted into a paint box.

Pastel
A colour drawing medium in which powdered pigments are bound with gum into sticks. Soft pastels, often called chalk pastels, are powdery. **Conté crayons** are harder. Both come in pencil form. Oil pastels are sticky and closer to painting media. By extension, a pastel is the term for a drawing made with pastels.

Perspective
The method of creating a sense of **depth** on a flat surface through the use of **modelling**, **linear** and **aerial perspective**, and **foreshortening**.

Picture plane
The flat surface of the picture as if transparent, held parallel to the artist's face, depicting imaginary space. The best way to visualize it is as a glass pane with the picture pressed on to it.

Pigment
The colouring agent used in pastels, coloured pencils, and all paints. Nowadays most pigments are synthetic.

Plasticity
A tactile quality which makes you want to touch the work to feel how it is made. Oil paint has this quality because it can be used to create visible brush marks and thick textures.

Portrait format
Paper in the shape of a rectangle that is taller than it is wide. It was traditionally used for standing portraits.

Positive shape
The outline shape created by an object.

Primary colours
There are three primary colours – yellow, red, and blue – which cannot be made by mixing any other colours. When placed next to each other they give the strongest contrast of all colours. Any two of these colours can be mixed together to make a **secondary colour**. On the **colour wheel** they are placed opposite each other, forming a triangle on the wheel.

Proportion
The relative measurements of an object, such as the height compared with the width, or the relative measurement of one area to another.

Recession
Movement from near distance through to far distance. Colour recession is the use of **warm** and **cool** colours to create the sense of **depth** in a composition.

Related colour
Colours near each other on the **colour wheel**, such as yellow and orange, and which harmonize when used together in a composition.

Resist
A method of preserving highlights on paper by applying a material that repels paint. Materials that can be used as resists include **masking fluid**, masking tape, and wax.

Rigger
A long, fine brush that is used for detailed work.

Rough paper
Paper with a highly textured surface that has been left to dry naturally, without pressing.

Rubbing out
In painting, using an eraser, or carrying out any action which takes paint off the **support**, usually by wiping an area with a cloth, which may be soaked in turpentine. A residue of paint will be left, which will affect the subsequent overpainting.

Rule of thirds
An aid to composition, which divides a picture into thirds horizontally and vertically to make a grid of nine squares. Points of interest

are placed on the "thirds" lines, and the focal point or points are placed on one or more of the intersections for maximum visual effect. The rule is especially useful when composing landscapes.

Sable
Sable fur is used in the finest quality paint brushes. The long, dark brown hairs have a great capacity for holding paint and create a fine point.

Scale
Objects that are the same size appear to get smaller the further away they are. For example, identical buildings appear to be different sizes if each one is at a different distance from the viewer.

Scraping back
Using a sharp blade to remove layers of dry watercolour paint in order to reveal the white paper below and create highlights.

Scratching
Scraping off paint or pastel crayons with a sharp object or a painting knife to reveal the colour below.

Scratching in
Any action whereby marks are scratched into applied paint to give added texture. Any moderately sharp object is suitable – for example, nails, the side or point of a painting knife, the back of a brush handle, or a comb – as long as the **support** is not damaged.

Scrunching
A technique that uses the texture of scrunched-up paper, plastic, or aluminium foil to stamp texture or a colour into a paint layer.

Scumbling
An oil-painting technique in which a brush is used to apply paint which has only been slightly moistened with medium. The brush strikes lightly over the paint surface, depositing paint irregularly on the raised and dryer parts of the surface and so creating an uneven texture, while allowing patches of the colour underneath to show through. (*See also* **Dry brushwork**.)

Secondary colours
Colours made by mixing two **primary** colours together. The secondary colours are green (mixed from blue and yellow), orange (mixed from red and yellow), and purple (mixed from blue and red).

Shading
The application of tone to a drawing, for instance by varying the pressure of a charcoal stick, to give a three-dimensional impression.

Shadow
The darkness cast when light is obscured, either on an object or by it.

Side lighting
Light that shines on the side of the subject, either sunlight or from an artificial source, which reveals shape and creates both light and dark areas on the subject.

Sighting
Using a brush or pencil to measure relative sizes and so draw objects in correct proportion to each other. It is important to keep the arm straight, the head still, and one eye closed for consistent measurements that mimic the single viewpoint of the drawing. The same method of holding up the brush or pencil can be used to assess angles against horizontal or vertical lines.

Sizing
Sealing a paper's fibres with glue to prevent paint from soaking into the paper. Blotting paper is un-sized and therefore very absorbent.

Softening
In watercolour, blending the edges of a paint stroke with a brush loaded with clean water to prevent paint from drying with a hard edge. In oil painting, hard edges can be softened with a brush and paint, a cloth, or even the hand.

Spattering
Flicking paint from a loaded paintbrush or toothbrush to produce texture or to modify areas of the composition.

Sponging
Pressing a sponge dipped in wet paint on to paper to create a mottled mark; good for creating texture.

Stay-wet palette
A manufactured palette that is designed specifically for use with acrylic paints. It has a damp layer under the main mixing surface to keep paints moist while being used.

Stippling
The application of relatively neat dots to form a colour field or to create shading. Dots in two or more colours can be applied next to, or partially overlapping, each other for a more interesting paint surface, forming a new colour when viewed from a distance. Stippling is a useful technique for linear media such as pen and ink.

Squirrel brush
A very soft brush made from squirrel hair. Squirrel brushes do not hold much paint but are good for softening and blending colours.

Strengthening
Building up layers of paint – especially watercolour paints – to make colours stronger. This is frequently done because paint colours become paler when they dry.

Stretching
The method of taping paper down, wetting it with a damp sponge, and letting it dry flat. Stretching paper helps to prevent the paper buckling when you paint on it.

Students' colours

A less expensive range of paints than **artists' colours**. Student's colours do not contain the same level of pigments as artists' colours and tend not to have the same brilliance, transparency or opacity, or stability found with artists' colours.

Support

Any surface upon which a drawing is made or paint is laid, from paper and boards to cotton or linen canvas.

Technical pen

A disposable pen with an inflexible nib that produces a consistent line regardless of pressure. Technical pens are measured by the width of the nib in millimetres. Much used by architects and engineers for accurate diagrammatic images but also useful for the artist.

Texture paste

A painting medium that is added to thicken acrylic paint in order to build up heavy **impasto** – or raised – textures.

Thick over thin

The invariable rule of oil painting that thick paint, which has more oil in it, should be painted over thinned paint, and not the other way round. This is to avoid cracking of the surface layer of paint (also referred to as "fat over lean").

Tone

The relative lightness or darkness of a colour. Some colours are inherently light or dark in tone; yellow, for example, is always light. The tone of a paint can be altered by diluting it with water (in watercolour), mixing with white paint or with a darker pigment, or surrounding it with other colours.

Toned paper

Paper that has a coloured surface. White paint has to be added to coloured paints to make the lightest tones on such paper.

Tooth

The raised grain of textured paper, which bites into the medium applied to it. Powdery media such as charcoal or soft pastel need paper with a tooth to stick to the surface.

Translucency

Clear, transparent effect in painting by applying thin layers of colour allowing the support to shine through. In watercolour and acrylic the effect is achieved by adding sufficient water to the paint.

Turpentine (or turps)

A flammable solvent with a strong smell used as a painting medium to thin oil paints. It is also used to clean brushes and hands. Odourless thinner is an effective substitute.

Two-point perspective

In **linear perspective** an object such as a building has vertical edges parallel to the picture plane, but its sides are seen at angles. The horizontal lines of the sides appear to converge at two separate vanishing points on the eye-level horizon line.

Vanishing point

In linear **perspective**, this is the point in the distance at which receding parallel lines appear to converge.

Varnishing

The application of a protective resin over a painting that has thoroughly dried, which takes from a few weeks to up to six months. Varnish is removable.

Viewfinder

A framing device that can be used to show how a subject will look in a variety of compositions before painting or drawing it. A simple viewfinder can be made by cutting a rectangular hole in a piece of cardboard, which can be held closer or further away from the eye to decide what will be included in the work.

Viewpoint

The position from which the artist sees and draws subject matter. As well as moving from side to side, raising or lowering the **eye level** creates a different viewpoint.

Volume

The bulk of an object; its three-dimensional solidity.

Warm colours

Colours with a reddish or orange tone. Warm colours appear to come forward in a picture and can be used to help create a sense of **depth**.

Wax resist

Method of using candle wax to prevent the surface of the paper from accepting paint. Once applied, the wax cannot be removed.

Wet-in-wet

In watercolour, adding layers of paint on to wet paper or paint that is still wet. This method makes it possible to build up paintings quickly with soft colours, but it is less predictable than painting over paint that has already dried. Since oil paint takes a long time to dry, the entire painting is technically done wet-in-wet. Thicker paint is applied with each subsequent layer, and can be worked in totally or partially with the previous layer on the support.

Wet on dry

Adding layers of paint on top of colour that has already dried. Painting in this way produces vivid colours with strong edges, so the method can be used to build up a painting with a high level of accuracy.

White spirit

A flammable solvent that is used to clean brushes and hands after a painting session. It evaporates quickly.

Index

Acknowledgments

Picture credits:
Key: t=top, b=bottom, l=left, r=right, c=centre

32 Lucy Watson. **33** Lynne Misiewicz. **36** Bryan Scott. **37** Lucy Watson (r). **39** Lucy Watson (b). **46 Christie's Images Ltd** (tr); **Corbis**/Alinari Archives (br). **47 Corbis**/ Franklin McMahon (b). **48–51** Rosie Morgan. **52–55** Lynne Misiewicz. **56–59** Liane Holey. **61** Lucy Watson (b). **64 Corbis**/Albright-Knox Art Gallery (b). **65 Christie's Images Ltd** (br). **66–69** Lynne Misiewicz. **70–75** Anita Taylor. **76–81** Lynne Misiewicz. **86 The Art Archive**/ University of Wesleyan Middletown USA/Album/Joseph Martin (t). **87 Corbis**/Burstein Collection (t); **Corbis**/ Historical Picture Archive (bl); **The Art Archive** (br). **88–91** Mark Topham. **92–95** Barry Freeman. **96–101** Rosie Morgan. **106 Christie's Images Ltd** (br). **107 Corbis**/Christie's Images (cr). **108–113** Mark Topham. **114–117** Barry Freeman. **118–123** Ruth Geldard **161 Corbis**/Robert McIntosh (tr). **178 The Art Archive**/ British Museum/Eileen Tweedy (bl). **179 Corbis**/ Philadelphia Museum of Art (c). **198 The Art Archive**/ Private Collection London (b). **218** Phyllis McDowell (t). **220 The Art Archive**/Victoria and Albert Museum London/Sally Chappell (t). **221 Corbis**/Brooklyn Museum of Art (t). **274 www.bridgeman.co.uk**/Private Collection (bl). **275 www.bridgeman.co.uk**/Private Collection (t). **292 www.bridgeman.co.uk**/Will's Art Warehouse/Private Collection (t). **www.bridgeman. co.uk**/Private Collection (b). **312 www.bridgeman. co.uk**/Panter and Hall Fine Art Gallery, London/Private Collection (tl). **386 www.bridgeman.co.uk**/Musée Marmottan, Paris (tl). **404 Christie's Images Ltd** (br). **405 www.bridgeman.co.uk**/Lefevre Fine Art Ltd/Private Collection (br). **425 Freeman's**/DK/Judith Miller. **426 www.bridgeman.co.uk**/Hermitage, St.Petersburg, Russia (tl). **427 Christie's Images Ltd** (t). **447** Lindsay Haine. **448 www.bridgeman.co.uk**/Christie's Images/Private Collection (br). **449 www.bridgeman.co.uk**/Palazzo Pitti, Florence(bl).

All jacket images © Dorling Kindersley.

Dorling Kindersley would like to thank the following for producing the books from which this single-volume compilation has been created:

Drawing Workshop:
Editor Kathryn Wilkinson • **Project Art Editor** Anna Plucinska • **Senior Editor** Angela Wilkes • **DTP Designer** Adam Walker • **Managing Editor** Julie Oughton • **Managing Art Editor** Heather McCarry • **Production Controller** Wendy Penn • **Contributing Editor** Anna Fischel • **Contributing Artist** Lynne Misiewicz • **Photography** Andy Crawford

Watercolour Workshop:
Editor Kathryn Wilkinson • **Project Art Editor** Anna Plucinska • **Senior Editor** Angela Wilkes • **DTP Designer** Adam Walker • **Managing Editor** Julie Oughton • **Managing Art Editor** Heather McCarry • **Production Controller** Wendy Penn • **Photography** Andy Crawford

Acrylics Workshop:
Project Editor Kathryn Wilkinson • **Project Art Editor** Anna Plucinska • **DTP Designer** Adam Walker • **Managing Editor** Julie Oughton • **Managing Art Editor** Christine Keilty • **Production Controller** Shane Higgins • **Photography** Andy Crawford • **Art Editor** Vanessa Marr (for Design Gallery) • **Project Editor** Lynn Bresler (for Design Gallery) • **Managing Editor** David Garvin (for Design Gallery)

Oil-painting Workshop:
Project Editor Kathryn Wilkinson • **Project Art Editor** Anna Plucinska • **DTP Designer** Adam Walker • **Managing Editor** Julie Oughton • **Managing Art Editor** Christine Keilty • **Production Controller** Rita Sinha • **Photography** Andy Crawford • **Art Editor** Vanessa Marr (for Design Gallery) • **Project Editor** Geraldine Christy (for Design Gallery) • **Managing Editor** David Garvin (for Design Gallery)

Dorling Kindersley would also like to thank Kajal Mistry for her editorial help in producing the current volume.